Chagall Monica Bohm-Duchen

ART&IDEAS

Φ

Chagall

Opposite
Marc Chagall
in 1920

Marc Chagall (1887–1985) is simultaneously one of the best-loved and
least understood of all twentieth-century artists. Indeed, it remains
something of a mystery that an artist whose work constantly refers to
the narrow milieu of his childhood, the now vanished world of eastern
European Jewry, should have achieved such extraordinary popularity.
One major reason must surely be the way in which Chagall's art is
unashamedly rooted in the particular, yet succeeds in transcending the
particular to strike emotional and spiritual chords of universal relevance.
Virtually alone among the major twentieth-century artists, he concerns
himself with both tragedy and joy; his most characteristic work possess-
es a *joie de vivre*, a playful wit and sense of the fantastical rarely found
in the art of any period. Also unusual is the unabashed celebration of
romantic love to be found in so much of his work.

The prevalent image of Chagall as an entirely intuitive and untutored
genius was one that the artist himself did much to encourage. However,
as this book aims to show, he was far more subject to external influences
than he ever chose to admit. Although much of his work does seem
endearingly naïve, refreshingly 'primitive' in both style and iconography,
Chagall was in fact an extremely complicated individual, whose long
career as an artist straddled no fewer than eight decades, several highly
disparate cultures, and a wide range of different media. A mass of appar-
ently contradictory qualities, Chagall was both naïve and sophisticated,
modest and arrogant, jealous and generous, melancholy and witty.
Similarly, he found it hard to tolerate criticism of his own work, but
was quick to criticize others. Chameleon-like, he veered, sometimes
uneasily, between two radically different personae: on the one hand,
the 'little Jew from Vitebsk' and on the other, the cosmopolitan citizen
of the world.

Closer scrutiny of almost any example of Marc Chagall's art reveals a
complex talent at work. To a large extent, his best work functions on

the level of poetry – a point that the artist himself, far more attracted by poets than painters, was always keen to emphasize. At the same time, Chagall was always extremely reluctant to acknowledge artistic influences, or to expound on his work and working methods, claiming that he worked in a semi-intuitive manner which could never be subjected to rational analysis; one of his favourite expressions was 'la chimie' (chemistry) as a term to identify, but not explain, the mysteries of creation (although alchemy might have been a more apposite one). If pressed, he preferred to make sweeping, grandiose and sometimes rather sentimental pronouncements about the nature of his art. This attitude goes a long way to explain his utter disregard for factual accuracy, whether in relation to the – often retrospective – dating of his work or the events that affected him. Chagall's autobiography, *My Life*, written when he was still in his late twenties and early thirties, is as colourfully idiosyncratic as his paintings and notoriously unreliable when it comes to facts; it should be regarded more as a vivid work of art in its own right than as documentary source material. Unless otherwise indicated in the text, all quotations in this book come from this source.

To Chagall, poetry functioned primarily on a sensuous and aesthetic level, and hence the epithet 'poetic', when applied to his own work, was one he was happy to accept. To have it labelled 'literary', with its implication of literalness and its downplaying of visual considerations, was another matter altogether. In the art world of the first half of the twentieth century, dominated by abstraction and the notion that art should refer only to itself, his work was indeed often criticized for being over-'literary', over-narrative and over-anecdotal – a charge he went to great lengths to deny, and which accounted for his constant need in later life to make statements such as the following:

And so if in a painting I cut off the head of a cow, if I put the head upside-down, if I have sometimes worked on paintings the wrong way up, it is not to make literature. It is to give my picture a psychic shock that is always motivated by plastic reasons … If finally, one nevertheless discovers a symbol in my picture, it was strictly unintentional on my part … *I am against any sort of literature in painting.*

In a sense, Chagall was right: the creative process is ultimately a

mysterious one; and any artist worthy of the name must indeed put aesthetic considerations first. On the other hand, as this book makes clear, there are numerous references in his art which can, with help, be identified, and which go a long way towards elucidating the artist's intentions, conscious or otherwise. A long way, but not all the way, however; for, contrary to the opinion of certain Chagall scholars, there are no definitive readings of Chagall's, or any other artist's work, and therein, almost certainly, lies much of its power. Similarly, an understanding of the different cultural milieux in which Chagall operated offers important insights into his artistic development, without in any way detracting from his originality.

In this book, therefore, biographical details are interwoven with a close examination of key works in a broad range of media – from oil painting and printmaking to stained glass and tapestry design – and of the artistic, religious, social, economic and political factors that impinged on his creativity. Sceptical of the notion of the genius working in splendid isolation, it aims to demonstrate the fascinating relationship between Chagall's cultural context, his life and his art. As the first monograph able to take full account of the wealth of new material, both visual and documentary, on the artist available to the West since *glasnost* (the policy of greater 'openness' adopted by the Soviet leadership in the late 1980s after the decades of the Cold War), this book devotes proportionately more space to his Russian years than to other periods of his life. The intention throughout, however, is to encourage a critical reappraisal of all stages and aspects of Chagall's long, complex and sometimes perplexing career.

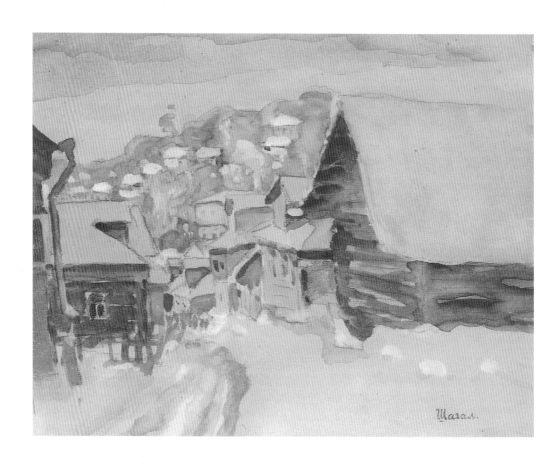

1
Vitebsk,
Yureva Gorka,
1906.
Watercolour on
cardboard;
21·4 × 27·4 cm,
8½ × 10¾ in.
Private collection

Marc Chagall was born Moyshe Shagal on 6 July 1887, into a working-class Jewish family in the Belorussian town of Vitebsk. This place was to occupy so central a position in Chagall's art that – to those in the West at least – the two names have become virtually synonymous. Yet contrary to the image conjured up by many of the paintings (1), Vitebsk was not a picturesque Jewish village or *shtetl* (a small community made up mostly of Jews), but a bustling town of over 65,000 inhabitants. Located on the confluence of the Vitba and Dvina rivers, it was a place where Jews and Christians coexisted and commerce flourished. Capital of the province of Vitebsk, the town forms part of the larger geographical area known variously as Belorussia, Byelorussia, Belarus or White Russia. An essentially fertile land of plains and forests, it has had a chequered political history. Between the late fourteenth and late eighteenth centuries, it belonged to Poland–Lithuania, but with the partition of Poland (1772–95), it became part of the vast Russian Empire first established by Tsar Peter I in the early eighteenth century. It was at this point that the Pale of Settlement (2) was established, stretching along the western borders from the Baltic to the Black Sea, as a means of asserting control over the large numbers of Jews previously resident in Poland. Jews could live outside this area only with a permit.

Ruled over by rich aristocratic, and mostly absentee, landlords, the majority of the inhabitants of Belorussia were illiterate, impoverished peasants. In 1897 Jews comprised 13·6 per cent of the total population of Belorussia, residing either in the larger towns such as Vitebsk and Minsk, where they formed a substantial majority, or in the smaller, predominantly Jewish *shtetls*. Most were poor but religiously both observant and well educated, with little in common with the peasantry beyond their poverty – and indeed much to fear from the peasants' superstitious bigotry. Such peaceable contact as there was between Jews and gentiles was primarily through trade in products such as timber, hemp and flax. Jewish traders had arrived in Vitebsk in the sixteenth

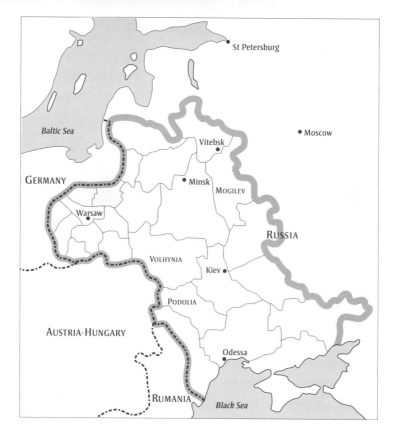

century, possibly earlier, and by 1897, when Chagall was ten years old, Jews comprised over half the town's total population. This was due in part to the expulsion in 1891, prompted largely by commercial jealousy, of approximately 30,000 Jews from Moscow, a substantial number of whom transferred their trades to Vitebsk, bringing with them a new and liberating secularism.

In its layout, Vitebsk was typical of many Belorussian towns of that period. Thus, while the old centre (3) featured numerous imposing historic edifices – above all, the Uspensky Cathedral, but also a large number of fine palaces and Baroque churches – with the coming of the Orel–Vitebsk–Dvinsk railway in the 1860s, and the bridges, station and hotel that accompanied it, the town expanded considerably and modernity began to leave its mark. By the late nineteenth century, Vitebsk was a significant railway junction, where trains passed from Odessa and Kiev to St Petersburg (some 560 km or 350 miles north of Vitebsk), and from

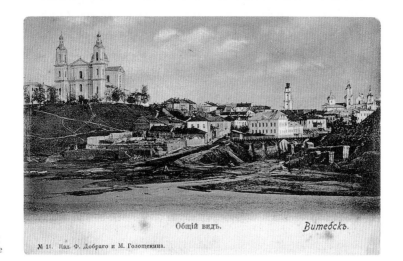

Общій видъ. Витебскъ.

№ 11. Изд. Ф. Добраго и М. Голощекина.

2
The Pale of
Settlement at
the end of the
19th century

3
A postcard of
the centre of
Vitebsk at
the end of the
19th century

4
The outskirts of
Vitebsk at the
end of the
19th century

Riga and the west to Moscow (some 480 km or 300 miles to the east), making the two most important cities in Russia easily accessible. It boasted a lively cultural life, particularly in the fields of music and drama; significantly, its intelligentsia was predominantly Jewish.

On the outskirts (4) of the town, however, where the vast majority of the Jews of Vitebsk resided in working-class districts such as Pestkovatik, where Chagall was born, life retained its humble, self-contained and

semi-rural character – not dissimilar to that of Lyosno, an almost exclusively Jewish village some 48 km (30 miles) from Vitebsk and the home of Chagall's maternal grandfather. Lyosno also featured prominently in the artist's childhood. There was little doubt, moreover, as to which was the 'host' culture. Chagall himself suffered from anti-Semitism at school and, as he tells us in his autobiography, witnessed a pogrom at first-hand, with a strange mixture of fear and fascination. Pogroms, government-condoned attacks perpetrated by Christians against the Jews of Russia and eastern Europe, involving looting and rape as well as murder, were a tragic fact of life during the late nineteenth and early twentieth centuries and prompted massive waves of Jewish emigration to the West and in particular the United States in this period. As a Jew, Chagall could hardly ignore the Russian Christian culture that to a considerable extent shaped – and intensified – his own sense of Jewishness. The way churches so often dominate the skyline in Chagall's visions of Vitebsk is both a literal reference to their conspicuousness in a town where synagogues, by official decree, could only be modest, low-lying structures, and a metaphor for gentile power over the Jewish population.

Until recently the precise date of Marc Chagall's birth was hard to verify, due in part to a lack of documentary evidence, in part to the artist's pronounced tendency to mythologize his own origins. While some books

5
Chagall's parents' house, Pokrovskaya Street, Vitebsk

6
Marc Chagall (standing, second from right) with his parents, siblings and other relatives in Vitebsk, c.1908

(largely on his own earlier, and now discredited testimony) cite 1889 as the year of his birth, Chagall himself, always a superstitious man, favoured the seventh day of the seventh month, 1887 as his 'officially' correct birthdate. However, recent research by a Russian scholar, Aleksandra Shatskikh, has revealed that the fire in Vitebsk which Chagall claims in his autobiography was raging at the time of his birth, actually took place on 24 June according to the 'old' Julian calendar – which, when converted to the 'new' Gregorian calendar (adopted by the Communist regime in 1918), becomes 6 July. So it seems fairly safe to say that Marc Chagall came into this world not on the seventh but the sixth day of the seventh month, 1887.

At the time of his birth, the Shagals lived on the outskirts of Vitebsk in a modest house (5) close to the railway station and to the seventeenth-century wooden Ilinskaya church. The eldest of eight children (6), he had six sisters – Aniuta, Zina, twins Lisa and Manya, Rosa and Mariaska – and one brother, David, born after Aniuta. A ninth child, Rachel, died in childhood. Chagall was given the Yiddish names Moyshe (Moses) Hatskelev which became 'russified' to Moissey Sacharovich. The family name had originally been Segal, and had been changed, probably by the artist's father, to Shagal. In Russian, 'shagal' means 'strode' – perhaps an indication, even at that point, of the family's aspirations. The artist

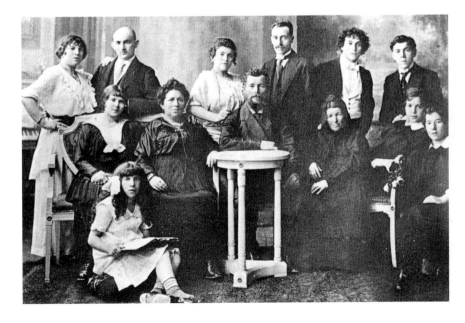

was to rename himself Marc Chagall shortly after his arrival in Paris in 1910, partly to Europeanize and de-judaicize his name, and partly in homage to one of the first Jews – the realist sculptor Mark Antokolsky (1843–1902) – to have made an impact on the Russian art scene. To his family and close friends, however, he remained Moissey (or Moshka, a diminutive of Moyshe) for many years. Yiddish, that richly idiomatic amalgam of Hebrew, German and various Slavic languages, was spoken at home; Hebrew itself was reserved for the world of religious ritual, while Russian was the language in which he addressed the wider world. French (later to become Chagall's adoptive tongue, though he never spoke it like a native) was spoken in Russia only by the aristocracy and the intelligentsia. Small wonder that linguistic confusion, both intentional and unconscious, was so often to enter his art.

His father, Sachar (Hatskel in Hebrew), earned a meagre living as a manual labourer in a firm of herring wholesalers called Jachnin; although undeniably pious – his own father was a scholar and teacher of religion – he was, so Chagall tells us, far too exhausted at the end of each day to do anything but doze, slumped over the family dining table. His mother, Feiga-Ita, daughter of the kosher butcher in Lyosno, was – as so often the case in traditional Jewish communities, where religion was considered the sphere of men, practical domestic realities the domain of women – the driving force behind the family. In addition to looking after the household, she managed to supplement her husband's modest income by running a small grocery store and by renting out three wooden *isbas* or huts in the household compound; so that the family, though far from being well off, was never actually on the poverty line.

The artist's autobiography makes it clear that Chagall saw himself as 'different' from an early age, both physically – he was apparently a strikingly beautiful child – and psychologically. At first, however, his ambitions were unfocused: 'I'll be a singer, a cantor … a violinist … a dancer … a poet … I no longer knew where to let myself go.' After Chagall had attended *heder* (Hebrew school) for at least six years as a young boy, probably between the ages of seven and thirteen, a fifty-rouble bribe from his determined mother opened the doors of the local Russian-speaking elementary school, from which Jews were officially barred. The pressure

to perform well in this alien milieu soon caused him to develop a stammer and an apparent contempt for learning. There were compensations, though – in retrospect at least: 'What I liked best was geometry. At that I was unbeatable. Lines, angles, triangles, squares, transported me into the realms of delight. And during the drawing period, I had everything but a throne.'

In a 1958 interview with the critic Edouard Roditi, Chagall reiterated, in similarly apocryphal terms, the account he had given in *My Life* of his artistic awakening:

In our little provincial ghetto, among the petty traders and craftsmen that my family knew, we had no idea of what it meant to be an artist. In our own home, for instance, we never had a single picture, print or reproduction, at most a couple of photographs of members of the family. Until 1906, I never had occasion to see, in Vitebsk, such a thing as a drawing. But one day in grade school, I saw one of my class-mates busy reproducing, in drawing, a magazine illustration … As I watched him draw, I was completely dumbfounded. To me, this experience was like a vision, a true revelation in black and white. I asked him how he managed such a miracle. 'Don't be such a fool,' he replied. 'All you need to do is to take a book out of the public library and then to try your luck at copying one of the illustrations out of it, as I am doing right now.'

And that is how I became an artist. I went to the public library, selected at random a bound volume of the illustrated Russian periodical *Niwa*, and brought it home. The first illustration that I chose in it and tried to copy was a portrait of the composer Anton Rubenstein … But I was still far from thinking of art as a vocation or profession. At most, it was still but a hobby, though I already began to pin up all my drawings, at home, on our walls.

It was only, he continued, when 'one of my class chums, a boy of a more fortunate and more cultivated family than mine, came to see me at home', and 'went into ecstasies about my drawings', exclaiming 'But you're a real artist!', that it dawned on him that art could indeed become a vocation and a profession. There is a certain irony, of course, in the fact that it was art's mimetic powers that first astonished him – for he was very soon to turn his back on the idea of art as imitation.

Although far more sympathetic than her husband to her eldest son's needs, even Feiga-Ita had no real understanding of his aspirations. When, for example, he showed her one of his early paintings, she apparently responded thus: 'Yes, my boy, I see; you have talent. But listen to me, child. Perhaps you ought to be a clerk. I feel sorry for you … Where do you get that talent?' At least, however, she took his ambition seriously; it was she, not his father, who in 1906 took him to see the well-known Jewish artist Yehuda Pen (1854–1937), who in 1897 had opened a School of Drawing and Painting in Vitebsk – the first predominantly Jewish art school in the Russian Empire. Pen's laconic verdict, 'Yes … he has some ability', was enough to convince her of her son's potential. His father merely mustered enough energy to throw some coins in his direction, to enable those first lessons to be paid for.

While Chagall's mother must undoubtedly take much of the credit, there is another factor that helps to explain the relative ease with which, despite the traditional Jewish opposition to image-making, Chagall obtained his father's (albeit grudging) permission to become an artist. This is the distinctive attitude to religion and learning that characterizes the Hasidic form of Judaism, and the Habad variety of Hasidism in particular, which was the religion of Chagall's parents and grandparents. Vitebsk itself had been a stronghold of Hasidic Judaism since the early eighteenth century. Originating in the extreme southeast of Poland—Lithuania in the 1730s under the leadership of the Ba'al Shem Tov (Hebrew for 'Master of the Good Name'), the movement – which had immense popular appeal – opposed the rationalism, intellectual pedantry and élitism of orthodox Judaism with an emphasis on ecstatic, intuitive communion with God, whose 'holy' sparks were to be found in all things, great and small, and in all people, good and bad. The Habad movement (Habad being the Hebrew acronym for 'Wisdom, Insight, Knowledge') was founded later in the eighteenth century by Schneur-Zalman of Lyady, who was born in Lyosno and tried to counter this anti-rationalism with a continued respect for learning. Generally speaking, though, love for all people and all things and, through them, for God, is central to the Hasidic concept of a religious life: a loving heart is ultimately more important than learning. A Hasidic parable tells of a boy found reciting the Hebrew alphabet in the synagogue; he explains

that since he cannot read the prayer book he is sending the letters up to heaven, where he is sure God will assemble them into a prayer for him. The Hasidim, moreover, were unusually considerate to animals, believing that the souls of sinners transmigrated after death into the bodies of dumb beasts. Chagall's lifelong emphasis on 'that clamorous love that I have, in general, for mankind', his anti-intellectualism and distrust of conventional logic, even his intense empathy with animals are all – in part at least – a legacy of his cultural and religious heritage.

Indeed, it can be seen that, in spite of Chagall's later rejection of organized religion, Hasidic Judaism lies at the very centre of his art. His first wife Bella describes in her memoirs the Jewish festival of *Simchat Torah* (literally, 'Rejoicing of the Torah', *ie* the Pentateuch or Five Books of Moses) celebrated in Hasidic fashion thus:

The table is pushed to one side, the chairs are kicked away. The walls seem to be swaying. The tablecloth slips. Pieces of cake and some glasses fall to the floor. The men begin to leap, to stamp in one spot. They turn the flaps of their coats, and they form little dance circles … With a shout, a tall, thin Jew bounces into the room. He turns a somersault and lands on his feet.

Although there is little doubt that Bella's memories were strongly coloured by the world of her husband's imagination, from this description to the seeming disregard for gravity and logic that characterizes a painting by Chagall seems but a small step. Although by the end of the nineteenth century Hasidism had, in fact, lost much of its original impetus and in many areas had declined into superstition and charlatanry, in Chagall's paintings it was to remain alive and well.

A similar world emerges in the tales of late nineteenth- and early twentieth-century Yiddish writers who were equally nourished by eastern European Hasidism. Sholom Aleichem's story *The Bewitched Tailor*, for example, contains precisely that almost seamless blend of the mundane and the magical that was to become the hallmark of Chagall's paintings. Cows and goats flying to the heavens were not invented by Chagall; on the contrary, Yiddish literature is full of them. Chagall's uniqueness may well lie in the way he was able, in a cultural environment traditionally more sympathetic to the written word, to transpose such

imagery from the realm of the verbal to the visual – without, however, being in any way literal or over-literary. Paradoxically, these flying creatures, born of the milieu in which he grew up, were also a symbol of his desire to break free – and ultimately, a means of doing just that.

Had Chagall been born into a non-Hasidic environment, the pressure on this gifted boy to become a religious scholar would have been much greater. It is also possible that the more sensual nature of Hasidic Judaism – combined with the growing secularization affecting sections of Vitebsk's Jewish community – meant that image-making was regarded with rather less abhorrence than was the case in other, more conservative Jewish communities. Chaim Soutine (1893–1943), another member of that remarkable generation of Jewish artists of Russian and eastern European origin later to congregate in Paris, came from non-Hasidic Smilovitchi in Lithuania and was locked in a cellar for daring to put pen to paper – despite the fact that the image (admittedly, of a rabbi) had been drawn from memory. Yet even in Vitebsk, one of Chagall's many uncles was, the artist tells us, 'afraid to offer me his hand. They say I am a painter. Suppose I was to sketch him? God forbids it. A sin.'

The taboo on 'graven images' contained in the Second Commandment has, in fact, been far less consistently adhered to by the Jews than is commonly believed. The prohibition needs to be seen in its original biblical context, that of Israel seeking to establish monotheism in a sea of idolatry. Later, when the context changed, the Jewish attitude to figurative art varied considerably from area to area and from period to period, for reasons as often political as religious. Prior to the nineteenth century, however, Jewish art, figurative or otherwise, tended to be the work of anonymous craftsmen (not all of them Jewish) producing ritual objects for use in home or synagogue, to the greater glory of God. Art as the celebration of Man (as in the classical and Renaissance traditions) or, more recently, art for art's sake, has usually been regarded with suspicion. In this respect, too, Chagall's Jewishness asserted itself: a sense of a transcendent reality permeates his entire *oeuvre*; while he frequently decried the twentieth-century tendency to make 'a god out of formalism'.

In late nineteenth-century Europe, the political and social emancipation of the Jews and their increasing secularization meant that Jewish artists

were beginning to make their mark in the mainstream art world, without having to suppress every trace of their Jewishness, as had hitherto been the case. Some were leading figures in progressive art movements, for example the Realist painter Jozef Israels (1824–1911) in Holland, the Impressionist Camille Pissarro (1830–1903) in France and the Naturalist Max Liebermann (1847–1935) in Germany. In Russia, one such artist was Mark Antokolsky. Born Mordechai Antokolsky in Vilna in 1843 into a poor and pious family, he achieved the distinction of becoming the first – and at the time, only – Jewish student at the Imperial Academy of Arts in St Petersburg. By the mid-1860s, encouraged by the influential art critic Vladimir Stasov (1824–1906), he had won a considerable reputation for himself as the maker – in defiance of the dominant classical ideal – of realistic sculpted images of Jewish life and history. By the mid-1870s, although remaining religiously observant, he had abandoned overtly Jewish subject matter. This did not, however, protect him from virulent anti-Semitic attacks on his supposed effrontery in dealing with Christian and Russian themes; his depiction of Jesus as a young Jew complete with orthodox side-curls was deemed particularly outrageous (7). Deeply embittered, he was to become a keen supporter of the artistic efforts of younger Jewish artists, and wrote extensively on artistic matters. As he

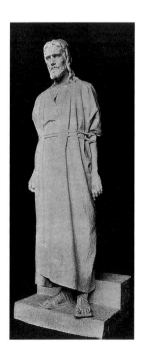

7
Mark Antokolsky,
Ecce Homo,
1876.
Marble;
h.195 cm,
76¾ in.
Tretyakov
Gallery,
Moscow

himself put it, 'I see being a Jew as a big honour for me. I am proud of it and I would like everyone to know that I am a Jew … I hope that Jewishness should not impede my artistic work, I can even serve my own people's wellbeing by means of art.'

In this period of change many Russian Jews turned either to socialism or to Zionism as a means of fulfilling their political aspirations. These two great causes, however, seem hardly to have impinged on the young Chagall's consciousness. Virtually the only reference in *My Life* to social injustice comes in a passage in which he describes his father hard at work while 'his fat employer stood around like a stuffed animal', while a passage that expresses his surprise that gentiles as well as Jews often suffered hardship in Tsarist Russia confirms his political *naïveté*. In point of fact, Vitebsk was one of the earliest centres of the Bund, the name by which the Algemeyner Yidisher Arbeter Bund in Lite, Poyln un Rusland (General Jewish Workers Union in Lithuania, Poland and Russia) was widely known. Founded in Vilna in 1897, the fiercely left-wing Bund came to be associated with a devotion to Yiddish culture, to autonomy and to secular Jewish nationalism within eastern Europe.

Members of Hibbat Zion (Love of Zion) were also as active in late nineteenth-century Vitebsk as elsewhere. This was in effect the first Zionist mass movement, and gave practical encouragement to Jewish emigration to, and settlement in, Palestine, then a politically insignificant part of the vast Ottoman Empire. Just as Chagall's art tells us nothing of endemic Russian anti-Semitism or of the poverty, drudgery and physical drabness that characterized so many Jewish lives, including that of his father, so too it ignores the changes that were already undermining traditional Judaism in Vitebsk – long before its further erosion by the Soviet regime, and its ultimate destruction by the Nazis.

These social, political and artistic currents form the background to the nineteen-year-old Chagall's first period of artistic study with Yehuda Pen. Originally from the small town of Novo-Aleksandrovsk in Lithuania, Pen was a member of a group of young Jews who, thanks in part to the precedent set by Antokolsky, were able to study at the Imperial Academy of Arts in St Petersburg in the 1880s. From the early 1870s the democratic, anti-academic ideas of the group of Realist artists known as the

Wanderers (*Peredvizhniki*), who aimed to bring art to the people through travelling exhibitions, had paved the way for Jews who sought access to the Russian art world, enabling Isaac Levitan (1861–1900) and Leonid Pasternak (1862–1945) to emerge as successful artists. In contrast to prevailing ideals, Vladimir Stasov, the main spokesman for the movement, actively sought to encourage artistic expressions of ethnic and religious difference. The otherwise anti-Semitic climate of that period meant, however, that these artists, and those who followed them, tended to keep together, all too well aware of the problems – as well as the challenges – facing the Jew who aspired to be a professional artist. Thus it was that Pen chose in 1897 to open his art school in Vitebsk.

It is clear, therefore, that Chagall's retrospective claim, 'But a word as fantastic, as literary, as otherworldly as the word "artist" – well, I might have heard of it, but it had never been uttered by anyone in our town', was a gross exaggeration, made presumably to dramatize the inauspiciousness of his origins. The word 'artist' may indeed have been an alien one to Chagall's devout, working-class parents; but there were other Jews, more affluent and secularized (his future in-laws among them), for whom this was no longer the case. Nevertheless, the fact that Pen was a religiously observant Jew must have reassured not only Chagall's mother but other Jewish parents in Vitebsk, and made his School of Painting and Drawing the obvious choice for a substantial number of aspiring young Jewish artists, both male and (more surprisingly) female.

Chagall's encounter with Yehuda Pen gave him his first heady, if ambivalent whiff of freedom:

Even as I climbed his stairs I was intoxicated, overwhelmed by the smell of the paints and the paintings. Portraits on every side. The governor's wife. The governor of the town himself. Mr L– and Mrs L–, Baron K– with the Baroness and many others. Did I know them?
A studio crammed with pictures from floor to ceiling. Stacks and rolls of paper are heaped on the floor too. Only the ceiling is clear.
On the ceiling, cobwebs and absolute freedom.
Here and there stand Greek plaster heads, arms, legs, ornaments, white objects, covered with dust.
I feel instinctively that this artist's method is not mine.

8
Yehuda Pen,
*Portrait of
Marc Chagall*,
1906–8.
Oil on canvas
mounted on
cardboard;
57·5 × 42 cm,
22⅝ × 16½ in.
Belorussian
State Art
Museum, Minsk

9
Yehuda Pen,
*An Old Man
with a Basket*,
before 1912.
Oil on canvas;
70 × 59·5 cm,
27½ × 23½ in.
Museum of
Regional and
Local History,
Vitebsk

Predictably, Chagall later claimed to have learnt nothing whatsoever from his apprenticeship with Pen. However, the opening up to the West since the late 1980s of the Vitebsk Museum of Regional and Local History and, above all, the Belorussian State Art Museum in Minsk have enabled western viewers at last to assess Pen's *oeuvre* for themselves. Pen was certainly no genius, and to this day is remembered more for being the first teacher of a far greater talent (8) than for his own productions. Yet while it is true that neither fashionable portraiture nor academic Neoclassicism ever held the slightest appeal for Chagall, his retrospective account fails to mention the fact that Pen was probably best known as the producer of conventional but sensitive scenes of Jewish life (9), which undoubtedly influenced the young man's development. Since, moreover, we know that Pen was a subscriber to the Berlin-based Zionist monthly magazine *Ost und West* and took an active interest in the idea of a Jewish cultural renaissance espoused by Vladimir Stasov and his circle, it would have been in Pen's studio that Chagall first encountered contemporary Jewish culture and the lively debates surrounding it.

For all the undeniable differences in approach between Chagall and naturalistic, often nostalgic painters such as Pen, the importance for

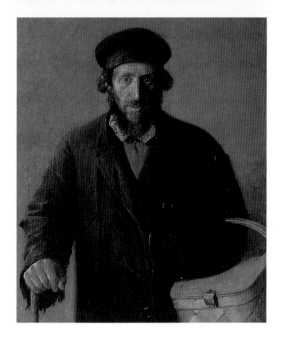

him of the existence of an established tradition of Jewish genre painting should not be overlooked. In Europe, this was exemplified by artists such as Moritz Oppenheim (1800–86) in Germany and Isidor Kaufmann (1853–1921) in Austria–Hungary; elsewhere in Russia, by artists such as Isaac Askenazi (1856–1902), Mordechai Zvi Mane (1859–86) and Moses Maimon (1860–1924); while in Vitebsk, Pen's influence on a large number of younger artists – including Abel Pann (1883–1963), Solomon Yudovin (1892–1954) and El Lissitzky (1890–1941) – was pronounced. Indeed, Pen's influence on Chagall – as we shall see – extended well beyond these early student days. Nor, finally, should it be forgotten that when parental financial support dwindled, the kindly Pen continued to teach Chagall free of charge.

What was the work that Chagall produced in these very early apprentice years before 1907 like? Was it indeed the 'painting different from the painting everyone else does', to which he already aspired? From the few works that have survived, it seems that his early productions – most of them works on paper – were distinctly tentative. Many of them are hesitant renderings of the modest wooden structures that formed his immediate physical environment, as in a watercolour of 1906 entitled *Vitebsk, Yureva Gorka* (see 1), but already possessing a not-quite-ingenuous

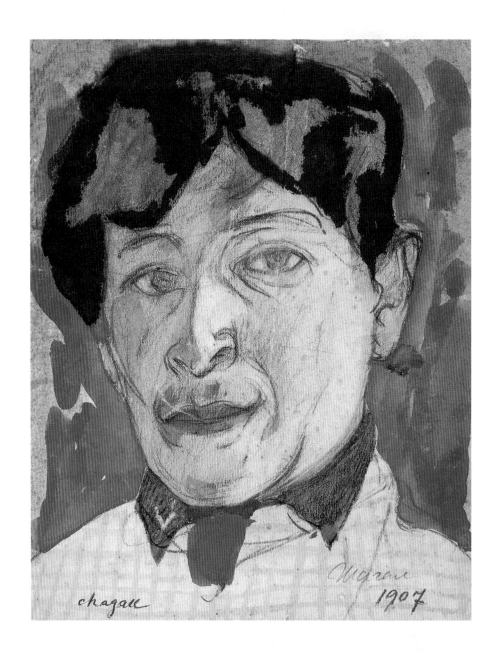

chagall

Шагал
1907

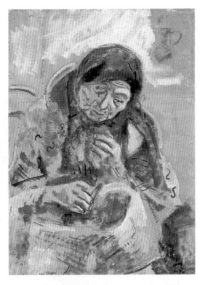

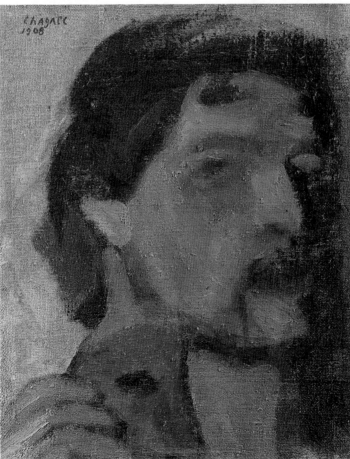

10 **Opposite**
Self-Portrait,
1907.
Pencil and
watercolour on
paper;
20·7 × 16·4 cm,
8¹⁄₈ × 6¹⁄₂ in.
Musée National
d'Art Moderne,
Centre Georges
Pompidou, Paris

11 **Above left**
*Woman with
a Basket*,
1906–7.
Gouache, oil
and charcoal
on cardboard;
67·5 × 49·3 cm,
26 × 19³⁄₈ in.
Tretyakov
Gallery, Moscow

12 **Above right**
Paul Gauguin
Self-Portrait,
c.1888.
Oil on canvas;
46 × 38 cm,
18¹⁄₈ × 15 in.
Pushkin
Museum of Fine
Arts, Moscow

13 **Left**
Self-Portrait,
1908. Oil on
canvas;
30·2 × 24·2 cm,
11⁷⁄₈ × 9¹⁄₂ in.
Musée National
d'Art Moderne,
Centre Georges
Pompidou, Paris

oddness in, for example, perspectival detail, that makes it clear that realism was never his primary aim. Portraits, either of himself or others, for example *Self-Portrait* of 1907 (10) and *Woman with a Basket* of 1906–7 (11), are technically clumsy but pyschologically penetrating.

In contrast, a *Self-Portrait* of 1908 (13) expresses a new confidence, and is clearly inspired by the arrogant self-portraits produced by Paul Gauguin (1848–1903) in the late 1880s (12). Another painting of this period, *The Window* of 1908, also reveals a new level of accomplishment. More technically assured and aesthetically resolved, its restrained blue, green and brown tonalities are both lyrical and darkly atmospheric, the rainbow and luminous flowers lending the composition an aura of strangeness. *The Dead Man* (14) of c.1908 reveals an even more certain touch, a vision consolidating itself and the emergence of an unusual talent. The colours are muted in keeping with academic practice, but the acidic green of the sky jars against the predominantly reddish-brown hues of the lower part of the composition. This adds to the surreal quality evoked also by the stylized, 'primitive' postures, the denial of traditional perspective and modelling, and by one of the first appearances in Chagall's work of the figure of the fiddler on the roof.

14
The Dead Man, c.1908.
Oil on canvas;
68·2 × 86 cm,
26⅞ × 33⅞ in.
Musée National d'Art Moderne, Centre Georges Pompidou, Paris

Like so much of Chagall's mature work, *The Dead Man* seems to have been inspired in part by composite childhood memories, in part by a cunning visualization of linguistic idioms. According to *My Life*, it was not uncommon in Vitebsk for people to escape on to the rooftops in times of danger or excitement, or simply to get away from it all. Other clues can be found in autobiographical references to one of Chagall's uncles, who 'played the violin, like a cobbler' – which helps explain the boot suspended in the air, reminiscent of a shop sign. The painting also relates to a description of an adolescent encounter with death:

One morning, well before dawn, cries suddenly rose from the street …
I managed to make out a woman running alone through the deserted streets. She is waving her arms, sobbing, imploring the occupants, who are still asleep, to come and save her husband … Startled people come running from every side … The dead man is already lying on the ground in sad solemnity, his face illuminated by six candles … They carry him away.

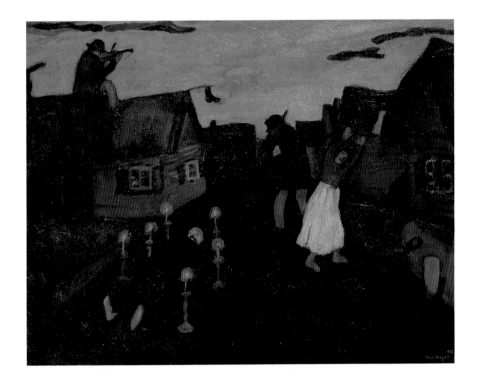

It is important to remember, however, that *My Life* was completed in the early 1920s and is as much a response to pictures already painted as a record of actual childhood experiences. Nor, in this case, does it explain all the painting's main features – the figure of the street sweeper, for example, with its resonances of Death the Reaper.

Much later, in 1959, Chagall stated that the painting's source was an eerie experience of a lonely street in Vitebsk: 'How could one paint a street with psychic forms but without literature? How could one construct a street as black as a corpse but without symbolism?' This gives us a clue to a different level of meaning. The Yiddish expression for a deserted street means literally a 'dead street'. This phrase might have suggested to Chagall 'a street as black as a corpse', and prompted him to place the corpse in the street (not a traditional Jewish practice). Once this was done, that other childhood memory may well have taken over.

By the time the 1908 *Self-Portrait*, *The Window* and *The Dead Man* were painted, Chagall had left Vitebsk and was living in St Petersburg. It was another Jewish student of Yehuda Pen, a boy called Victor Meckler, from a far more affluent background than Chagall, who suggested that they should try to find fame and fortune in the big metropolis; and in the winter of 1906–7, not yet twenty years old, still 'pink and curly-haired', and armed with a mere twenty-seven roubles from his father, Chagall made ready to depart. First, however, he had to obtain the papers that would allow him access to the city, since the Russian imperial capital lay outside the Pale of Settlement where most Jews were permitted to live, and which remained in force until the Revolution of 1917. Although the Pale's five million predominantly Yiddish-speaking Jews could travel more or less freely within the territory, maintaining their distinctive religious and cultural identity, permission to live and work outside was restricted to an élite few. There were loopholes, however, which the Chagall family was apparently able to exploit: 'My father obtained a provisional certificate from a tradesman, as though I had been instructed to go and take delivery of some goods for him.' Thus armed, Chagall set out, 'towards a new life, in a new town'.

This 'new town', commanding the mouth of the River Neva, had been founded by Tsar Peter I (Peter the Great) in 1703 and named St

Petersburg after his patron saint. Russia's first Westernized metropolis, it was the seat of government until Moscow became the capital in 1918. By the late eighteenth century, it was one of the most important cultural centres of eastern Europe and with its broad avenues and Neoclassical buildings, one of the most elegant. The development in the nineteenth century of harbour facilities, and the industrial and population growth that accompanied this, led to a dramatic polarization between the poverty of the factory workers and the luxury of the royal court. These social extremes in due course led to political unrest and revolutionary ferment: both the 1905 and the 1917 Revolutions began in St Petersburg (renamed Petrograd in 1914 because the former name sounded too Germanic when Russia and Germany were enemies in World War I). Indeed, at the time of Chagall's arrival, the memory of the 1905 Revolution, following defeats in the Russo-Japanese War of 1904–5, would have been fresh in every resident's mind, its consequences vividly felt. Although Tsar Nicholas II ultimately crushed the revolution, he made certain important concessions in the form of granting the country a constitution and appointing a prime minister and a parliament (the Duma) for the first time in Russian history. Reflecting the turmoil of the period, the history of the Duma, which lasted from 1906 until 1917, was a turbulent and volatile one.

The story of Jewish residence in the capital was also a chequered one, periods of relative tolerance alternating with ones of constraint, persecution and even expulsion. It was only in the late nineteenth century, during the reign of Alexander II, that laws were passed granting right of residence outside the Pale of Settlement to merchants, craftsmen and intellectuals. These wealthy, educated and secularized Jews soon wielded an influence both on Russian Jewry and Russian society as a whole which was disproportionate to their numbers. By 1914 there were 35,000 Jews living legally in St Petersburg, comprising a mere 1·8 per cent of the total population. If one takes into account those residing there illegally or semi-legally, like Chagall, the numbers were significantly higher.

In physical terms, St Petersburg was far larger, grander and more Western in appearance than Vitebsk. In cultural terms too, Chagall's native town faded into relative insignificance. Although he would not

mix directly in élite intellectual and artistic circles until after his
return to the city in 1915, Chagall soon became aware of the presence
of talented and innovative figures in all the arts, such as the composer
Igor Stravinsky or the poets Anna Akhmatova, Osip Mandelstam and
Aleksandr Blok.

Unsurprisingly, then, it took Chagall some while to find his feet in St
Petersburg. He himself admits that he failed to feel any elation when he
left his home town: 'I knew that I had to leave,' he says, but adds, 'I
found it difficult to define exactly what I wanted.' Moreover, the prob-
lem of obtaining the necessary permit for residence in the capital contin-
ued to beset him. Temporary solutions were found – for a while he was
registered as a servant at the home of an affluent Jewish lawyer and art
patron called Goldberg, but at one point actually spent the night in
prison for not having the permit on his person when questioned by the
authorities. Although he seems to have found the experience a fascinat-
ing one (it would later find ambivalent expression in a gouache of 1914
entitled *In Prison*), he determined on his release to become apprenticed
to a sign-painter, since evidence of learning a trade would entitle him to
the all-important residence permit.

His artistic training also suffered several setbacks. As a Jew without a
high-school certificate, he could not even hope to enter the Imperial
Academy of Arts, and he failed the entrance examination for Baron
von Steiglitz's prestigious School of Arts and Crafts. Chagall thus had
to content himself with enrolling in an 'easier' school, that of the
Imperial Society for the Protection of the Arts, while also working
part-time as a retoucher for a photographer called Jaffe. His contact
with photographers – for whose bourgeois complacency he expressed
a lively contempt – had in fact started in Vitebsk, where he had worked
briefly as a retoucher for a man called Meshchaninov while studying
under Yehuda Pen.

By his own witty but misleading account, the school had little to
offer him:

What did I do there? I couldn't tell you.
Numerous plaster heads of Greek and Roman citizens projected from every

corner and I, poor provincial, had to pore over the wretched nostrils of
Alexander of Macedonia – or some other plaster idiot.
Sometimes I walked up to those noses and punched them. And, from the
back of the room, I stood and stared at the dusty breasts of Venus.

In fact, it seems that the school's director, Nikolai Roerich (1874–1947),
allowed his students considerable freedom, encouraging them to discov-
er the riches of the city's museums. It was at this juncture that Chagall
first looked seriously at Christian icons in the Russian Museum, and at
the work of Andrei Rublev (c.1360–1430) in particular.

Roerich is now best known for his stage designs for the Ballets Russes
(Russian Ballet), which, under the direction of the impresario Sergei
Diaghilev, became famous for its revolutionary blend of modern music,
choreography and design. It was through Roerich's intervention that
Chagall was exempted from military service – as Chagall wrote to his
teacher in 1908: 'I love art too much, I have lost and will lose again too
much to accept the notion of wasting three years of my life in the ser-
vice.' Moreover, in spite of Chagall's apparent restlessness, he was one of
only four students offered a scholarship to the school – fifteen roubles a
month for a whole year. When that money ran out, a letter of introduc-
tion from the Jewish sculptor Ilya Ginsburg (1859–1939) to the scholar
and philanthropist Baron David Ginsburg provided Chagall with a
patron – albeit only for a few months. Ilya Ginsburg, a teacher at the
Academy, with whom Yehuda Pen had associated in the 1880s, was then
at the height of his fame as a producer of fashionable portrait busts.

Dissatisfied with the School of the Imperial Society for the Protection
of the Arts and unable, moreover, to handle the public criticisms of his
work that he received there, Chagall left in July 1908, and spent a few
months at a private school run by the naturalistic genre painter Savely
Zeidenberg (1862–1924). Equally ill at ease with what was on offer there,
he looked around for something better. That 'something better' turned
out to be the Zvantseva School, 'the only school animated by a breath of
Europe', in which Léon Bakst (1866–1924) was then teaching. Bakst, well
established as a leading light in the progressive Russian art world but
equally at home in Paris, could offer Chagall wider horizons than any
other artist then living in St Petersburg.

When Chagall actually came face to face with Bakst, he immediately
felt a certain empathy with him: 'Reddish curls clustered above his ears.
He could have been my uncle, my brother.' As Chagall intuited, Bakst –
whose real name was Lev Samuilovich Rosenberg – was indeed a Jew
(albeit from a more assimilated background than Chagall), a fact that
must have helped reassure the younger man that he was not entirely out
of his depth. In artistic terms, however, he was at Bakst's mercy, and
for a second time he waited on the verdict of 'the great man': 'If my
first visit to Pen only mattered to my mother, the one I paid to Bakst
mattered a great deal to me, and his opinion (whatever it was) would
be decisive.' In the event, the verdict was positive, but qualified, as he
'drawled in his lordly accent: "Ye … es, ye … es, there's talent there;
but you've been spo … iled, you're on the wrong track, spo … iled, …
spoiled, but not completely."'

So Chagall became Bakst's pupil, together with such luminaries as the
dancer and choreographer Vaslav Nijinsky, a leading member of the
Ballets Russes. Once again, however, Chagall was to be disappointed:
'What's the use of pretending: something in his art would always be
alien to me.' The fault, Chagall later claimed, may well have lain not
with Bakst personally, but with Mir Iskusstva, the artistic society to
which he belonged. Mir Iskusstva (World of Art) was a group of Russian
artists and writers, founded in the 1890s, and in many respects the
Russian counterpart of the Aesthetic and Symbolist movements in the
West. Opposed to academic and naturalistic art alike, their motto was
'art for art's sake', and their views, propounded in the journal *Mir
Iskusstva,* which Diaghilev edited from 1898 to 1904, were highly
influential. Such artists as Roerich, Alexandre Benois (1870–1960),
Valentin Serov (1865–1911), Bakst and Mstislav Dobuzhinsky (1875–1957),
who was to teach Chagall at the Zvantseva School after Bakst's depar-
ture for Paris, looked both to traditional Russian culture and to the
major modern movements in Europe for inspiration.

15
Léon Bakst,
Set design for
the ballet
Schéhérazade,
1910.
Watercolour,
gouache and
gold on paper;
54.5×76cm,
21½×30 in.
Musée des Arts
Decoratifs, Paris

Although Chagall later characterized Mir Iskusstva as an alien milieu in
which 'stylization, aestheticism and all kinds of worldly styles and man-
nerisms flourished', his own earliest extant poems, mostly rather indul-
gent reveries on the theme of love, written in 1909–10, are distinctly

stylized and aestheticized. And the work of these artists undoubtedly opened the young Chagall's eyes to the colourful possibilities of exploiting the exotic eastern elements of Russian folklore (15). Bakst's exhortation to his students to regard colours as compositional elements in their own right would have a lasting impact on him; while it may well have been Bakst's interest in folk art and the art of children – expressed more directly in his writings than his visual imagery – which alerted Chagall to their relevance for his own art. Others shared this interest; notable

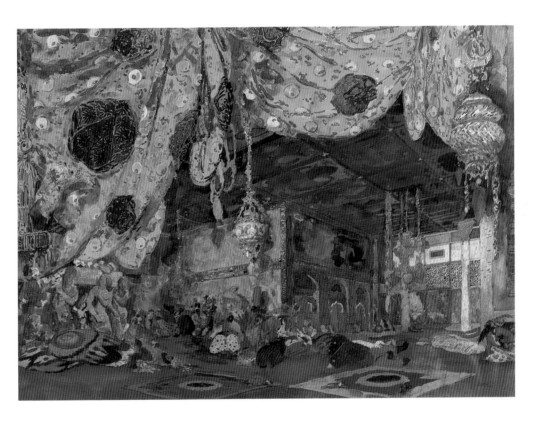

among them was the poet Aleksandr Blok, a close associate of Bakst, who in 1908 called on artists to combine the 'soul of a beautiful butterfly and the body of the useful camel'.

It can hardly be a coincidence that around this time a new Russian avant-garde was emerging whose interests were in marked contrast to those of the Mir Iskusstva group and in some respects ran parallel to Chagall's own. Artists such as Mikhail Larionov (1881–1964) and Natalia Goncharova (1881–1962) were based in Moscow, and hence unlikely at

this juncture to have been known to Chagall; they opposed the hot-house atmosphere of Bakst's kind of art with a deliberate primitivism (16) inspired by folk imagery derived primarily from the *lubok*, a type of popular woodblock print (17), Russian icons and the art of children.

In some respects, this art looked back to the earthy qualities (18) of an earlier generation of Russian artists, the group of late nineteenth-century populist realist painters known as the Wanderers, led by Ilya Repin (1844–1930), for whom Chagall expressed a certain sympathy, and who, decades earlier, had given support and encouragement to the young Yehuda Pen. That, in contrast, Repin himself had little time for the new, anti-naturalistic tendencies is evidenced by his derisive reaction

16
Mikhail Larionov, *Soldier at the Hairdresser*, 1910–12. Oil on canvas; 117 × 89 cm, 46 × 35 in. Location unknown

17
Barber Cutting the Beard of an Old Believer, c.1770s. Woodcut; 35.3 × 29.6 cm, 13⅞ × 11⅝ in

18
Ilya Repin, *Religious Procession in Kursk Province*, 1880–3. Oil on canvas; 175 × 280 cm, 69 × 110¼ in. Tretyakov Gallery, Moscow

to an exhibition of work by students of the Zvantseva School, and Chagall's work in particular. The exhibition was held at the St Petersburg premises of the magazine *Apollon* in the spring of 1910 – the first ever public showing of any work by Chagall. Others responded in a similarly mocking fashion to this display of student avant-gardism. In a contemporary caricature showing viewers at the exhibition two of Chagall's contributions are immediately recognizable.

As important as all these influences were the solitary, intimate lessons Chagall learnt at the Hermitage Museum, where for the first time he encountered some of the great works of art of the past. As paintings such as *Self-Portrait with Brushes* of 1909 (19) testify, it was above all in

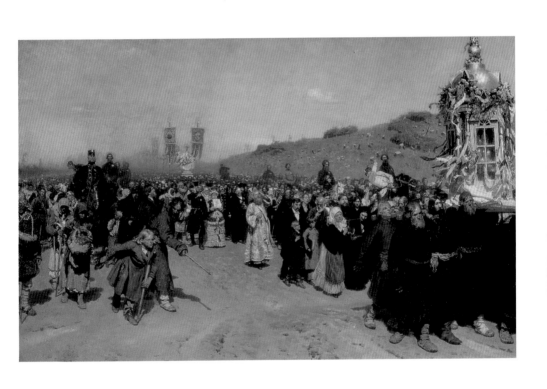

Rembrandt van Rijn (1606–69) that he discovered a kindred spirit – and a new confidence, bordering on defiance, learnt also from Gauguin. In his 1914–15 series of paintings of old Jews, Chagall was to pay further homage to the Dutch master, even inscribing his name in Hebrew on the painting *Jew in Bright Red* (see 69); while *My Life* includes the bitter-sweet lines: 'Neither Imperial Russia nor Soviet Russia needs me. I am a mystery, a stranger to them. I'm certain Rembrandt loves me.' It is inter-esting to note that a disproportionate number of modern Jewish artists have felt a strong empathy with Rembrandt. The Israeli artist Moshe Castel (1909–92), for example, spoke of Rembrandt's work as 'reflecting the holy spirit' and of his ability to transform 'the plasticity of the flesh into a biblical holiness as a pure Jew' – which may go some way to explain why this has been the case.

It was while studying at the Zvantseva School that Chagall also first encountered names such as Paul Cézanne (1839–1906), Édouard Manet (1832–83), Claude Monet (1840–1926) and Henri Matisse (1869–1954): 'Without even knowing there was such a place as Paris, I found a miniature Europe in Bakst's school.' The journal *Apollon*, with which Bakst was closely associated, was one of several publications which demonstrated their support for French avant-garde art by organizing exhibitions in St Petersburg of work by such artists as Gauguin, Pierre Bonnard (1867–1947), Édouard Vuillard (1868–1940), André Derain (1880–1954) and Matisse. Once Paris and its promise of artistic and per-sonal freedoms entered his consciousness, it was almost inevitable that his sights should thereafter be set on getting there. He turned first to Bakst himself, who offered him the chance of joining him, Diaghilev and the by now famous Ballets Russes in Paris, if he could prove his cre-dentials as a painter of scenery for the ballet *Narcisse* – which, although he leaves this unsaid in *My Life*, he failed to do. In the end, he had to find his way to Paris by an alternative route.

That route turned out to be through the assistance of one of a growing number of cultured patrons, Max (Maxim) Moisevich Vinaver. Vinaver was a liberal lawyer and politician, one of the first Jewish members of the Duma, who, like some of his other patrons – by Chagall's own account – 'dreamt of seeing me become a second Antokolsky'. These

19
Self-Portrait with Brushes, 1909.
Oil on canvas; 57×48 cm, 22½×19 in.
Kunstsammlung Nordrhein-Westfalen, Düsseldorf

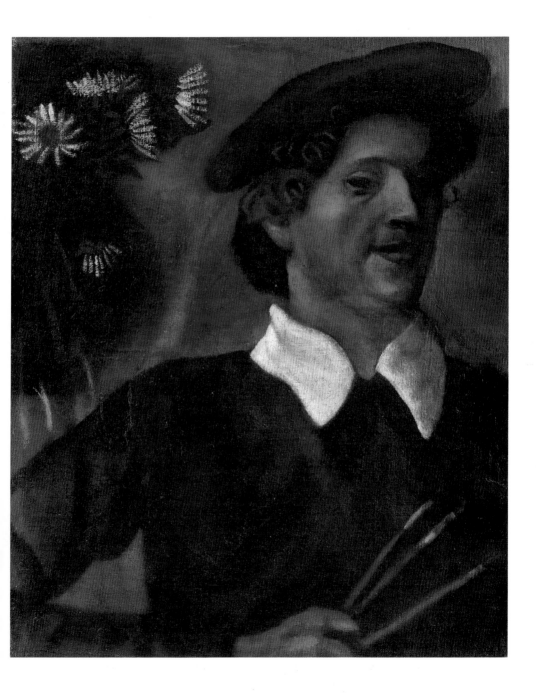

men, who included Vinaver's brother-in-law Leopold Sev, the critic Maxim Syrkin and the social historian and writer Solomon Pozner, were closely associated with the Jewish cultural journal *Novyi Voskhod* ('New Dawn'), the Russian-language mouthpiece of secularized Jews eager to promote a Jewish national consciousness. It was Vinaver who, having provided Chagall with living accommodation in the flat occupied by the editorial staff of the journal, became 'the first person in my life to buy two of my pictures'. Although an eminent public figure, Vinaver was not too lofty, Chagall tells us, to love 'those poor Jews, coming down with the bride and groom and musicians from the top of my canvas'. This is almost certainly a reference to *Russian Wedding* (20), painted in 1909, one of a series of folkloristic, self-consciously 'primitive' works concerned with the landmarks of human existence. *The Dead Man* of *c.*1908 (see 14) can be seen to belong to this cycle, as can the equally remarkable *Birth* of 1910 (21).

20
Russian Wedding, 1909.
Oil on canvas; 68 × 97 cm, 26³⁄₄ × 38¹⁄₄ in.
E G Bührle Foundation, Zurich

Someone else, meanwhile, had paid him a more dubious compliment. A picture-framer and dealer, to whom Chagall had taken first his own copy of a work by the Jewish landscape painter Levitan (from Vinaver's collection) and then fifty or so of his own canvases, pretended, when Chagall reappeared the following day, to have no knowledge either of him or his paintings. This was the first of a series of major losses that go a long way to explain Chagall's sometimes paranoid attitude to strangers and his jealous suspicion of other people's motives in later life.

In the meantime, probably in 1909, on one of his frequent return visits to Vitebsk, Chagall met Bella Rosenfeld, the girl who some six years later would become his wife, muse and surrogate mother. His adolescent relationships with members of the opposite sex had been numerous, romantically intense but essentially chaste: Nina, Aniouta, Olga and Thea all receive a brief and slightly wistful mention in *My Life*. Thea Brachman, the last of these girls, belonged to the cultured milieu in Vitebsk to which Chagall had been given access by Victor Meckler, who had suggested the move to St Petersburg. She was the daughter of a Jewish doctor and at the time was studying in St Petersburg; it was through her that Chagall met Bella, eight years his junior and then only in her early teens:

Suddenly I feel that I should not be with Thea, but with her!
Her silence is mine. Her eyes, mine. It's as if she had known me for a long
time, and knew all my childhood, my present, and my future; as if she had
been watching over me, reading my innermost thoughts, although I have
never seen her before. I knew that this was she – my wife.

Although Bella's parents were also observant Hasidic Jews, they were
considerably better off than Chagall's parents. Indeed, the Rosenfelds
were one of the wealthiest families in Vitebsk, and the secularization
of Jewish middle-class culture, which allowed Bella, their eldest daugh-
ter, to take a passionate interest in the theatre and in seventeenth-
century Dutch and Italian painting and enabled her to study in Moscow,
was already well under way in that household. Her father owned three
lucrative shops selling jewellery, clocks and watches – which is one
explanation, if only a partial one, of the clocks that appear as powerful
leitmotifs in Chagall's *oeuvre*. The different social status of the two
families made it inevitable that Bella's parents should frown upon any
intimacy between the young couple (22). Chagall himself realized that
marriage would have to wait until Bella was older and until he had
proved himself in the world. Whether his commitment to Bella would
have affected his determination to go to Paris is open to question; in
any event, what he chose to perceive as the small, enclosed world of
Vitebsk was hemming him in more than he could bear:

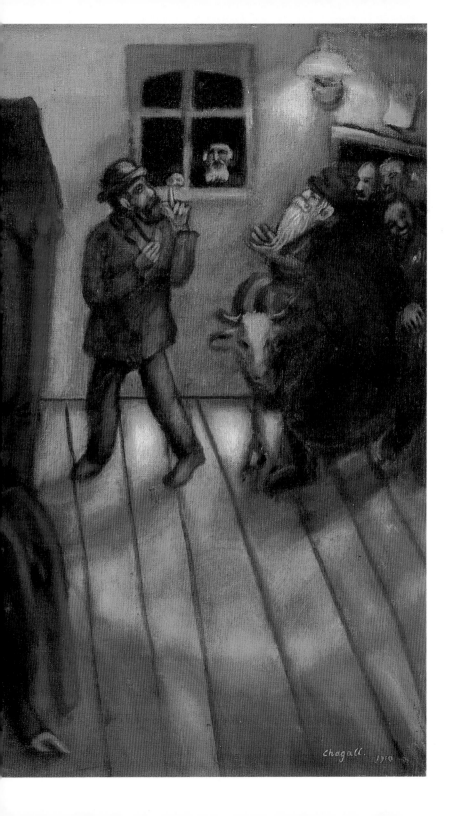

21
Birth,
1910.
Oil on canvas;
65 × 89 cm,
25⅝ × 35 in.
Kunsthaus,
Zurich

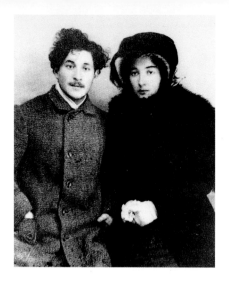

But I felt that if I stayed in Vitebsk any longer, I should be covered with hair and moss.

I roamed the streets, I searched and prayed.

God, Thou who hidest in the clouds, or behind the cobbler's house, iay bare my soul, the aching soul of a stammering boy, show me the way. I do not want to be like all the others; I want to see a new world.

In answer, the town seems to snap like the strings of a violin, and all the inhabitants begin walking above the earth, leaving their usual places.

Familiar figures install themselves on the roofs and settle down there.

All the colours spill out, dissolve into wine, and liquor gushes out of my canvases.

I am very happy with you. But … have you heard of traditions, of Aix, of the painter with the severed ear, of cubes, of squares, of Paris?

Vitebsk, I'm forsaking you.

Stay on your own with your herrings!

It was shortly after buying the two pictures mentioned above that Vinaver guaranteed Chagall the monthly stipend of forty roubles, to be paid through the Credit Lyonnais, that enabled the young man to convert his dream of living in Paris into a reality. After a gruelling four days in a third-class railway carriage, the 23-year-old Chagall – accompanied by much of his artistic output to date – arrived in Paris, probably in the late summer of 1910.

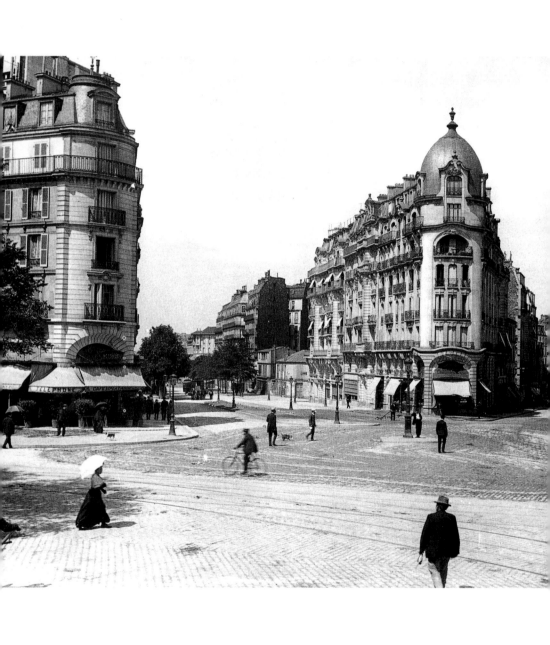

When Chagall arrived in Paris from Russia in 1910, his old friend from
Vitebsk, Victor Meckler, was there to meet him at the Gare du Nord.
Meckler had arrived in Paris the year before, and was already thoroughly
disillusioned; within the year, he would be back in Russia. Although
Chagall's own love affair with the city of Paris was to be of far longer
duration, it must have been reassuring to be met by a familiar face. If
the Jewish boy from provincial Vitebsk had taken a while to find his feet
in St Petersburg, how much more daunting – albeit exhilarating – a
prospect Paris must have presented. 'Only the great distance that sepa-
rates Paris from my native town prevented me from going back home
immediately or at least after a week, or a month,' Chagall tells us in
My Life. But, he continues, 'it was the Louvre that put an end to all
this wavering.' The sense at last of having direct access to the great
traditions of Western art (previously only glimpsed at in his visits to
the Hermitage) confirmed his suspicion that Russian art was 'condemned
by fate to follow in the wake of the West'; that it was in Paris rather
than St Petersburg that his artistic allegiances lay. Yet, as we will see, it
was precisely his exotic 'otherness', in personal and artistic terms alike,
that was to lead to his success in the city of art.

Paris, with its acknowledged masters, its lively café life, its numerous
art schools, museums, galleries, dealers and exhibition spaces, had
been the undisputed centre of the art world for at least a century.
Painters and sculptors – many of them foreigners – had first begun to
settle in Montparnasse, in the southern part of the city, in the early
nineteenth century, attracted by its semi-rural openness and tranquillity.
By the middle of the century, the character of the area was changed
dramatically by the construction of two grand avenues, the boulevard
du Montparnasse and the boulevard Raspail, which formed part of
Baron Haussmann's radical transformation of the city between 1852
and 1870. The number of artists residing there continued to grow, so
that by 1890 nearly one-third of all painters and sculptors in Paris lived

23
The Carrefour
Vavin, Paris,
c.1910

in Montparnasse; while during the first three decades of the twentieth century, foreign artists comprised between thirty and forty per cent of all artists living in that area. Although there was always a substantial number of artists from neighbouring Switzerland, Belgium and Holland, before the Franco-Prussian War of 1870 the majority of foreign artists were German. From the 1880s onwards, the Americans formed the largest single group, followed by those who came from Russia and eastern Europe; after World War I the latter would become the largest group.

At first, due partly to the physical proximity of the École des Beaux-Arts, the most prestigious and traditional art school in Paris, and of the studios of some of its teachers, most of the Montparnasse-based artists were of an academic persuasion. Until the 1860s, the annual Salons, the exhibitions held in the Salon d'Apollon in the Louvre by the French Royal Academy of Painting and Sculpture, were the only public art exhibitions in Paris. In protest at their conservatism and élitism, alternative exhibiting opportunities were established in the late nineteenth and early twentieth centuries, primarily in the form of the Salons des Indépendants and the Salons d'Automne, held each year in the spring and autumn respectively. Hand in hand with these developments came the emergence of private gallery spaces and commercial art dealers such as Paul Durand-Ruel, Daniel-Henry Kahnweiler and Ambroise Vollard.

It was in the more obviously picturesque quarter of Montmartre, on a hill on the other side of the city, that the more bohemian artists gathered in the nineteenth century. In the first decade of the twentieth century, one of the Bateau Lavoir studios in the rue Ravignan was home to the charismatic Spaniard Pablo Picasso (1881–1973), who settled in Paris in 1904. It was here in 1907 that Picasso would create *Les Demoiselles d'Avignon* (24), the painting that, in its borrowings from African and Iberian sculpture, its fragmentation of form and use of multiple perspectives, was to prove a seminal work in the development of Cubism.

By the time Chagall arrived in Paris, Cubism was unequivocally the most influential art movement of the day. The Analytical Cubist paintings of Picasso and his fellow pioneer Georges Braque (1882–1963) were radically questioning the logic of a single, fixed viewpoint, the basic premise of realist art since the Renaissance, and were forcing artists to explore

the paradoxes involved in transposing a three-dimensional scene to a two-dimensional surface. Indeed, by 1910 it was already possible to talk about a Cubist 'school', comprising for the most part artists of lesser stature, such as Henri Le Fauconnier (1881–1946), Jean Metzinger (1883–1956) and André Lhôte (1885–1962), who produced a more decorative and less conceptually challenging version of Cubist painting. Other artists, such as Fernand Léger (1881–1955) and Robert Delaunay (1885–1941), were artists of greater originality, who in due course would produce their own distinctive brand of Cubism.

Prior to the triumph of Cubism, it was Fauvism that dominated the Parisian avant-garde art world. Although ultimately less radical and influential than Cubism, its use of strong, often anti-naturalistic colour and vigorous, emphatic brushstrokes, indebted in large measure to the work of Paul Gauguin and Vincent van Gogh (1853–90), shocked a public still attuned to the muted tones and urbane illusionism of so much late nineteenth-century French art. The Fauve group, which included Henri Matisse (25), André Derain and Maurice Vlaminck (1876–1958), first exhibited together at the Salon d'Automne of 1905; it was on seeing their work here that a bewildered critic dubbed them 'fauves' (wild beasts).

Henri Matisse, at the time of his leadership of the Fauve group, was living in Montparnasse. Indeed, by 1910, the focus of avant-garde artistic activity in Paris was shifting to this area (Picasso, too, would move there in 1912). At its heart was the Carrefour Vavin (23), at the intersection of the boulevards du Montparnasse and Raspail, home to cafés such as La Rotonde, Le Coupole, Le Dôme and Le Select, and studios and art schools such as the Académies Colarossi and de la Grande Chaumière.

After a few nights spent on the floor of Meckler's hotel room, no doubt listening with dismay to his friend's complaints, Chagall took up residence in comfortably furnished lodgings at 18 impasse du Maine in Montparnasse, rented from an artist who was a cousin of the writer Ilya Ehrenburg and one of the large number of Russian *émigrés* of all political, religious and artistic persuasions who, wary of the instability caused by the 1905 Revolution, were then congregating in Paris. Shrewdly, he was soon to sublet one of the two rooms to a copyist named Malik, thus supplementing his modest monthly stipend from Vinaver.

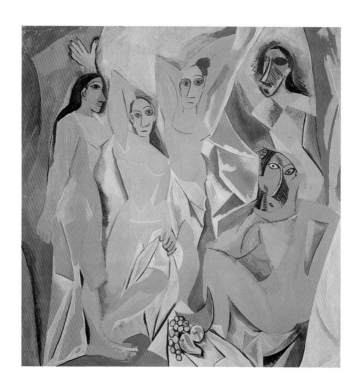

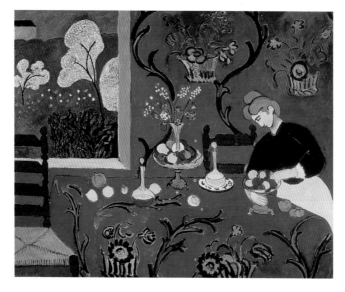

24
Pablo Picasso,
*Les Demoiselles
d'Avignon*,
1907.
Oil on canvas;
244 × 234 cm,
96 × 92 in.
Museum of
Modern Art,
New York

25
Henri Matisse,
La Desserte,
1908.
Oil on canvas;
180 × 220 cm,
71 × 86¾ in.
Hermitage,
St Petersburg

26
Reclining Nude,
1911.
Gouache on
cardboard;
24 × 34 cm,
9½ × 13⅜ in.
Private
collection

The next step was to enrol in classes at two of the many private art schools or académies that flourished in Paris at this period. Chagall always claimed that his sporadic and half-hearted attendance of the Académies de la Chaumière and de la Palette, where he would have had the opportunity to do studies from the nude, had little direct impact on his artistic development. Yet, as ever, we need to treat this denial of influence with a certain scepticism and to look more closely at the evidence. For it was at the Académie de la Palette that he would certainly have encountered Cubism: it was run by the minor Cubist painter Henri

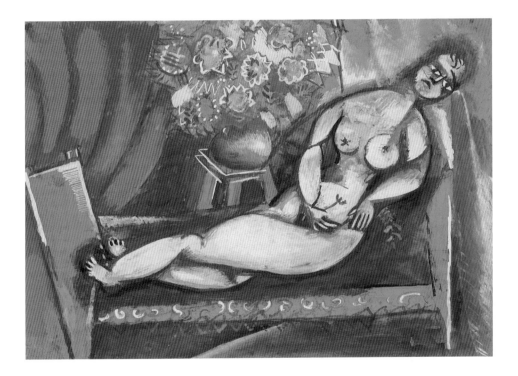

Le Fauconnier, who, with his Russian-born wife, attracted a number of other Russian students besides Chagall to the school, where the Cubist painter–theorist Jean Metzinger was a teacher. A small sketchbook of nudes has survived, providing an interesting insight into Chagall's working methods at this time: on one page is a relatively naturalistic life drawing; on the opposite page, a deliberately geometricized and primitivized rendering of the same motif. A whole series of nudes painted in gouache between 1911–12 and 1913–14 reveals not only bold stylistic experimentation but a strong erotic charge.

Chagall's earlier attempts at depicting the female nude, hedged about with social and religious constraints, had – with one or two exceptions, such as the *Red Nude Sitting Up* of 1908 – been hesitant and tentative. Only in Paris did he allow freer rein to the more sensual side of his nature. A painting such as the curiously stilted *Reclining Nude* of 1911 (26) shows Chagall paying uneasy homage to the centuries-old Western tradition of the reclining female figure, while its awkwardly 'cubified' appearance (influenced in large measure by African art) recalls similar distortions of the female form by artists such as Picasso, Aleksandr Archipenko (1887–1964) and Fernand Léger (the latter also attended the Académie de la Chaumière) and confirms, once again, that Chagall was by no means as immune to influence from teachers and fellow students as he was later to make out.

Chagall's real lessons, according to the artist himself, were learnt wandering round the Louvre and the large annual public exhibitions, the Salons d'Automne and des Indépendants, and peering into the shops of avant-garde dealers such as Durand-Ruel (where he gazed at 'hundreds of Renoirs and Monets'), Alexandre Bernheim ('they have Van Gogh, Gauguin, Matisse'), Kahnweiler (a pioneering promotor of Cubism) and Vollard.

Vollard's shop particularly appealed to me. But I didn't dare go in. In the dark, dusty windows, nothing but old newspapers and a small statue by Maillol that looked lost there. I looked for the Cézannes. They are on the wall at the back, unframed. I press against the window, flattening my nose on it, and all of a sudden I bump into Vollard himself. He is alone in the middle of his shop, wearing an overcoat. I am afraid to go in. He looks bad-tempered. I daren't.

In fact, as events turned out, Vollard was to play an important role during the 1920s in nurturing Chagall's talents as a graphic artist and book illustrator.

The earliest works that Chagall produced in Paris were low-key and tentative, giving little hint of the explosion of originality, both stylistic and iconographic, that was to follow. *The Model* of 1910 (27) – typical in its domesticity of Chagall's output in the first year of his Parisian sojourn –

27
The Model,
1910.
Oil on canvas;
62×51.5 cm,
$24\frac{3}{8} \times 20\frac{1}{4}$ in.
Private
collection

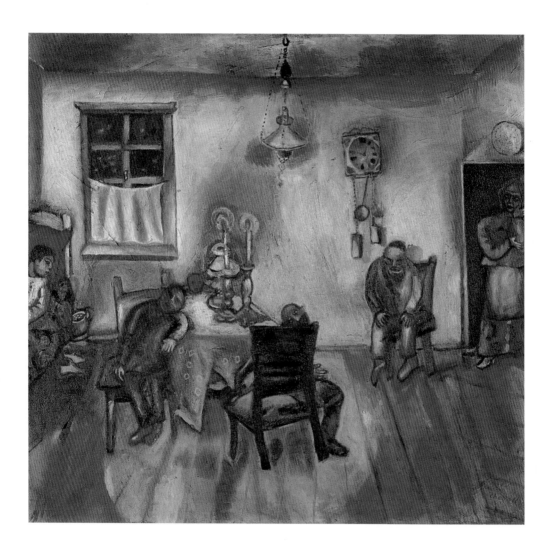

28
The Sabbath,
1910.
Oil on canvas;
89·8 × 95 cm,
35 3/8 × 37 3/8 in.
Museum
Ludwig,
Cologne

was almost certainly one of the earliest works completed after his arrival in Paris, painted over an old picture to save money. This may well have been one of the paintings left behind by Ehrenburg which Chagall in his autobiography admits – somewhat sheepishly – to having reused; certainly, the details of the furnishings, similar to those depicted in the slightly later *The Studio* (29), reveal that *The Model* was indeed executed in the apartment in the impasse du Maine. Although the thick under-painting of this canvas (prompted in the first instance by the need to cover the original image) was to characterize all Chagall's Parisian works, its relatively dark tonalities hark back to the work he was pro-ducing before he left Russia. A new approach to the handling of paint is in evidence, however: broader and more vigorous brushstrokes achieve a new richness of texture indicative of the methods he was to develop in Paris.

To Chagall, Paris came to represent 'light, colour, freedom, the sun, the joy of living'. Under the influence of that light, both physical and metaphysical, and partly too under the influence of Fauvism, Chagall's colours – as evidenced by paintings such as *The Sabbath* (28) and *The Studio* (29), both of 1910 – soon became stronger and brighter. Chagall tells us that when he re-encountered Léon Bakst at the Ballets Russes in Paris, the embarrassment engendered in him by Bakst's abrupt greet-ing, 'So you came, after all?', was alleviated by the verdict pronounced by his erstwhile mentor on a subsequent visit to Chagall's studio: 'Now,' he announced, 'your colours sing.'

The Studio (29) pays homage not only to Fauvism but also to the Dutch artist Vincent van Gogh, another northerner who nearly three decades earlier had, like Chagall, been intoxicated by the light of France. Indeed, both the colours and the composition of *The Studio* bring to mind Van Gogh's *The Artist's Room in Arles* (30), but are, if anything, more intense and violent, prophetic of the distortions of Chaim Soutine (a fellow Russian–Jewish *émigré* whose uncouth ways, however, Chagall could not abide). *The Sabbath* (28), too, recalls the work of Van Gogh – in this case, *The Potato Eaters*, for its subject matter, and *The Night Café*, for its colours. Although its air of brooding tragedy is rare in the work of Chagall's first Parisian period, the preoccupation with the world

29
The Studio,
1910.
Oil on canvas;
60×73 cm,
23⅝×28¾ in.
Musée National
d'Art Moderne,
Centre Georges
Pompidou,
Paris

30
**Vincent van
Gogh**,
*The Artist's
Room in Arles*,
1889.
Oil on canvas;
57·5×74 cm,
22⅝×29⅛ in.
Musée d'Orsay,
Paris

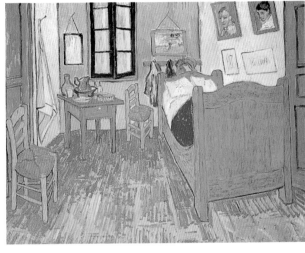

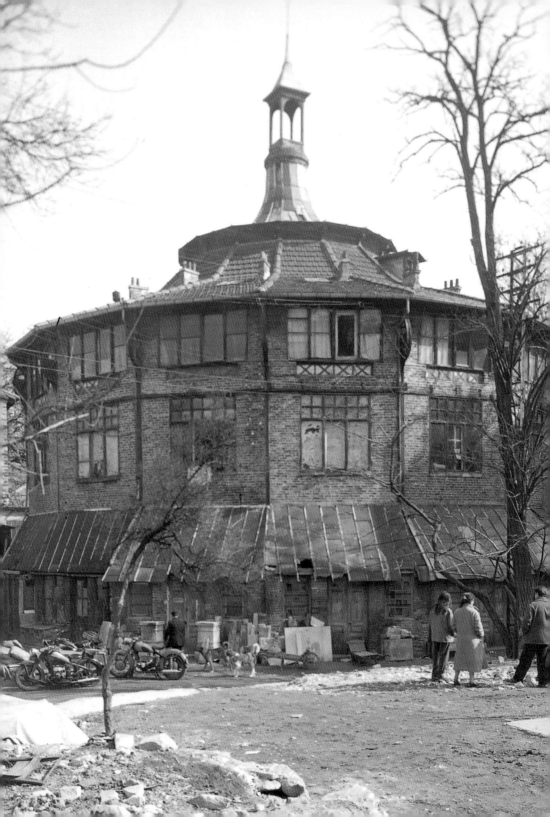

of the artist's childhood revealed here was to be far more typical of his output during these years than the more impersonal and conventional iconography of *Reclining Nude*, *The Model* or *The Studio* (26, 27 and 29).

Sometime in the winter of 1911–12 or the spring of 1912, Chagall moved to accommodation by his own admission more in keeping with his means. This was La Ruche (The Beehive), a ramshackle complex of about one hundred and forty studios (31, 32), 'occupied by artistic bohemians from all over the world', situated on the seedy outskirts of Montparnasse, near the slaughterhouses of the Vaugirard district that may well have awoken in Chagall ambivalent childhood memories of his maternal grandfather, the kosher butcher in Lyosno. La Ruche was the idea of a successful and philanthropic academic sculptor, Alfred Boucher (1850–1934), who had devised the utopian scheme of setting up an artist's commune, using architectural fragments left over from the Paris Universal Exposition of 1900. This had marked a high-point of the sinuous Art Nouveau style of decorative art and design. The central structure of La Ruche was a three-storey rotunda reminiscent of a beehive, which had been the Pavilion of Wines, while the wrought-iron gates came from the Pavilion of Women, and the two cement caryatids flanking the entrance had graced the Indian Pavilion. Thus it was that in 1902, in the presence of the Under-Secretary of State for the Fine Arts and to the tune of the Marseillaise, the commune that was to become so integral a part of the mythology of bohemian Paris officially came into being.

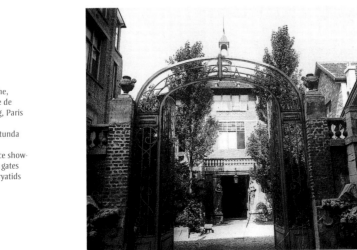

31–32
La Ruche,
Passage de
Dantzig, Paris
Left
The Rotunda
Right
Entrance show-
ing the gates
and caryatids

Thanks to Vinaver's continuing support, Chagall was able to afford one of the big studios on the top floor of the rotunda – the only floor to receive proper daylight from the opening in the cupola. Most of the artists, less well supported than Chagall, had to content themselves with darker, less spacious but cheaper accommodation (33) on the lower floors – dubbed 'coffins' even by their inhabitants – or in one of the smaller structures that surrounded the main building of the compound. Even then, the kindly concierge, Madame Segondet, often bailed out the more indigent tenants, referring to them affectionately as 'mes pauvres abeilles' ('my poor bees').

The conditions of apparently picturesque squalor that prevailed in La Ruche clearly helped fuel the myth that poverty and artistic creativity are intimately and inextricably linked. As Chagall himself was later to comment: 'In La Ruche, you died or came out famous.' Certainly, the roll-call of artists who lived and worked there is impressive – although far outnumbered by the artists whose names have long been forgotten.

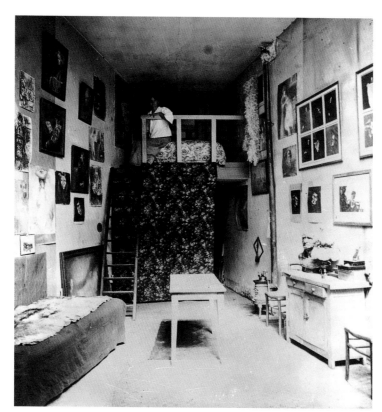

33
A typical artist's studio in La Ruche, 1906

By far the majority of the 'bees' were *émigrés*: Russian and Polish Jews predominated – among them, the painters Chaim Soutine and Michel Kikoine (1892–1968), and the sculptors Jacques Lipchitz (1891–1973) and Ossip Zadkine (1890–1967), and Yiddish was the language most commonly heard. There were a few non-Jewish Russians too: the sculptor Archipenko, for example, who arrived in Paris in 1908 and lived in La Ruche for a while. However, Frenchmen born and bred, such as Fernand Léger, of Normandy peasant stock, were very much the exception. Not all the inhabitants of La Ruche were artists: there were writers (among them André Salmon and Blaise Cendrars), actors, aristocrats such as the nephew of an Indian Maharajah with artistic pretensions – even political agitators, including Vladimir Ilyich Ulyanov, now better known as Lenin, and Anatoly Lunacharsky, later to play so crucial a role in Chagall's life.

For most of the early twentieth-century *émigrés*, Paris promised artistic freedom – but the promise, for the many Jews among them, of religious and social freedom too was just as important. Chagall himself was later eloquently to describe the light of Paris as 'lumière liberté', the light of liberty. It is ironic, therefore, but not entirely surprising, that the Jewish artists gravitated towards each other for company. These artists may for the most part have turned their backs on their eastern European roots in their choice of subject matter; but the decision of so many of them to congregate in La Ruche and in favourite cafés such as La Rotonde, Le Dôme or La Coupole suggests a hankering for the company of kindred spirits. Indeed, there was a disproportionate number of Jews among the *émigrés*, including Jewish artists from other countries, such as Amedeo Modigliani (1884–1920) from Italy and Jules Pascin (1885–1930) from Bulgaria. This phenomenon soon gave rise to the concept of an *École juive*, a Jewish enclave within the so-called *École de Paris* or School of Paris, a term used to describe the large numbers of – mostly foreign – artists who congregated in that city in the early part of the twentieth century. This *École juive* was seen by some commentators as a positive and healthy phenomenon, and by others of a more xenophobic persuasion as a dangerously subversive threat to the 'purity' of French culture.

'Paris, you are my second Vitebsk!', Chagall was later to declare triumphantly; but the equation was never a simple one. *Self-Portrait with Seven Fingers* of 1912–13 (34) vividly expresses Chagall's dual, if not triple, allegiances during this first Parisian period. On the one hand, there was Paris, indisputable art capital of the world, embodied here by the Eiffel Tower, seen through the window on the left-hand side of the composition; on the other, Vitebsk, represented – significantly – not by a synagogue but a church, glimpsed as if in a dream on the right-hand side. Although the rendering of Chagall's own body pays stylistic tribute to Cubism, the painting shown on the easel, immediately recognizable as the extraordinary *To Russia, Asses and Others* (35), makes it abundantly clear which of the two geographical locations dominated Chagall's artistic imagination. (Interestingly, the original of *To Russia, Asses and Others* is considerably more Cubist in style than the miniature version here would have us believe.) The additional fact that Paris and Russia are identified as such in Yiddish may hint at a certain tension between

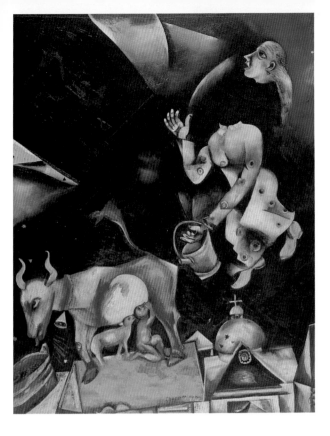

34
*Self-Portrait
with Seven
Fingers*,
1912–13.
Oil on canvas;
126 × 107 cm,
49⅝ × 42⅛ in.
Stedelijk
Museum,
Amsterdam

35
*To Russia, Asses
and Others*,
1911–12.
Oil on canvas;
157 × 122 cm,
61¾ × 48 in.
Musée National
d'Art Moderne,
Centre Georges
Pompidou,
Paris

his Russian and his Jewish roots. The frowning concentration on the
artist's face suggests an inner, rather than an outer vision; while the
mysterious extra fingers on his left hand can be explained by a Yiddish
saying, whereby to do things with seven fingers means doing something
really well and with all one's heart.

In an essay of 1922, entitled 'What is a Jewish Artist?', Chagall was
to recall:

Once, in Paris still in my La Ruche room where I worked, I heard through
the ... wall Jewish immigrant voices: 'And what do you think after all, was
not Antokolsky a Jewish artist? And how about [Jozef] Israels or [Max]
Liebermann?' The lamps burned weakly illuminating my picture ... and at
the end when the day broke and the sky of Paris brightened I heartily
laughed at the foolish, senseless ideas of my neighbours about the fate of
Jewish art. Well, talk as you like, I will work.

The 'Jewish immigrant voices' derisively referred to here were almost certainly those of a group of artists of Russian and eastern European origin, which included the painters Henri Epstein (1891–1944), Leo Koenig (1889–1970) and Marek Schwarz (1892–1962) and the sculptor Léon Indenbaum (1892–1981). Dubbing themselves the Machmadim (Hebrew for 'Precious Ones'), they published a short-lived journal of the same name in 1912, which, although textless, 'without manifestoes and without theories', in its selection of images reflected the group's preoccupation with the possibility of a modern Jewish art. The graphic artist and sculptor Joseph Tchaikov (1888–1986), who lived at La Ruche between 1910 and 1914 before returning to Kiev, was to act as an important mediator between the ideas of the Machmadim and Russian artists such as El Lissitzky, Nathan Altman (1889–1970) and Boris Aronson (1898–1980), who just a few years later would explore similar issues in their own work, and with whom for a while Chagall was to be closely associated.

Even in Paris, however, Chagall was not as immune to the ideas of the Machmadim as his own, perhaps over-emphatic, statements would have us believe. Recently discovered correspondence between Chagall and Leo Koenig has revealed a far greater sympathy between the two men and their artistic ideas than the former ever admitted. After all, the Russian–Jewish folk culture in which the Machmadim took so great an interest was a vital source of inspiration for Chagall as well. Indeed, much of Chagall's impatience with the group may have stemmed from the fact that he had heard all their ideas before – both in Pen's studio in Vitebsk and in St Petersburg. Here they were talking the night away while he, Chagall, was busy creating the very kind of art for which they were so earnestly and naïvely looking. If, moreover, one compares Chagall's gouache *Cain and Abel* of 1912 (36) with a rendering of the same subject published in the Machmadim's journal (37), it becomes clear that Chagall was not above competing with them in order to prove his own superiority. And indeed, the striking, staccato primitivism of Chagall's image makes the technically clumsy, stylistically derivative and essentially academic nature of the Machmadim's version all the more evident.

In fact, although Chagall's talent was undoubtedly of a quite different order, the iconography of his first Parisian period allies him far more

36
Cain and Abel,
1912.
Gouache on paper;
22 × 28·5 cm,
8⅝ × 11¼ in.
Private collection

37
Anonymous
Cain and Abel.
Published in
Machmadim
no.5, Paris,
1912.
Hectography;
202 × 155 cm,
79½ × 61 in.
Israel Museum,
Jerusalem

closely to the little-known Machmadim than to such figures as Soutine, Pascin or Modigliani – artists of much greater aesthetic stature, but whose work reveals virtually no interest in overtly Jewish subject matter. The relationship between Chagall's Jewishness and his artistic identity, however, was always ambiguous: throughout his life he resisted being labelled a Jewish artist, preferring – in public at least – to be seen as a universal one. Mané-Katz (1894–1962), son of a Ukrainian synagogue beadle, who arrived in Paris in 1913 and returned to Russia during World War I before settling in Paris for good in 1921, was one of the few other *émigré* artists to choose explicitly Jewish subjects for his paintings. Yet Chagall would always shudder if anyone dared utter their names in the same breath. In fairness to Chagall, Mané-Katz's paintings often succumb to a nostalgic sentimentality and superficiality quite absent from Chagall's own early work.

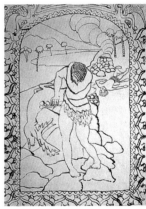

The fact that from 1912 Chagall successfully submitted work to the annual Salons des Indépendants and Salons d'Automne, and even sent paintings to the avant-garde exhibitions, the *Donkey's Tail* and *Target*, held in Moscow in 1912 and 1913 respectively, suggests an eagerness to stand up and be counted in progressive art circles. His artistic influence, moreover, was beginning to be felt: in Moscow, for example, the paintings he submitted to the above-mentioned exhibitions may well have prompted the non-Jewish artists Natalia Goncharova and Mikhail Larionov to produce a number of neo-primitive images of Jewish life (38).

Yet Chagall persisted in cultivating the image of the eccentric loner, utterly dedicated to his art:

While an offended model sobbed in the Russian ateliers; the Italian studios rang with songs and the sound of guitars, the Jewish ones with discussions, I was alone in my studio in front of my oil lamp. A studio crammed with pictures, with canvases that were not really canvases, but my tablecloths, sheets and nightshirts torn into pieces.
Two or three o'clock in the morning. The sky is blue. Dawn is breaking. Down there, a little way off, they slaughtered cattle, cows bellowed, and I painted them.
I used to sit up like that all night long …
My lamp burned, and I with it.

The use of this metaphor, combined with the fact that Chagall, by his own account, preferred to paint in the nude, suggests that on one level at least, art – in the absence of his fiancée – became an outlet for sexual energy.

The artist Jacques Chapiro, in his memoir of La Ruche, reinforces this essentially romantic image of Chagall, as remembered by those who had known him at the time (Chapiro himself arrived in Paris only in 1925):

His hair in an aureole, as if it had never known a comb, his visage drawn, his grey eyes – wild, mobile, haunted with creative passion, in which there dwelt an expression sometimes infantile and sometimes similar to that of a

very old man – the pupils, like grains of rice, sometimes lighting up with an enigmatic and demented fire, Chagall often remained at twilight seated on the debris of one of the statues or under a lilac bush, gesticulating, drawing his future works in the air. Miscarried canvases or those which turned out badly, Chagall would simply hurl out of the window or shove behind the piles of garbage.

In his La Ruche studio, Chagall seems to have found a startling new confidence. The works that he was to produce between late 1911 and 1914 have no parallel in the output of the early twentieth-century avant-garde (Parisian or otherwise), and indeed, are often regarded as the most original and outstanding of his entire career. Unlike Victor Meckler who, in the face of artistic innovation, chose instead to emulate the style of the fashionable American portrait painter John Singer Sargent (1856–1925), Chagall was acutely aware of the latest avant-garde developments and – whether he chose to admit it or not – absorbed and adapted for his own purposes many of their characteristics. Indeed, a thorough analysis of his output of these years makes it clear that he was by no means unconscious of the stylistic options at his disposal. Thus the *faux naïf* primitivism which reminded many of his French admirers of the work (39) of Henri Rousseau ('Le Douanier'; 1844–1910), the celebrated naïve artist who had died just a few weeks prior to Chagall's arrival in France, was as much a matter of choice as the Fauve or Cubist elements present in so many of his Parisian works.

39
Henri Rousseau, *The Anglers*, 1908. Oil on canvas; 46 × 55 cm, 18 1/8 × 21 5/8 in. Musée de l'Orangerie, Paris

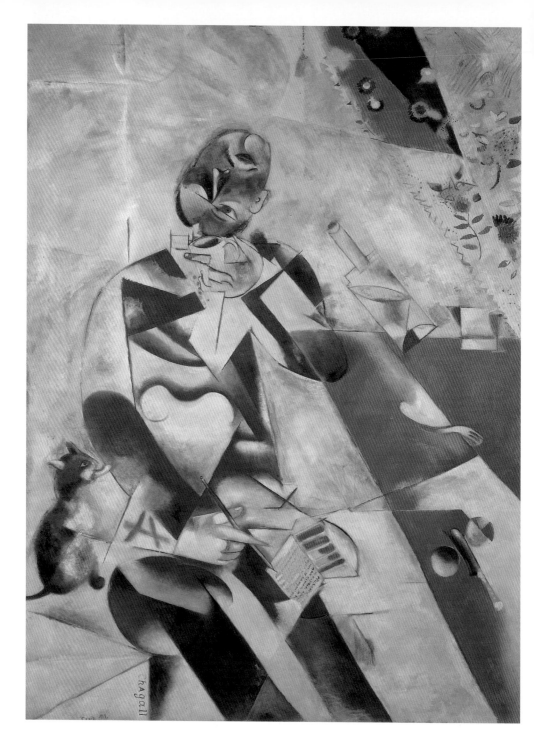

40
Half Past Three
or *The Poet*,
1911.
Oil on canvas;
196×145cm,
77¹⁄₈×57 in.
Philadelphia
Museum of Art

41
Pablo Picasso,
*Portrait of
Ambroise
Vollard*,
1910.
Oil on canvas;
92×65cm,
36¹⁄₄×25⁵⁄₈in.
Pushkin
Museum of
Fine Arts,
Moscow

Thus, the fragmentation of forms and spatial ambiguity to be found in paintings such as *Half Past Three* (or *The Poet*) of 1911 (40), *Adam and Eve* of 1912 and *Paris through the Window* (42) of 1913 reveal a considerable debt to Analytical Cubism (41), the dominant avant-garde art movement of the day – and this in spite of the fact that Chagall always denied its influence. 'Down with naturalism, impressionism and realistic cubism!', he declared in *My Life*. 'Let them choke themselves with their square pears on their triangular tables! ... What is this age that sings hymns to technical art and makes a god of formalism? ... Personally, I do not think a scientific bent is good for art. Art seems to me to be a state of soul.' Unlike many of his contemporaries, Chagall intuited –

42
*Paris through
the Window,*
1913.
Oil on canvas;
135·9 × 141·6 cm,
53½ × 55¾ in.
Solomon R
Guggenheim
Museum,
New York

perhaps rightly – that the Cubist experiment was at heart another form of realism, intent perhaps on capturing the essence of appearances but prosaic nevertheless. His pronouncements on the issue of realism can be confusing, however: a few lines further on, for example, he exclaims: 'Don't call me fanciful! On the contrary, I am a realist. I love the earth.' As ever, Chagall goes out of his way to avoid neat categorization.

The strong, non-naturalistic colour of a painting such as *Half Past Three* owes more to the example of Fauvism and the work of Robert Delaunay, instigator of the more colourful and poetic variant of Cubism known as Orphism, than to mainstream Cubism. Indeed, if there are Cubist echoes in Chagall's work, they refer less to the muted earth tones of Picasso's and Braque's pioneering Cubist images than to the more sensual and less intellectually rigorous version of Cubism espoused by artists such as Metzinger and Le Fauconnier, with whom Chagall had direct contact through the Académie de la Palette. Delaunay, however, seems to have been the only painter with whom Chagall enjoyed a close relationship. The fact that he was married to Sonia Delaunay-Terk (1885–1979), herself a painter of Russian–Jewish origin, may partly explain the particular intimacy that existed between them, since Chagall claimed to have little understanding of his art. Delaunay's influence was nonetheless a considerable one – precisely because Chagall made no effort to understand the theories underlying Orphism, as expounded mainly by the poet and critic Guillaume Apollinaire, and thus felt utterly at liberty to take from it what he needed for his own highly individual purposes.

The humour and fantasy of *Half Past Three*, however, has few counterparts in Parisian painting of the period. The cat, traditional symbol of lust but also of insight and foresight, is lent a devilish aspect by its pointed, horn-like ears and its bright green hue which allies it with the upside-down head of the poet (Chagall himself, perhaps, or one of his Parisian writer friends, possibly Mazin, whom he depicted in another, less cubistic image). All this evokes the topsy-turvy world of the poet's imagination – helped, no doubt, by the liquor from the precariously tilted bottle on the table. As so often in Chagall's work, a Yiddish idiom gives us a crucial clue to the painting's origin and meaning: translated literally, the phrase 'fardreiter kop' means a 'turned head', and denotes

a state of confusion or giddiness bordering on craziness. Yet the fragments (in Cyrillic) of a love poem by the contemporary Russian poet Aleksandr Blok on the man's lap – the painting is sometimes also known as *The Rendezvous* – suggest that his apparently inebriated state may be due as much to love and creative fervour as to alcohol.

Even more intimately tied up with the written word is the most arcane of Chagall's Parisian canvases, *Homage to Apollinaire* of 1911–12 (43). The painting seems to have been given its present title in 1913, when Apollinaire, 'that gentle Zeus', visited Chagall's studio for the first time and pronounced favourably on his work. 'He reddens, puffs out, smiles, and murmurs: "Surnaturel!" [Supernatural] …' Thus, in front of Chagall's canvases, the concept that later became 'Surrealism' was coined – although in the 1920s Chagall would deny any real kinship with the Surrealists. The 'valentine' addressed to Apollinaire, to Herwarth Walden, director of Der Sturm gallery in Berlin (whom at this juncture, Chagall had met only once), to Blaise Cendrars, the eccentric Swiss poet and close friend and supporter of Chagall, and to Riciotto Canudo, Italian editor of an important modern art magazine, *Montjoie*, was also added later – a gesture that may have seemed endearingly naïve, but that was actually far from ingenuous.

Although in this painting the forms are fragmented and faceted, creating the spatial ambiguity characteristic of Analytical Cubism, and the sense of movement, the disc motif and the bright colours suggest the influence of Delaunay and Orphism, the subject matter has little to do with the 'square pears on triangular plates' for which Chagall expressed such contempt. A preparatory drawing reveals an Adam/Eve chimera in the Garden of Eden, complete with serpent and Tree of Knowledge. In the painting, the garden has disappeared, leaving only a single apple and Adam's (phallic) hand to indicate the biblical source. The story of the creation of Eve out of Adam's body has, it seems, been combined here with the story of the Fall.

Clouds, birds and the midnight blue suggest infinity, while the circle becomes a clock, symbol of the finite. Although letters had already been introduced into painting by the Parisian Cubists, their function here is quite different. In the Midrash, the Hebrew legends that Chagall would

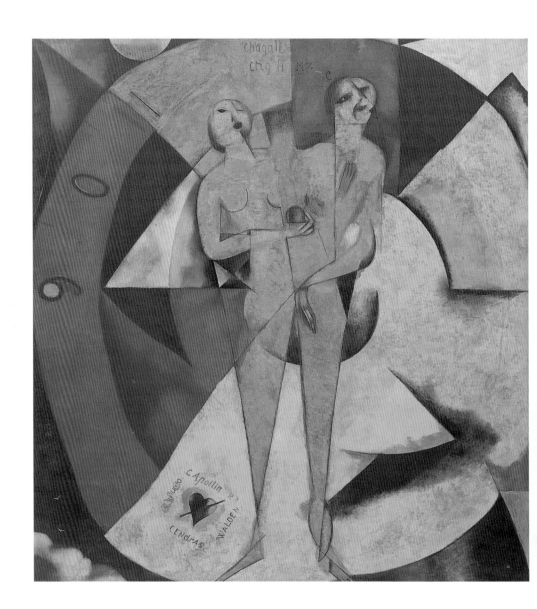

have heard as a child, the creation story is set into a twelve-hour day, each hour symbolizing a stage in the narrative. The hours chosen by Chagall are: nine o'clock – the hour that Adam and Eve were warned not to eat of the tree; ten o'clock – the hour they transgressed; and eleven o'clock – the hour they were judged. The fact that Chagall inscribes his name 'Chagall', then 'Chgll', without the vowels, as in Hebrew, and finally 'Marc', with the 'a' and the 'r' in Hebrew characters, suggests that a hidden Jewish meaning derived from the Midrash is plausible.

The circle, moreover, is an ancient symbol of wholeness and divinity. Perhaps, therefore, the Adam/Eve figure stands also for the possibility of unity in duality: there are many references, both in Jewish religious writings and in other paintings by Chagall, to suggest a link between love of man and woman and love of Man and God. The numbers 9011 may, in addition, be a playful allusion to the year in which the painting was begun; in a similar way, the names of his 'friends' contain within them – in the case of Apollinaire, picked out in different colours – allusions to nature and the elements: air (Apollinaire), *Wald*, German for forest (Walden), *cendres*, French for ashes (Cendras [*sic*]) and water (Canudo, the final 'o' sounding like *eau*, the French for water). The possible interpretations are endless. Although it is unlikely, given Chagall's insistence throughout his life on the essentially intuitive nature of the creative process, that the artist was consciously and consistently drawing on arcane sources, *Homage to Apollinaire* remains one of his most esoteric and cerebral works.

Yet even an apparently straightforward image such as *The Ferris Wheel* of *c.*1912 (45) contains hidden meanings. The subject of this painting was probably inspired by Robert Delaunay's renderings (44) of the same Parisian landmark (46) from 1910 onwards; and like Delaunay, Chagall may well have based his composition on a contemporary photographic postcard. The acidic colours that dominate the painting are far from naturalistic, however; while the inclusion of the word *pari* (Paris, with the final 's' missing, as a foreigner might be forgiven for spelling it) adds a quite different dimension: for once the viewer realizes that the word *pari* means 'bet' in French, the big wheel suggests not just the fun of the fair, but the Wheel of Fortune itself. Parallel references can be found in the

43
Homage to Apollinaire, 1911–12. Oil, gold and silver powder on canvas; 200×189·5 cm, 78³⁄₄×74⁵⁄₈ in. Stedelijk van Abbemuseum, Eindhoven

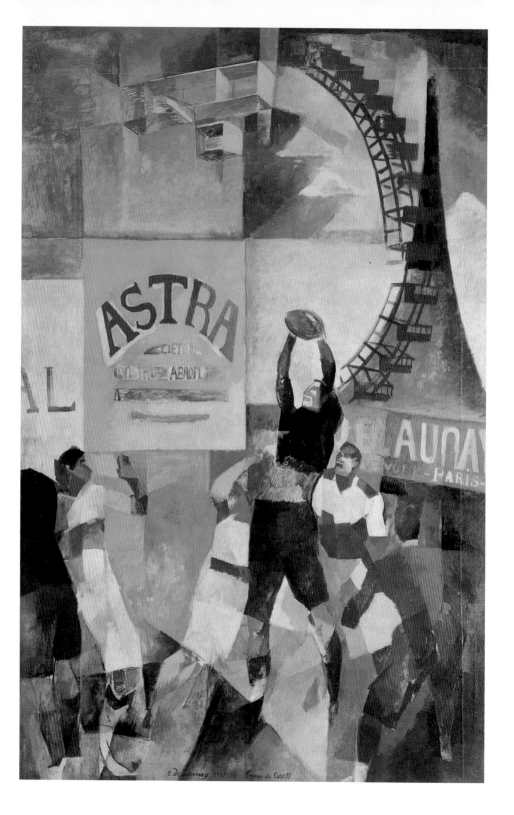

44
Robert Delaunay,
The Cardiff Team,
c.1912.
Oil on canvas;
326·4 × 221 cm,
128 1/2 × 87 in.
Musée d'Art Moderne de la Ville de Paris

45
The Ferris Wheel,
c.1912.
Oil on canvas;
65 × 92 cm,
25 5/8 × 36 3/5 in.
Private collection

46
Ferris wheel built for the 1900 Universal Exposition

work of both Delaunay and Cendrars to confirm this more metaphorical and poetic interpretation of the image.

The most distinctive and ultimately the most popular of Chagall's early Parisian works, however, are those which allude to the faraway world of his childhood. Some, such as *Birth* of 1911 (47), represent a stylistically and iconographically more complex reworking of elemental themes already treated in paintings executed in Russia (see 21). Another series, which includes *The Pinch of Snuff* (48) and *Jew at Prayer*, both of 1912, deals exclusively with Jewish religious themes, and appears to be a response to similar subjects treated by Chagall's erstwhile teacher Yehuda Pen, which were reproduced in the August 1912 issue of the

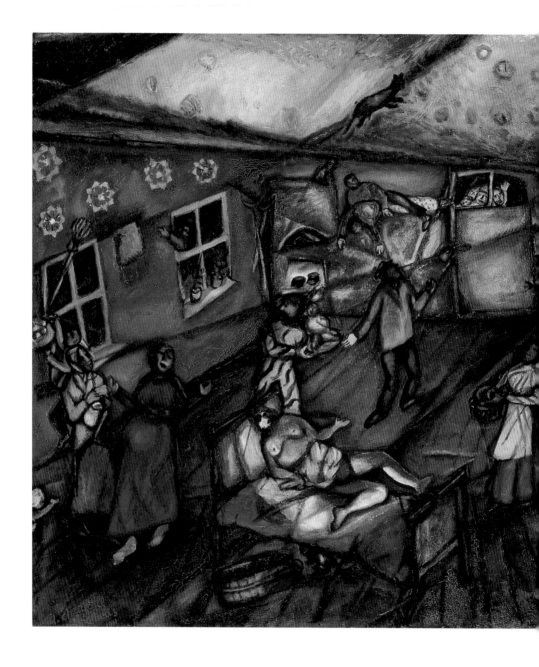

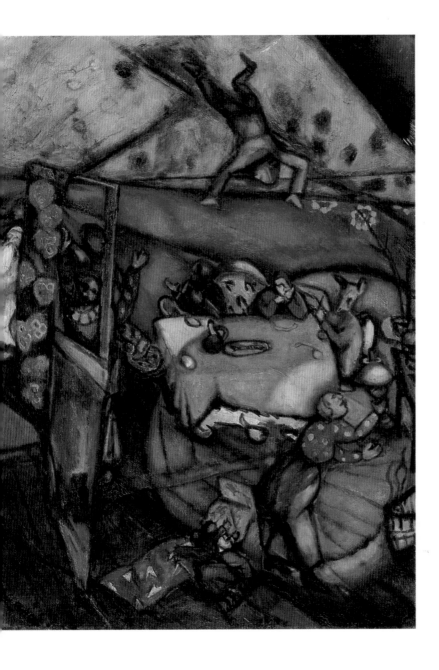

47
Birth,
1911.
Oil on canvas;
113·3×195·3 cm,
44⅝×76⅞ in.
The Art
Institute of
Chicago

48
The Pinch of Snuff,
1912.
Oil on canvas;
117 × 89·5 cm,
46 × 35¼ in.
Öffentliche
Kunst-
sammlung,
Kunstmuseum,
Basle

49
Yehuda Pen,
Morning Chapter from the Talmud,
before 1912.
Oil on canvas.
Museum of
Regional and
Local History,
Vitebsk

50
The Cattle Dealer,
1912.
Oil on canvas;
97 × 200·5 cm,
38 × 79 in.
Öffentliche
Kunst-
sammlung,
Kunstmuseum,
Basle

journal *Ost und West*, which Chagall would almost certainly have seen.
On one level, *The Pinch of Snuff* is a consciously primitivistic reworking
of Pen's *Morning Chapter from the Talmud* (49). On another, its title
alludes to the short story of the same name by the Yiddish writer
I L Peretz, in which a saintly rabbi falls prey to Satan's wiles only
because of his weakness for a 'pinch of snuff'. Interestingly, in the
first version of this painting, Chagall inscribed his original name,
'Segal, Moyshe', on the open book, but facing the viewer, as if publicly
to affirm his Jewish identity; while his usual international signature,
'Chagall', is written upside-down, facing the pious Jew, as if simultane-
ously to affirm his secular identity in the face of religious orthodoxy.

Other paintings – *To Russia, Asses and Others* (see 35), *The Cattle Dealer*
(50), *I and the Village* (51) and *The Flying Carriage*, for example, all
produced between 1911 and 1913 – refer more obviously to Russian (non-
Jewish) peasant life, although many of their idiosyncratic, apparently
illogical elements can be explained by reference not to Russian, but to
Yiddish idioms. The quintessentially Chagallian *The Violinist* of 1912–13
(52) similarly combines Jewish and non-Jewish Russian references. The
violin, plaintive, intense, easily portable in times of persecution, has
often been seen as a peculiarly Jewish instrument. Certainly, a strolling
fiddler was almost always present at Russian Jewish weddings and other
festive occasions. There may also be autobiographical elements here:

51 Left
I and the Village,
1911.
Oil on canvas;
192·1 × 151·4 cm,
75⅝ × 59⅝ in.
Museum of
Modern Art,
New York

52 Right
The Violinist,
1912–13.
Oil on canvas;
188 × 158 cm,
74 × 62¼ in.
Stedelijk
Museum,
Amsterdam

**53 Below
Mstislav
Dobuzhinsky**,
*Window at the
Hairdresser*,
1906.
Charcoal,
gouache and
watercolour;
28·2 × 20·9 cm,
11⅛ × 8¼ in.
Tretyakov
Gallery,
Moscow

My Life contains references to relatives both playing the violin and escaping to the rooftops; while Chagall himself had learnt to play the violin, and was to remain a lover of music throughout his life.

On the other hand, the building that dominates the background of the picture is unequivocally Christian; while the three heads so curiously placed one on top of the other may well have been inspired by a similar motif in a painting of 1906 entitled *Window at the Hairdresser* by Mstislav Dobuzhinsky (53), who had been one of Chagall's teachers at the Zvantseva School in St Petersburg. The possibility of a political dimension to Chagall's image is borne out by the fact that one of the Russian-language newspapers published in Paris in November 1912 contained an article describing how an Estonian violinist, then playing at fund-raising *émigré* concerts in Paris, had led marches through the streets during the 1905 revolution, seeking to rouse the proletariat by means of his playing. Typically, however, the painting also contains references to completely different cultures. A green head had already featured in *Half Past Three* (see 40), slyly indicative of a state of drunkenness. But green was also the colour chosen by the ancient Egyptians for the faces of certain gods, notably Osiris, to denote resurrection. If all this sounds far-fetched, one must remember that Chagall was now mixing in highly sophisticated and cosmopolitan circles where knowledge of widely disparate cultures was taken almost for granted.

While these hidden references undoubtedly add to the richness of an image such as this, and make it clear, moreover, that Chagall was by no means the cultural ingénue he often liked to make out, *The Violinist* and paintings like it can be enjoyed and appreciated even without any extra knowledge. For all its complexity, the basic message of *The Violinist* is clear enough: for is this not ultimately an image of the triumph of art and music over mundane reality, of art endowed with a logic-defying power not dissimilar to that of religion? At any rate, it is hardly surprising that *The Violinist*, when exhibited at the 1914 Salon des Indépendants together with the equally original *Pregnant Woman* (or *Maternity*) of 1913 (57) and the *Self-Portrait with Seven Fingers* (see 34), created quite a stir.

Earthy yet spiritual, witty yet serious, these paintings stand alone in the history of the early twentieth-century avant-garde. It was surely works such as these that Apollinaire had in mind when he described Chagall in the *Paris-Journal* as: 'a young Russian–Jewish painter, a colourist full of imagination who, although at times influenced by the whimsy of popular Slavic imagery, always transcends it. He is an artist of enormous variety capable of monumental painting, and not encumbered by any theory.'

The wonderfully apposite title of *To Russia, Asses and Others* (see 35), and of several other memorably named canvases – *I and the Village* (51), for example, or *From the Moon* – were the felicitous invention of the poet Blaise Cendrars. (The first of these paintings was originally given the equally memorable title of *The Aunt in the Sky*.) The son of a Swiss hotel entrepreneur, Cendrars was a colourful figure, an eccentric and extrovert globetrotter who had spent some time in St Petersburg (and therefore spoke Russian) and translated his bizarre travel experiences into what have been described by the writer Sidney Alexander as 'gallicized Whitmanesque exultations of the open road', 'stenographic repetitive slangy musings ... all flung together in topsy-turvy fashion'. Cendrars' passionate belief in the fusing of the sacred and the secular, in what he called 'psychic unity', a deeper reality that transcends reason and logic, and in the need to communicate to as wide a public as possible meant that he struck a chord of sympathy in Chagall at this time that few others managed to do.

The painter described the poet thus, in words more akin to poetry than prose:

There, another light resonant flame – Blaise, my friend Cendrars.
A chrome smock, socks of different colours. Floods of sunshine, poverty and rhymes ...
He read me his poems, looking out of the window, smiled at my pictures to my face, and we both laughed.

Although elsewhere in *My Life*, Chagall admits that he rarely heeded Cendrars' advice, his claim in later years that the Russian Revolution of 1917 and his meeting with the poet were the two most important events

in his life, makes it clear how much Cendrars meant to him in these crucial years of his creative development. Cendrars, in turn, paid idiosyncratic homage to Chagall in a number of memorable poems. In his *19 Poèmes élastiques*, for example, we read:

He sleeps
He is awake
Suddenly he paints
He grabs a church and paints with a church
He grabs a cow and paints with a cow
With a sardine
With heads, hands, knives
He paints with a bull's tendon
He paints with all the grubby passions of a little Jewish village
With all the exacerbated sexuality of a Russian province …

The day after he pronounced his work 'surnaturel', Apollinaire sent Chagall a letter containing the poem 'Rotsoge', 'dedicated to the painter Chagall', which in 1914 would be published under the title 'Rodztag' in the magazine *Der Sturm* as the introduction to Chagall's first one-man exhibition in Berlin. The poem begins:

Your scarlet face your biplane convertible into hydroplane
Your round house where a smoked herring swims …

As evidenced even by these brief quotations, the kaleidoscopic liberties taken with the visible, rational world, and the arresting juxtapositions found in the work of avant-garde poets such as Apollinaire and Cendrars clearly have affinities with Chagall's painted world. It is unsurprising, therefore, that Chagall found kindred spirits more easily among the writers than the painters of prewar Paris.

Indeed, Chagall's closest friends throughout his life tended to be poets, partly because of his suspicion of fellow painters, partly perhaps because of the essentially poetic nature of his imagination. Chagall's closest associates in Paris between 1910 and 1914 seem to have been the poets Cendrars, Apollinaire and Ludwig Rubiner, although the Russian–Jewish *émigré* poet André Salmon and the writer Max Jacob, an eccentric Jewish convert to Catholicism, also receive a special mention in *My Life*.

However valuable in establishing Chagall's reputation in the longer term and in boosting his morale in the short term, the support of such writers as Apollinaire and Cendrars did little to help Chagall's paintings sell. Aware that it was extremely rare to be given a one-man exhibition in those days ('Matisse and Bonnard were practically the only people to have them,' he was later to recall), Chagall duly submitted works to the annual Salons d'Automne and Salons des Indépendants, only to have one of them – *The Ass and the Woman* of 1911, later retitled *Dedicated to My Fiancée* (54) by Cendrars – removed from the walls of the 1912 Salon des Indépendants an hour after the opening for its alleged obscenity. Few people knew quite what to make of the canvases – *To Russia, Asses and Others* (see 35) and *The Drunkard* – that did remain on the wall. In spite of a letter of introduction from Canudo, his attempts to interest private collectors in his work were largely unsuccessful. In desperation, Chagall even at one point tried to paint a landscape in the more readily marketable style of the nineteenth-century French landscapist Jean-Baptiste-Camille Corot (1796–1875): 'I took a photograph, but the more I tried to do a Corot, the further I got from it, and I ended up in the style of Chagall!'

The real turning point in Chagall's exhibiting fortunes came when Apollinaire introduced him, at one of the many gatherings in his own 'garret', to the German–Jewish publisher and dealer Herwarth Walden (born Georg Levin), whose Berlin gallery Der Sturm and magazine of the same name had already gained an international reputation as the promoter of Expressionism, the dominant avant-garde art movement in Germany prior to World War I. 'A little man is sitting in one corner. Apollinaire goes up to him and wakes him up: "Do you know what we ought to do, Monsieur Walden? We ought to organize an exhibition of this young man's works. Don't you know him …? Marc Chagall …?"' In the event, Walden suggested that Chagall submit a number of works to the first German Herbstsalon (Autumn Salon) of September 1913, organized by Walden on the lines of the Parisian Salon d'Automne. Among the many members of the European avant-garde represented in this Salon was Franz Marc (1880–1916), whose visionary series of animal paintings of *c.*1908–14 (55) have certain affinities with some of Chagall's work. Chagall travelled to Berlin for the occasion in the company of

54 Left
*Dedicated to
My Fiancée,*
1911.
Oil on canvas;
213 × 132·4 cm,
83⅞ × 52⅛ in.
Kunstmuseum,
Berne

**55 Below left
Franz Marc,**
*Little Blue
Horse,*
1912.
Oil on canvas;
58 × 73 cm,
22⅞ × 28¾ in.
Saarland
Museum,
Saarbrucken

56 Right
*Dedicated
to Christ,*
1912.
Oil on canvas;
174·6 × 192·4 cm,
68¾ × 75¾ in.
Museum of
Modern Art,
New York

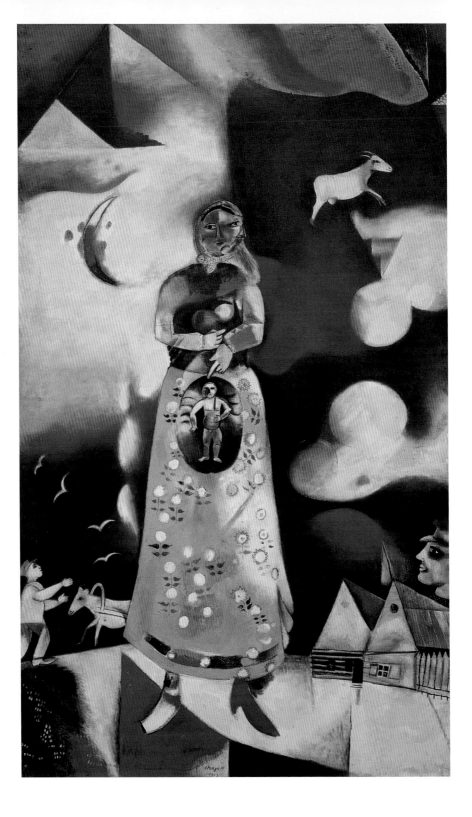

Cendrars; the paintings he submitted were *To Russia, Asses and Others* (see 35), *Dedicated to My Fiancée* (54) and *Dedicated to Christ* (56) of 1913 (later renamed *Golgotha*, and later still, *Calvary*).

Dedicated to Christ, which was bought by the German collector Bernhardt Kohler, was the first major work by Chagall to be sold, and also the first to reveal his lifelong preoccupation with the figure of Christ. That an interest in Christian imagery dates back to his early days in Russia is borne out by such quietly subversive works as *The Family* or *Maternity* of 1909 (also known as *Circumcision*) and *The Holy Family* of 1910. *Pregnant Woman* or *Maternity* of 1913 (57), with its half-mocking reference to a certain type of Madonna and Child to be found in Russian icons (58), is another example of this fascination persisting into his first Parisian period.

57
Pregnant Woman or *Maternity*, 1913.
Oil on canvas; 194 × 114.9 cm, 76³⁄₈ × 45¹⁄₄ in. Stedelijk Museum, Amsterdam

58
Icon, c.12th century.
Tempera on panel; 194 × 120 cm, 76³⁄₈ × 47¹⁄₄ in. Tretyakov Gallery, Moscow

In its inconsistent perspective and non-naturalistic use of space, *Dedicated to Christ* recalls not only Parisian Cubism but the tradition of Russian icons; in its splintered chromaticism, it anticipates the stained-glass images that Chagall was to create half a century later (see Chapter 7). Christ is flanked by an enormous bearded Jew and a Mary dressed in oriental finery; while a mysterious figure carrying a ladder (symbolic of the link between earth and heaven, Man and God) and a diminutive figure in a boat (Charon, the ferryman of classical mythology?) complete the enigmatic scenario. In a mysterious gesture reminiscent of the earlier *Holy Family*, in which the Christ-child was given a beard, the crucified Christ is depicted here as 'a blue child in the air'. This is not the image of Jesus as Jewish martyr that Chagall was to explore from the 1930s onwards, but it is certainly no conventional Christian rendering of the scene. Indeed, it may well have been painted partly as a response to the so-called Beilis Affair in Russia, when a Jew called Mendel Beilis was arrested in 1911 on the age-old, trumped-up charge of having murdered a Christian child for ritual purposes; he was finally acquitted in 1913. Something of an international *cause célèbre*, it received extensive coverage in the French press, and the anti-Semitic press in particular. Chagall's distaste for a religion which still permitted this sort of outrage may well have fuelled his brush on this occasion, and further intensified his ambivalence towards Christian culture.

In April 1913 Chagall shared an exhibition at the Der Sturm gallery with the proto-Surrealist Austrian artist Alfred Kubin (1877–1959). Only subsequently did Walden offer him his first one-man show. This was a modest and informal affair: forty or so canvases, unframed but representing almost his entire Parisian output (plus the portrait of his sister Aniuta, which he had brought with him from Russia), were hung close together on the walls of the editorial office of *Der Sturm*, while well over one hundred watercolours, drawings and gouaches were simply spread out on tables. The exhibition, held in May–June 1914, was critically well received. Attempts to locate Chagall neatly in the Expressionist camp were doomed to failure, however. Although his non-naturalistic handling of space and colour does indeed possess certain affinities with the work of artists such as Ernst Ludwig Kirchner (1880–1938) or Karl Schmidt-Rottluff (1884–1976), his work has little of the deliberate

59
Heinrich Campendonck,
Family Portrait,
c.1914.
Oil on canvas;
91 × 121 cm,
35⅞ × 47⅝ in.
Städtische
Kunsthalle,
Bielefeld

rawness, the outpouring of soul and the self-conscious angst of the true Expressionist. By now, Chagall's work was being exhibited in other countries as well, and was exerting a distinct, if limited, influence on other artists. In Germany, for example, Heinrich Campendonck (1889–1957) was inspired by Chagall's one-man exhibition at Der Sturm to produce quirky but comparatively anodyne images reminiscent of the latter's imaginative universe (59).

Although he did meet with critics and visited several museums and galleries in Berlin, including a Van Gogh retrospective at the Paul Cassirer Gallery, Chagall himself was in too much of a hurry to continue eastwards towards his native Vitebsk, to wish to linger in Berlin. A cryptic postcard sent to Robert Delaunay on 15 June, just before Chagall boarded the train for Russia – 'It's hot. It's raining. Sauerkraut. German girls are quite extraordinarily not pretty' – confirms his lack of interest in exploring the lively culture of Berlin. Immersion in that culture would have to wait until his return, under radically different circumstances, in 1922. The final sentence of the postcard hints at the main reason for Chagall's dissatisfaction with Berlin: namely, his impatience to see his girlfriend Bella again. The wedding of one of his sisters seems to have been another reason for the journey.

Four years had passed since the lovers had last seen each other, and although they were in regular correspondence, Bella's letters were getting perceptibly cooler and more matter-of-fact in tone. Probably quite sensibly, Marc realized that action was necessary. His plan, it seems, was to arrive in Vitebsk, marry Bella, whisk her off first to Germany to share in the success of his exhibition and then return with her to Paris. Little did he realize then that, as he later put it, 'the bloody comedy would begin that was to transform the whole world, and Chagall with it.'

Chagall's first response to his re-immersion in Russian–Jewish life in the fateful summer of 1914 was to paint his loved ones and their environment obsessively and, for the most part, with far greater fidelity to appearances than had characterized the work of his Parisian years. *David in Profile* of 1914 (60), which shows the artist's consumptive younger brother pensively playing the mandolin, owes more to Matisse and Fauvism than to Cubism. *The Artist's Sister*, sometimes known as *Lisa at the Window*, also of 1914, is unusual in that it was painted on canvas, unlike most of his work of this period, which, due to wartime shortages of materials, was painted on cardboard. This image too is relatively naturalistic, and poignantly captures the expectant stillness of the adolescent girl.

60
David in Profile, 1914. Oil on paper, fixed on board; 50×37·5 cm, 19³⁄₄ × 14³⁄₄ in. Finnish National Gallery, Helsinki

Bella Rosenfeld he found more beautiful than ever, and considerably more worldly-wise than she had been in 1910. In his absence, she had studied and lived alone in Moscow, graduating from the faculty of History and Philosophy at the Guerrier College for Girls, with ambitions of becoming an actress. Any concern that Chagall may have felt about her apparent intimacy with his old friend Victor Meckler was allayed by the passion of their reunion, and their mutual conviction that they were made for each other. A series of lyrical love paintings of 1914–17, some tender, such as *Lovers in Grey* (61), *Lovers in Blue* and *Lovers in Pink*, others more overtly erotic (*Lovers in Green*, *Lovers in Black*), vividly evoke the sensuous pleasures of their relationship.

The outbreak of World War I in August 1914 put paid to Chagall's earlier plan to stay in Vitebsk for just three months before taking Bella back with him to western Europe. Dismay at being trapped – bereft, moreover, of his prodigious output of the last four years – was countered by his delight at being reunited with his fiancée and family, and his reawakened sense of allegiance to the milieu that always lay at the heart of his art. 'It's only my town, mine, which I have rediscovered. I come back to

it with emotion. It was at that time that I painted my Vitebsk series of 1914. I painted everything that met my eyes. I painted at my window, I never walked down the street without my box of paints.' This 'Vitebsk series' includes works such as *The Moscow Bank in Vitebsk*, *The Uncle's Shop in Lyosno* (62), *The Pharmacy in Vitebsk* and *View from the Window, Vitebsk* – all of them a far cry from the fantastical images of Russia he had produced in Paris. Another reason for the relative conservatism of these 'documents' (the term is Chagall's) perhaps lay in his desire to communicate directly to those close to him, whose visual sensibilities were considerably less sophisticated than his own, while the Van Gogh retrospective he had seen in Berlin may also have encouraged a

greater realism and accessibility. Yet two self-portraits of 1914, in their veiled arrogance combined with introspection, hint at the ambivalence of Chagall's position at this time (63). Equally, there are other portraits of his brother David, also painted in 1914, which – unlike the one already mentioned – are broodingly Expressionist in style.

During the war Chagall himself never saw active service, although he initially applied to be assigned to a camouflage unit – naïvely believing that there at least his artistic talents might be put to good use. Instead, through the intervention of Bella's brother Yakov, a successful lawyer and economist, he spent much of the war as a woefully inefficient clerk in the Office of War Economy in Petrograd (since 1914 the name for

St Petersburg), where he and Bella moved shortly after their marriage in 1915. Despite, or perhaps because of, his ineptitude, much of his time at the Office of War Economy seems to have been his own. Indeed, it was here that Chagall, as a young man in his late twenties, embarked on the audacious task of penning his autobiography. The publication in 1918 of a Russian edition of Paul Gauguin's memoir *Noa-Noa*, containing a title page designed by El Lissitzky, and of Wassily Kandinsky's *Reminiscences* almost certainly encouraged Chagall to continue writing through all his later trials and tribulations. Meanwhile, a series of sombre but vivid images of soldiers and street life produced in 1914 (many of them stark black-and-white drawings) testifies to the fact that the traumas of war

61
Lovers in Grey,
1916–17.
Oil on
cardboard
on canvas;
69 × 49 cm,
27¹⁄₈ × 19¹⁄₄ in.
Musée National
d'Art Moderne,
Centre Georges
Pompidou,
Paris

62
*The Uncle's
Shop in Lyosno*,
1914–15.
Oil on board;
37·1 × 48·9 cm,
14⁵⁄₈ × 19¹⁄₄ in.
Tretyakov
Gallery,
Moscow

63
*Self-Portrait
with White
Collar*,
1914.
Oil on paper-
board;
30 × 26·5 cm,
11³⁄₄ × 10¹⁄₂ in.
Philadelphia
Museum of Art

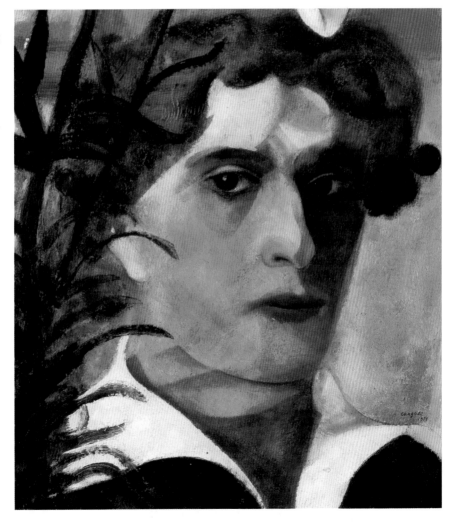

64
*Wounded
Soldier*,
1914.
Oil on card-
board;
49×36 cm,
19¹⁄₄×14¹⁄₈ in.
Philadelphia
Museum of Art

65
Feast Day (*Rabbi
with Lemon*),
1914.
Oil on canvas;
104×84 cm,
41×33 in.
Kunstsammlung
Nordrhein-
Westfalen,
Düsseldorf

66 Below right
The Praying Jew
(*Rabbi of
Vitebsk*),
1914.
Oil on card-
board;
101×80 cm,
39³⁄₄×31¹⁄₂ in.
Stiftung
Sammlung Karl
und Jürg im
Obersteg,
Geneva

67 Below far
right
Jew in Red,
1914.
Oil on card-
board, mounted
on canvas;
101·1×81 cm,
39³⁄₄×31⁷⁄₈ in.
Stiftung
Sammlung Karl
und Jürg im
Obersteg,
Geneva

did indeed impinge on his artistic consciousness. Images such as the *Wounded Soldier* (64) and the *Leave-taking Soldiers* rely on an almost Expressionistic distortion of the human figure to bring home the pathos of their subject matter.

For the most part, however, he concentrated on portraits of his immediate family like the ones already mentioned, and on images of archetypal members of the Vitebsk Jewish community, swollen (like many other Russian towns) by the influx of Jews – some 200,000 in total – expelled from Lithuania by the Germans during 1914–15. Chagall was clearly well aware of the renewed anti-Semitism provoked by the war, in which every Russian military defeat was 'an excuse ... to blame the Jews', and confesses in *My Life* to the urge to 'keep them safe ... by having them all put on to my canvases'. Today, Chagall's ability to preserve in much of his work the flavour of a community that was to be finally destroyed in the Holocaust is undoubtedly one of the factors contributing to his popularity. Itinerant Jewish pedlars and beggars, happy to pose in return for a few kopecks, served as his models. The figures of *The Newspaper Vendor, Feast Day* (*Rabbi with Lemon*; 65), *The Praying Jew* (*Rabbi of Vitebsk*; 66) and *Jew in Red* (67), all painted in 1914, with more than a

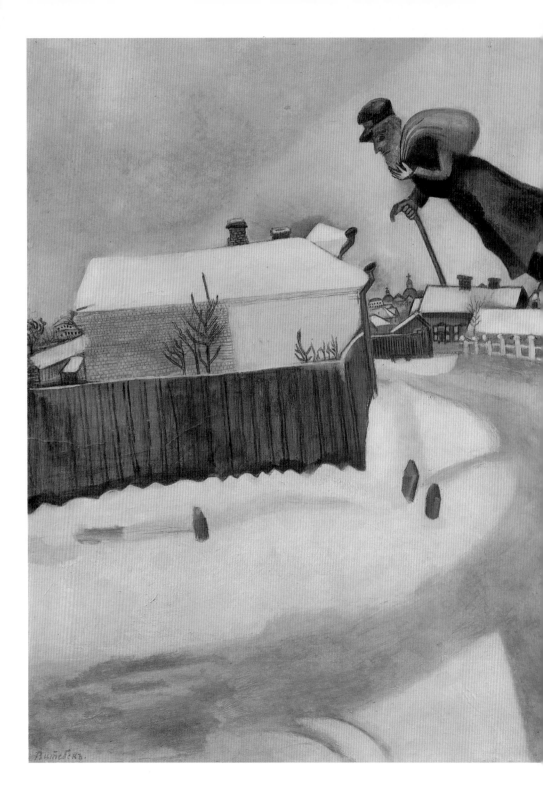

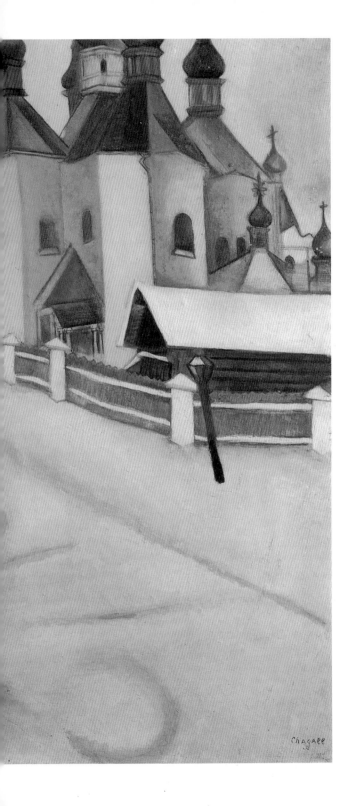

chaɡall

68
Over Vitebsk,
1914.
Oil on card
on canvas;
70·8×90·2 cm,
27⅞×35½ in.
Art Gallery
of Ontario,
Toronto

passing reference to the work of Yehuda Pen (see 9), are quite literally more earthbound than the characters which so memorably peopled his Parisian canvases, though not without their own ambiguities.

One notable exception to the more matter-of-fact approach of these paintings is *Over Vitebsk* (68), in which the bearded Jew with the sack floating over the rooftops alludes to the redemptive figure of the prophet Elijah and to the archetypal figures of the Wandering Jew and the Luftmensch. The latter, a man who walks and lives on air, surviving against all the odds by his own resources, is a commonplace of Yiddish literature and appears frequently in Chagall's *oeuvre*. The curious positioning of the figure can also be explained by a popular Yiddish expression, whereby to 'walk over the city' alludes to the practice of door-to-door begging indicative of the poverty of so many eastern European Jews at the time. Interestingly, however, once back in Russia, Chagall seems to have felt less need to transpose verbal idioms into paint than he did in Paris – a reflection, perhaps, of a feeling that it was no longer necessary or desirable to hide his meanings from the viewer, although his work in the more private medium of drawing continued to contain references to Yiddish idiomatic expressions. When he does

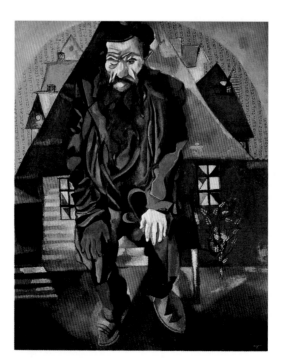

69
Jew in Bright Red,
1915.
Oil on cardboard;
100 × 80·5 cm,
39$^3$⁄$_8$ × 31$^3$⁄$_4$ in.
Russian Museum, St Petersburg

incorporate words into his images of this period, it tends to be in a more literal fashion, as in *Jew in Bright Red* (69).

When Chagall married Bella on 25 July 1915, her socially superior family was still expressing its grave misgivings about the match. During this year his art concerned itself above all with their union, simultaneously sensual and transcendent. 'I had only to open my window, and blue air, love and flowers entered with her. Dressed all in white or all in black, she has long been flying over my canvases, guiding my art.' Bella's own memoirs, written thirty-five years after their first meeting, are if anything more fervent still. In *First Encounter*, she recalls how she had managed, with great difficulty, to discover Marc's date of birth, and visited him on that day, carrying food and flowers in embroidered shawls. The shawls were draped around the room, and Chagall began to paint. The result was orgasmic:

Spurts of red, blue, white, black … suddenly you tear me from the earth, you yourself take off from one foot … You rise, you stretch your limbs, you float up to the ceiling. Your head turns about and you make mine turn … You brush my ear and murmur.

The resulting painting, *The Birthday* of 1915 (70), provides a vivid testimony to the gravity-defying self-sufficiency of their partnership.

The Poet Reclining (71), also of 1915, is a more restrained and tranquil tribute to their love. Chagall confirmed that it was painted during their honeymoon: 'Alone together in the country at last. Woods, pine-trees, solitude. The moon behind the forest. The pig in the sty, the horse outside the window, in the fields. The sky lilac.' The fact that Chagall here identifies himself as a poet is significant, since – as we have seen – he was always attracted to poets, himself wrote poetry of considerable merit and, above all, wished his painting to work on the viewer much as poetry does. Just visible beneath the final layer of paint is a second figure – presumably Bella – which originally lay alongside that of Chagall. Its removal makes the painting less obviously sensual, more meditative, even spiritual – especially if one recalls the Hasidic perception of the natural world as allowing one direct access to the Divinity. *The Wedding* of 1918 (72), with its angel hovering protectively over the

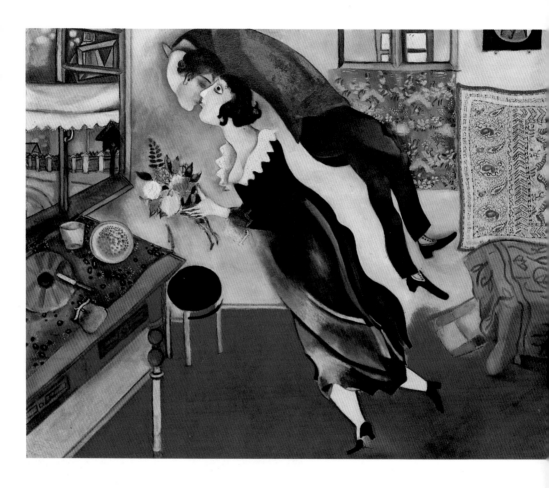

70
The Birthday,
1915.
Oil on canvas;
80·5×99·5 cm,
31³⁄₄×39¹⁄₈ in.
Museum of
Modern Art,
New York

71
*The Poet
Reclining*,
1915.
Oil on
millboard;
77×77·5 cm,
30³⁄₈×30¹⁄₂ in.
Tate Gallery,
London

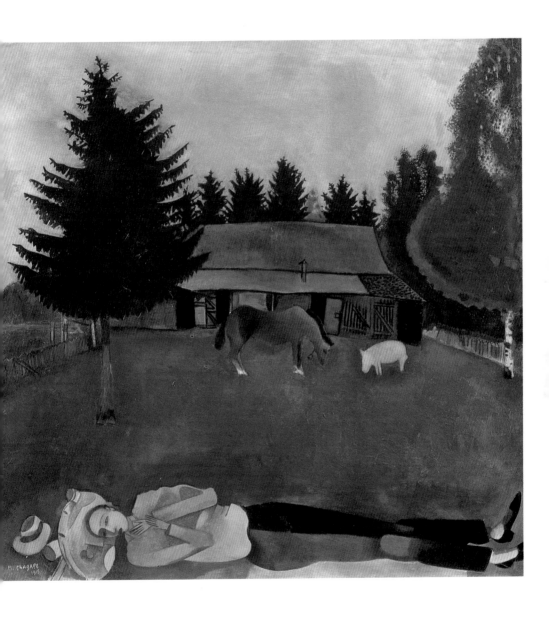

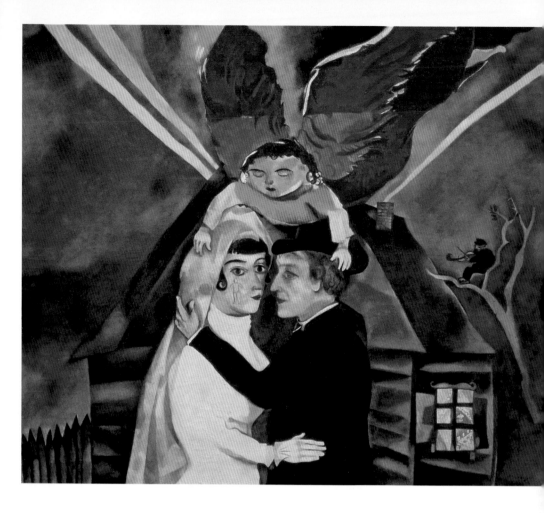

2 Left
The Wedding,
1918.
Oil on canvas;
100 × 119 cm,
38⅜ × 46⅞ in.
Tretyakov
Gallery,
Moscow

3 Below left
Nicolas Dipre,
*The Meeting at
the Golden
Gate*,
c.1500.
Oil on wood;
99 × 44 cm,
53⅜ × 17⅜ in.
Musée de
Carpentras

4 Right
Marc, Bella and
Ida, 1917

5 Far right
*The Infant's
Bath*,
1916.
Oil on paper on
cardboard;
44 × 44 cm,
14¼ × 17⅜ in.
Museum of Art,
History and
Architecture,
Pskov

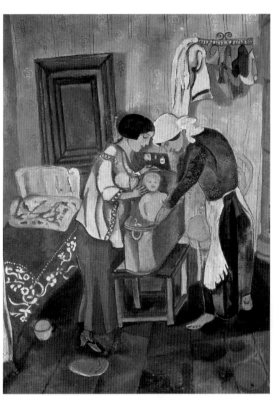

couple – a motif he seems to have borrowed directly from an early
French painting, *The Meeting at the Golden Gate* (73) of c.1500, now
in the museum at Carpentras – makes Chagall's sense of his and Bella's
union as divinely ordained and blessed more explicit.

The birth in May 1916 of Bella and Marc's first and only child, Ida,
seems to have cemented their domestic bliss (74), and finds expression in
a number of charming and relatively naturalistic renditions of family life
with a young child: among them, *Bella and Ida at the Window* and *The
Infant's Bath* (75), both of 1916. In reality, Chagall did not take to father-
hood naturally or easily, admitting to a distaste for the noises and smells
of babyhood. The fact, moreover, that the baby was a girl so disappoint-
ed him that he delayed visiting mother and child for four whole days.

It was at this time that Chagall also began to illustrate Yiddish texts – notably, two poems by 'Der Nister' ('The Hidden One', pseudonym of Pinkhes Kahanovich), entitled 'The Rooster' and 'The Little Kid', and I L Peretz's humorous short story 'The Magician', the results of which were exhibited in 1916. Chagall's decision to work as an illustrator may have been prompted by his personal acquaintance with the authors, but may also have been a defiant reaction to the ban on Yiddish publications that existed first between 1883 and 1905, and then again from 1910 until the Revolution. These wittily economical, apparently childlike but actually highly sophisticated, ink drawings (76), his first foray into this field, drew the highest praise from the critic Abram Efros: 'With a hand turned terse and limpid … Chagall has now conquered the world of illustration.' Indeed, these images can be seen as paving the way for a more widespread interest among avant-garde Russian–Jewish artists in creating a secular Yiddish art book tradition.

76
Illustration for
I L Peretz's,
'The Magician',
1915.
India ink, wash
and white
gouache on
paper;
22.5 × 18 cm,
8⅞ × 7⅛ in.
Israel Museum,
Jerusalem

In a more public sphere, Chagall managed during 1915–17 to consolidate his position as the leading light among the younger generation of Russian artists by participating in a number of important avant-garde exhibitions. In March 1915, for example, he was invited – on the recommendation of the critic Yakov Tugendhold – to send twenty-five of his Vitebsk 'documents' to the exhibition *The Year 1915* at the Mikhailova Gallery in Moscow. Both Abram Efros and Tugendhold, who together would soon write the first critical work on Chagall, wrote favourably of the familiar, folkloric quality of these works; in an article entitled 'New Talent', Tugendhold referred to him as 'an artist mostly unknown in Moscow, but already famous abroad'. In April 1916 sixty-three of Chagall's works were exhibited at the Dobychina Gallery in Petrograd. Otherwise known as Nadezhda Dobychina's Bureau, this was the most significant commercial gallery in Russia in the period 1911–17. Its Jewish owner was the foremost dealer in modern Russian art during this time, and promoted not only Chagall but Goncharova, Altman, Olga Rozanova (1886–1918) and many others. It was here, for example, in the autumn of 1915, that Kasimir Malevich (1878–1935) first exhibited his radical paintings in the geometric abstract style to which he gave the name Suprematism. In November 1916, forty-five of Chagall's works were hung in the Knave of Diamonds group show in Moscow, in which most of the

other participants, among them a number of Jewish artists, adhered
to a stylization of form derived from Cézanne. And in November 1917,
sixty-nine of Chagall's drawings and four of his paintings were again
exhibited at the Dobychina Gallery.

He also acquired an influential and enthusiastic patron, the engineer
and collector Kagan Chabchai, who purchased thirty of Chagall's works
for his projected Museum of Jewish Art – an idea never realized because
of the Revolution. Ivan Morosov, who was best known as a major collec-
tor of Impressionist and Post-Impressionist works, also acquired his first
Chagalls at this time. Chagall himself began to associate with a number
of Russian intellectuals, many of whom he had already encountered dur-
ing his earlier residence in St Petersburg between 1907 and 1910. They
included the poets Aleksandr Blok, Sergei Esenin, Vladimir Mayakovsky,
Boris Pasternak and Demyan Bedny, the art critic Maxim Syrkin and
the physician Dr Isidor Eliashev, who wrote literary criticism under the
Yiddish pseudonym Ba'al Makhshoves (The Thinker). It was Mayakovsky

77
The Traveller,
1917.
Gouache and
graphite on
paper;
38·1×48·7 cm,
15×19 1/8 in.
Art Gallery
of Ontario,
Toronto

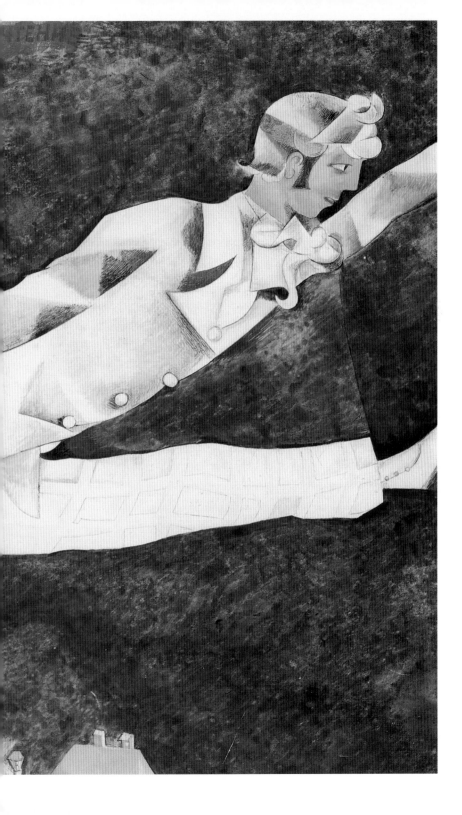

who, although not a close friend of the artist, dedicated one of his books as follows: 'God grant that everyone may *chagalle* [*ie* stride forward] like Chagall.' An image such as *The Traveller* of 1917 (77) suggests that Chagall felt similarly optimistic as regards his own progress through life.

In fact, Chagall showed considerable distaste for the 'clamour and public drivel' represented by cultural activists such as Mayakovsky, feeling far closer to the quieter talents of the poets Blok and Esenin: 'I preferred Esenin … He also shouted, but intoxicated by God, not by wine … It may be that his poetry is imperfect. But is it not, after that of Blok, the only cry from the depths of the Russian soul?' Esenin's empathy with animals and, through them, his cosmic insights no doubt struck a chord of recognition in Chagall. The artist clearly felt an affinity with the musical flow of Blok's poetry, in particular his mystical dream-universe. He was also sympathetic to Blok's critique of the mundane, uninspired qualities of European civilization. The stylistic influence of these writers on Chagall's idiosyncratic autobiography should not be underestimated.

The year 1918 saw the publication in Russian of the first monograph devoted to Chagall's work. Entitled *The Art of Marc Chagall*, this contained a logo by El Lissitzky, two essays by Efros and one by Tugendhold, who had first met Chagall while living in Paris as correspondent for the Russian journal *Apollon*; it was translated into German in 1921. Interestingly, two of Chagall's Parisian works were reproduced in the book, proving that he must have brought at least some photographs of his paintings with him to Russia. The texts, although short, are full of vivid, if occasionally fanciful, insights into the artist's work and personality. Efros, for example, wrote:

Approaching Chagall is difficult because one has to resolve his contradictions, create a synthesis of them and reveal the single core and governing force behind the disparate elements. Chagall is a genre painter, but Chagall is also a visionary, Chagall is a narrator, but Chagall is also a philosopher, Russian Jew and Hasid, and also a pupil of the French modernists and, finally, also a cosmopolitan fantasist …

This was also the period when Chagall forged close contacts with a group of artists, including Nathan Altman and El Lissitzky, who were intent on

exploring and exploiting Russian–Jewish folk art (78) in their quest for an authentic modern Jewish art – a quest in which Efros also fully and eloquently participated. In a 1918 essay entitled 'Aladdin's Lamp' Efros claimed in no uncertain terms:

The *lubok*, the gingerbread, the toy and the painted cloth constitute an entire programme for the practical aesthetics of contemporaneity … If Jewry wishes to live artistically and if it is looking for its aesthetic future, then this presupposes an inexorable, thorough and totally active connection with the popular arts.

As we have seen, Chagall, although affecting disdain for their fervour, was well aware of the presence of the Machmadim group of artists in Paris, and was familiar with the debates raging in the pages of cultural journals such as *Ost und West*. Altman, to whom Chagall related in a spirit of friendly competition, was particularly active in this search, helping to found the Society for the Encouragement of Jewish Art in Petrograd with Chagall's old mentors, Ilya Ginsburg, Vinaver, Pen and others in late 1915 or early 1916. Chagall himself participated in the first exhibition of the Society in the spring of 1916; and in April 1917 fourteen of his paintings and thirty drawings were included in a controversial show entitled *Paintings and Sculptures by Jewish Artists*, staged by the Society and held at the Galerie Lemercier in Moscow. In the pages of the Moscow-based Yiddish journal *Shtrom*, Chagall defended the project,

expressing his pride in belonging to 'this little Jewish people who gave
birth to Christ and Christianity. When there was a need for something
else [they] came up with Marx and Socialism. So why couldn't [the
Jewish people] also give the world a specifically Jewish art?'

The roots of this interest date back as far as 1886, the year in which
Vladimir Stasov, in collaboration with Baron David Ginsburg, had com-
piled a volume of illuminated pages from medieval Hebrew manuscripts;
a French edition of this, entitled *L'Ornement hébreu*, was published in
Berlin in 1905. In 1908, the Jewish Historical and Ethnographical Society
was founded in St Petersburg. Prominent among its members was the
writer and ethnographer Shloyme Ansky, who from 1909 onwards pub-
lished articles on Yiddish folklore and between 1912 and 1914 headed a
major ethnographical expedition, the findings of which were to be
deposited at a short-lived Jewish National Museum, established in 1915.
The artefacts gathered and recorded on these forays into the towns and
villages of remote regions such as Volhynia and Podolia in the southwest
Ukraine were to have a lasting impact on a whole generation of Jewish
avant-garde artists. Through this encounter not only with synagogue
decoration and ritual objects, but with *lubki* (woodblock prints; 78) and
domestic items such as clothing, collected precisely at the point at which
the way of life they represented was being eroded, the artists formed
their own conclusions: that, for example, the principles of Jewish folk
art included flatness, ornamental design, autonomy of Hebrew
lettering, subdued colours and a tendency to abstraction and symmetry,
which they could transpose into their own productions.

It was this Society which financed the expeditions of artists Issachar
Ryback (1897–1935) and El Lissitzky, who in 1916 started exploring and
recording the art and architecture of the wooden synagogues along the
River Dnepr. The simple exterior of these buildings (now known only
through such records as this, and through photographs, since few of
them survived World War II) gave little indication of the profusion
of ornament within. Apparently naïve, their wall-paintings clearly
possessed an infectious exuberance and vitality, an intuitive sense of
surface pattern comprised of organic and animal forms endowed with
anthropomorphic characteristics. The most notable of these interiors

was found in the eighteenth-century synagogue of Mogilev (79) some 160 km (100 miles) south of Vitebsk – unusual not only for the quality of its paintings but also for the fact that the latter bore the inscription 'By the artisan who is engaged in sacred craft, Haim the son of Isaac Segal from Sluzk.' Significantly, it was this man, Haim Segal of Sluzk – one of the relatively few Jewish craftsmen whose name has been preserved – whom Chagall claimed as his 'distant ancestor'.

It may have been through the Society for the Encouragement of Jewish Art that Chagall in 1916–17 received his first public commission, to decorate the walls of a Jewish secondary school, housed in the building of the main synagogue of Petrograd. The extant studies – a watercolour entitled *Visit to the Grandparents*, two images of religious festivals, *The Feast of Tabernacles* (80) and *Purim* (in gouache and oils respectively), and two final sketches, one for *Purim* and one entitled *Baby Carriage Indoors* – reveal that he here abandoned the essentially realist style,

79
Issachar Ryback, The ceiling of the Mogilev Synagogue (detail), *c.*1916. Watercolour and Indian ink over black chalk on paper; 64·5 × 48 cm, 25⅜ × 18⅞ in. Israel Museum, Jerusalem

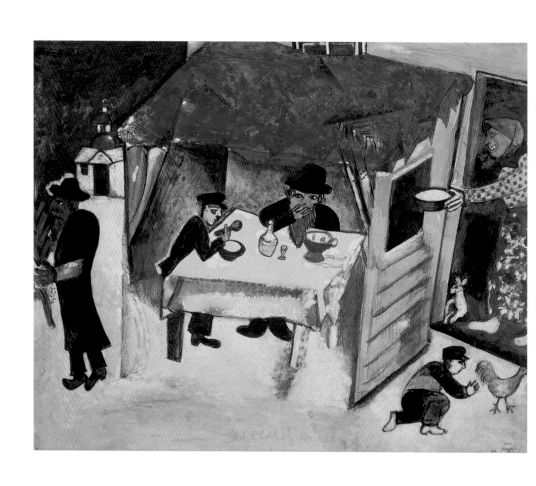

albeit informed by Cubism, in which many of the paintings of this period had been rendered, in favour of a more populist *faux naïf* folk style indebted to the tradition of Jewish *lubki* and painted wooden synagogue interiors. *The Feast of Tabernacles*, moreover, was based on an image of the Passover Seder in the Mantua *Haggadah* of 1560 (81), which had been reproduced in the journal *Ost und West* – proof that Chagall was still looking beyond Russia for artistic inspiration. The outbreak of the Russian Revolution, however, meant that the large-scale paintings for which these studies were intended were never executed.

80
The Feast of Tabernacles, 1916.
Gouache;
33×41cm,
13×16⅛in.
Private collection

81
Passover Seder, Mantua *Haggadah*, 1560.
Reproduced in *Ost und West*, vol.4, 1904

The Revolution of 1917 that ended centuries of Tsarist autocracy had its roots deep in the past. The power of the Tsars had already been weakened by Russian defeat in the Crimea in 1856 and by the Revolution of 1905. Although the long-term cause of revolution lay in the fundamental tension between the divine rights claimed by Russia's rulers and an increasingly industrialized and politicized society, its immediate cause was the failure of the existing regime to cope with a world war. In two and a half years there were five and a half million Russian casualties; the troops were short of ammunition, the civilian population short of food; the transport system in chaos and the government utterly in disarray. The so-called February Revolution of 1917 was led by the liberal intelligentsia who believed that Russia could still win the war and be transformed into a democratic republic. A provisional government, headed by Aleksandr Kerensky, was elected by the Duma.

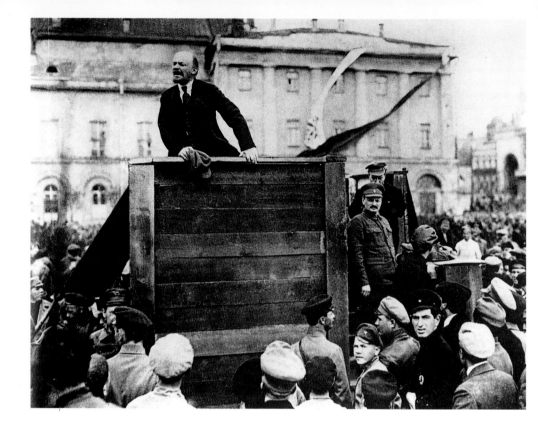

The October Revolution, in contrast, was led by the Bolsheviks and social revolutionaries, who considered the 'imperialist' war already lost, and sought to transform the economy as a basis for transforming the entire social structure of Russia. On 25 October 1917 Lenin (82) ordered the Red Army to occupy the Winter Palace in Petrograd, seat of the provisional government. A newly created all-Russian congress of soviets entrusted authority to the Bolsheviks, who organized a Council of People's Commissars as its executive body. An armistice was arranged in late 1917, formalized by the Treaty of Brest-Litovsk in March 1918. Radical and dramatic measures followed: the workers were given control of factories, private trade was prohibited; the property of the Church and counter-revolutionaries confiscated; discriminatory laws against Jews and other minorities abolished.

Chagall's reaction to the Russian Revolution of 1917 was more enthu-siastic than his previously apolitical stance would have led anyone – including himself – to expect. But as a Jew and as an artist, he could not

fail to be excited at the prospects opening up before him. For the Jews of Russia, the new order promised full citizenship for the first time: the liquidation of the infamous Pale of Settlement, an end to the quota system in universities and to the internal passport system that had once landed Chagall in prison. For orthodox Jews (such as Chagall's father, Sachar), the Revolution offered the hope that they would at last be able to practise their religion without fear of prejudice and persecution. Ironically, for already secularized Jews such as Chagall, the Revolution promised to sweep away not only Tsarist tyranny, but the tyranny of Jewish orthodoxy as well. Unsurprisingly then, Jews – above all, Lev Kamenev (born Rosenfeld) and Leon Trotsky (born Lev Bronstein) – figured prominently among the revolutionary leaders.

As an artist, Chagall – like so many of his peers – made the romantic mistake of equating revolutionary politics with revolutionary art. Certainly, the whole art establishment in Russia was to undergo a radical restructuring that initially seemed to favour the avant-garde. After 1917, a complete reorganization of state machinery was undertaken, and a new bureaucracy set up. The old ministries were replaced by commissariats, and Anatoly Lunacharsky was appointed head of the People's Commissariat of Enlightenment or NARKOMPROS, a body which combined the ministries of culture and education. The visual arts section of NARKOMPROS, known as IZO, headed first by David Shterenberg (1881–1948) and later by Nathan Altman – both of them Jewish – was formally established in January 1918. A literature department, LITO, followed in late 1919; while other sections dealt with music (MUZO), theatre (TEO) and photography and cinema (FOTO-KINO). Hitherto the exclusive province of the privileged classes, both culture and education were now regarded as a means of liberating the masses. One should remember, however, that in 1917 seventy-five per cent of the Russian population was totally illiterate and eighty per cent of working-class children had no access to formal schooling. It is hardly surprising, therefore, that for the revolutionary leaders education took priority over the arts. Literacy first, culture second.

In spite of this – and the fact that Lenin himself took little direct interest in cultural matters – Lunacharsky, an individual of considerable

sensitivity and tolerance, was eager to harness the enthusiasm of the Russian avant-garde to his own revolutionary ends. Lenin once described him as possessing 'a sort of French brilliance … His light-mindedness is also French: it comes from his aesthetic inclinations.' While their public pronouncements made it clear that the avant-garde wished their kind of art to dominate, if not monopolize, the new art scene, Lunacharsky believed that artists of all persuasions had a role to play in the massive task of developing a new populist, egalitarian Soviet culture. Indeed, only a few years later, in the less liberal climate of 1922, he was to claim that:

In Russian bourgeois society [the Futurists] were to some extent persecuted and considered themselves revolutionaries in artistic technique. It was natural that they soon felt some sympathy for the Revolution, and were attracted to it when it extended a hand to them … It must be confessed that, above all, it was my hand. I extended it not because I admired their experiments but because in the general policy of NARKOMPROS we needed to depend on a serious collective of creative artistic forces. I found it almost exclusively there, among the so-called 'left' artists. Yes, I extended a hand to the 'leftists', but the proletariat and peasantry did not extend a hand to them.

Although in the Russian context the term 'Futurist' is most commonly applied to the self-identified, pre-Revolutionary groupings of avant-garde artists which included figures such as Aleksandr Rodchenko (1891–1956), Lyubov Popova (1889–1924), Vladimir Tatlin (1885–1953) and Malevich, it can also be seen to embrace more independently minded individuals such as Kandinsky and Chagall who were equally keen to involve themselves with the new order. Lunacharsky, a former resident of La Ruche, had already encountered and admired Chagall and his work in Paris, and it was largely at the former's suggestion that Chagall was nominated for the post of Director of Fine Art in the Petrograd Ministry of Culture. That Mayakovsky was to be his counterpart in literature, Vsevolod Meyerhold in theatre was, moreover, an indication of the high esteem in which Chagall was now clearly held. Surprised but flattered, and ready to agree, Chagall was nevertheless persuaded by Bella's entreaties to turn down the honour: 'Seeing me neglect my painting, my wife wept. She warned me that it would all end in insults, in snubs.'

83
The Promenade, 1917–18. Oil on cardboard; 170 × 183·5 cm, 66 × 72¼ in. Russian Museum, St Petersburg

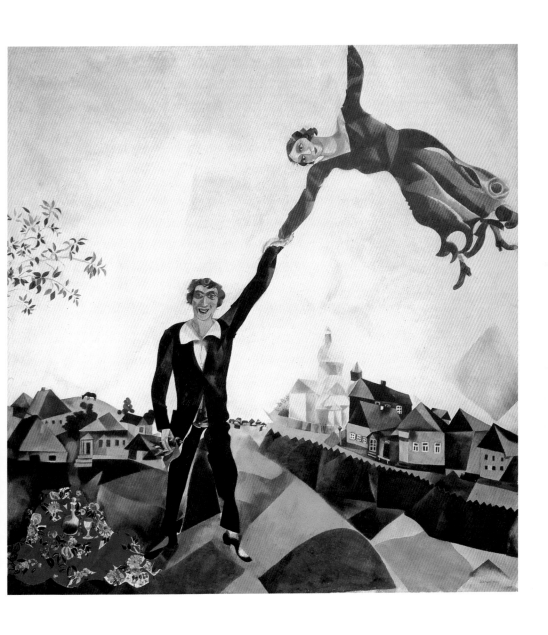

In November 1917, therefore, the Chagall family went back to Vitebsk, 'my town and tomb', where for a while they lived comfortably in Bella's parents' house. Vitebsk was as yet unaffected by political events, and remained a relatively sleepy backwater. It was during this first winter of the Revolution that Chagall produced the monumental and euphoric air-borne lovers of *Over the Town*, *The Promenade* (83) and *Double Portrait with Wineglass* (84), as well as *The Blue House* (85) and the curious and striking *The Apparition* (86). *My Life* contains a description of a purport-ed visitation by an angel that bears a close resemblance to this cubistic image. Chagall's interest in Cubism (and Picasso in particular) would have been revived in this year by the publication in Russian of the first monograph on Picasso in any language, by the critic Ivan Aksenov.

'Russia was covered with ice. Lenin turned her upside down the way I turn my pictures,' Chagall would write. Now, however, for the only time in Chagall's life, it was not enough to create a new reality on canvas or cardboard, and it was apparently the artist himself who suggested to Lunacharsky that he, Chagall, should set up and direct a school of fine arts in Vitebsk. In retrospect, Chagall spoke disparagingly of Marxism:

my knowledge of Marxism was limited to knowing that Marx was a Jew, and that he had a long white beard [in fact, since his father had converted, Marx was technically a Protestant; and his beard was jet-black] … I said to Lunacharsky: 'Whatever you do, don't ask me why I painted in blue or green, and why you see a calf inside the cow's belly, etc. On the other hand, you're welcome: if Marx is so wise, let him come back to life and explain it himself.'

But this was written after Chagall had become embittered by the power struggles that were to rage in the school. To start with, he determined to put himself at the service of the Revolution, whatever the personal cost.

While waiting for Lunacharsky's response to his proposal, Chagall orga-nized a large exhibition of work by Vitebsk artists. With uncharacteristic generosity, he paid homage to his former teacher, Yehuda Pen, by allo-cating him a large hall – in contrast to the small back room he reserved for his own work. Paintings by another of Pen's pupils, Chagall's friend Victor Meckler, were also included in the show. In this context, the origi-nality of Chagall's art must have been obvious to all.

84
Double Portrait with Wineglass, 1917–18.
Oil on canvas; 235 × 137 cm, 92 1/2 × 54 in.
Musée National d'Art Moderne, Centre Georges Pompidou, Paris

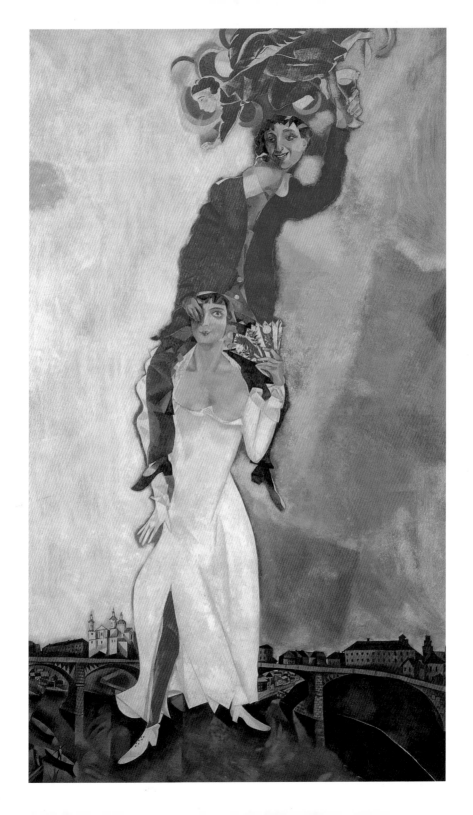

85
The Blue House, 1917.
Oil on canvas;
66 × 97 cm,
26 × 38½ in.
Musée d'Art
Moderne, Liège

86
The Apparition,
1917–18.
Oil on canvas;
157 × 140 cm,
61⅞ × 55⅛ in.
Private
collection

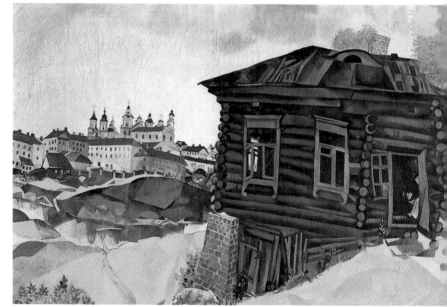

Lunacharsky responded to Chagall's idea of setting up an art academy with enthusiasm; and on 12 September 1918 he was formally appointed Commissar for Art in Vitebsk. His new job endowed him with far more authority than he had bargained for: as well as being put in charge of the new school, he was given the task of organizing 'art schools, museums, exhibitions, lectures on art, and all other artistic ventures within the limits of the city and region of Vitebsk'.

The fact that Vitebsk was considerably more fortunate than the rest of famine-stricken Russia (due to its proximity to fertile farmland, food rationing here was less severe than in other parts of the country), coupled with Chagall's non-doctrinaire attitude to the teaching of art, meant that he was able to attract an impressive array of artists to the new academy, which was housed in a former banker's villa and inaugurated in late January 1919. Although some remained only for a few months, these included Mstislav Dobuzhinsky, who had been one of Chagall's teachers at the Zvantseva School in St Petersburg; Victor Meckler; Ivan Puni (later known as Jean Pougny; 1894–1958) and his wife Ksenia Boguslavskaia (1892–1972), who although sympathetic to Malevich's brand of geometric abstraction, left the academy before the latter's arrival on the scene in November of that year. El Lissitzky joined the staff of the school in the early summer of 1919, as instructor in the architecture department and head of the graphics workshop.

It was Dobuzhinsky who became the first director of what was now known as the Vitebsk Public Art School; it was only when he left that Chagall took up that post, to be replaced in due course (possibly as early as the spring of 1919) by Vera Ermolaeva (1893–1940), because the authorities considered Chagall too bourgeois in his attitudes. Thus, although he was only briefly its official director, Chagall clearly saw himself throughout as both morally and practically responsible for the running of the school (he described himself as 'its director, its president and everything else').

Yehuda Pen was not among those first recruited by Chagall. Although the latter claimed to be catholic in his approach (in *My Life*, he writes of his wish to see 'all the trends ... represented there'), naturalistic painting was not, it seems, to feature at this early stage. Pen responded by

producing a parody of the famous painting *The Island of the Dead* by the Swiss Symbolist artist Arnold Böcklin (1827–1901), in which it is Pen himself who is depicted as lying on his deathbed, and the features of the devil lying in wait for his soul are suspiciously like those of Marc Chagall. This was only the beginning of what Chagall dubbed a 'basket of crabs'. When in late 1919 Pen was invited to join the school after all, it was primarily as a means for Chagall to get his revenge on the ascendant Suprematists, although a sense of residual loyalty to his first teacher may also have played a part.

Meanwhile, ambitious plans were afoot throughout Russia to celebrate the first anniversary of the Revolution, which now fell on 6 November rather than 25 October. This anomaly was due to the shift from the Julian to the Gregorian calendar (as with the French Revolution, a calendar change was deemed to lend cosmic justification to political events). In Petrograd, Nathan Altman was in charge; the huge square in front of the Winter Palace was to be draped in Cubo-Futurist designs. Chagall was determined not to be outdone, and quickly set his assistants to work. On 6 November the citizens of Vitebsk awoke to find their peaceful provincial town utterly transformed: thousands of metres of red cloth had been used to make hundreds of banners; façades of buildings and trolley buses had been repainted – not just in red, but in other colours too. Chagall himself had produced a dozen or so sketches which he called upon local painters to reproduce on a huge scale and to exhibit throughout the town:

My multicoloured animals swung all over the town, swollen with revolution. The workers marched up singing the International. When I saw them smile, I was sure they understood me. The leaders, the Communists, seemed less gratified. Why is the cow green and why is the horse flying through the sky, why? What's the connection with Marx and Lenin?

Indeed, even before the spectacle was unveiled, the local newspaper *Izvestiya* had published an attack headlined 'Let's not make fools of ourselves'; and in a subsequent article, those same green cows and flying horses were dismissed as a 'mystical and formalistic bacchanal'. Interestingly, while Efros in 1930 confirmed that Chagall did indeed cover 'all the fences and signs with upside-down cows and pigs',

87
War on Palaces,
c.1918.
Watercolour and
pencil on paper;
33·7×23·2 cm.
13¹⁄₄×9¹⁄₈ in.
Tretyakov
Gallery, Moscow

88
El Lissitzky,
Ilustration for
Had Gadya,
1918–19.
Gouache, India
ink and pencil
on paper;
28×22·9 cm,
11×9 in.
Tel Aviv
Museum of Art

89
El Lissitzky,
Proun 30 t,
1920.
Mixed media
on canvas;
50×62 cm,
19³⁄₄×24¹⁄₂ in.
Sprengel
Museum,
Hanover

the three sketches for this monumental project that have survived are considerably less fanciful than the artist's own description would have us believe. In fact, *War on Palaces* (87) is probably the most overtly and crudely propagandistic image that Chagall ever produced.

For the time being Chagall's eyes continued 'to blaze with administrative fire': 'Wearing a blouse, with a leather case under my arm, I looked every inch the Soviet civil servant.' Chagall's own ideological position found clearest expression in an article entitled 'Revolution in Art', published in *Revoluzionnoya Iskusstvo*, a local journal that produced only one issue, in the spring of 1919:

The art of today, like that of tomorrow, needs no content … The real proletarian art will succeed with simple wisdom in breaking inwardly and outwardly with all that can only be branded as literature … Proletarian art is neither an art for proletarians nor an art by proletarians … It is the art of the proletarian painter. In him 'creative talent' is combined with proletarian conscience, and he knows full well that both he and his gifts belong to the collectivity … In contrast to the bourgeois painter, who endeavours to meet the taste of the crowd, the proletarian painter never stops fighting against routine. He draws the crowd along in his wake … The art of two times two

equals four which is closest and most accessible to the crowd, is unworthy of our time. Ever since antiquity true art has always been in the minority. But now that is going to change.

This was apparently a sincere but naïve attempt by Chagall to adapt long-held personal beliefs to the greater cause, but his impassioned plea for individual expression fell on deaf ears. The Soviet authorities meanwhile ordered numerous academic statues of Karl Marx to adorn Vitebsk's public spaces; and only the fact that Chagall had the support of Lunacharsky meant that he was permitted to continue relatively unmolested.

It was not only the artistically conservative Soviet ideologues who looked askance at Chagall's activities. Within the academy, too, he was rapidly running into trouble. El Lissitzky was to prove the main target for Chagall's bitterness. Born Eliezer Markovich Lissitzky near Smolensk in 1890, he spent his childhood in Vitebsk where Yehuda Pen encouraged his interest in art; between 1909 and 1914 he studied architecture and engineering in Darmstadt, Germany before returning – like so many of his compatriots – to Russia. Based in Moscow, Lissitzky had been one of the prime movers behind the pre-Revolutionary movement to create an authentic Jewish art, sharing Chagall's enthusiasm for indigenous Russian–Jewish folk art. The charming, *faux naïf* illustrations to the *Had Gadya* ('A Kid for Two Farthings'), one of the songs traditionally sung at

Passover, that he produced in 1918–19 (88) certainly bear out Chagall's
claim that Lissitzky was at first 'my most ardent disciple'. Indeed, one
of Lissitzky's works of this period was sold in Germany after 1945 as an
authentic Chagall. But he was soon to change his artistic allegiances,
championing the brand of purist geometric abstraction favoured by
his new hero Malevich. His *Proun* ('Towards a New Art') series of 1919
onwards (89) shows how far he was travelling in a radically different
direction.

Thus it was probably on Lissitzky's suggestion that the charismatic
Malevich was invited to join the teaching staff of the Vitebsk School
(90). Once the latter arrived on the scene in late 1919, a complete polar-
ization of artistic positions was inevitable. Malevich had for some years
been a leading figure in the Moscow avant-garde. An early exponent
of what has been called the 'Russian Impressionist' style, in 1908 he
switched to a kind of neo-primitivism, also espoused by his associates
Mikhail Larionov and Natalia Goncharova, with which the work of
Chagall at this period also has affinities. His work of 1911–14 developed
under the influence of Cubism, but by 1915 he had abandoned figurative
references altogether, in favour of the rigorous geometric abstraction he

himself dubbed 'Suprematism' or 'Non-Objective' painting (91). In Malevich's own words: 'The Suprematists have given up the objective representation of their surroundings in order to reach the summit of the true "unmasked" art and from this vantage point to view life through the prism of pure artistic feeling.' To Malevich, the truest signifiers of 'pure artistic feeling' were the rectangle, the circle, the triangle, the cross – and, purest of all, the square. By 1917 his paintings had become increasingly minimal and mystically inclined, culminating in his famous, not to say notorious, 'White on White' series.

Like Chagall, Malevich saw the role of art as essentially non-utilitarian, unlike those abstract artists who belonged to the Constructivist group (such as Aleksandr Rodchenko, Vladimir Tatlin and El Lissitzky) who gave priority to functional art forms such as the poster (92), but who were nonetheless profoundly influenced by Malevich's formal vocabulary. For him the applied arts, although important in the revolutionary context, could only follow on the heels of autonomous artistic activity. In fact, by the time Malevich joined the Vitebsk School, he had virtually abandoned the act of painting in favour of an investigation of new pedagogical methods, and of writing treatises on the history of the

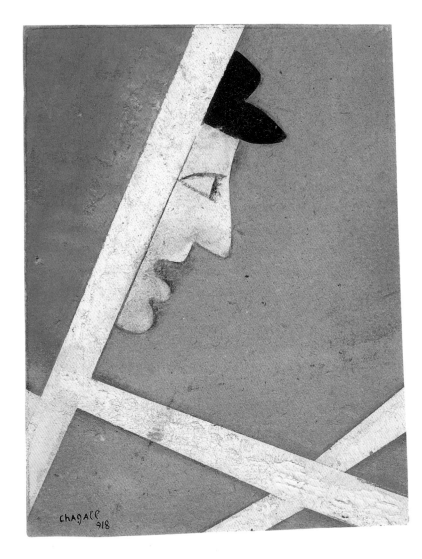

modern movement and the nature of art. One of these, *On New Systems in Art*, later to be known as *From Cubism and Futurism to Suprematism*, was published by Lissitzky's graphics department while its author was teaching in Vitebsk.

There was indisputably a certain amount of personal antagonism, even jealousy, between Chagall and Malevich at the Vitebsk School, where, unlike Chagall, Malevich showed himself to be a natural leader. While naming no names, Chagall wrote in *My Life* of the teacher who 'surrounded himself with women smitten with "suprematic" mysticism'. The artistic divide between them, moreover, was essentially unbridgeable. Yet although Chagall was generally far too busy thrashing out administrative problems to concentrate on his own creative work, it is revealing that much of the work he did produce contains references – albeit of a barbed or sardonic nature – to the geometric abstraction espoused by his rival. In *Composition with Goat* of *c.*1920, for example, the apparent formalism and 'purity' of the geometric forms are slyly subverted by the figurative elements in the work: above all, the rather mischievous-looking goat appearing from behind the wall, and the pair of feet poking out from beneath it. Much the same holds true of other works of this period, such as *Profile at Window* (93), *Peasant Life* and *Self-Portrait at Easel*.

92
Agit poster in Vitebsk, 1919. The text reads: *The machine tools of the depots, factories and plants are awaiting you*

93
Profile at Window, 1918. Gouache and ink on brown card; 22·2 × 17 cm, 8³⁄₄ × 6³⁄₄ in. Musée National d'Art Moderne, Centre Georges Pompidou, Paris

The only consolation to Chagall amid all his troubles in Vitebsk was the prominence given to his work in the *First State Exhibition of Revolutionary Art*, held between April and June 1919 in the former Winter Palace in Petrograd. This was a massive exhibition, comprising almost 3,000 works by over 350 artists. Yet the first two rooms in the exhibition were given over entirely to Chagall (fifteen major paintings were on show, and numerous drawings). The state did him the further honour of purchasing twelve of his paintings, which, with the exception of two works acquired at a later date, were the last of Chagall's works to be bought by the Soviet authorities. Between 1918 and 1920, in contrast, the government acquired twenty-nine works by Kandinsky and thirty-one by Malevich. Chagall's fortunes under the Bolshevik regime were clearly on the decline.

The exact sequence of subsequent events is hard to establish with any certainty. Chagall, it seems, was forced with increasing frequency to

make the difficult journey to Moscow to seek out food, funds, materials and moral support from his ever more harrassed comrade Lunacharsky. In his absence, dissension grew:

One day when I was off on one of my usual expeditions to get bread, paints and money for them, all the teachers rebelled and drew my pupils into their rebellion. God forgive them! And with the support of all those I had welcomed, assured of bread and employment, they passed a resolution deciding that I should be expelled from the school within twenty-four hours ... I could laugh. Why rake up all this old rubbish? I shall say no more of friends and enemies. Their features are embedded in my heart like blocks of wood.

Chagall's bitterness, in this account written soon after the events described, is almost palpable. In reality, however, the final, decisive rebellion of May 1920 had been preceded by another, in September 1919 (well before Malevich arrived in Vitebsk), during which Chagall's students had rallied to his support, and persuaded him not to resign after all. By mid-1920, however, the Suprematist camp had won the day: this time, it seems, there were few students to speak up in Chagall's defence.

94
Boris Kustodiev, *Bolshevik*, 1920. Oil on canvas; 101 × 141 cm, 39³⁄₄ × 55¹⁄₂ in. Tretyakov Gallery, Moscow

The year 1920 represented the nadir of Russia's fortunes. Belorussia did not escape the turmoil. Having become a Soviet republic in 1918, it was invaded by Poland in January 1919 in an attempt to re-establish the latter's historic borders. In the ensuing Treaty of Riga of 1921 Poland was granted the western part of Belorussia, while the rest, including Vitebsk, became the Belorussian Soviet Socialist Republic, one of the many that comprised the Union of Soviet Socialist Republics (the USSR), established in 1922. The political and military chaos caused by invasion and civil war between the Bolsheviks and those opposed to Communism combined with famine to ensure that art was even lower down the list of the authorities' priorities than it had been hitherto. Many of the teachers at the Vitebsk School chose to leave. The Chagalls were forced to move home several times, into ever more unsatisfactory accommodation. Although Chagall recounts in some detail how Bella's once rich parents had had their fine home looted by the Soviets (notwithstanding their son-in-law's involvement with the regime), he tells us little about his own family's circumstances during this troubled period. All we discover from *My Life* is that his sister Rosine (Rosa) and his brother David died

(the latter in the Crimea); that his father spent the last years of his life loading lorries, one of which ran him over and killed him; and that by the early 1920s his mother too had passed away. In any event, in May 1920 Chagall, Bella and Ida left Vitebsk for good, to settle in Moscow.

Lissitzky left Vitebsk in early 1921, while Malevich remained until 1922. Although he was able for a while to implement his pedagogical ideas unhindered, these became more and more hermetic and cryptic, and hence less and less acceptable to the Soviet authorities. By the mid-

1920s, the tide was turning decisively away from the avant-garde, in favour of a more conservative policy that gave priority to art that was more readily accessible to the man – or woman – in the street, and that could be more easily used as propaganda (94). Lunacharsky himself was to resign in 1929. Utterly disillusioned and without any means of earning a livelihood, large numbers of avant-garde artists were to leave Russia in the 1920s, many of them – Lissitzky, for example – retaining strong links with those who remained. Others, including Malevich, stayed in the Soviet Union but established influential links with avant-garde artists in the West, where the Bauhaus in Germany was an especially important

and fertile breeding ground for such cross-cultural exchanges. Malevich himself was to return to a more traditional figurative art in the late 1920s, and in 1934, just a year before his death, a repressive Socialist Realism was declared official Soviet policy in all the arts.

Settled in Moscow in mid-1920, the Chagall family subsisted for the first few months in a miserable single room. No more works by Chagall were purchased by the state, and the committee that determined official salaries for artists, which included Malevich, Rodchenko and Kandinsky among its members, had no hesitation in placing Chagall into the badly paid third category. It is hardly surprising that most of Chagall's artistic energies were now to focus on the only institution that seemed to want him: namely, the burgeoning Jewish theatre.

Chagall's interest in the theatre dated back to his early days in St Petersburg. Indeed it was as a set designer for Léon Bakst that the young Chagall had hoped to escape to the freedom of Paris. Characteristically, in his autobiography and elsewhere Chagall chose to understate his early interest in the theatre, failing, for example, to mention the influence on him not only of Bakst himself but also of Mstislav Dobuzhinsky. As well as teaching drawing at the Zvantseva School, Dobuzhinsky had been active as a set and costume designer, both for that staunch advocate of naturalism in the theatre, the director Konstantin Stanislavsky, and for the more symbolistically inclined director Nikolai Evreinov. Indeed, it was the latter who in 1916 had commissioned Chagall to produce his first independent work for the theatre, the set for a musical sketch entitled *A Thoroughly Joyful Song*, staged at a Petrograd nightclub, The Comedian's Halt – one of many such clubs and cabarets frequented and decorated by the Russian avant-garde in these years. Evreinov's dismissal of naturalism in favour of a ritualistic emphasis on the milestones of human life undoubtedly struck a chord with Chagall. One should note, too, that other Russian directors at this time, such as Meyerhold, were turning increasingly to the anti-rational traditions of burlesque and carnival for inspiration. For *A Thoroughly Joyful Song*, an enlarged reproduction of Chagall's 1911 painting *The Drunkard* formed the backdrop, while at the artist's insistence, the faces of the actors were painted green, their hands blue.

It was only in the wake of the 1917 Revolution, however, that a specifically Jewish theatre was able to flourish. In 1918 in the Ukrainian capital Kiev an umbrella organization called Kultur-Lige (Culture League) was formed, whose manifesto declared: 'Kultur-Lige stands on three pillars: Yiddish education for the people, Yiddish literature and Jewish art. The goal of the Kultur-Lige is to make our masses intelligent and make our intelligentsia Jewish.'

In a similar spirit, a Jewish Theatre Society, which had been established in Petrograd in 1916, resurfaced after the Revolution in the guise of a 'Yiddish Workers' Theatre', affiliated to the theatre and performance department of the People's Commissariat of Education. In February 1919 a modest studio theatre was established, and Aleksandr Granovsky – a secularized, non-Yiddish-speaking Jew trained in Germany and a disciple of the Austrian theatre producer Max Reinhardt – appointed its artistic director. Five months later, the studio acquired the official title 'Yiddish Chamber Theatre', and opened its doors to the public. Its repertoire included the work of Yiddish and non-Yiddish writers alike; essentially, this was an aesthetically highbrow theatre that just happened to perform in the Yiddish language. As Granovsky wrote in 1919: 'Yiddish theatre is first of all a theatre in general, a temple of shining art and joyous creation – a temple where the prayer is chanted in the Yiddish language.'

Petrograd, however, proved unreceptive to the theatre's efforts, and in July and August 1919 the company shifted its activities to the nearest important centre of Jewish life – namely, Vitebsk – at the very time that Chagall was so active there. Indeed, Vitebsk, with its Municipal and Tichanovsky Theatres, was very much on the itinerary of professional theatre groups, and home, in addition, to several amateur companies. Yet Chagall, despite the fact that his brief as Commissar for Art included the theatre, took little interest in the Yiddish theatre at this juncture, unimpressed by its preference for derivative Symbolist designs. In contrast, in early 1919 he produced designs for two plays by Gogol for the Petrograd Hermitage Studio Theatre, and for the Irish playwright J M Synge's *Playboy of the Western World* for the Stanislavsky Theatre (both of these, however, were rejected). Recent research has revealed that

Chagall also took an active and sustained interest in a new kind of non-Jewish Russian theatre that emerged in Vitebsk, known as Terevsat, an acronym for Theatre of Revolutionary Satire. It seems that he was the only artist associated with Terevsat during the 1919–20 season, designing costumes and sets for at least ten productions, all of them rooted in a tradition of carnival and earthy folk humour. Like Chagall himself, Terevsat moved to Moscow in 1920; in 1922, it was renamed Theatre of the Revolution at the Moscow Soviet, and Meyerhold appointed its director. In late 1921, Chagall designed one last production for Terevsat, *Comrade Khlestakov*, a Revolutionary parody based on Gogol's *The Inspector General* (or *The Government Inspector*, 1836). The artist's enduring ambivalence about his cultural loyalties is in evidence here – as well as in the outrage he felt because the Yiddish theatre refused to open its doors to non-Jewish audiences.

Returning to Petrograd in the autumn of 1919, the Yiddish Chamber Theatre remained closed to the public for the 1919–20 season, owing to inadequate heating facilities, although rehearsals continued behind the scenes, enabling Granovsky radically to rethink the company's aesthetic and ideological position. In the meantime, a parallel initiative was underway in Moscow, where in September 1918 the government's Jewish Commissariat had founded a theatre section as part of its education department, and an independent actors' studio was set up in 1919. In 1920 Lunacharsky decreed that the Yiddish Chamber Theatre move to Moscow (where the Jewish proletariat numerically far exceeded that of Petrograd), where it soon merged with the actors' studio already established there. Actors from theatre studios in Vitebsk and Vilna also joined the company, now formally known as the State Yiddish Chamber Theatre (Gosudarstvenni Evreiskii Kamernyi Teatr or GOSEKT) with Granovsky still at its head. In Yiddish, the word Yiddish means both Yiddish and Jewish which is why in English the theatre is sometimes referred to as the State Jewish Chamber Theatre. On the second floor of a building on Great Tchernichevsky Street in central Moscow, the former residence of a Jewish businessman, the new theatre could accommodate a mere ninety or so spectators. The actors were given living quarters in the same building.

By this point, Granovsky's artistic position had crystallized, bringing his ideas more or less in line with those of Chagall: absorbing the latest avant-garde, essentially anti-naturalistic, trends while simultaneously finding inspiration in Yiddish folk traditions. Indeed, by 1920 the Jewish theatre had become a primary focus for other artists, including Nathan Altman. Similarly disenchanted with the mainstream avant-garde, while well aware of the experimental theatre designs produced by Constructivist artists such as Popova, they were grateful for a practical outlet for their interest in creating an authentic modern Jewish art form. Indeed, it was in the theatre that this previously widespread interest lived on, long after it was suppressed in other areas of cultural activity.

Thus, it was the Moscow State Yiddish Chamber Theatre which enabled Chagall to set to work in 1920 with a renewed creative passion (although some images are retrospectively dated 1919). This time, Bella, who herself had once hoped to make a career on the stage, was more enthusiastic. She even went as far as taking acting lessons, until a fall during a rehearsal made it impossible to continue. The following is Chagall's own vivid, and reasonably accurate, description of events:

'There you are,' said Efros [Chagall's long-standing admirer, and artistic director of the theatre since its move to Moscow], leading me into a dark room, 'these walls are yours, you can do what you like with them.'
It was a completely demolished apartment that had been abandoned by bourgeois refugees …
'Down with the old theatre that stinks of garlic and sweat. Long live …'
And I flung myself at the walls.
The canvases were stretched out on the floor. Workmen, actors walked over them …
They asked me to paint the murals in the auditorium, and the scenery for the first production.
'Ah!', I thought, 'here's an opportunity to shake up the old Jewish theatre, its psychological naturalism, its false beards. There, on the walls at least, I can let myself go and freely show everything I think necessary to the rebirth of the national theatre.'

The resultant canvases were the largest, most complex and most ambitious works Chagall had yet produced. (Only after World War II was he

95
Costume
design for *The
Agents* by
Sholom
Aleichem,
1920.
Pencil, black
ink and
gouache on
paper;
27 × 20·3 cm,
10⅝ × 8 in.
Musée National
d'Art Moderne,
Centre Georges
Pompidou,
Paris

96
Set design for
The Agents by
Sholom
Aleichem,
1920.
Pencil, ink and
gouache on
paper;
25·6 × 34·2 cm,
10 × 13½ in.
Musée National
d'Art Moderne,
Centre Georges
Pompidou,
Paris

97
Set design for
Mazel Tov
by Sholom
Aleichem,
1920.
Pencil and
watercolour on
paper;
25·5 × 34·5 cm,
10 × 13½ in.
Private
collection

able to work on such a scale again.) The paucity of materials – the images, painted on canvas, were executed mainly in gouache and tempera as well as kaolin mixed with paint and water, pencil, sawdust and impressions of lace dipped in paint – seems only to have fuelled the artist's imagination. Viewed as an ensemble, the paintings can be seen as a striking distillation of the artist's overriding preoccupations, both formal and iconographic, at this crucial juncture of his life.

Within twenty-six days, Chagall had covered all the walls, and the ceiling as well, creating a total environment. Since the sets and actors' costumes for the theatre's first production (three short pieces by Sholom Aleichem: *The Agents*, *Mazel Tov* and *The Lie*) were also – with the exception of the last, created by Altman – designed by the artist (95–97), the final effect was both homogeneous and overwhelming. Perhaps unsurprisingly, the theatre was soon nicknamed 'Chagall's Box'.

The visitor to the theatre would have entered the auditorium to be met on the left-hand side of the room by the largest, most dynamic and monumental of Chagall's murals, the so-called *Introduction to the Yiddish Theatre* (98, 99). This crowded, exuberant and complex composition has elicited numerous interpretations and, although clearly no single or definitive reading of the work is possible, certain pointers to its meanings will be helpful.

maïс Chagall
1919 moscou

Эскиз "агентъ" Илья Абелькинъ Евр. Гос Театр.

мазл-тов декор Илья Абельх. Moscou Chagall 19

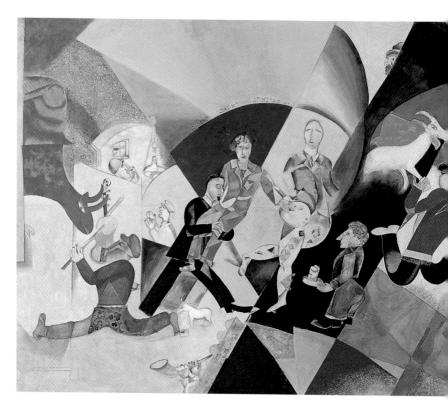

98
Study for
*Introduction to
the Yiddish
Theatre*,
1920.
Pencil, black
ink and water-
colour on
brown paper;
180×480 cm,
70⅞×189 in.
Musée National
d'Art Moderne,
Centre Georges
Pompidou,
Paris

99
*Introduction to
the Yiddish
Theatre*,
1920.
Tempera,
gouache and
opaque white
on canvas;
284×787 cm,
111⅞×309⅞ in.
Tretyakov
Gallery,
Moscow

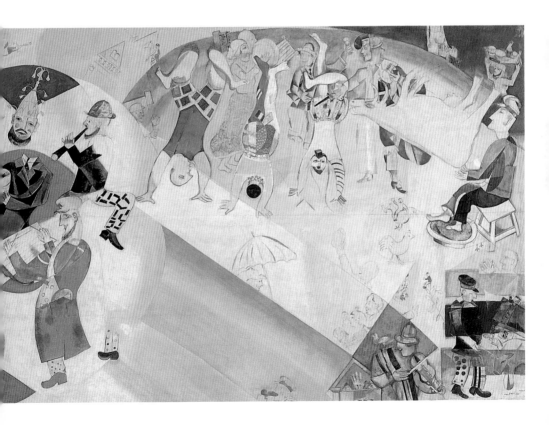

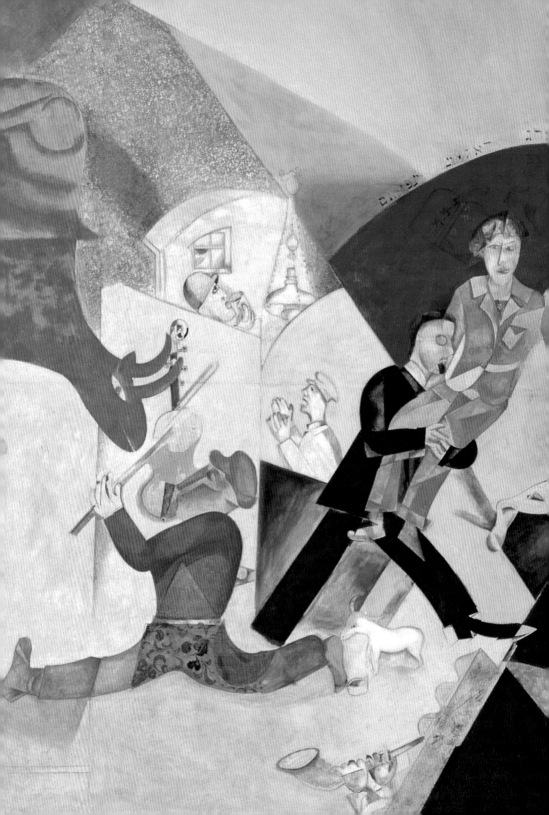

100
*Introduction to
the Yiddish
Theatre* (detail
of 99)

101
Marc Chagall
with Solomon
Mikhoels as
Reb Alter dur-
ing rehearsals
of *Mazel Tov* at
the Yiddish
Chamber
Theatre,
Moscow, 1921

In the first group of figures on the left of the composition, the man
doing the splits (100) is probably the actor Solomon (Shloyme) Mikhoels
(101), star of the troupe and particularly close, both personally and artis-
tically, to Chagall. With a gesture reminiscent of the Presentation of
Jesus in the Temple, Efros (in black) presents the artist to the assembled
company, while the latter offers his services, in the form of his palette,
to Granovsky. The diminutive figure serving tea probably represents
the actor Krashinski, but also makes reference to the janitor Ephraim.
Behind Chagall are images relating to the art of the synagogue. The four
figures in the centre are a band of traditional folk musicians, directed by
the cymbalist, who resembles Lev Pulver, the theatre's first composer.

The fact that the next major grouping of figures includes an acrobat
wearing phylacteries (scriptural texts worn in small boxes on the fore-
head or left arm) suggests Chagall's determination to throw the old
Jewish world into creative confusion. This reading is confirmed by the
adjacent figure holding a gun, who may well be Uriel da Costa, the
real-life subject of a play by the nineteenth-century German playwright
Karl Gutzkow. The seventeenth-century philosopher and free thinker Da
Costa ended up committing suicide with a pistol but was later seen as a
hero by secular Jews (such as Chagall) who wanted to be cosmopolitan,
Jewish and anti-religious at the same time. The figure in the red shirt
on the far right is harder to identify. Is he a representative of the

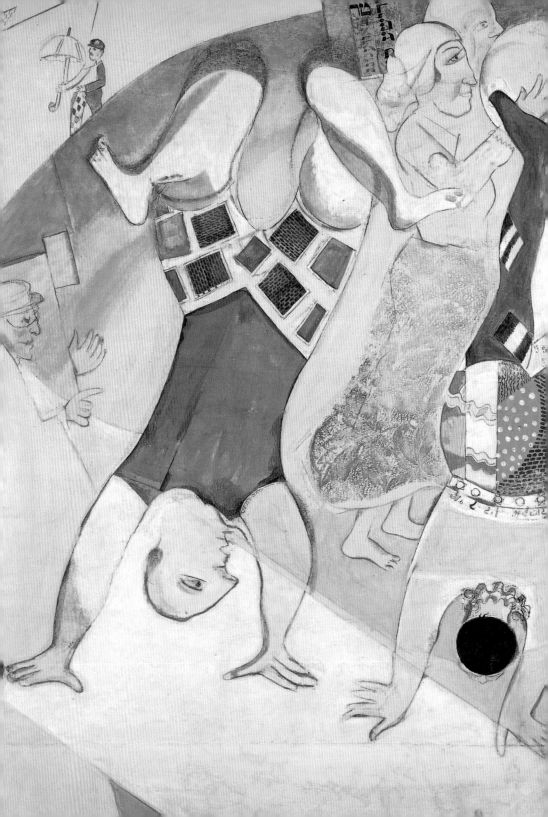

proletariat, or perhaps Granovsky again, resting, content that the task of revolutionizing Jewish culture is well under way? As for the cow, depicted twice, it may well be on one level a reference to the artist himself, charging in at the left, green and vigorous, to accomplish the task in hand, and white and tranquil, albeit upside down, on the right.

There is of course a host of smaller images, each one with its – often witty – contribution to the total meaning of the work. Consider, for example, the patch on the leg of the middle acrobat (102), which lists in fragmentary fashion the classic trio of modern Yiddish literature: Sholom Jacob Abramovitz (better known as Mendele Mocher Sforim), I L Peretz and Sholom Aleichem; as well as Yiddish writers of Chagall's own generation: 'Der Nister' and Ba'al Makhshoves. For all its complexity, the *Introduction to the Yiddish Theatre* is a remarkable feat of aesthetic integration, its disparate component parts bound together by a dynamic and rhythmic geometric structure – indebted not only to Chagall's much earlier encounter with Orphism but also, ironically, to his far more recent and painful brush with Suprematism.

According to the Russian invitation to the exhibition of Chagall's murals (they were first exhibited *in situ* in June 1921 and again in the spring of 1922), the four paintings that hung to the audience's right represented *Music*, *Dance*, *Drama* and *Literature*. In 1928, however, Chagall preferred to describe them as 'klezmers [folk musicians], a wedding jester, women dancers, a Torah scribe' – representatives, in other words, of four traditional Jewish activities which, since theatre as a genre barely existed in Jewish culture, can be seen as prefiguring important aspects of the modern Yiddish theatre. Of the four figures (103–107), only *Music* (103) has a clear precedent, being an obvious reworking of Chagall's famous *The Violinist* of 1912–13 (see 52), with significant changes (notably, the rueful reference to Malevich contained in the black square at the top right-hand corner of the composition visible only in the finished painting). Above these four vertical images hung a witty and whimsical frieze, *The Wedding Table* (probably in reference to the happy double wedding in *Mazel Tov*); while across from the stage hung a quieter and more obviously Cubist-inspired, poetically suggestive image entitled *Love on the Stage* (108). The ceiling,

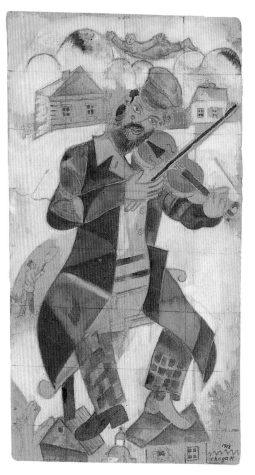

103
Study for
Music, 1920.
Gouache and
watercolour on
brown paper;
24·7×13·3cm,
9⅞×5⅛in.
Musée National
d'Art Moderne,
Centre Georges
Pompidou, Paris

104
Study for
Dance, 1920.
Pencil and
watercolour on
paper;
24·4×16cm,
9⅝×6¼in.
Musée National
d'Art Moderne,
Centre Georges
Pompidou, Paris

105
Study for
Drama, 1920.
Crayon, water-
colour, black ink
and gouache on
paper;
32·4 × 22·3 cm,
12¾ × 8¾ in.
Musée National
d'Art Moderne,
Centre Georges
Pompidou, Paris

106
Study for
Literature, 1920.
Pencil and
watercolour on
squared paper;
26·8 × 11·5 cm,
10⅝ × 4⅜ in.
Musée National
d'Art Moderne,
Centre Georges
Pompidou, Paris

107
Literature, 1920.
Tempera,
gouache and
opaque white on
canvas;
213 × 81·3 cm,
85 × 32 in.
Tretyakov
Gallery, Moscow

108
*Love on the
Stage*,
1920.
Tempera,
gouache and
opaque white on
canvas;
283 × 248 cm,
111 1⁄2 × 97 5⁄8 in.
Tretyakov
Gallery, Moscow

it seems, was adorned by Chagall with an image of flying lovers; while even the stage curtain boasted a pair of mythic white goats. Neither of these works, however, has survived.

When the success of the State Yiddish Chamber Theatre necessitated a move to larger premises on Malaya Bronnaya Street a year later, Chagall's murals were left behind. After 1924, however, the murals were displayed in the foyer of the new auditorium. By the late 1920s, with the tightening of state control over artistic matters, the names of both Chagall and Granovsky (who left Russia in 1928) were virtually unmentionable. During the purges of the late 1930s (probably in 1937), the murals were hidden, unsurprisingly suffering damage in the process. The actor Mikhoels was murdered by order of Stalin in 1948; the theatre was closed down in 1949, and most of its actors – together with nearly all other representatives of Soviet Yiddish culture – exiled or killed.

The official Soviet version of events is that the commission for the liqui-
dation of the theatre dutifully handed Chagall's paintings over to the
state Tretyakov Gallery in Moscow in 1950. In fact, it was almost certain-
ly Aleksandr Tyschler (1898–1980), an artist associated with the Yiddish
Theatre and a passionate admirer of Chagall, who physically carried the
murals to the Tretyakov for safe-keeping.

Safe they may have been, but until the advent of *glasnost* they were kept
in storage by the Russian authorities, virtually inaccessible to Russian,
let alone Western eyes. Chagall himself saw them again only once, in
1973, on his only return visit after he left Russia in 1922; he was invited
to add his signature to them at a semi-official ceremony. It was not until
1991 that they were finally taken out of storage; now at last thoroughly
cleaned and restored, they have been exhibited throughout the world.

Chagall's images for the Yiddish Theatre proved highly influential: the
actor Mikhoels, for example, claimed to have learnt a 'new way of using
my body, of moving and speaking' from the study of Chagall's paintings,
while the Sholom Aleichem evening became an established part of the
theatre's repertoire. However, a clash in artistic ideologies between
Chagall and Granovsky ultimately led to a parting of the ways. On

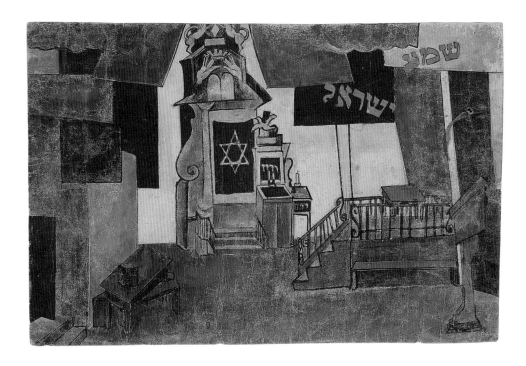

the evening of the opening performance, Granovsky – according to Chagall – had the effrontery suddenly to hang up a real duster on stage, thus introducing an unacceptable element of realism:

I sigh and shout:
'A real duster?'
'Who's stage manager here, you or me?' retorts Granovsky.
My poor heart!
Papa, Mamma!
Naturally, the performance was not an artistic whole, in my opinion.
But I felt that my task was finished.

The anti-naturalistic idiosyncrasy and overwhelming individuality of the artist's approach to the theatre perhaps made it inevitable that his collaboration with Granovsky would be short-lived. Chagall was apparently also furious that chairs were to be placed in the auditorium, thus fixing the position of the spectators. Clearly, his artistic ego made it almost impossible to concede to the demands of the theatrical medium as a team effort.

According to Chagall, an invitation followed to create sets and costume designs for a production of Ansky's play *The Dybbuk* at the Habima Theatre. Founded in Moscow in 1917, this was the first modern professional theatre company to perform plays in Hebrew, thereby transforming it from the sacred tongue of the Bible into a living, secular language. It was both the rival and the antithesis of Granovsky's theatre since Evgeny Vachtangov, the Habima's manager, also worked as an actor in Stanislavky's theatre and was an ardent advocate of the latter's brand of dramatic naturalism. But nothing seems to have come of this project and it was Nathan Altman who eventually produced the designs for *The Dybbuk* (109). Yet 'it turned out, as someone told me afterwards, that a year later, Vachtangov was spending hours in front of my murals in Granovsky's theatre ... And I've also heard that they go far beyond Chagall at Granovsky's now!' Indeed, when the Yiddish Chamber Theatre toured Europe to considerable acclaim in 1928, the German critic Max Osborn immediately detected the influence of Marc Chagall. If one looks at the stage designs of Chagall's mostly slightly younger contemporaries, such as Aleksandr Tyschler and others, that influence is undeniable.

109
Nathan
Altman,
Set design for
The Dybbuk by
Shloyme Ansky,
1920.
Pencil, Indian
ink, gouache
and tempera
on paper;
27 × 41 cm,
10⁵⁄₈ × 16¹⁄₈ in.
Collection
of Habima
Theatre,
Tel Aviv, on
loan to Tel Aviv
Museum of Art

While Chagall was working for the theatre, Bella and Ida lived in Malakhovka, a country village near Moscow. Chagall's train journeys between the two opened his eyes to the harshness of everyday life for the masses in post-Revolutionary Russia, and when his work for the theatre ground to a halt, it was with some relief that he accepted an invitation from NARKOMPROS to teach children (110) orphaned by pogroms, war and revolution in a colony known as the 'Third International', also in Malakhovka. The work, although unpaid, at least provided him and his family with board and lodging. Brutalized by their appalling sufferings, these children could hardly have been the

most forthcoming of students. Yet Chagall recalled with real tenderness how, 'I continued to delight in their drawings, their inspired stammering, until the moment I had to leave them.'

What has become of you, my dears?
When I remember you, my heart aches.

After all, the untutored art of young children possesses an intuitive vigour and spontaneity akin to that found in folk art, which had long acted as an inspiration to Chagall. The children's disinterested affection for him, moreover, must have come as a great relief after the infighting and cliquishness of the Vitebsk and Moscow art worlds.

The last substantial artistic project on which Chagall worked during this period is the little-known series of illustrations to *Troyer (Mourning)* of 1921–2. These eleven poems written in Yiddish by David Hofshteyn form a lament for the Jewish victims of recent Russian history, the civil war and the pogroms of 1917–21, with a particular emphasis on the suffering of the children and artists. In contrast to the illustrations to *My Life* that Chagall was shortly to produce in Berlin, these images represent a striking stylistic fusion of Cubist-inspired multiple perspective, Russian Futurist graphic experiments and Suprematist simplification of form with an explicitly Jewish content (111, 112).

In the meantime Chagall tried hard but unsuccessfully for two years to get financial recompense for the murals he had produced for the Jewish theatre. Lack of proper recognition for his efforts and his talents combined with the deprivations of daily existence led to his decision to leave Russia for good: 'I've had enough of being a teacher, a director. I want to paint my pictures. All my prewar canvases are still in Berlin and Paris, where my studio awaits me, full of sketches and unfinished pictures … Neither Imperial Russia nor Soviet Russia needs me.' And the epilogue to *My Life*, written in Berlin although dated Moscow 1922, ends thus: 'perhaps Europe will love me, and, with her, my Russia.'

Numerous Jewish artists – and indeed, many non-Jewish members of the avant-garde – chose to leave Russia around this time. In later years, Chagall was to claim that his reasons for leaving were 'purely artistic', having nothing whatever to do with the worsening economic and political situation, or the needs of his family. It is difficult to know what to make of such a statement. Chagall's motives were always complex, his explanations for his actions less honest or straightforward than they might have been. In reality, practical conditions in Russia in the early 1920s were appalling. The bloody civil war that had raged in the wake of the 1917 Revolution between the anti-communist White Army and the Bolshevik Red Army ended formally in 1920 with the brutal defeat of the White Russians, leaving a legacy of economic ruin and social confusion. The task of reconstruction facing the victorious Bolsheviks was a huge one. Meanwhile, for individual families, daily life showed no sign of getting easier.

In any event, the intervention of the still faithful and supportive Lunacharsky enabled Chagall to obtain a visa and a passport without too much difficulty. The writer Demyan Bedny, whom Chagall had first met in Petrograd in 1915, was now close to Lenin, and may also have proved a useful contact. A collector friend advanced money for the trip; while another friend, the poet Jurgis Baltrusaitis, Soviet Ambassador to Lithuania, permitted Chagall to send a consignment of paintings and drawings, as well as the nearly completed manuscript of *My Life*, by diplomatic courier to Kaunas, then on the border between Russia and Lithuania. Many of these works officially belonged to the collector Kagan Chabchai, who entrusted them to Chagall to prevent his collection being nationalized by the Soviets.

Remarkably, given the circumstances of his brief stay there, Chagall's friends and admirers managed to organize an exhibition of his work at the Kaunas Authors' Club. The catalogue lists sixty-five items in all. A special evening, organized by his old friend Dr Eliashev and Max Kaganovich, brother of 'Der Nister', was set aside for a reading by Chagall of portions of his autobiography. Aged nearly thirty-five, he finally arrived in Berlin in May 1922, to be followed at the end of the year by Bella and Ida.

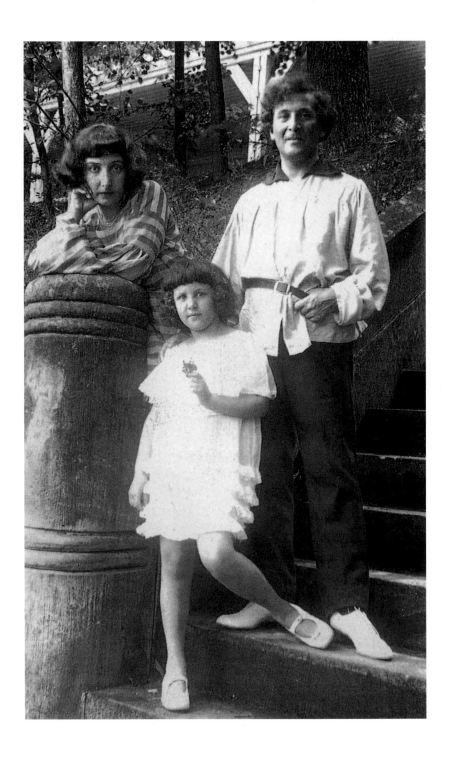

During the last year of World War I, Chagall had received a letter from his old friend Ludwig Rubiner, in Berlin. 'Are you still alive?', wrote Rubiner:

The rumour here is that you were killed in the war. Do you know that you're famous here? Your paintings created Expressionism. They're selling for big prices. However, don't count on the money that Walden owes you. He won't pay you. He maintains that fame will suffice for you.

Through all the turbulent Russian years, Chagall had continued to fear for the safety of the large body of work he had left behind in Paris and Berlin before the outbreak of World War I and it was almost certainly Rubiner's double-edged missive that prompted him, once the decision to leave Russia had been made and permission to do so received, to head straight for Berlin.

A native of that city, Rubiner was an Expressionist poet, playwright, essayist and passionate pacifist. Chagall had first met him in Paris before the war, but by the time he reached Berlin, Rubiner himself was dead. His widow Frieda, however, a good friend of Bella, proved a useful ally. Tracking down Herwarth Walden was no problem: Der Sturm – both gallery and publication – were, if anything, more influential in the German art world now than they had been before the war. But to his horror, Chagall now discovered that his fears had been well founded: all the works he had left with Walden – forty oil paintings and over one hundred works on paper – had vanished.

Walden had continued to promote Chagall throughout the war years, by arranging exhibitions and publishing reproductions of his work in *Der Sturm*, and even devoting an entire volume of *Der Sturm Bilderbücher* (picturebooks) to it – all this, in spite of the fact that once war between Germany and Russia had been declared, Chagall was technically an enemy alien, and his works therefore subject to confiscation. So success-

ful was Walden that he apparently had little trouble in placing most of the works left behind by Chagall with German private collectors. In addition, a number of particularly fine works had been acquired by Walden's Swedish wife, Nell – apparently to pre-empt the seizure of these works by the German police. In fairness to Walden, it seems that he deposited the proceeds of these sales with a notary, pending Chagall's return, even though rumours of the latter's death had long been circulating in the Berlin art world. When Chagall reappeared and duly demanded his money, Walden withdrew it and offered it to the artist without demur. Massive inflation in the early 1920s following Germany's defeat in World War I and the grotesque depreciation of the German mark meant, however, that the sum now being offered was barely enough to buy a packet of cigarettes.

Chagall, not surprisingly, went almost beserk with rage, refusing to be placated either by Walden's subsequent offer of a million Reichmarks, which, since his works were then being auctioned in Berlin for one hundred times that amount, was hardly a generous offer, or his republishing in 1923 of the earlier *Bilderbuch*, or his willingness to continue exhibiting Chagall's work. When Walden refused to comply with Chagall's demand that he at least reveal the names of the purchasers, the situation deteriorated to the point that the artist started legal proceedings against Walden. Although the dealer was ordered by the court to divulge these names, as well as to increase the amount of money being offered, Chagall's insistence that all the pictures be returned to him proved fruitless.

The case dragged on until 1926, when it was finally settled out of court. In return for his dropping the lawsuit and all demands for financial compensation, Nell, who in the meantime had divorced Walden and remarried, gave Chagall the opportunity to select three oils and ten gouaches from her own collection. The three paintings Chagall chose to reclaim – *To Russia, Asses and Others* (see 35), *I and the Village* (see 51) and *Half Past Three* (see 40) – were among the finest productions of his prewar period.

The sense of loss and betrayal remained, however, never fully to be assuaged. Compounded and intensified by similar experiences at other

points in his career – first in St Petersburg before 1910, and again in
Paris in 1923 – it goes a long way to explain the core of bitterness and
suspicion, verging sometimes on paranoia, that was to characterize
many of the artist's personal relationships – especially if money was
involved.

At the time of Chagall's arrival in Berlin, the capital of Germany was still
recovering from the extreme political turmoil that had followed that
country's defeat in World War I. The Kaiser's abdication in November
1918 had led to the establishment of the Weimar Republic. The new
Social Democratic government was opposed by the revolutionary
Spartacists, who became the German Communist party in January 1919
and swiftly launched a revolt in Berlin. This was brutally suppressed
and its leaders Rosa Luxemburg and Karl Liebknecht arrested and mur-
dered. The 'November Revolution' and its aftermath had a profound
effect on the intelligentsia of Berlin. Prewar Expressionism now seemed
self-indulgently subjective and apolitical, and artists of a left-wing per-
suasion sought to organize themselves into politically active groups
intent on alerting the German public both to the insanity of the war
and its aftermath, and to economic and social injustices. Visual artists
and writers alike revelled in exposing the extremes of luxury and depri-
vation, corruption and sexual depravity, glamour and squalor, vividly
evoking a society both profoundly flawed and vibrantly alive.

Ironically, in view of the German Communists' idealization of
Bolshevism, the cultural scene in Berlin was being further enlivened not
only by White Russians on the run from the Bolsheviks, but also by an
influx of formerly enthusiastic Russian artists and intellectuals, now
utterly disillusioned by the turn of events in their native country. As
Chagall, who numbered among these, told the critic Edouard Roditi in
1958, Berlin had become

a kind of vast clearing-house of ideas where one met all those who came and
went from Moscow to Paris and back. Later, I found for a short while a simi-
lar atmosphere on the Paris Left Bank, in Montparnasse, then again in New
York during World War II. But in 1922, Berlin was like a weird dream, some-
times like a nightmare. Everybody seemed to be busy buying or selling some-
thing. Even when a loaf of bread cost several million marks, one could still

find patrons to buy pictures for several thousand million marks which one had to spend again the same day, in case they might become valueless overnight. In the apartments around the Bayrischer Platz, there seemed to be as many theosophical or Tolstoyan Russian countesses talking and smoking all night around a samovar as there had ever been in Moscow, and in the basement of some restaurants in the Motzstrasse, as many Russian generals and colonels, all cooking or washing dishes, as in a fair-sized Tsarist garrison-town. Never in my life have I met as many miraculous Hasidic Rabbis as in inflationary Berlin, or such crowds of Constructivists as at the Romanisches Kaffeehaus.

Bella (whose broken arm had prevented her from accompanying her husband in May) and Ida soon joined him in Berlin (113). In the course of a year, they changed apartments four times, all except the last centrally located near Pragerplatz, where many of the Russian *émigrés* lived. The Chagalls seemed more or less impervious to the decadent allure of Weimar Berlin, preferring to mix with a small circle of talented but relatively sober acquaintances, many of them fellow *émigrés*. These included the Russian–Jewish arts activist David Shterenberg and his wife Nadezhda, a friend of Bella; the Russian sculptor Aleksandr Archipenko, whom Chagall had known in prewar Paris; the German painter and graphic artist Karl Hofer (1878–1955) and the Polish–Jewish painter Jankel Adler (1895–1949). A particularly close friend at this time seems to have been the Russian–Jewish poet and ardent Zionist Chaim Bialik.

114
Odalisque,
1913–14.
Gouache on
paper;
20·2 × 28·8 cm,
8 × 11³⁄₈ in.
Private
collection

Issachar Ryback, Nathan Altman and Boris Aronson (the latter, like Chagall, studied under Hermann Struck) were also in Berlin at this juncture, although Chagall appears to have had little contact with them. Lissitzky, who lived in the city between 1922 and 1923, was one artist whom – for obvious reasons – Chagall studiously avoided. Yet, ironically, some of the graphic work that Lissitzky produced in the early 1920s (notably, his 1922 illustrations to Ilya Ehrenburg's *Six Tales with Easy Endings*) represents a striking amalgam of Chagallian visual humour and Suprematist geometric rigour. Nor was Lissitzky (like Ryback) averse to publishing his work in the journal *Rimon*, organ of the German–Jewish cultural movement. Only after 1925, the date of his return to the Soviet Union, did Lissitzky finally abandon all Jewish references in his work.

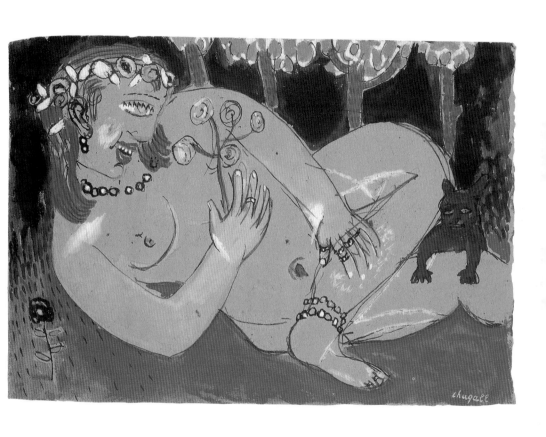

Rubiner's grandiose claim notwithstanding, the relationship of Chagall's work to German Expressionism remained ambiguous and for the most part oblique. Only in the broadest sense do Chagall's emphasis on the primacy of the individual imagination, his non-naturalistic use of colour and deliberate and earthy primitivism ally him with practioners of Expressionism proper. There are, it is true, the occasional, almost certainly fortuitous visual similarities: Chagall's *Odalisque* of 1913–14 (114), for example, is reminiscent of certain images of women of the same period by members of Die Brücke (The Bridge) group, such as Ernst Ludwig Kirchner, Erich Heckel (1883–1970) and Karl Schmidt Rottluff. It is hardly typical of Chagall's own work at this time, however, and was, in any event, painted while Chagall was living in Paris, and before he had visited Berlin. On the other hand, the witty lightness of touch, the strong element of surreal fantasy and the iconographic complexity – all so characteristic of Chagall's work – have little place in mainstream Expressionism. In any case, by 1922 the German avant-garde art world was beginning to be dominated not by Expressionism but by the so-called Neue Sachlichkeit or New Objectivity movement. This combined cynical realism with nightmarish distortion in a virulently left-wing brand of social criticism, born of Germany's wartime and postwar experience. Its main practitioners in Berlin were Otto Dix (1891–1969) and George Grosz (1893–1959). Chagall's years in Revolutionary Russia had taught him to distrust any art that sought to enter the political arena, so it is hardly surprising that he regarded the movement with considerable suspicion. Surprisingly, though, Grosz, whom Chagall had first encountered in Paris, appears to have been one of the few visual artists with whom he established a personal relationship in Berlin. Indeed, echoes of the former's acerbic linearity (115), albeit devoid of any overtly political commentary, can be found in Chagall's illustrations to *My Life* and to Nikolai Gogol's *Dead Souls*.

115
George Grosz,
Perfect People,
1920.
Lithograph;
26·8×20cm,
10$\frac{1}{2}$×7$\frac{7}{8}$in

In the meantime, two exhibitions in Berlin not only relieved Chagall of financial pressure, but also brought him to the attention of a growing number of influential people. The first, in 1922, was a pioneering group show at the Van Diemen Gallery, entitled *Die Erste russische Kunstaustellung* (First Russian Art Exhibition), organized by David Shterenberg. The second, in 1923, was a one-man show at the same

gallery, now renamed Galerie Lutz, consisting of 164 works produced between 1914 and 1922. The publication in 1921 of a German translation by Frieda Rubiner of the monograph by Efros and Tugendhold, and the appearance of several other shorter monographs also helped boost the artist's reputation. These included a remarkably perceptive pamphlet in Yiddish and German by Boris Aronson, which Chagall himself found intrusively intimate.

With the exception of some watercolours painted while on holiday in Thuringia and the Black Forest, and a number of drawings and water-colours of his wife and daughter, Chagall's output at this juncture con-sisted primarily of work in the graphic media. Although partly due to the

116
Hermann Struck,
Portrait of Marc Chagall.
Etching from Struck's *Die Kunst des Radierens*, 5th edition, Berlin, 1923

lack of proper studio facilities, this was largely because the innovative German–Jewish publisher and dealer Paul Cassirer had expressed a wish to produce an illustrated version of *My Life* (to the text of which Chagall was now putting the finishing touches). That it was in Germany that Chagall set out to master the art of printmaking was probably not coincidental. Since the fifteenth century, when such artists as Martin Schongauer (d.1491) and Albrecht Dürer (1471–1528) had taken printmaking to new heights, Germany had been the traditional home of graphic art, and in the twentieth century the Expressionists had done much to revive that tradition, albeit in unorthodox ways.

Also fitting was the fact that Chagall first received technical instruction in the woodcut medium from Joseph Budko (1888–1940), and that his second and more important teacher was the much-respected graphic artist Hermann Struck (1876–1944), both of them active participants in the quest for a modern Jewish art and contributors to the journal *Ost und West*. Struck had earlier acted as teacher to the eminent painters Max Liebermann and Lovis Corinth (1858–1925), and in 1908 had produced a book entitled *Die Kunst des Radierens* ('The Art of Etching'), reprinted many times. Indeed, the fifth, and much expanded, edition of this publication was in preparation while Chagall was his student, and contains a fine portrait by Struck of his new pupil (116) as well as three of the latter's etchings, two of them radical reworkings of other images in the book, *Death in the Sick Room* by Edvard Munch (1863–1944) and *Polish Jew* by Struck himself, much of whose work concerned itself with Jewish life, depicted in a far more straightforwardly descriptive manner than in Chagall's art. In the text, Struck described Chagall as 'the most important symbol of the artistic and spiritual evolution of the new Russia. A wild enthusiast who races like lightning, with the unconscious energy of genius, through all the different stages; that of naturalistic mastery of his everyday surroundings to that of mystic formulation.'

As was always to be the case with his forays into new media, Chagall rapidly familiarized himself with the art of printmaking, prepared from the start to employ unconventional and daring techniques to achieve the effects he sought. Although he concentrated on etching for the purpose of fulfilling Cassirer's commission, Chagall also

Marc Chagall

117
*Man Drinking
Tea*,
1922–3.
Lithograph;
27×19·5 cm,
10 5⁄8×7 3⁄4 in

118
*Goat with
Violin*,
1922.
Woodcut;
20×27·5 cm,
7 7⁄8×10 7⁄8 in

experimented with lithography and woodcuts (indeed, it was Cassirer who had first urged him to try his hand in these media). The results (117, 118), though crude – perhaps deliberately so – are full of an earthy wit and vigour. The woodcuts stand somewhere between the boldly experimental productions of the Expressionist Die Brücke group (119) and the more traditional wood engravings of the Russian artist Vladimir Favorsky (1886–1964), whose work Chagall would have known. His only previous experience of printmaking had been in 1915–16 when he illustrated a story by I L Peretz (see 76) and two poems by 'Der Nister', and in 1922, when he illustrated David Hofshteyn's *Troyer* (see 111, 112). This was not a hands-on experience, however, since the drawings would have been transferred by someone else to a lithographic plate or stone, to allow the image to appear the right way round when finally printed. Although transfer lithography had been the favourite medium of the Russian avant-garde, and woodcuts were the preferred medium of the German Expressionists, Chagall seems to have sensed – correctly – that the less fashionable and more time-consuming medium of etching would allow him a far greater and more subtle range of graphic possibilities.

119
Erich Heckel,
*Squatting
Woman*,
1913.
Woodcut,
42 × 31 cm,
16¹⁄₂ × 12¹⁄₄ in

120
**Issachar
Ryback**,
*Religious
School* from
Shtetl Album,
Berlin, 1923

In any event, he seems to have felt a natural empathy with the print
medium. As he later stated: 'When I held a lithographic stone or a cop-
per plate in my hand I thought I was touching a talisman.' Within a
mere three weeks he had completed fifteen plates to accompany the text
of his autobiography; to these, he added five extra images, some in a
combined drypoint and etching technique. As it turned out, the idiosyn-
cratic Russian text of *My Life* proved too much for the German transla-
tor, and the portfolio entitled *Mein Leben*, published by Cassirer in 1923,
consisted of the illustrations alone: twenty prints in an edition of 110
numbered copies, twenty-six on Japanese paper and eighty-four on hand-
made paper. Chagall's long and distinguished career as an innovative
and inventive printmaker was launched. Issachar Ryback's autobiograph-
ical volume of lithographs, *Shtetl Album* (120), published in Berlin in the
same year, is directly comparable to Chagall's *My Life* images in terms of
subject matter but far more ponderous and Cubist-inspired in style.

Many of the images in *Mein Leben* are variations on motifs that had
already featured in paintings or drawings; others relate directly to the
text itself. One of the supplementary plates, known as *The Rabbi* (121),
for example, is based on *Feast Day (Rabbi with Lemon)* of 1914 (see 65);

The Dining Room (123) recalls an even earlier painting, *The Sabbath* of
1910 (see 28); while his images of Russian soldiers are clearly based on
drawings executed in 1914. Another of these supplementary plates, *The
Musician* (122), depicting a cellist apparently playing on his own, cello-
shaped body, seems to be a more original invention; the figure resur-
faces in a later painting, *Wedding Candles* of 1934–45. Some of the
images are primarily linear: sometimes witty, sometimes extremely
moving in their understatedness and restraint (124). Others are more
pictorial, anticipating the richly varied surface textures that were to
characterize Chagall's later work in the etching medium, but also remi-
niscent, in their deployment of seemingly random dots and dashes, of
Chagall's drawing style just before he left Russia. Paul Klee (1879–1940)
may well have been an influence here, though an unacknowledged one.
In his *Creative Confession*, published in Berlin in 1920, he wrote memo-
rably of 'taking a line for a walk', and some passages reveal a witty and
whimsical imagination that would surely have been congenial to Chagall:
'We start from a point that gives us a line. We stop once or twice; the
line has been broken or articulated … A flash of lightning on the hori-
zon (a zigzag line). There are still stars overhead (scattered dots).'

121
The Rabbi,
1922.
Supplementary
illustration for
Mein Leben,
Etching;
25 × 18·5 cm,
9⅞ × 7¼ in

122
The Musician,
1922.
Supplementary
illustration for
Mein Leben.
Etching and
drypoint;
27·5 × 21·5 cm,
10⅞ × 8½ in

123
*The Dining
Room*,
1922.
Illustration for
Mein Leben.
Drypoint;
21 × 28 cm,
8¼ × 11 in

Despite his apparent success in Germany, Chagall still had his sights set on returning to his beloved Paris. A letter from his old friend Blaise Cendrars, received after years of silence, proved decisive; it informed him that the dealer Ambroise Vollard was keen to offer Chagall a major commission: 'Come back, you're famous, and Vollard is waiting for you.' It was no simple matter, however, to obtain the necessary documents. Since the Chagalls were still formally Soviet citizens, they were technically forbidden to enter France. But the presentation of the certificate from the French Prefecture of Police, which he had obtained on his departure from France in 1914, apparently convinced officials at the French Consulate in Berlin to relax the rules; and on 1 September 1923 Chagall and his family arrived at the Gare de l'Est in Paris.

Chagall was now thirty-six years old, his most turbulent and traumatic years seemingly behind him. Although the next decade was to prove far more serene and unclouded, it was prefaced by a major shock. For when Chagall rushed back to La Ruche to recover the one hundred and fifty or so works he had left in his studio – little dreaming, when he locked the door with a makeshift piece of wire, that he would be gone for nine years – he discovered to his horror that they had disappeared almost without trace, and that the studio was now occupied not by an artist but a poor pensioner installed there by the French government during the war. Combined with the grievous loss of so many of the works left in Berlin in 1914, this meant that almost his entire prewar *oeuvre* had vanished.

Chagall persisted in believing that his so-called friends had simply helped themselves to his paintings and sold them off when they needed the cash. Blaise Cendrars, he was convinced, was more to blame than anyone else, since the poet had apparently signed certificates of authenticity for many of the canvases purchased after Chagall's departure by the critic Gustave Coquiot. Like most other members of the art world in Paris and Berlin, Coquiot must have assumed that Chagall had perished during the Russian Revolution. Whatever the truth of the matter, Chagall severed all relations with his old friend, and Cendrars' extensive memoirs contain only a couple of bitter allusions to the artist: 'that was when Chagall had genius, before the war of 1914', and, more indirectly,

124
Mother's Grave,
1922.
Illustration for
Mein Leben.
Etching;
12 × 9 cm,
4³₄ × 3¹₂ in

'all those painters – millionaires today – who are still indebted to us, poor poets'. The two men were to meet again, for a brief and touching reconciliation, in 1960, just a few weeks before Cendrars' death.

In fact, it is far more likely that Chagall's work suffered the fate meted out to all abandoned and unclaimed artworks in La Ruche during World War I. At the outbreak of hostilities the residents of La Ruche gradually abandoned their ramshackle studios. Although a few of the non-French artists enlisted in the French Foreign Legion, most returned to their countries of origin; while most of the native-born artists found themselves drafted into the French Army. It seems that when a studio was vacated, the original benefactor of La Ruche, Alfred Boucher, had its contents completely cleared away, stored elsewhere, and left to the vagaries of fortune. Thus – incredible as it may seem – some of Chagall's canvases ended up as roofing for the concierge's rabbit hutch.

Chagall was thus in an unusual and unenviable position: that of a mature artist, famous if not yet rich, his reputation resting on an extraordinary body of work that for the most part had vanished or been dispersed. It is hardly surprising, therefore, that much of his time and energy during the 1920s was occupied in literally recreating that *oeuvre*. Where possible, he borrowed back works from their current owner and copied them. More often, he relied on photographs or his own excellent memory to create new versions of works first produced before 1914. Needless to say, all this activity caused considerable consternation among dealers and collectors, since the existence of a copy naturally depreciated the value of the original artwork. Katia Granoff, for example, who acted as Chagall's Paris dealer for three years, categorically refused to lend the artist the pre-1914 painting by him in her own collection.

A notable example of all this is the canvas *I and the Village*. The original version (see 51) was painted in Paris in 1911 and exhibited for the first time in Berlin in 1914; in 1923–4, probably working from a photograph published in *Der Sturm Bilderbücher* of 1923, Chagall produced a smaller version of the same composition. As with many of these 'copies', subtle differences manifest themselves: in this case, an increased emphasis on the diagonal division of the canvas weakens the circular, rhythmic sweep of the original. Another painting, entitled *Peasant Life* of 1925 (125) can

125
Peasant Life,
1925.
Oil on canvas;
100 × 81 cm,
39³⁄₈ × 31⁷⁄₈ in.
Albright-Knox
Art Gallery,
Buffalo,
New York

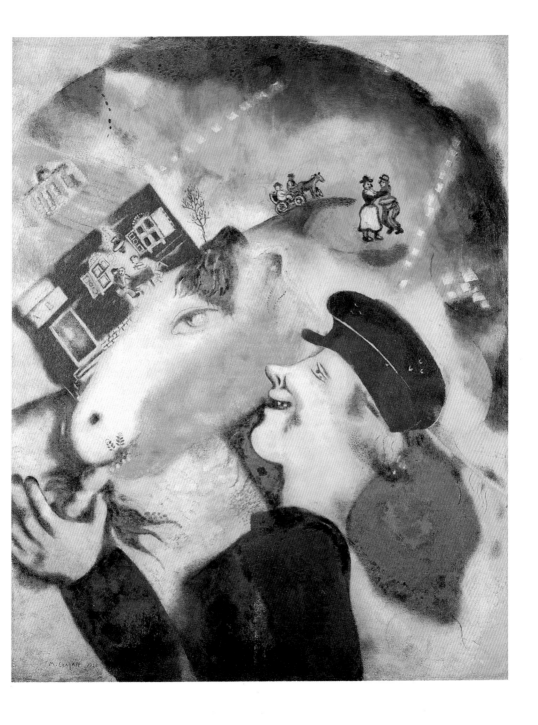

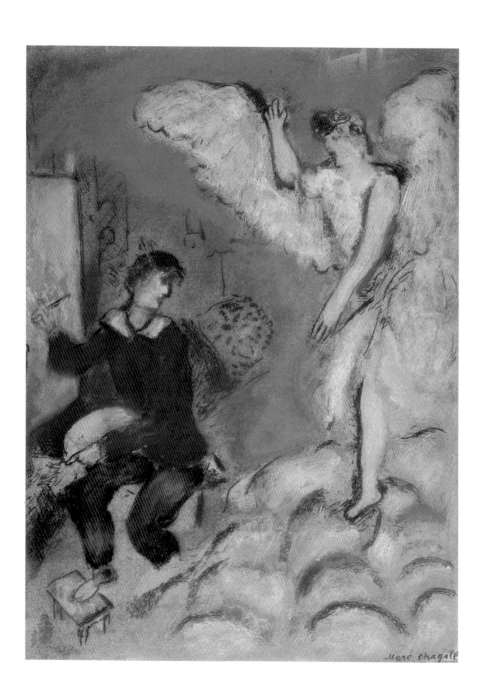

be seen as a freer reworking of the 1911 *I and the Village. The Cattle Dealer* of 1912 (see 50), also exhibited at Der Sturm gallery in 1914, is another example of a canvas replicated by Chagall in the 1920s; here too, the main difference between the two renderings is a loosening of the geometric structure in the later version. A comparison of the 1924–5 print of *The Apparition*, reworked in 1937 (126), with the 1917 painting of the same name (see 86), reveals the relative timidity and conservatism of the later works even more vividly: in this instance, the iconography has been preserved, but the boldly cubistic style completely abandoned.

This habit of replicating, or at any rate reworking, older canvases became deeply entrenched – ultimately, it could be argued, to detrimental

126
The Apparition I, 1924–5/c.1937. Etching and aquatint, handcoloured in gouache and pastel; 48·8×38·3cm, 19¼×15⅛in. Tate Gallery, London

127
Chagall, Bella and Ida in their studio apartment in the avenue d'Orléans, Paris, 1924

y

179 Berlin and Paris, 1922–1930

effect. Even in the early 1920s, it was not always the disappearance of a painting that caused Chagall to recreate a work, since he also painted replicas and variants of works executed in Russia, many of which he himself, acting as courier for the collector Kagan Chabchai, had brought to Paris. Some of these can be seen in the background of a charming photograph of 1924 (127), showing the Chagall family in their studio apartment in the avenue d'Orléans, formerly the studio of the Polish-born painter Eugène Zak (1884–1926), a minor member of the School of Paris. This was their home from early 1924 until 1925. Prior to this, they had lived in more modest lodgings at the Hôtel Médical in rue du Faubourg

St Jacques, a bizarre combination of clinic and rooming house for foreign artists; at one point, it seems, they were living near the Place d'Alésia in a sort of garage. Other earlier images Chagall recreated at this time include *The Green Violinist* of 1923–4 (128), which is clearly related to the image *Music* (see 103) that he had created for the walls of the Yiddish Theatre in Moscow in 1920, and of whose fate Chagall at this stage knew nothing; as well as to the earlier *Violinist* of 1912–13 (see 52), although there are significant compositional and stylistic differences between all three works. *Feast Day (Rabbi with Lemon)*, originally executed in 1914 (see 65), is yet another work of the period which Chagall copied, more faithfully in this case, on his return to Paris.

As the 1920s progressed, the financial necessity of parting with a given work would prompt Chagall to produce variants of that image. A case in point here is the magnificent *Praying Jew (Rabbi of Vitebsk)* of 1914 (see 66). Virginia Haggard McNeil, who was Chagall's companion from 1945 to 1952, recalled how Marc had told her

that for years in Russia, he had kept the *Rabbi* under his bed to protect it from the vicissitudes of his precarious life. He prized it as his masterpiece and said it was the nearest he had ever come to the sublimity of Rembrandt. He loved it so much that in France, when he was obliged to sell it for want of money, he first made a copy of it. Finally he sold the copy as well and made a third, which he also sold. The first of these versions (1914) is in the collection of J im Obersteg in Geneva; the second (1923) is in Chicago and the third (1928) is in the Museo d'Arte Moderna in Venice. Each time he sold the picture he was bereft, but he needed money badly. He called these copies 'variants', although they were almost exact replicas (except for their slightly different dimensions; also the first version was painted on cardboard, while the others were done on canvas). These copies were freely and beautifully done and as good as the originals, he assured me, but he kept quiet about them, because there was some trouble with the collectors when they discovered that their pictures were not unique … In the case of *The Praying Jew*, his favourite work, this meticulous copying was certainly not distasteful to him; perhaps he enjoyed going through this act of creation a second and a third time, trying to probe its mystery.

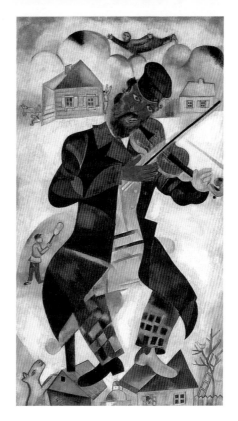

128
The Green Violinist,
1923–4.
Oil on canvas;
198×108·6 cm,
78×42¾ in.
Solomon R
Guggenheim
Museum, New
York

Due largely to his association with Ambroise Vollard, the 1920s was also the decade in which Chagall consolidated his talents as a graphic artist of real distinction. Vollard, who in Chagall's first Parisian period had so intimidated the young man, had seen his work in the apartment of Gustave Coquiot and, duly impressed, was now to offer him a series of major commissions to illustrate well-known texts, unaware of the considerable experience of book illustration Chagall had acquired in the meantime. The first of these texts, Gogol's *Dead Souls*, for which Chagall produced 107 full-page etchings between 1923 and 1927, was apparently the artist's own choice.

Vollard cut a curious figure in the Parisian art world. As insensitive to the individual personalities and needs of his artists as he was sensitive to the value, both aesthetic and monetary, of their products (he had, after all, been daring enough to back both Cézanne and the Cubists), he was shrewd, avaricious and an obsessive hoarder of artworks. As Chagall himself put it:

Vollard loved possessing with a kind of sadism. When you didn't work for him, he couldn't stand it. When you did work for him, he stored everything you brought him in his basement. He never even looked at the engraved plates [for *Dead Souls*] which I brought him, one by one, as they were finished.

Yet Vollard's own memoirs, in which he describes how 'Chagall contrived to suggest, with remarkable truth, the rather Louis-Philippe [*ie* physically grotesque] appearance of Russia in Gogol's time', make it clear that, despite appearances to the contrary, he did indeed take the time to appraise the finished product.

The poet Ivan Goll, one of Chagall's close associates at this time, has provided a vivid description of the artist at work on *Dead Souls*:

Marc sits there like a cobbler hammering away on his copperplates, an upright craftsman of God. His wife, who ministers to his art as a nurse ministers to a sick man's fever, reads the chapter aloud to him. They keep on laughing. Ida, their seven-year-old, jumps down from the piano and wants to hear the story as well, and now the fantastic situations are re-created to the accompaniment of laughter by a strange family, with all the humour and tragedy of Russia.

Just as Chagall could never bring himself to subordinate his stage designs to the wider demands of the theatre, so his illustrations of literary texts were never merely illustrations. Indeed, the images that accompany the text of *Dead Souls* have no identifying titles (nor did Chagall at first know where they would be placed); but serve rather as a lively pictorial complement to the text. In fact, Gogol's great novel, published in 1842, has distinct affinities with Chagall's visual universe. Gogol's characters, like those who people so many of Chagall's pictures, are larger than life, wittily exaggerated, even 'surnaturel', in a (not always flattering) attempt to capture the true flavour of life in provincial Russia. The fact that *Dead Souls* was written while its author was living outside Russia was undoubtedly another reason for its appeal to Chagall. Moreover, its critique of Russian society, its corruption and the inhumanity of its bureaucracy, was as relevant in the 1920s as it had been in the 1840s.

Certainly, as one of the plates (129) – used as a frontispiece in 1948, the year in which the work was finally published – makes clear, Chagall closely identified himself with the author, both as a kindred spirit and as an artist whose contribution to the volume was as vital as that of Gogol himself. In 1928, when his old colleagues Mikhoels and Granovsky visited Paris with the Yiddish Theatre, Chagall chose to overlook past misunderstandings and entrusted them with ninety-six of the *Dead Souls* etchings to donate to the Tretyakov Gallery in Moscow – a touching gesture of lingering affection towards his native land, which at the time went almost completely unappreciated.

The etchings for *Dead Souls* are witty and satirical, possessing an acerbity that on occasion – and unusually for Chagall – verges on cruelty, reminiscent of the work of George Grosz, whom Chagall had known in Berlin. Some, in their earthy humour, contain references to the work of sixteenth- and seventeenth-century Flemish artists such as Pieter Bruegel (*c*.1525–69) and David Teniers (1610–90), to which Chagall was probably introduced by the Belgian critic Florent Fels, whom he met in the mid-1920s. Unlike the *Mein Leben* prints, where large parts of the picture surface were frequently left unworked, these are for the most part crowded, even jostling compositions, gratifyingly rich in texture and anecdotal detail. In these remarkable and visually inventive images (130), human foibles and weakness, even grotesqueness are acknowledged as an integral part of human life.

In 1926 Chagall embarked on a new commission from Vollard, a series of gouaches to illustrate the *Fables* of the seventeenth-century French poet Jean de la Fontaine. In his memoirs, Vollard relates how, 'one of my most cherished ambitions had been to publish a La Fontaine, worthily illustrated. As a child I had detested La Fontaine … But as I began to grow up, many a verse of the poet's came back to me, and I gradually discovered their charm.' Postwar France was so chauvinistic, however, that the exhibition of these gouaches in 1930 caused a furore. How scandalous, it was argued, to commission a foreigner, a Russian Jew at that, to illustrate that enduring and quintessential classic of French literature. The affair was even debated in the Chamber of Deputies, where Chagall was disparagingly described as a 'Vitebsk sign painter'.

129
Dead Souls,
Frontispiece,
1948.
Etching and
drypoint;
27·3 × 21 cm,
10¾ × 8¼ in

130
Manilov,
illustration
for *Dead Souls*,
1923–7.
Etching and
drypoint;
28·5 × 22 cm,
11 1/4 × 8 5/8 in

Vollard, however, stood firm, pointing out in a newspaper article that the oriental origin of many of the stories in this moralizing bestiary

gave me the idea that an artist whose birth made him familiar with the magic of the Orient could not but produce a plastically sympathetic rendering … Now if you ask me: 'Why Chagall?' my answer is, 'Simply because his aesthetic seems to me in a certain sense akin to La Fontaine's, at once sound and delicate, realistic and fantastic.'

Vollard's characterization of Chagall's origins may have been inaccurate and far-fetched, but the resultant imagery did indeed suggest a natural empathy with La Fontaine's text. Chagall would, in fact, have been more familiar with the Russian fables of Ivan Krylov, which, like those of La Fontaine, drew on Aesop. Certainly, the notion of animals expressing truths about human nature is one that Chagall had always held dear – as so many of his earlier works testify. Yet, as with the illustrations to *Dead Souls*, these plates too were stored away in Vollard's dusty basement, to be resurrected by the Greek-born critic and publisher Tériade only many years later, in 1952.

Vollard had originally hoped that Chagall would produce hand-coloured etchings, for which the gouaches were to act as preliminary studies (131). In the event, after several master-printers had tried unsuccessfully to transpose these images into the print medium, Chagall in 1928 undertook the task himself, using different methods and resigning himself to working in black and white. Using mainly drypoint, he often proceeded to cover up the lines with a stopping-out varnish – a technique which heightened the pictorial effect and created an astonishing variety and richness of surface texture, which more than compensates for the lack of colour. Out of a wealth of almost abstract markings, Chagall mysteriously yet meticulously builds up his idiosyncratic repertoire of animal, and occasionally human, forms. However original the final product, he was not, it seems, averse to borrowing motifs from other sources: several of the compositions are clearly indebted to a nineteenth-century illustrated edition of the *Fables* (132, 133).

In 1926 Vollard had also invited Chagall to use his box at the famous Cirque d'Hiver in Paris on a regular basis, in the hope that this would

131 **Right**
The Bird Wounded by an Arrow, *c*.1927.
Gouache;
51·4 × 41·1 cm,
20¼ × 16¼ in.
Stedelijk Museum, Amsterdam

132 **Far right**
The Bird Wounded by an Arrow, 1928–31.
Illustration for *The Fables of La Fontaine*.
Etching;
29·4 × 23·5 cm,
11½ × 9¼ in

133 **Below**
Karl Girardet,
The Bird Wounded by an Arrow, vignette in *Fables of La Fontaine*, Tours, 1858

inspire the artist to produce a series of etchings on the theme of the circus. And indeed, in the winter of 1926–7 Chagall obligingly produced a series of nineteen boldly handled gouaches, now known as the *Cirque Vollard* to distinguish them from his later explorations of the same subject, although, in the event, only a few of these were translated into the print medium (134). Like many other twentieth-century artists – Picasso and Georges Rouault (1871–1958), for example – Chagall had long been fascinated by the circus. As a child, travelling acrobats, musicians and jesters were probably the first 'artists' he had encountered. An interest in carnival and burlesque, moreover, was widespread among the early

134
The Circus Rider,
1926–7.
Etching and drypoint;
32·9 × 24 cm,
13 × 9½ in

135
Circus (Circus Rider),
1927.
Oil on canvas;
100·6 × 81 cm,
39⅝ × 31⅞ in.
Narodnie Galerie, Prague

twentieth-century Russian avant-garde. The circus performer – actor, magician, clown – entertaining the masses yet relegated to the fringes of society, evidently struck a chord of recognition in the artist. 'For myself,' Chagall once said, 'there is something magic about the circus … it's a world in itself … The most intense cry in relation to man's search for amusement or joy often takes on the form of the highest poetry.' The ability of the circus, moreover, to create an illogical, gravity-defying spectacle and to hold an audience spellbound, suspending its disbelief, clearly has parallels in Chagall's own art.

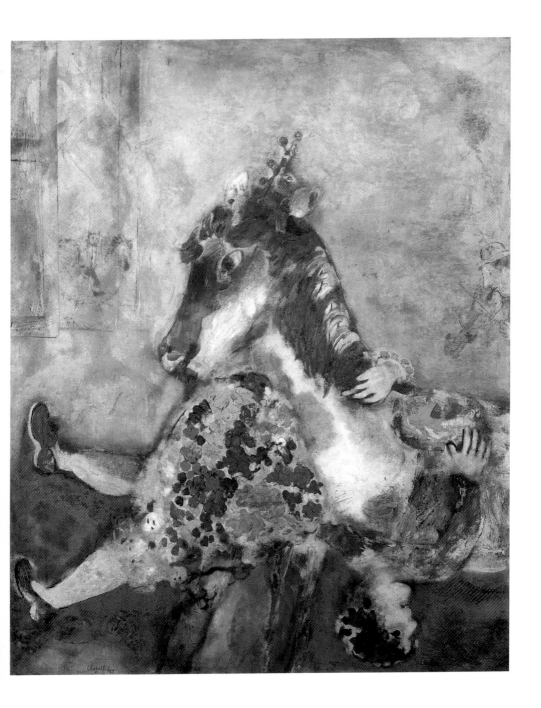

This first-hand experience of the world of the circus encouraged Chagall to explore it in other media too. Although acrobats had already featured in a number of earlier images – notably, *Village Fair* of 1908, the striking *Acrobat* of 1914 and the *Introduction to the Yiddish Theatre* of 1920 (see 99) – it was only in the later 1920s, as evidenced by paintings such as *Circus (Circus Rider)* of 1927 (135), that they became one of the leitmotifs of his art. In marked contrast to the deliberate angularity, strident colouring and compositional daring of the 1914 painting, Chagall's acrobats of the 1920s are rendered with a softer, more sensual and painterly brushstroke, typical of his handling of the oil medium in this decade.

Even more conspicuously than acrobats, lovers with flowers dominate Chagall's *oeuvre* at this point in his career. One should remember, perhaps, that flowers were hardly a common feature of his childhood years. Emblematic of affluence, if not luxury and sensuous abandon, they appear only rarely in his earlier work, in, for example, *The Birthday* of 1915 (see 70). In the very different context of Paris in the 1920s – where, moreover, from late 1925 onwards he lived close to the magnificent Jardin Fleuriste (municipal gardens) near the Bois de Boulogne – lovers and flowers abound. In *Lovers under Lilies* of 1922–5 (136), for example, a couple embrace with a sexual explicitness rare in Chagall's work, under a bouquet of giant lilies, so that the figures can be read either as a receptacle for the flowers, or – if the flowers are read as a tree – as the trunk of that tree. Hovering in the middle background is the shadowy winged figure that features in a number of these compositions – a reminder of the notion of human love as divinely sanctioned which found expression in earlier works such as *The Wedding* of 1918 (see 72). This kind of suggestive ambiguity – however mild when compared with his prewar images – reappears in works such as the deceptively sweet *The Rooster* of 1929 (137) and *The Dream* of 1927 (138). On one level, the latter is almost a parody of the classical myth of the Rape of Europa; its original title was *The Rabbit*, a humorous reference, perhaps, to Lewis Carroll's *Alice's Adventures in Wonderland* (1865). The combination in these works of a ground of thin oil paint overlaid in places with a thicker application of paint is characteristic of a number of Chagall's paintings of this period.

136
Lovers under Lilies,
1922–5.
Oil on canvas;
117 × 89 cm,
46 × 35 in.
Private
collection

191 Berlin and Paris, 1922–1930

137
The Rooster,
1929.
Oil on canvas;
81 × 65 cm,
31⅞ × 25⅝ in.
Fundación
Coleccion
Thyssen-
Bornemisza,
Madrid

138
The Dream,
1927.
Oil on canvas;
81 × 100 cm,
31⅞ × 39⅜ in.
Musée d'Art
Moderne de la
Ville de Paris

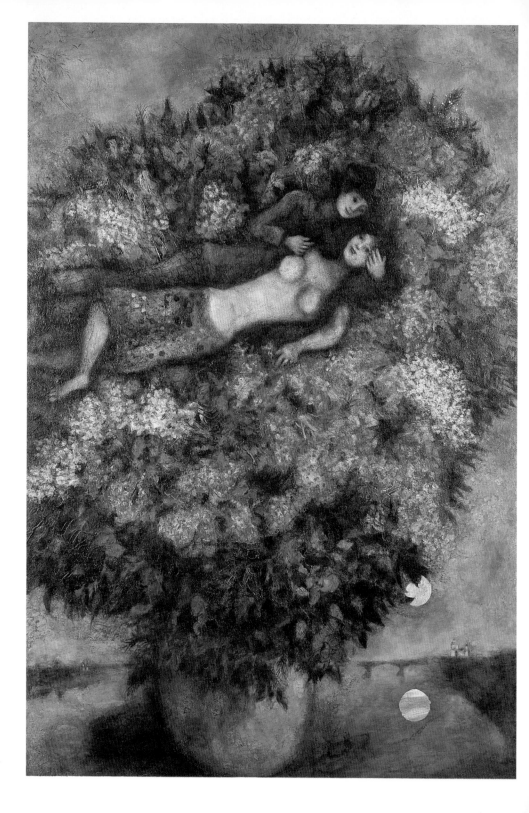

Lovers in the Lilacs of 1930 (139) is a more restrained and lyrical variation
on a similar theme; while the dreamily introspective *Lovers with Flowers*
of 1927 is a rather more orthodox rendering of the subject. Occasionally,
flowers – as in *Peonies and Lilacs* and *Chrysanthemums*, both of 1926 –
feature independently of the human presence. The last of these seems
to have been painted expressly to be sold, a sure indication of the mar-
ketability of such canvases, and of Chagall's relatively new awareness of
the commercial aspects of art-making. The fact that most of these lovers-
with-flowers ended up in private rather than public collections is hardly
accidental. At best, however, these paintings corroborate the artist's
claim that 'there lies in the flowers I paint a subtle spell which makes
them akin to the flowers of God.'

Tranquil images of Bella and Ida also feature prominently in Chagall's
work of this period, as confirmation of the domestic harmony that
seems to have prevailed in the artist's life at this time. Many of them,
such as *Ida at the Window* of 1924 (140) and *Bella at Mourillon* of 1926,
were produced on family holidays. It was in the 1920s too that Chagall

139
*Lovers in
the Lilacs*,
1930.
Oil on canvas;
128 × 87 cm,
50³⁄₈ × 34¹⁄₄ in.
Private
collection

140
*Ida at the
Window*,
1924.
Oil on canvas.
105 × 74.9 cm,
41³⁄₈ × 29¹⁄₂ in.
Stedelijk
Museum,
Amsterdam

took an increasing interest in unpeopled landscapes, although signs of human activity are rarely completely absent. Indeed, it is striking how often a corner of the French countryside is made, in Chagall's hands, to look suspiciously like the Lyosno of his childhood. Part of the reason for this new emphasis on landscape lies in the numerous holidays the Chagall family took throughout the decade to different parts of rural France – symptomatic, once again, of their more relaxed and leisured circumstances. On one of the earliest of such trips, to Normandy, Chagall wrote: 'We are silly and happy here.' In the summer of 1924 they spent a month on the island of Bréhat, off the north Brittany coast, where Chagall painted both *Ida at the Window* and the closely related *The Window*, in which the landscape outside dominates, creating a marked ambiguity of interior and exterior spaces. The rural folk traditions of Brittany may, moreover, have had some influence on the imagery of the *Dead Souls* illustrations.

In 1925 the Chagalls stayed at Montchauvet, near Versailles (141); and much of 1926 and 1927, when Chagall was hard at work on the brilliantly coloured gouaches for La Fontaine, was spent outside Paris, at Mourillon near Toulon, and later in the Auvergne and the French Riviera (142). Some writers have tried hard to identify the influence of the light and colours of a particular country or part of France on Chagall's art. However, given the quirkiness and obliquity of the artist's imagination and the fact that he only rarely painted out-of-doors, this attempt seems necessarily, with a few obvious exceptions, doomed to failure.

The completely new departures represented by the paintings that Chagall produced in the 1920s testify both to his hard-won contentment and to the more conservative tenor of the art world generally. In the images of landscapes, flowers, lovers and acrobats that characterize this decade of Chagall's career, there remains little of the complexity and idiosyncratic fantasy of the work he produced in his first Parisian period, or even in Russia. Conversely, these more lyrical and serene works reveal a rediscovery of the joys of colour – due in part, one speculates, to the renewal of Chagall's friendship with Robert and Sonia Delaunay, but also to a new sense of physical and psychological wellbeing. At best, Chagall's new paintings of this period are a pleasing paean to the

141
Montchauvet,
1925.
Gouache and
watercolour;
63 × 47·8 cm,
24¾ × 18¾ in.
Private
collection

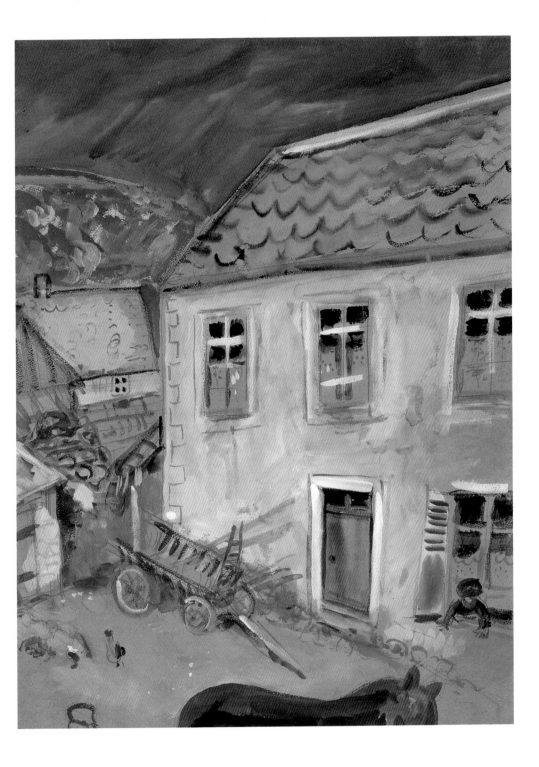

142
French Village,
1926.
Gouache;
52.5 × 66.5 cm,
20 $\frac{5}{8}$ × 26 $\frac{1}{4}$ in.
Israel Museum,
Jerusalem

sensuous but innocent pleasures of life – often with an element of witty unpredictability in iconography or composition. The less successful images, however, reveal a tendency to blandness, a sweetness that threatens to become saccharine – to which the etchings of this decade act as a salutary and refreshing antidote.

Paris in the 1920s was a very different place to the city Chagall had known and loved before 1914. The heady experimentation that had characterized the Parisian avant-garde just prior to World War I had for the most part been replaced by an emphasis on more classical and (by implication) enduring values. This emphasis was to be found in French culture and society generally, and was commonly referred to as a *rappel à l'ordre* or 'call to order', after the trauma and upheaval of war. Picasso, Braque and Matisse, whose innovations had shocked conservative taste in the prewar years, were now the great triumvirate of the art establishment, to which Chagall would continue to relate in an ambiguous way. A vivid demonstration of the cultural change that had taken place is the almost schizophrenic nature of Picasso's work in the early 1920s, which veers between a more decorative form of Cubism and a self-conscious Neoclassicism (143).

143
Pablo Picasso,
Three Women at the Spring,
1921.
Oil on canvas;
203·9 × 174 cm,
80¼ × 68½ in.
Museum of Modern Art,
New York

Of those artists and writers whom Chagall had known before the war, Apollinaire and Modigliani were dead; Max Jacob was hidden away in a monastery; Soutine, thanks to his American patron Dr Albert C Barnes, was living it up, mainly on the French Riviera; Blaise Cendrars, because of his alleged treachery in the matter of Chagall's pre-1914 paintings, was *persona non grata*. The School of Paris, based in Montparnasse, had re-formed, consisting chiefly of foreign-born artists from all over the world (many of them Jewish) intent on being artistic bohemians regardless of talent. Many of the artists who had lived there before the war now flocked back, among them Moïse Kisling (1891–1953), Mané-Katz and Jules Pascin, but there were also many newcomers. Although, ironically, by the late 1920s Chagall was widely perceived as being the leader of this school, he for the most part held himself firmly aloof from its activities.

It was Guillaume Apollinaire who had dubbed Chagall a surrealist: 'surnaturel!' he had exclaimed in front of his work in 1913, long before the term had been formally coined. The Surrealist movement was officially launched in Paris in 1924, and its members, in particular the artist Max Ernst (1891–1976; 144) and the poet Paul Éluard, were keen to enlist Chagall to their ranks. Surrealism, like its precursor Dada, was based on a deep distrust of the rational mind – the 'logic' that had brought about and sustained the war in the trenches, in which Ernst and other young artists and writers had served. It emphasized, by contrast, a faith in the irrational and the workings of the unconscious mind; the concept of the artist as an intuitive rather than intellectual being; and an admiration, shared with the Expressionists, for so-called primitive art, folk art, the art of children and the insane. The psychoanalytical theories of Sigmund Freud played a crucial role in Surrealism. According to Freud, human experience was shaped by powerful repressed desires which generally remained unconscious, and therefore inaccessible to the rational mind.

Chagall shared many of the Surrealists' preoccupations, yet, as ever, he fought shy of any association with a programmatic movement. This was not only because of his perennial desire to be independent, but because, in this case, he felt justifiably suspicious of a movement that – in a very French fashion – used reasoned arguments to attack the rule of reason, and relied – too heavily as he saw it – on literary sources. Nor, moreover,

144
Max Ernst,
The Horde,
1927.
Oil on canvas;
114·9×146cm,
45¼×57½in.
Stedelijk
Museum,
Amsterdam

could he subscribe to the Surrealists' theoretical emphasis on automa-tism, or complete surrender of the conscious will, in the creative act. Although much of his imagery derives from unconscious sources, Chagall would never have claimed that a picture or a poem could create itself. Aesthetic choices had to be made, to give form to that imagery and to justify the existence of the artist. Boris Aronson had described Chagall in 1922 as 'organized inspiration', while the artist saw himself as 'an unconscious–conscious painter'.

In a 1944 interview, Chagall would recall:

On my return to Paris in 1922 [*sic*], I was agreeably surprised to find a new artistic group of young men, the surrealists, rehabilitating to some degree that term of abuse before the war, 'literary painting'. What had previously been regarded as a weakness was now encouraged. Some did go to the extreme of giving their work a frankly symbolic character, others adopted a baldly literary approach. But the regrettable part was that the art of this period offered so much less evidence of natural talent and technical mastery than the heroic period before 1914 … For my part, I have slept well without Freud. I confess I have not read a single one of his books; I surely will not do it now. I am afraid that as a conscious method, automatism engenders automatism.

Chagall's refusal to join the ranks of the Surrealists in the 1920s caused the latter to attack him – somewhat mysteriously – for being a 'mystic'. It was only in 1945 that André Breton, the doctrinaire 'pope' of Surrealism, as he was sometimes called, would publicly recant on this judgement.

Once again, therefore, Chagall felt an outsider, alienated both from what he perceived as the vulgarity and superficiality of the Montparnasse art world, and the machinations and ambitions of the Surrealist movement. Protected from all this by the safe intimacy of his domestic circumstances, he chose for the most part to remove himself from the hubbub, both psychologically and physically. Even the Russian *émigré* community held little lasting attraction for him. A 1925 photograph (145), showing the artists and writers who attended a special evening in honour of Georges Rouault, does, however, suggest that Chagall mingled with his fellow artists more than he later led people to believe. On the whole, though, meetings with their relatively few close friends – Robert and Sonia Delaunay, the writers Claire and Ivan Goll, Jules Supervieille, Paul and Gala Éluard, René Schwob and Jacques and Raissa Maritain – increasingly took priority over larger and more raucous gatherings.

While it is difficult to cite specific cases of literary influence on Chagall's visual output, it is more than likely that he occasionally drew inspiration from some of the imagery used by his friends – and vice versa. On the whole, it was a more generalized sense of personal and/or artistic affinities that attracted him to certain writers. The relationships established in the late 1920s were to be enduring ones, lasting until World War II, and in many cases well into the postwar period.

It cannot be accidental that many of these friends, like Chagall and Bella, had their roots outside France, and never fully entered the mainstream of French culture. Although much of their writing shows the influence of Surrealism, and hence the love of incongruous and sometimes startling juxtapositions also favoured by Chagall, they generally steered clear of involvement with programmatic groups. Jules Supervieille, for example, was born in Uruguay to French parents; his writing reveals a witty tendency to treat the fantastic in an everyday

fashion – a quality more characteristic of South American (and indeed, Russian–Jewish) than French culture. Similarly, Claire Goll was German in origin, while her husband came from Alsace, with its chequered history of French–German territorial conflict. The Jewish René Schwob was also ultimately an 'outsider'; in the early 1930s his book *Chagall and the Jewish Soul* was illustrated by the artist. Even Paul Éluard, more closely associated with Breton and the Surrealist movement than Chagall's other friends at this time, remained relatively independent in his literary creations, and in the 1930s was to turn his back on Surrealism in favour of an allegiance to the Communist Party.

It was Supervielle, Schwob and Éluard who first provided Chagall with an introduction in the late 1920s to Jacques and Raissa Maritain. For the next ten years, Chagall and Bella regularly frequented the literary gatherings that took place every Sunday at their home at Meudon just outside Paris. Jacques Maritain was an influential Catholic philosopher and theologian with a strong interest in the arts; in 1934 he published an essay on Chagall's Bible etchings in *Cahiers d'Art*, and by 1937 was a passionate opponent of anti-Semitism. Raissa Maritain, a poet, was herself of Russian–Jewish origin, but since 1906 an ardent convert to Catholicism. Georges Rouault and Raissa's fellow convert Max Jacob were close associates. Like her husband, Raissa chose – in defiance of the evidence – to view Chagall as a Christian mystic despite himself; in the late 1940s she wrote a half astute, half far-fetched book expounding this view of Chagall called *L'Orage enchanté* ('The Enchanted Storm'). Chagall, meanwhile, was appreciative of their friendship and the intellectual stimulus of their company, but remained impervious to their blandishments.

After 1927, when the Chagall family moved to Boulogne-sur-Seine, closer to the Maritains and an hour's journey from Montparnasse, the artist's forays into the city became rarer. Financial security, if not actual affluence, was provided by the steady income from Vollard and, between 1927 and 1929, a contract with the dealer Bernheim-Jeune, as well as by the commercial demand for his more conservative images – the flower pieces in particular. In 1928 the poet and art critic André Salmon began working on a French translation of *My Life*; when the idiosyncrasies of

145
Party held in honour of Georges Rouault, Paris, 1925. Georges Rouault is seated on the front right, standing next to him on the right is Bella Chagall. Jacques Lipchitz is in the back row at the centre between the mirrors, André Salmon is to the right of him. André Lhôte is standing fourth from the right against the right-hand wall, Marc Chagall is standing on the extreme right

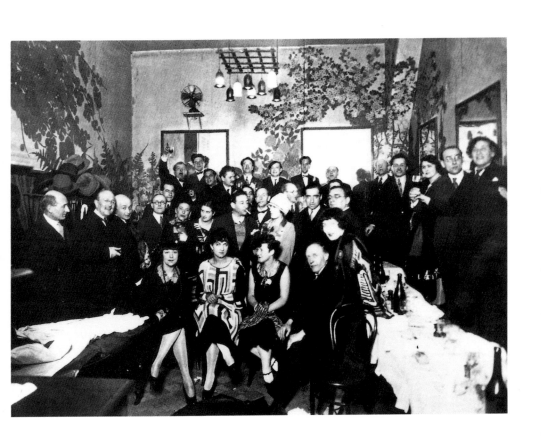

the original Russian text proved too much for him, Bella took over, aided by Ida's French teacher and the poet Jean Paulhan. (The volume was finally published in 1931.) Meanwhile, Chagall was offered an ever-increasing number of one-man exhibitions, both in Europe, starting with the Galerie Barbazanges-Hodebert in Paris in 1924, and America, where his first solo show was held at the Reinhart Galleries in New York in 1926. Together with the appearance of an ever-growing number of mono-graphs and other publications devoted to Chagall's art, these established his international status beyond doubt. All in all, Chagall could well afford to turn his back on bohemia.

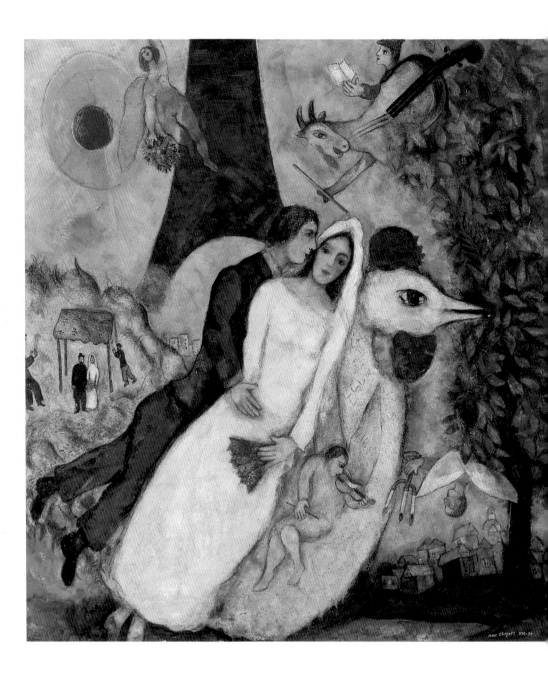

For once, a new decade found Chagall still in the same place. Nevertheless, as that decade progressed, a significant change of mood could be detected in much of the artist's work. Although, as paintings like *Lovers in the Lilacs* (see 139) and *The Young Acrobat* (both of 1930) and even later images such as *Bouquet with Flying Lovers* (1934/47) and *Bride and Groom of the Eiffel Tower* of 1938–9 (146) testify, he continued to produce numerous tranquil images of lovers, flowers, acrobats and the like, the most memorable and original works of this decade are undoubtedly those born out of a profound sense of unease and foreboding.

It was in 1930 that Vollard formally commissioned Chagall to illustrate the Old Testament – a project that, although in many ways a logical extension of many of the artist's earlier preoccupations, would itself help bring about a distinct shift in consciousness. In the same year, Chagall was introduced to the mayor of Tel Aviv, Meir Dizengoff, then visiting Paris, and soon became enthused by the latter's ambitious plans for a new art museum in that rapidly developing Jewish city, even agreeing to become a member of the Paris committee set up to promote the project. Thus, although Chagall was later to claim that it was largely the commission from Vollard that prompted him to visit Palestine for the first time, there were other reasons too: not least, as his response to Dizengoff's ideas makes clear, a curiosity about the Jewish state-in-embryo being created there (statehood would be achieved in 1948), and a desire to participate in its cultural development. Although neither a fervent Zionist nor a religiously observant Jew, Chagall could hardly fail to feel the lure of this 'Old–New Land'.

Early in 1931, therefore, at Dizengoff's invitation, Chagall and his family set sail for Palestine. This was without question the most important of the many trips he took abroad in the 1930s. Significantly, nearly all his travelling in the previous decade had been within France itself, an

indication on one level of financial constraints, but also of the artist's
curiosity about his adopted country. Now, in the 1930s, his greater
affluence combined with a renewed restlessness (partly innate and partly
exacerbated by world events) compelled him to travel further afield.

The journey lasted from February to April; on board ship they enjoyed
the company of the Russian-born Zionist poet Chaim Bialik (whom they
had already befriended in Berlin) and the French–Jewish writer Edmond
Fleg. Stops in Cairo, Alexandria and Beirut added interest, but had noth-
ing of the emotional impact of Palestine itself. Chagall was received with
all the pomp and circumstance the embryonic state could muster, and
was deeply touched and flattered. In Haifa he visited his erstwhile
teacher Hermann Struck, resident in Palestine since 1923, and presented
him with a copy of the 1924–5 etching *Self-Portrait with Smile* (147) –
not, interestingly, its more ambiguous companion piece, *Self-Portrait
with Grimace* – as if to demonstrate his now unquestionable prowess in
the graphic medium. He gave another copy of this print, which would
find its way into the Tel Aviv Museum's permanent collection, to Meir
Dizengoff. In later life, Chagall was to imply that he had been present
for the opening of the museum in April 1932; and before donating his
painting *The Wailing Wall* (148) in 1953 signed and dated it 'Palestine

147
*Self-Portrait
with Smile*,
1924–5.
Etching and
drypoint;
38 × 28 cm,
15 × 11 in

148
*The Wailing
Wall*,
1932.
Oil on canvas;
73 × 92 cm,
38³⁄₄ × 36¹⁄₄ in.
Tel Aviv
Museum of Art

'1932'. In reality, he was present only for the laying of the museum's foundation stone. His relationship with the museum, moreover, was less simple than he liked to make out: his initial enthusiasm seems to have been replaced, on his return to France, by a more equivocal attitude to the whole project, based on his doubts about its artistic integrity.

Palestine was now a British Mandate, following the break-up of the Ottoman Empire after World War I, with the British authorities torn between the obligation to the Jews embodied in the Balfour Declaration of 1917 and the territorial claims of the Arabs. Although at this point in history, the majority of the Jewish settlers in Palestine came from eastern European communities not dissimilar to that of Vitebsk, most of them were anxious to turn their back on European Jewish culture and to create a new one, based above all on the rebirth of the Hebrew language and the cultivation of the soil. A significant number, however, still remained faithful to Yiddish as a language and a culture. While Chagall

149
*The Synagogue
at Safed,*
1931.
Oil on canvas;
73 × 92 cm,
38¾ × 36¼ in.
Stedelijk
Museum,
Amsterdam

could admire the pioneering spirit of the former, it is hardly surprising that he felt a far greater personal affinity with the latter, and felt very much at home in their company. When it came to recording his impressions on paper or canvas, rather than portray the new culture of the *Kibbutzim* (communal agricultural settlements), he chose to focus on the Bedouin nomads with their biblical aura, and on the orthodox Jews reminiscent in their garb and customs of Vitebsk Jewry.

His immediate artistic response to the visit was to produce a number of surprisingly naturalistic and unemotional renderings of ancient sites of religious worship, such as the so-called Wailing Wall in Jerusalem (148) or a synagogue at Safed (149), as though a physical encounter with the solemn reality of such places halted his imagination in its tracks. A photograph from that time, moreover, shows the artist painting out-of-doors in a rocky landscape, something he did only rarely – again, an indication of the dramatic, and very physical, impact on him of the land itself. Fleg has provided us with a telling description of Chagall at work outside Jerusalem with his wife and daughter, which stands in dramatic contrast to the apparently urbane, cosmopolitan and increasingly assimilated persona he had forged for himself in 1920s Paris:

this Bohemian of the Ghetto always paints in the midst of his family. He had told me many times on the boat, with his malicious smile: 'I am a little Jew of Vitebsk. All that I paint, all that I do, all that I am, is just the Little Jew of Vitebsk. So what am I to do in Palestine?' And then pointing out to me with the end of his brush, the cactus, the towers and the cupolas, all the splendours of Jerusalem, he cried: 'There is no longer a Vitebsk!'

Chagall's statements about the relationship between Palestine and his own perception of the Bible are frequently contradictory. 'I did not see the Bible. I dreamed it,' he declared on one occasion. Vollard for one knew that a visit to the Holy Land was not strictly speaking necessary, suggesting, with a hint of malice, that the notorious Place Pigalle in the Parisian red-light district would do just as well. And indeed Chagall's Bible illustrations make it clear that, in general, the land and its people had little direct influence on his vision of the Old Testament. Exceptions to this include the Bedouin costumes in *Jacob and Rachel at the Well*, the presence of David's Tower and the walls of Jerusalem that feature as

a backdrop in *King David*, and the image of *Rachel's Tomb*, which is a direct transcription of an oil painting that he executed in front of the tomb itself.

Yet, elsewhere, Chagall wrote as follows:

I never work from my head … I wanted to see Palestine, I wanted to touch the earth. I went to verify certain feelings, without a camera, without even a brush … There in the steep streets, from thousands of years before Jesus walked. There, far away, bearded Jews dressed in blue, yellow, red, wearing fur caps, go and come back to the Wailing Wall. Nowhere will you see so much despair, so much joy; nowhere will you be so distressed and so happy as when seeing the age-old mass of stones and dust of Jerusalem, of Safed, of the mountains where prophets are buried over prophets.

However selective and partial Chagall's perception of the country, the emotional importance of this first visit to Palestine cannot be denied.

For his Bible images, as for the illustrations to the *Fables* of La Fontaine, Chagall used gouache drawings as a means to explore visual ideas later to be transposed into the graphic medium, and to establish the correct balance of tones. Unlike the brightly coloured preparatory studies for La Fontaine, these gouaches rely for their power on a blend of subtle, deep and closely related hues. The great French Romantic painter Eugène Delacroix (1798–1863), whom Chagall described as 'one of the gods' on the occasion of a major retrospective exhibition held at the Louvre in 1930, was clearly an important inspiration here. Whereas the composition of the La Fontaine images was often deliberately asymmetrical and idiosyncratic, that of the Bible illustrations tends to be magisterial, even hieratic, with an emphasis (especially in the earlier plates) on figures depicted from close-up, to increase their aura of monumentality. A deliberate primitivism in the rendering of the forms in these works similarly serves to increase their almost archaic grandeur.

By 1939 Chagall had completed sixty-six plates, and had started work on thirty-nine more. Vollard's death in that year, combined with the outbreak of war prompted by the Nazi invasion of Poland in September, halted work on the project until 1952, after Chagall's return to France. The entire series of 105 etchings was finally completed in 1956 and pub-

lished by Vollard's successor, Tériade, in the same year. The considerable
dramatic power of the Bible prints showed Chagall yet again to be com-
plete master of his medium. As ever, his approach to printmaking was
essentially pragmatic, resulting in a freedom unavailable to the purist.
The Bible etchings underwent a large number of stages, with extensive
alterations made in the process. Etching was usually completed with dry-
point; while previously etched areas were often covered with a moder-
ately porous lacquer and reworked with a burin to produce light–dark
relationships of great intricacy and intensity. Light areas were also
achieved by smoothing the surface of the plate with a buffer, and half-
tones by rubbing it with sandpaper.

Chagall's choice of subjects is often unusual, too, and there are
relatively few iconographic borrowings from other visual sources –
although considerably more than Chagall's persistent assertion of
artistic self-sufficiency would lead us to expect. Such references as do
exist to earlier works of art are primarily to Rembrandt, and the Spanish
masters Diego Velázquez (1599–1660), Francisco Goya (1746–1828) and El
Greco (1541–1614). Exceptions to this are the allusion in *Abraham and
the Three Angels* (150) to a well-known icon by Andrei Rublev in the
Tretyakov Gallery, Moscow (151), in which the three angels are clearly
intended to prefigure the Trinity, a Christian reading of the image that
Chagall chose to ignore, and the borrowing (in reverse) of the figure of
the patriarch in *The Dream of Jacob* by José de Ribera (1591–1652) for his
own *Jacob's Ladder*. Although Chagall had long admired both the paint-
ings and graphic work of Rembrandt, a visit to Holland in 1932 gave him
an unprecedented opportunity to study that great artist's work at first
hand. An account of that journey published in the same year includes
the following description (redolent of his own experience on his return
to Vitebsk in 1914) of his visit to Rembrandt's house, which at that
period was still in the middle of Amsterdam's vibrant Jewish quarter:
'Opposite … huge merchants were selling fish, chickens, as in pictures
by the old masters … Rembrandt had only to go into the street to secure
the first Jew to come along as a model. King Saul, prophet, merchant,
beggar are the same Jews, his neighbours.' Images such as *Potiphar's
Wife*, *The Blessing of Ephraim and Manasseh* and *The Sacrifice of
Manoach* do indeed recall aspects of Rembrandt's work; while the

150
Abraham and the Three Angels, 1931.
Oil and gouache on paper; 62·5 × 49 cm, 24 ⅝ × 19 ¼ in.
Musée National Message Biblique Marc Chagall, Nice

151
Andrei Rublev, *Icon of Three Angels*, 1420.
Tempera on panel; 142 × 114 cm, 55 ⅞ × 44 ⅞ in.
Tretyakov Gallery, Moscow

similarities between *Moses with the Tablets of the Law* by the Dutch master (152) and his own rendering of the subject (153) are striking.

In a similar vein, a visit to Spain in 1934 led to Chagall's new intimacy with the work of El Greco, Velázquez and Goya (as well as the chance to see the above-mentioned Ribera painting). The influence of El Greco is less marked than that of Rembrandt, although traces of it are evident in the anatomical distortions of *Pharaoh's Dream* and *Darkness over Egypt*. Chagall's admiration for the work of Velázquez and Goya manifests itself in a more generalized sense still, in the increasing monumentality and

152 Below
Rembrandt
van Rijn,
*Moses with
the Tablets
of the Law*,
1659.
Oil on canvas;
167 × 135 cm.
65¼ × 53⅛ in.
Staatliche
Museen,
Gemäldegalerie,
Berlin

153 Above right
*Moses Breaking
the Tablets
of the Law*, from
the *Bible*,
1931–9/1952–6.
Etching and
drypoint;
29.4 × 23.1 cm,
11⅝ × 9⅛ in

154 Opposite
*Abraham
Weeping
for Sarah*,
1931.
Gouache;
62.5 × 49.5 cm,
24⅝ × 19½ in.
Musée National
Message
Biblique Marc
Chagall, Nice

seriousness of Chagall's vision, not only in these biblical images but in much of his work of the 1930s and 1940s. In *The Dove from the Ark*, for example, the forms of humans and animals alike are hieratic, still and full of *gravitas*. *Abraham Weeping for Sarah* (154) is another image full of tragic grandeur; while *The Capture of Jerusalem*, the last plate etched in 1939, with its surprising – and possibly fortuitous – reference to the figure of the avenging angel in *The Last Judgement* by John Martin (1789–1854), is full of grim foreboding, as if anticipating the fate awaiting European Jewry. In contrast, *The Dance of Miriam, Sister of Moses*

(155) is a fine example of a lighter and more joyous image, in which the ecstatic dance movements recall the fervour of the Hasidic dancers of Chagall's childhood. The latter image also contains a rare reference to the work of a contemporary artist: namely, Goncharova's designs for Stravinsky's *Les Noces*, produced by Bronislava Nijinska in 1924 for the Ballets Russes.

The Old Testament, with its intimate historical as well as religious associations for the Jewish people, would be a major source of inspiration for Chagall thereafter, culminating in the huge canvases done for the specially created Museum of the Biblical Message in Nice in the 1950s and 1960s. Unburdened with a Christian sense of original sin, Chagall's vision of the Bible, as expressed even in these small-scale works, was of a grand human narrative of epic proportions, dominated by lofty emotions – be they tragic or ecstatic or even, occasionally, mixed with humour. As the artist himself put it: 'I went to the great universal book, the Bible. Since my childhood, it has filled me with visions about the fate of the world and inspired me in my work. In moments of doubt, its highly poetic grandeur and wisdom have comforted me like a second nature.'

His encounter with Palestine and his rediscovery of the Old Testament, combined with world events (above all, the rise of Nazism in Germany, but also the Stavisky affair of 1934, a scandal involving a Jewish petty crook implicated with the French government, which led to the polarization of political opinion in France and manifestations of latent anti-Semitism) forced Chagall to reassess his status as honorary Frenchman, and to stress once more his Jewish origins and allegiances. A remarkable example of this reawakened sense of Jewishness is *Solitude* (156), painted in 1933 largely in response to Hitler's accession to power. This is undoubtedly one of his most memorable paintings, compositionally and iconographically one of the simplest, yet one of the most haunting. Beyond the poignant and melancholy longing that permeates the work, the images' more specific associations lend it weight and complexity. As noted before, the violin is frequently regarded as a quintessentially Jewish instrument: the writer Sholom Aleichem, for example, had written in 1903 that 'you can compare the heart in general and the Jewish heart in particular to a violin with several strings'. Similarly, in the Old

155
The Dance of Miriam, Sister of Moses, from the *Bible*, 1931–9/1952–6. Etching and drypoint; 29·5 × 22·5 cm, 11⅝ × 8⅞ in

156 Overleaf
Solitude, 1933. Oil on canvas; 102 × 169 cm, 40⅛ × 66½ in. Tel Aviv Museum of Art

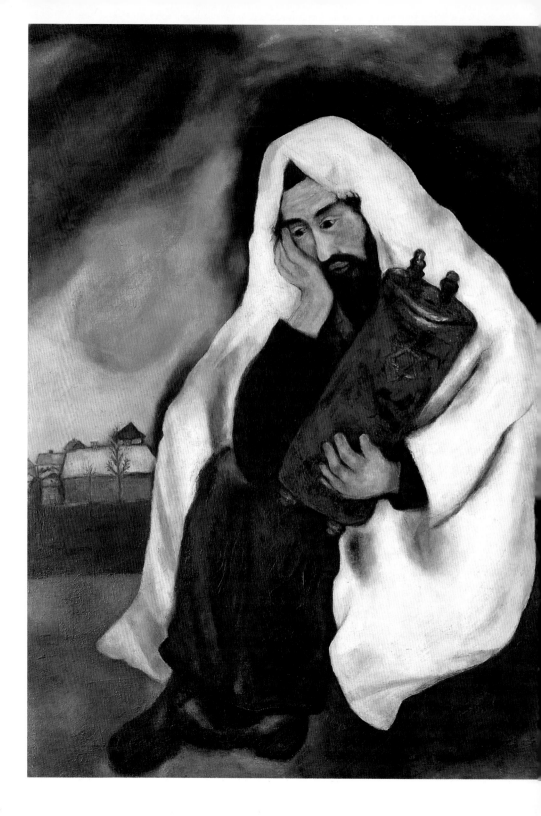

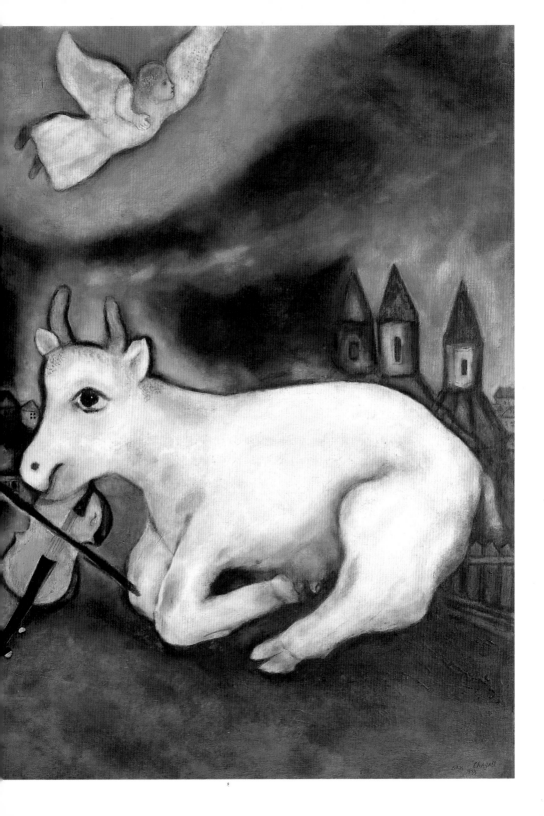

Testament Book of Hosea, Israel is referred to as a heifer and Chagall –
as he tells us in his autobiography – had long identified with the suffer-
ing of innocent cattle.

As well as marking Hitler's accession to power, 1933 was the year in
which a defamatory Nazi exhibition entitled *Images of Cultural
Bolshevism* at the Mannheim Kunsthalle included work by Chagall;
while his painting *The Pinch of Snuff* (see 48) was featured in a
Mannheim window display with the derisory caption: 'Taxpayer, you
should know how your money was spent'. In the same year, the artist
was denied French citizenship because he had once been a commissar in
Vitebsk. No wonder Chagall was forced to rethink his position in the
world. Through the intervention of the writer Jean Paulhan, Chagall was
finally granted French citizenship in 1937. However, 1937 was also the
year in which the Nazis confiscated over fifty of his works in German
public collections, and in which two of his paintings (*Purim* and *The
Pinch of Snuff*) and two watercolours (*Winter* and *Man with Cow*) fea-
tured in the infamous *Degenerate Art* exhibition in Munich. Three of
these were placed in the same room as the work of other Jewish artists,
all lumped together, regardless of style or subject, under the derisive
heading 'Revelation of the Jewish Racial Soul'. In 1939 *Winter, The
Pinch of Snuff* and *The Blue House* (see 85) were to be paid the dubious
honour of being included among 125 works of art from German public
collections auctioned on behalf of the Nazis at the Galerie Fischer in
Lucerne, Switzerland.

In 1935 Bella and Chagall had paid a visit to Vilna, then in Poland, at the
invitation of the Jewish Institute there, and had been deeply distressed
to witness the increasing signs of racial tension and anti-Semitism in
Polish society. In Vilna, a mere 320 km (200 miles) or so from Vitebsk,
Chagall depicted the interior of one of the synagogues in a relatively
documentary style, as if to preserve it for posterity, and initiated friend-
ships with several Yiddish writers, notably the poet Abraham Sutzkever
and the critic Talpiel, which would be resumed in Israel after the war.

A poem by Chagall in Yiddish, entitled 'The Vilna Synagogue', written
later, probably soon after World War II, seems to reflect the artist's reac-
tions to his visit:

The old shul [synagogue], the old street
I painted them just yesteryear
Now smoke rises there, and ash
And the parokhet [ark curtain] is lost.

Where are your Torah scrolls?
The lamps, menorahs, chandeliers?
The air, generations filled with their breath?
It evaporates in the sky.

Trembling, I put the colour,
The green colour of the Ark of the Covenant.
I bowed in tears,
Alone in the shul – a last witness.

The artist's faith in the future, encouraged by his granting of French citizenship, seems to have been seriously undermined by his visit to Vilna and his vilification by the Nazis.

It was also in 1937 that Chagall painted his first – and indeed only – major composition dealing explicitly with the Russian Revolution. One reason that this painting was executed so long after the event may have been the artist's earlier desire to push the bitter memories associated with that period to the back of his mind. Another, almost certainly, was the changed political climate in Europe, epitomized by the rise of Fascism in Germany, Italy and Spain, the outbreak of the Spanish Civil War and the involvement of numerous French intellectuals – many of Chagall's friends among them – with the Communist Party. Although the leftist Popular Front, led by Léon Blum, had come to power in France in 1936, many felt that the political situation demanded more radical measures. All this seems to have compelled Chagall both to confront the past and to comment upon the present.

The Revolution (157) is clearly divided into three parts, the central zone being occupied by the acrobatic figure of Lenin and an old Jew, who, sadly, has seen it all before. On the left are the revolutionary masses, complete with gravestones and a corpse boding ill for the future; the dominant colours here are deep bloody reds and venous purples. On the right, in contrast, is the domain of art, love and religion, bathed in a

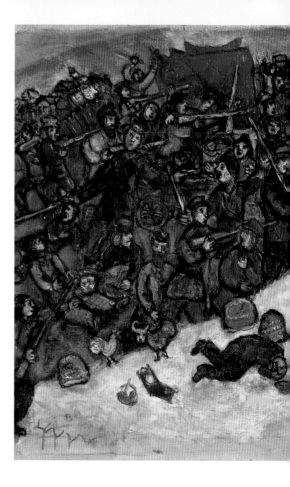

157
The Revolution,
1937.
Oil on canvas;
50×100 cm,
19³⁄₄×39³⁄₈ in.
Musée National
d'Art Moderne,
Centre Georges
Pompidou,
Paris

tender blue. There is little doubt as to which world the artist favours. Indeed, the mysterious intrusion into this politically non-revolutionary realm of a red flag bearing the first letter of the Hebrew alphabet suggests that, for Chagall, true revolution lies not in the domain of politics but in that of culture.

It may be that the artist baulked at the over-explicitness of this canvas. In the 1940s Chagall decided to cut the original large composition into three sections, already implicit in its layout, and radically rework each of these as separate paintings, subsequently known as *Resistance* (formerly *Ghetto*; 158), *Resurrection* (159) and *Liberation* (160). The original composition now exists only in the form of a smaller, albeit complete sketch (157). Since the painting was iconographically over-ambitious and formally unresolved, there were almost certainly aesthetic reasons for this deci-

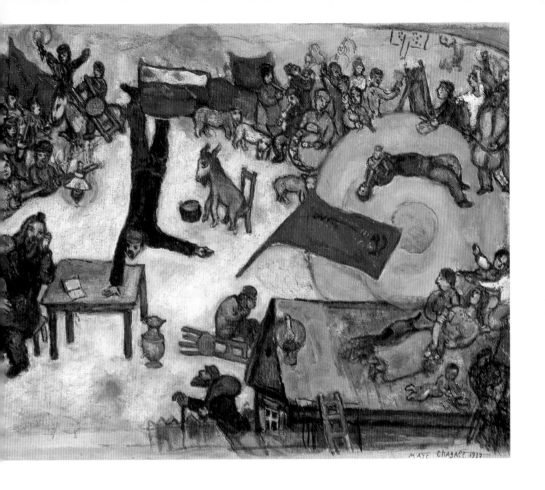

sion too; a number of other complex and monumental canvases of the 1930s met with a similar fate. The fact that *Resistance* and *Resurrection* are dominated by an unequivocally Jewish Christ figure is a strong indication of the importance of the latter in Chagall's consciousness from the late 1930s onwards.

The magnificent *White Crucifixion* of 1938 (161) represents the first, and probably most impressive, in a long series of Crucifixion images produced by Chagall in this period of his career. Each of these can be seen on one level as a direct response to specific historical events: in the case of this work, the German *Aktion* of 15 June 1938 in which 1,500 Jews were dispatched to concentration camps; the destruction of the Munich and Nuremburg synagogues on 9 June and 10 August respectively; the deportation of Polish Jews at the end of October; and the outbreak of

158
Resistance,
1937–48.
Oil on canvas;
168×103 cm,
66⅛×40½ in.
Musée National
d'Art Moderne,
Centre Georges
Pompidou, Paris

159
Resurrection,
1937–48.
Oil on canvas;
168×107·7 cm,
66⅛×42⅜ in.
Musée National
d'Art Moderne,
Centre Georges
Pompidou, Paris

160
Liberation,
1937–48.
Oil on canvas;
168×88 cm,
66⅛×34⅝ in.
Musée National
d'Art Moderne,
Centre Georges
Pompidou, Paris

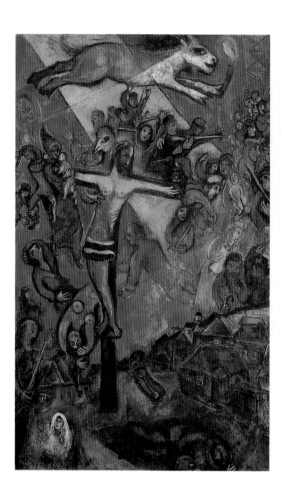

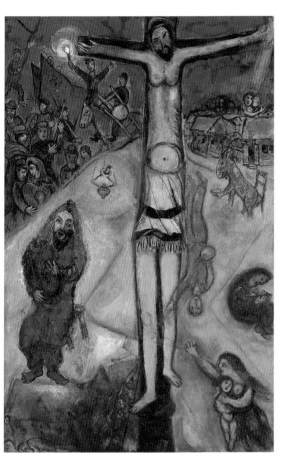
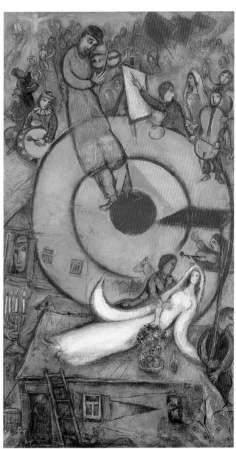

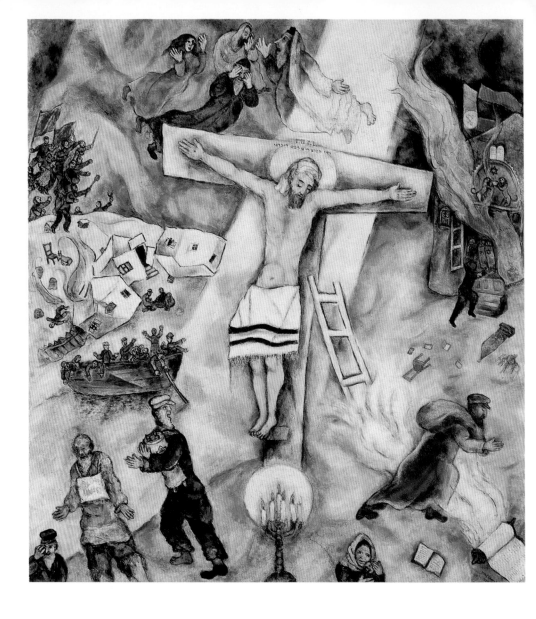

161
*White
Crucifixion,*
1938.
Oil on canvas;
155 × 139.5 cm,
61 × 55 in.
The Art Institute
of Chicago

vicious pogroms, including the infamous Kristallnacht, known as the Night of Broken Glass, of 9 November 1938 in which Jewish shops, property and synagogues were attacked and destroyed. Even the placard worn by the old Jew at the lower left of the composition, which once read (before Chagall reworked the painting) 'Ich bin Jude' ('I am a Jew') can be connected to Nazi policies forcing Jews to identify themselves.

White, as emblematic of sorrow, appears in other paintings of this period: in the earlier *Solitude* (see 156), in which the luminous yet ghostly whiteness of the heifer matches the colour of the Jew's prayer shawl, and in the disconcertingly funereal *The Bride's Chair* of 1934, painted on the occasion of the eighteen-year-old Ida's marriage to Michael Gorday, a young lawyer, also of Russian–Jewish origin. In *White Crucifixion*, small areas of intense colour activate a composition dependent on a deliberately naïve narrative style, in which disparate scenes are brought together in a manner reminiscent of the Russian Orthodox icons Chagall would have known in his youth. Christ's Jewishness is here established beyond question by the *tallith* or prayer shawl wrapped around his loins. Above his head are not only the Roman letters INRI, but also an inscription in Aramaic (Jesus' own language), both reading 'Jesus of Nazareth, King of the Jews'. Biblical patriarchs and a matriarch at the top weep at the scenes of fear and horror down below. On the right, a German soldier (the swastika on his armband was once more prominent) desecrates then sets fire to a synagogue. On the left, a rabble brandishing red flags surges up the hill. Some commentators have interpreted these figures as representing the Red Army as a positive, liberating force, but Chagall, with his personal experience of Russian politics and anti-Semitism, knew better. The overturned, burning houses thus become an omen of things to come: the world is truly turned upside-down, and pictorial logic no more inconsistent than that of the 'real' world.

Chagall had, in his own words, long been 'troubled by the pale face of Christ'. Indeed, he produced his first rendering of the Crucifixion theme as early as 1912, in the painting *Dedicated to Christ* (see 56). In the latter, however, the Jewish references are veiled and oblique. With the deterioration of the political situation in Europe in the late 1930s, a more direct identification of Jesus with the Jews seemed necessary.

And indeed, as that situation worsened still further with the outbreak of war, Chagall felt compelled in 1940 to produce another version of the *White Crucifixion*, in which Jesus is given a Jewish skullcap and the INRI sign is replaced by the Ten Commandments. The differences between this and the 1938 composition relate directly to current events: with the Nazi–Soviet non-aggression pact now in force, the candle at the foot of the cross has toppled over, indicating the hopelessness of the situation. Of the figures grouped around the cross, only the mother and child at the lower right escape – the refugees on the left fall out of the boat and drown.

Once Chagall was himself on the run from the Germans in early 1941, he began to use references to Christ as a means of commenting on his own plight. *The Way to Calvary* sketches of 1941, for example, express his fear of deportation: Christ is helped on his way by his fellow Jews, several of whom have already been crucified in the burning village seen in the background of the composition. A soldier raises his whip, in a gesture suggesting that of a Nazi guard. In contrast, *Yellow Christ*, probably of the same year, depicts Christ in a prayer shawl-cum-loincloth, smiling comfortingly at the refugees who leave the burning village and make their way to the immigrant ship. As we will see, once Chagall reached America, his personal identification with a Jewish Jesus was to become even more explicit.

Needless to say, Chagall's image of Jesus as Jewish martyr, human rather than divine, and his use of the Crucifixion motif to confront, and accuse, Christianity has aroused considerable controversy, not to say hostility among Jews and non-Jews alike. Yet a Christian artist, the great Spaniard Francisco Goya, had alluded to the Crucifixion as a metaphor for modern suffering as early as 1814 in his *Third of May 1808*, commemorating the execution of patriots in Madrid by Napoleon's troops (162). Another, earlier twentieth-century example is George Grosz's 1928 drawing *Christ with Gasmask* (163). Since the eighteenth century, many theologians, both Christian and Jewish, had sought to return Christ to his Jewish origins. Mark Antokolsky's sculpture *Ecce Homo* of 1873 (see 7) needs to be seen in this context. In 1937, with the rise of Fascism, a Jesuit could write the following: 'Like Jesus, the Jews have not ceased to mount

162
Francisco Goya, *Third of May 1808*, 1814. Oil on canvas; 266×345cm, 104³⁄₄×135³⁄₄ in. Museo del Prado, Madrid

163
George Grosz, *Christ with Gasmask*, 1928. Pencil on paper; 44×55cm, 17³⁄₈×21⁵⁄₈ in. Akademie der Kunst, Berlin

Golgotha; like him, they are always nailed to the cross.' After the war, the analogy between the martyrdom of Christ and that of the Jews became almost a commonplace: indeed, when Dachau was liberated, the road through the camp was renamed 'The Way of the Cross'; while Pope John Paul II could refer to Auschwitz as 'the modern Golgotha'. This identification was given further credibility by the terrible photographs that emerged of concentration camp victims, many of them frozen in poses reminiscent of the crucified Christ (164).

164
Concentration camp victim, Bergen-Belsen, 1945

165
Graham Sutherland, *Crucifixion*, 1946. Oil on hardboard; 244 × 228·6 cm, 96 × 90 in. St Matthew's Church, Northampton

Perhaps not surprisingly, therefore, both before, during and after the Holocaust, substantial numbers of artists chose to depict Jesus as the first Jewish martyr, and the Jews of Europe as his modern-day representatives. Jewish artists such as Mané-Katz and, more recently, R B Kitaj (b.1932) in his *Passion 1940–45* series of 1985, employ Christian imagery as a means of commenting on the Holocaust; while non-Jews such as Graham Sutherland (1903–80), in his Crucifixion images of the late 1940s (165), tend to refer to the horror of the Holocaust as a way of injecting a new and appallingly contemporary meaning into the story of Christ's suffering.

While more politically active artists and writers, among them Picasso, Léger, Éluard, Louis Aragon, Claire and Ivan Goll – many of them Chagall's friends – declared their allegiances by supporting the Soviet Union and in many cases joining the French Communist Party, Chagall in the 1930s took no stand in public, preferring to express his anxiety about the state of European politics through his art alone. (Exceptionally, in 1939 he contributed a linocut to a publication called *Pour la Tchécoslovaquie*, in protest against the German appropriation of the

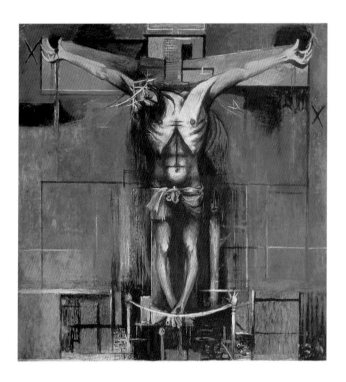

Sudetenland the year before.) This can be felt in the increasingly ominous mood of many of his images, and his Crucifixion images in particular. Even such works as *Time is a River without Banks* (166), begun in 1930 and reworked in 1939, which contain no obvious references to the contemporary political situation, strike a distinct note of foreboding.

The Chagalls were on holiday in the Loire district when news came of the Nazi–Soviet non-aggression pact in August 1939, swiftly followed by the outbreak of World War II. They remained in the area during the period of the so-called 'Phoney War', the lull between the declaration

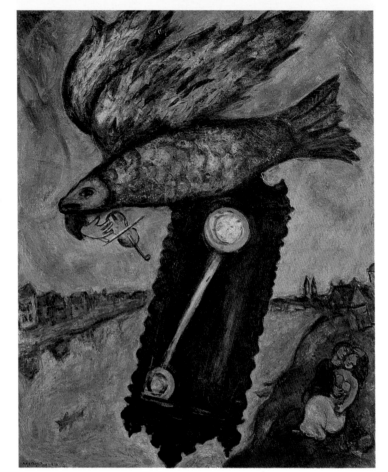

166
*Time is a River
without Banks,*
1930–9.
Oil on canvas;
100 × 81·3 cm,
39⅜ × 32 in.
Museum of
Modern Art,
New York

of hostilities and the spread of war to western Europe. In early 1940,
just before the German invasion and occupation of northern France,
which led to the establishment of the Vichy government in the south
in July, the Chagalls retreated to the remote and unspoilt Provençal
village of Gordes, where they were to live for a year. So impervious did
Chagall seem to the dangers of remaining in France, that he bought the
house in Gordes that the family had hitherto been renting on the very
day in May that the Germans invaded Holland and Belgium. Having
earlier removed most of his canvases from his Paris studio to a friend's
house in the Loire Valley, he now moved them again, to Gordes.
Delighted by the Provençal spring, Chagall busied himself painting
landscapes and still lifes.

In late 1940 a big American car swept into the little village, carrying Varian Fry, head of the US Emergency Rescue Committee, and Hiram Bingham, American vice-consul in Marseille, who brought with them an invitation to the Chagalls to come to the United States. Under the auspices of the Museum of Modern Art in New York, similar invitations were being offered to Matisse, Picasso, Rouault, Raoul Dufy (1877–1953), Kandinsky, Ernst, Jean Arp (1887–1966), Jacques Lipchitz (1891–1973) and André Masson (1896–1987). The Committee had been set up in mid-1940, in response to the Franco-German armistice, Article 19 of which stipulated the 'surrender on demand' to the Nazis of German refugees now resident in France. In the first instance, its brief was to rescue about two hundred eminent artists and intellectuals from the clutches of the Nazis, by providing them with emergency visitors' visas to America. In the end, Varian Fry, a young editor with connections to leftist political organizations, was personally responsible for the safe conduct of over two thousand refugees.

Chagall, however, was curiously unimpressed. After all, had he not recently been granted French citizenship; and was he not too famous for the Germans to lay hands on him? In any case, he failed to see what America could offer him. If many of his friends and acquaintances, the Golls, Léger, the Maritains, Éluard, Breton and Ernst among them, had already left for the States, others had chosen to remain in France – above all those two great rivals of his, Picasso and Matisse. Chagall's political *naïveté* and his obtuseness on this matter is hard to credit. The overwhelming danger presented by the mere fact of his Jewishness seems hardly to have registered at this juncture.

Only when France, under German pressure, adopted the anti-Semitic legislation which stripped all Jews of their French citizenship, did Chagall come to his senses. In April 1941 he moved with Bella and Ida to Marseille in preparation for departure. Even here, while applying for an exit visa, Chagall – remembering, no doubt, earlier uprootings and the difficulties they had encountered on returning to France in 1923 – insisted that their papers be in order for re-entry into France in the future. However, after he and Bella had been arrested during a raid at the Hôtel Moderne in Marseille and released only on the intervention

of Fry and Bingham, and the presentation to the police of his American Carnegie Prize Diploma (awarded in 1939), Chagall needed no further proof of the advisability of leaving his adoptive country.

It was indeed a wise move. Not only would the Chagall family have been at grave physical risk in Vichy France, but the cultural climate in that country was fast turning against them. In January 1940 it was still possible for the Galerie Mai in Paris (founded in 1939 by Yvonne Zervos) to hold a one-man exhibition of Chagall's work including his *White Crucifixion* (see 161), envisaged as the first of a whole series of shows intended to provide a home for modernist art in difficult times; by the end of that year, the gallery had been shut down. In 1942, Ralph Soupault, the anti-Semitic, pro-Nazi French art critic, colleague of the better-known and even more vocal Lucien Rebatet (who referred, for example, to 'purplish colours reminiscent of Jewish putrescence'), expressed the following opinion, chillingly similar to the ideas that held sway in the Third Reich: 'From a purely artistic point of view, Chagall's art is totally indefensible. We don't want to have anything to do with these Jewish morbidities, these women who walk upside down, these palavers of rabbis.'

On 7 May 1941, therefore, the Chagalls crossed into Spain, which, although Fascist under General Franco, victor in the 1936–9 Civil War, was officially neutral. Bella, in the tragic mood that seemed increasingly to beset her, spoke of her conviction that she would never see France again. In one of the last letters she wrote before they left, she declared that she 'felt sentenced to death'. Ida and her husband had miraculously managed to have most of Chagall's artistic output of recent years packed and shipped to Spain, awaiting transportation to Lisbon (Portugal was also officially a neutral country), and thence to America. An attempt by the German Embassy in Madrid to get the crates and packing cases impounded by customs was thwarted only by the intervention of a curator from the Prado museum. As soon as arrangements had been made for their luggage to be sent on after them, the Chagalls left Madrid for Lisbon. Arriving there on 11 May, they at last set sail for New York.

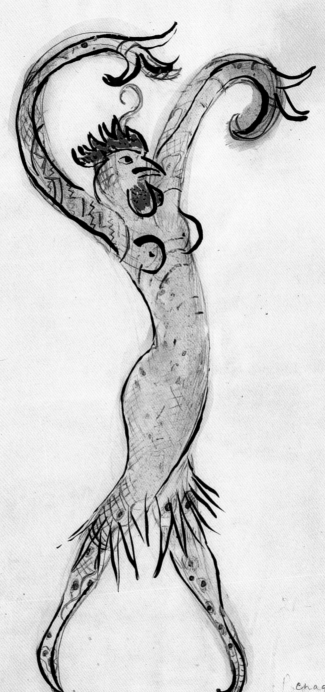

167
A Rooster,
costume design
for *Aleko*, 1942.
Gouache,
watercolour,
ink and pencil;
40·6×26·4 cm,
16×10⅜ in.
Museum of
Modern Art,
New York

Waiting on the pier to greet the Chagalls on their arrival in America was
Pierre Matisse, son of the artist, and now, as owner of the prestigious
Pierre Matisse Gallery, one of New York's leading art dealers. Having
already in the past acted as Chagall's American dealer, he would contin-
ue to represent the artist (albeit not continuously) for many years to
come, giving him the first exhibition of his years of exile as early as
November 1941. Since, in contrast to earlier uprootings, Chagall had
been able to bring the bulk of his interwar *oeuvre* with him, this exhibi-
tion took the form of a substantial retrospective. Numerous others
would follow, in 1942, 1944, 1945, 1946, 1947 and 1948 (the last after the
artist had already returned to France). Chagall supplied the dealer with a
certain number of paintings per year, and in return received a comfort-
able monthly allowance; yet, as he himself once put it, 'I shall never
have enough money, I shall never feel secure.' With Matisse's help, the
Chagalls were installed at the St Moritz hotel, on the corner of Sixth
Avenue and 59th Street; they later moved to the Plaza hotel on West
57th Street, near Central Park as well as many of the most important art
galleries. After spending several weeks in Connecticut to escape the sum-
mer heat, they returned to Manhattan in September and established
themselves in a small apartment on East 74th Street, which, draped with
hangings and adorned with Chagall's pictures, helped create the illusion
of being back in Paris.

After the trauma of yet another uprooting, another shock had awaited
Chagall: it transpired that their luggage, which included his precious
paintings, was still in Spain, the official excuse being that their belong-
ings had to be personally identified before being shipped off, and that
the agent to whom they had entrusted these matters was therefore
unable to help. An unwieldy bureaucracy and the confusion of war, com-
plicated perhaps by the earlier attempts of the Germans to seize
Chagall's paintings, thus continued to wreak havoc in the artist's life.
Fortunately, however, Ida was still in Gordes; and with her husband

Michael Gorday sprang to the rescue, pulling all the necessary strings. In due course, the young couple accompanied the crates across the Atlantic, and joined Bella and Marc in New York.

By a stroke of irony, the Chagalls had landed in New York on 23 June 1941, the day after the Germans invaded Russia. Although the entry of Russia into the war on the Allied side had removed one source of stress for him, Chagall's anxieties about the war in Europe would thereafter focus far more closely on the Eastern Front than on events in France. Indeed, his American exile would serve to accentuate his Russian–Jewish allegiances; conversely, his adopted 'Frenchness' would recede – temporarily at least – into the background. France's swift capitulation to the Nazis; the emergence of previously only latent French anti-Semitism; the very existence of the Vichy government in southern France, which, under the elderly Marshal Pétain, was virtually controlled by the Nazis – all these made Chagall considerably less sure about his beloved France than he had been before the outbreak of war. And all the while, Vitebsk and thousands of other centres of Jewish population were in the brutal hands of the Nazis whose avowed purpose was to make the world 'Judenrein' – free of Jews. With the Nazi conquest of Vitebsk in July 1941, part of its Jewish population fled into the interior of Russia; while the retreating Red Army set fire to the city. The 16,000 Jews who remained were imprisoned in a ghetto, and on 8 October 1941 their systematic liquidation began. Even though it was only after the war that the full horrors became public knowledge, relief at having escaped the dangers of war-torn Europe must, for Chagall as for many of the other *émigré* artists, particularly the Jewish ones, have been inextricably mingled with feelings of guilt.

Unsurprisingly, therefore, Chagall returned again and again in the work of his American period to the theme of the Jewish Jesus, the Crucified Jew. In *The Descent from the Cross* of 1941, the INRI inscription is replaced by the artist's name, Marc Ch. Saved from the still-smouldering *shtetl* in the background, Jesus–Chagall is taken down from the cross, the instrument of his suffering, and handed his palette and brushes by an angel summoning him to return to work. This identification of Christ on the cross not only with the suffering Jews of Europe but (more

168
Yellow Crucifixion, 1943.
Oil on canvas, 140 × 101 cm, 55 1⁄8 × 39 3⁄4 in.
Musée National d'Art Moderne, Centre Georges Pompidou, Paris

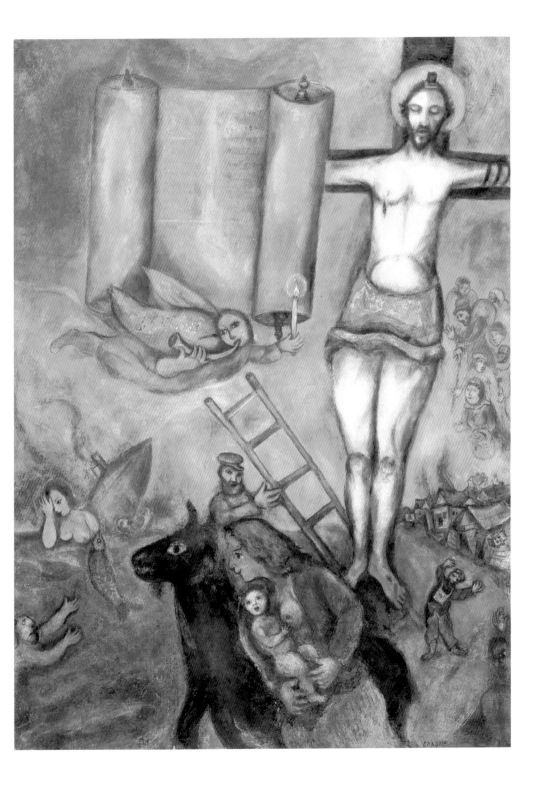

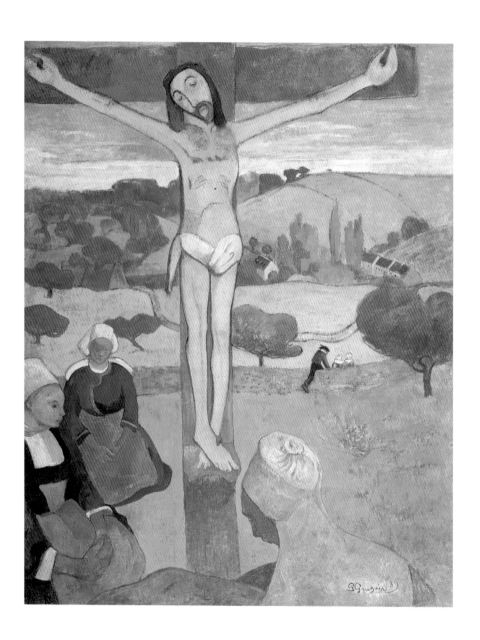

selfishly) with his own suffering, also finds expression in Chagall's poetry of these years:

Day and night I carry a cross
I am shoved, dragged by the hand
Already night surrounds me. And you
Abandon me, O God. Why?

Indeed, it was under the dark shadow of war that Chagall's much earlier interest in writing poetry resurfaced. Forced to leave France, his adoptive homeland, the artist chose Yiddish, and very occasionally Russian, as the language in which to express both his domestic grief and his pain at the course of world events. The witty lightness of touch still characteristic of some, at least, of his visual output, is conspicuously absent. For the most part, the poems are linguistically straightforward – showing little obvious sign of being influenced by the literary circles in which he moved – and imbued with an intense melancholy, an elegaic quality that sometimes runs the risk of being maudlin, but is redeemed by the fact that the sentiments expressed come straight from the heart. Through all of them runs a profound sense of loss, and of personal uncertainty and humility. In his poetry, Chagall reveals an intimate and private aspect of himself that his public persona had taught him to mask. Written primarily in the 1940s and 1950s, these poems were not originally intended for publication, and most of them first appeared in 1967 in *Di Goldene Keyt* ('The Golden Chain'), the Yiddish cultural journal edited in Israel by Chagall's old friend, the poet Abraham Sutzkever, who also gave some of them their present titles.

Chagall's personal identification with the suffering Christ persists in much of his visual imagery, but during the war he uses the figure of Jesus primarily as a symbol of Jewish martyrdom. Again, his poetry of the period confirms this preoccupation: 'A Jew passes with the face of Christ/He cries: Calamity is upon us/Let us run and hide in the ditches.' Thus, in *Yellow Crucifixion* (168) of 1943, whose title may well be an ironic homage to the more tranquil and religiously conventional *Yellow Christ* painted by Gauguin in 1889 (169), Jesus wears phylacteries and an open Torah scroll covers his right arm. *Obsession* of 1943 (170) embodies the artist's despairing mood at the darkest point of the war;

169
Paul Gauguin,
Yellow Christ,
1889.
Oil on canvas;
92×73cm,
36¼×28¾in.
Albright-Knox
Art Gallery,
Buffalo, New
York

170
Obsession,
1943.
Oil on canvas;
76 × 107·5 cm,
30 × 42³⁄₈ in.
Musée National
d'Art Moderne,
Centre Georges
Pompidou,
Paris

while *The Crucified* (171) of 1944 can be seen as expressing his reaction not only to the news of the liquidation of the ghettos of eastern Europe, but more specifically to the destruction of Vitebsk. Here it is the Jews of his native town, wearing smudged 'Ich bin Jude' signs, who are crucified among the corpses in the snowbound *shtetl*; and Christ himself is depicted in the garb of an eastern European Jew.

Although Chagall would continue to be preoccupied with the controversial notion of a Jewish Jesus, his postwar images of Christ are, perhaps not surprisingly, far more generalized, with few or none of the references to specific historical events that characterize his wartime Crucifixions. More telling, one might argue, than these later Crucifixions is the powerful canvas of 1947 entitled *Flayed Ox* (172), with its references to the paintings of a carcass of beef by Rembrandt and Soutine and the analogy (present in both earlier works, but here given shockingly contemporary relevance) drawn between the dead animal and a tortured human form. As the figure of Christ became a staple motif

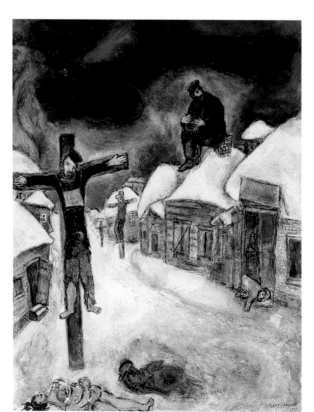

171
The Crucified,
1944.
Gouache on
paper;
62·2 × 47·3 cm,
24¹⁄₂ × 18⁵⁄₈ in.
Israel Museum,
Jerusalem

172
Flayed Ox,
1947.
Oil on canvas;
100 × 81 cm,
39³⁄₈ × 31⁷⁄₈ in.
Musée National
d'Art Moderne,
Centre Georges
Pompidou,
Paris

in Chagall's biblical images of the 1950s and beyond, the Holocaust references are often edited out. It thus becomes easier to view him either as one in the line of major Jewish prophets and a great poet (a view to which the artist himself adhered) or in more conventional Christian terms.

In the seven years that Chagall remained in America, he never attempted to master the English language, justifying his lack of interest by joking that it had taken him 'thirty years to learn bad French, why should I try to learn English?' He conversed with his family almost entirely in Russian, while nearly all his close friends in New York spoke either Russian, Yiddish or French. Chagall certainly enjoyed exploring Manhattan on foot; but found it an essentially alien and even hostile environment. New York was already a city of skyscrapers, an architectural form utterly foreign to Chagall. It was also, of course, a city of immigrants, home since the late nineteenth century to sizable Chinese and Italian communities, and during World War II, beginning to attract a

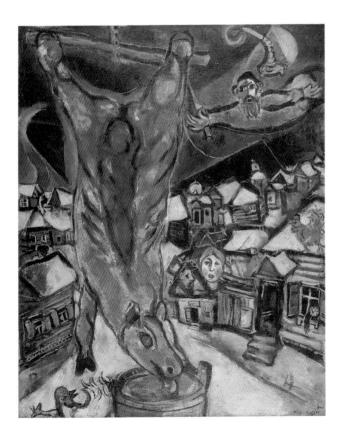

substantial Black population. The only area of the city for which he felt a natural empathy was the predominantly Jewish Lower East Side, still home to large numbers of working-class, Yiddish-speaking Jews who had sought refuge in America from the pogroms that afflicted Russia and eastern Europe in the late nineteenth and early twentieth centuries. For all his new reservations about the integrity of the French, Chagall knew that a return to Russia was utterly out of the question, that sooner or later his American exile would end, and that he would return to his adopted homeland.

In March 1942 an exhibition entitled *Artists in Exile* was held at the Pierre Matisse Gallery on East 57th Street. Printed in the catalogue for the show was a group photograph (173) featuring an impressive line-up of artists who had fled from Nazi Europe. Yet any impression of unity or community conveyed by this photograph is misleading. The Surrealists among them may have stuck together, but Chagall kept firmly to himself. His inclusion in the deliberately provocative exhibition organized in 1942 by Marcel Duchamp (1887–1968), Breton and the dealer Sidney Janis under the title *First Papers of Surrealism* does, however, suggest a greater willingness to be identified with the movement than he would later acknowledge.

He would, it is true, sometimes participate in the gathering of exiles that took place at the studio of Amédée Ozenfant (1886–1966); he might even occasionally be seen at the studio of Moïse Kisling, whose work and personality he had so much despised in Paris, and who was now throwing much the same wild parties, attended by many of the same Montparnasse crowd, as before the war. But on the whole, the Chagalls led essentially private lives, consorting with a relatively small number of close friends, many of them fellow *émigrés* who came from similar cultural backgrounds. Virtually the only time that Chagall adopted a public role was when he agreed to become Honorary President of the left-wing Jewish Writers and Artists' Committee; while, for her part, Bella, always a more reserved and retiring personality than her husband, was adjusting to their change of habitat with considerable difficulty.

In 1943 when the poet Itzik Feffer (whom Chagall had known during his teaching days at Malakhovka) and the actor Mikhoels of the State

173
Participants in the *Artists in Exile* exhibition, Pierre Matisse Gallery, New York, March 1942. Front row l to r: Roberto Matta, Ossip Zadkine, Yves Tanguy, Max Ernst, Marc Chagall, Fernand Léger; back row l to r: André Breton, Piet Mondrian, André Masson, Amédée Ozenfant, Jacques Lipchitz, Pavel Tchelitchev, Kurt Seligmann, Eugene Berman

Yiddish Theatre visited New York on an official Soviet cultural mission, Chagall was able to renew two old friendships. When they left, Chagall sent with them two paintings to be donated to Soviet museums, accompanied by an exaggerated but touching message that reveals the depth of his feelings for Russia in spite of everything: 'To my fatherland, to which I owe all I have done in the last thirty-five years and shall do in the future.' The paintings, it seems, were promptly relegated to the vaults of the Tretyakov Gallery in Moscow, while not long afterwards both Feffer and Mikhoels were murdered by Stalin.

As ever, Chagall preferred the less threatening company of writers to that of visual artists. Notable among his friends at this period were the eccentric poets Claire and Ivan Goll, and Raissa and Jacques Maritain, whom they had known in Paris before the war. New friends included the Italian–Jewish art critic Lionello Venturi, who in 1956 would write a perceptive study of the artist; the American–Jewish art historian of Lithuanian origin, Meyer Schapiro; and the Yiddish novelist and short story writer Joseph Opatashu. The sculptor Chaim Gross (1904–91), also of eastern European Jewish stock, was one of Chagall's few artist

friends. Yet his retrospective comment that Chagall's 'interest was entirely ego-focussed' reveals the implicit sense of rivalry that goes a long way to explain Chagall's own preference for the company of artists working in non-visual media. Another exception to the rule was the Chagalls' close friendship with the American sculptor Alexander Calder (1898–1976), whose ebullient directness and humour seemed to them quintessentially American. In fact, Calder had spent many years in France, which undoubtedly helped endear him to the newcomers.

It was Schapiro who, lamenting the lack of imagination shown in contemporary synagogue design, suggested to a rabbi from the Jewish Theological Seminary in New York that the architect Percival Goodman be commissioned to design a synagogue, for which Chagall and Lipchitz should also be commissioned to produce 'emblematic stained glass, tapestries and sculpture'. In the event, the plan came to nothing, and Chagall's experiments in these media would have to wait until the postwar period. As Schapiro later explained,

Lipchitz just hated Chagall. I don't know why. It was just another typical example of the competitiveness of artists. They just didn't get along at all. And then while these discussions were still going on, there came the news of the Holocaust and the demands for relief were so great that the project was dropped.

After the war and Chagall's return to Europe, other enlightened American rabbis sought to enlist the help of artists in designing synagogues. By this time, however, the astronomical prices charged for Chagall's work put it virtually out of reach; while his apparent preference for creating art for the Christian Church inevitably rendered him suspect in many quarters.

Although Chagall had been given his first New York exhibition as far back as 1926, at the Reinhart Gallery, and although his status in France was now established beyond doubt, his critical reputation in America at the time of his arrival there was by no means high. The explicit Jewishness of much of his subject matter found a ready enough market among American Jewry; but for artists of the American avant-garde, who were throwing off the shackles (as they were perceived) of European

traditionalism, Chagall's art was far too narrative in its implications, too folksy and quaint to meet with favour. Surrealism, it is true, had much to teach those heroes of the future, emerging Abstract Expressionists such as Mark Rothko (1903–70), Jackson Pollock (1912–56), Adolph Gottlieb (1903–74), Franz Kline (1910–62) and Barnett Newman (1905–70); and the presence in New York of such artists as Ernst, Masson and Roberto Matta (b.1911) was undoubtedly crucial. What the American artists learned from Surrealism, in particular its translation of 'psychic automatism' into the gestural freedom of 'plastic automatism', had little to do, however, with Chagall and the Surrealist elements in his work.

Interestingly, a disproportionate number of these American artists were themselves Jews whose families originally came from eastern Europe. Some commentators have claimed, quite plausibly, that their Jewishness, and their awareness of the taboo on graven images in particular, played a significant role in the development of their mystically inclined abstract art (174). If so, this is Jewishness expressed in a radically different way to Chagall. This fact may have combined with his commercial success, his low critical status in America and apparent stand-offishness to cause other artists to dislike him, or at any rate to regard him with a mixture of suspicion and jealousy.

In fairness to the Surrealists, they did make friendly overtures to Chagall during their American exile, trying again, without success, to persuade him to join their ranks. In 1945, moreover, while re-editing his manifesto *Surrealism and Painting*, Breton granted Chagall complete absolution by adding the following text:

For a long time one serious failing at the roots of those movements – Dada, Surrealism – which were to achieve the fusion of poetry and visual arts consisted in underrating the importance of Chagall. Yet the poets themselves were deeply indebted to him – Apollinaire for his 'Across Europe', possibly the freest poem of this century, and Cendrars for the 'Transiberian'; even Mayakovsky and Esenin echo him in their most convulsive moments … Today it is possible to situate Chagall's work more fairly. His complete lyrical explosion dates from 1911. It marked the triumphal appearance through his work and no other, of the metaphor in modern painting … No work was ever so resolutely magical.

Despite his ambivalent status in the New York art world, in 1942 Chagall received a commission from the American Ballet Theater to create costumes and sets for *Aleko*. This was the first time since 1920 that he had the chance to work for the stage, and his first opportunity ever to work for the ballet. (Although in 1932 he had created designs for *Beethoven Variations*, a ballet produced by Bronislava Nijinska, these were never executed.) The *Aleko* project, with its pronounced Russian accent, was a congenial one: the music was by Tchaikovsky, the choreography by Léonide Massine and the libretto, a tale of love, jealousy, betrayal and death, based on Pushkin's poem *The Gypsies*.

Since Chagall insisted on completing the sets for *Aleko* on-stage and American union laws expressly forbade him to do so, the entire troupe transferred to Mexico City. There, he painted the backdrops himself, while Bella supervised the making of the hand-painted costumes. Chagall seems to have been in his element, able for once to cast his anxieties about the war in Europe to one side. His designs are unusually dramatic, in terms of colour and composition alike, and may well have been influenced by Chagall's exposure both to Mexican folk art and the monumental mural tradition embodied by the work of artists such as José Clemente Orozco (1883–1949) and Diego Rivera (1886–1957), both of whom attended the ballet's much-praised première in Mexico City. In

174
Adolph
Gottlieb,
The Crest,
1959.
Oil on canvas;
275 × 203·8 cm,
108¼ × 80¼ in.
Whitney
Museum of
American Art,
New York

175
*The Fruit
Basket, Mexico*,
1942.
Gouache;
59·7 × 40·6 cm,
23½ × 16 in.
Baltimore
Museum of Art

addition, a few short excursions outside the capital inspired Chagall to produce a series of richly coloured gouaches (175).

Both the huge backdrops and the gouache studies for *Aleko* have survived. Particularly remarkable and reductive is the design for Scene 3 (176) with its two blood-red suns set in a yellow sky with a wheatfield below, a scythe projecting above it, an upside-down tree and a blue man in a blue boat. As the artist put it: 'I wanted to penetrate into ... *Aleko* without illustrating [it], without copying anything. I want the colour to play and speak alone.' Indeed, the broad expanses of pure colour are the

176
A Wheatfield on a Summer's Afternoon, set design for Scene 3 of *Aleko*, 1942. Gouache, watercolour, wash, brush and pencil; 38·5 × 57 cm, 15 $\frac{1}{8}$ × 22 $\frac{1}{2}$ in. Museum of Modern Art, New York

most striking feature of these designs: a response, perhaps, to the huge
open horizons of the American plains that Chagall encountered on his
overland journey from New York to Mexico; but also – ironically – a
surprising anticipation of the abstract colour field painting of Jewish-
American artists such as Rothko, Gottlieb (174) and Newman.

As with all his theatre projects, Chagall's designs tended to steal the
limelight. On this occasion, no doubt to his delight, Chagall had been
consulted about every aspect of the production, including costume
design (see 167 and 177), so it is hardly surprising that his artistic vision
dominated. When the production had its New York première at the
Metropolitan Opera House in October 1942, one dance critic wrote:

It is Chagall who emerges as the hero of the evening … The backdrops …
are not actually good stage settings at all, but are wonderful works of art …
So exciting are they in their own right that more than once one wishes that
all these people would quit getting in front of them.

Chagall's involvement with this production of *Aleko* and his concomitant
discovery of Mexican folk art led to a renewed interest in colour in his
work of this time, as evidenced by canvases such as *Listening to the
Cock* (178) of 1944. Other images of the period – for example *In the
Night* (179) of 1943, a poetic but melancholy reworking of *The Wedding*
of 1918 (see 72), or the luminous yet sombre *Madonna of the Village*
(180), begun in France in 1938 but completed in 1942 – are more brood-
ingly introspective.

178
*Listening to the
Cock*,
1944.
Oil on canvas;
92·5 × 74·5 cm,
36³⁄₈ × 29³⁄₈ in.
Private
collection

179 Left
In the Night,
1943.
Oil on canvas;
47 × 52·5 cm,
18¹₂ × 20³₄ in.
Philadelphia
Museum of Art

180 Above
*Madonna of the
Village*,
1938–42.
Oil on canvas;
102 × 98 cm,
40¹₈ × 38⁵₈ in.
Fundación
Coleccion
Thyssen-
Bornemisza,
Madrid

Paris was liberated at last on 25 August 1944, and Marc and Bella at once made plans to return to France. And then, in early September, tragedy struck. Accounts of the precise sequence of events vary. Virginia Haggard McNeil, however, recalls Chagall's own description of what happened:

'We were having a holiday in the Adirondacks, and she [Bella] suddenly got a bad sore throat. She kept calling me to give her boiling hot tea. The next day she was so feverish that I took her to the hospital, and when she saw a lot of nuns in the corridor she became upset. I must explain that in another place where we had been staying, in Beaver Lake, she had seen a sign saying that only white Christians were welcome, and she had been brooding on that. Strangely enough, just before falling ill, she finished writing her memoirs and said, "Look, here are all my notebooks. I've put everything in order, that way you'll know how to find them." Well, when she got to the hospital, they naturally asked her for particulars – name, age – but when they asked "religion" she wouldn't answer. She said "I don't like it here, take me back to the hotel." So I took her back, and the next day it was too late.' Marc heaved a deep sigh. 'But there was no penicillin. No penicillin,' he repeated to himself, as if to try and quell his tortured sense of responsibility.

Penicillin was reserved for military use in 1944; when Ida finally obtained an exemption from Washington, the viral infection had run out of control and Bella was past saving.

For virtually the only time in his whole life, this devastating personal tragedy temporarily robbed Chagall of his will to create. Ida persuaded him to join her and her husband in their spacious apartment on Manhattan's Riverside Drive, and with her help he concentrated exclusively on editing and illustrating Bella's memoirs *Burning Lights*. She had written the text in Yiddish between 1939 and 1944, almost as though she had foreseen her untimely end, although their 1935 visit to Poland had already wakened in her a wish to preserve the past. In the preface she had written in France in 1939, she stated: 'I have had a desire to write, and what is more, in my stammering maternal tongue, which I have almost never had occasion to speak ever since I left the house of my mama and papa.' According to Marc, her very last words were 'My notebooks …'. These memoirs are more straightforward than Chagall's own autobiography, but not untinged with poetry. Bella's lifelong love of lit-

erature had certainly rubbed off on her husband; equally, one senses that these memoirs are coloured almost as much by the world of her husband's imagination as by her own memories. To his old friend Sutzkever, Chagall wrote: 'She was the muse ... of Jewish art ... Were it not for her my paintings would not have been as they were. Read her heroic words. Simple and realistic like pearls, the pearls in her father's shop.' In keeping with his mood at this time, Chagall's illustrations to his wife's memoirs (181) are unusually spare and understated – and all the more poignant because of it.

Until the publication of Sidney Alexander's biography of Chagall in 1978, it was supposed that Chagall grieved alone, uncomforted by female company, until the appearance of his second wife Valentina Brodsky (Vava) in the early 1950s. In fact, his liaison with Virginia Haggard McNeil began as early as 1945, soon after Chagall's ever-efficient daughter Ida arranged for Virginia to keep house for Chagall; and in May 1946 Virginia bore him a son, named David after his younger brother (182). The unseemliness of the situation evidently caused Chagall considerable embarrassment, and at first he tried hard to keep their relationship a secret. The daughter of a British diplomat (himself the nephew of the English novelist Sir Henry Rider Haggard), with a highly cosmopolitan upbringing, Virginia had studied art in Paris and was thus both fluent in French and conversant with the world of art.

Meeting Chagall encouraged the thirty-year-old Virginia (twenty-eight years his junior, and thus the same age as Ida) to break free from her unhappy and deeply repressive marriage to another painter, John McNeil, with whom she had a five-year-old daughter, Jean. Although they were to live together for seven years, mostly in a simple wooden house reminiscent of a Russian *isba* at High Falls in the Catskill Mountains north of New York, they never married. So tight was the control that Vava exerted on her husband's reputation that David McNeil (as he was officially called), like his mother, was for many years simply omitted from official accounts of the artist's life.

A poem entitled 'The Painting' expresses in words something of the deep tensions and conflicting emotions experienced by the artist at this juncture of his life:

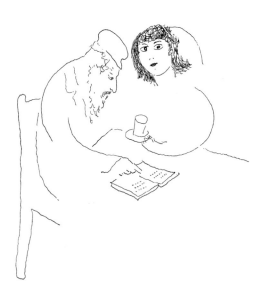

If only my sun had shone at night.
I sleep – steeped in colours,
In a bed of paintings,
Your foot in my mouth
Presses me, tortures me.

I wake up in pain
Of a new day, with hope
Not yet painted,
Not yet daubed with paint.

I run up
To my dry brushes,
And I'm crucified like Jesus,
With nails pounded in the easel.

Am I finished?
Is my picture done?
Everything shines, flows, runs.

Stop, one more daub,
Over there – black paint,
Here – red, blue, spread out,
Calmed me.

Can you hear me – my dead bed,
My dry grass,
My departed love,
My new come love,
Listen to me.

I move over your soul,
Over your belly –
I drink the calm of your years.

I swallowed your moon
The dream of your innocence,
To become your angel,
To watch you as before.

181
Illustration for
Bella Chagall's
Burning Lights,
1946

182
Chagall with
Virginia and
David McNeil,
1951

183
The Flying Sleigh,
1945.
Oil on canvas;
130 × 70 cm,
51¹⁄₄ × 27¹⁄₂ in.
Fukuoka Art
Museum, Japan

184
Bouquet with Flying Lovers,
c.1934–47.
Oil on canvas;
130·5 × 97·5 cm,
51³⁄₈ × 38³⁄₈ in.
Tate Gallery,
London

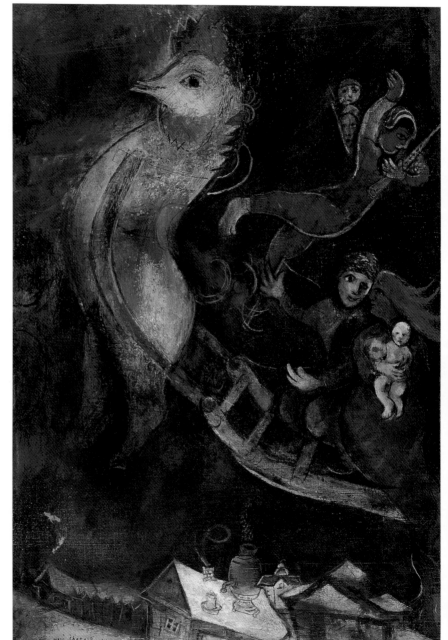

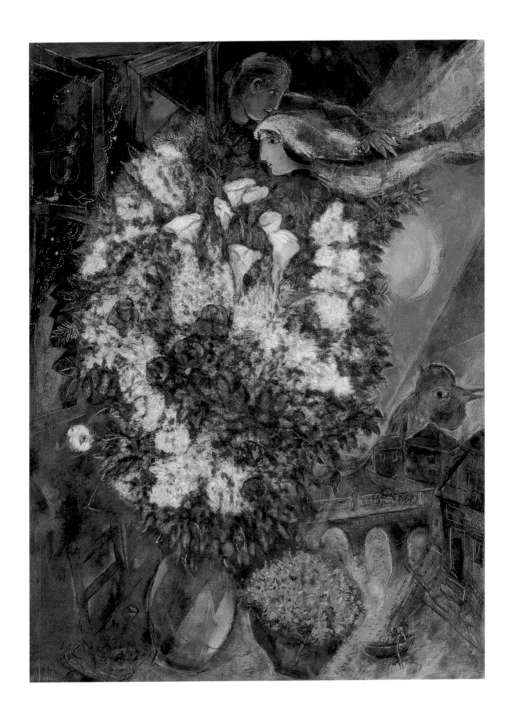

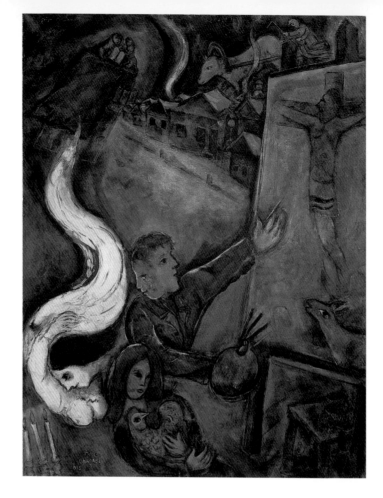

185
*The Soul
of the Town*,
1945.
Oil on canvas;
107 × 81·5 cm,
42¹₂ × 32¹₈ in.
Musée National
d'Art Moderne,
Centre Georges
Pompidou,
Paris

186
Around Her,
1945.
Oil on canvas;
130·9 × 109·7 cm,
51⁵₈ × 43¹₄ in.
Musée National
d'Art Moderne,
Centre Georges
Pompidou,
Paris

Chagall's relationship with Virginia goes a long way to explain the joyous
and almost disconcertingly life-affirming element that exists in much of
the work he produced shortly after Bella's death. *Cow with Parasol* of
1946, for example, possesses much of the earthy humour and *joie de
vivre* so characteristic of his very early work; while the couple and young
child in *The Flying Sleigh* (183) of 1945 triumphantly defy the forces of
gravity. In other canvases, such as *Bouquet with Flying Lovers* (184),
begun around 1934 and completed in 1947, nostalgia and hope coexist in
a single image, and give rise to a disturbing tension. In yet other works
of this period, notably the sombre *Soul of the Town* (185) of 1945,
Around Her (186) of the same year and the monumental, apocalyptic
and several times reworked *Falling Angel* (187) of 1923–47, the mood is
more unequivocally tragic.

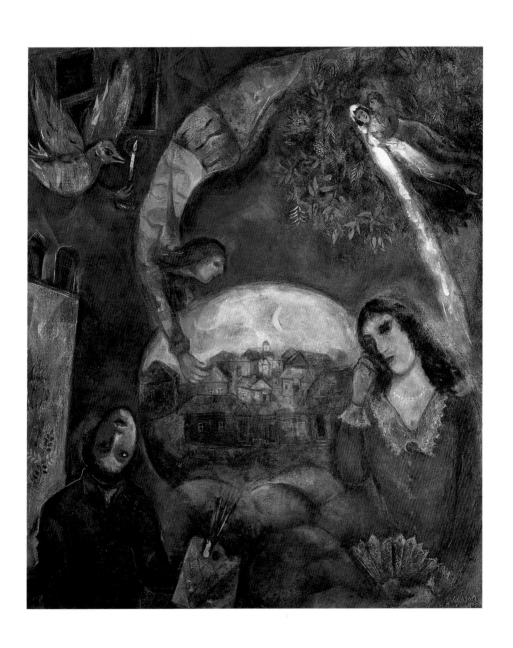

187
The Falling Angel,
1923–47.
Oil on canvas;
148 × 265 cm,
58¼ × 104⅜ in.
Öffentliche Kunst-
sammlung,
Kunstmuseum,
Basle

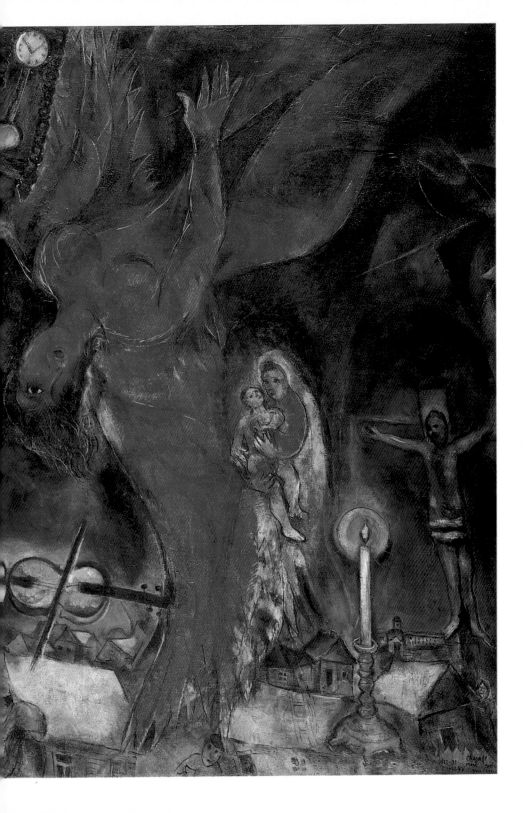

In the summer of 1945, Chagall was diverted from his (already equivocal) grief by another commission from the American Ballet Theater, this time to create sets and costumes for Stravinsky's *The Firebird* (188, 189). Virginia would later recall how

he listened to the music all day long in the big bedroom upstairs where he worked and at once he began to float in the Stravinsky element, completely tuned in to its mysterious archaic strength. He started sketching feverishly, jotting down vague ideas, sometimes in colour, sometimes in pencil. These were barely more than abstract shapes, movements, masses. They contained the living seed that would grow into birds, trees and monsters.

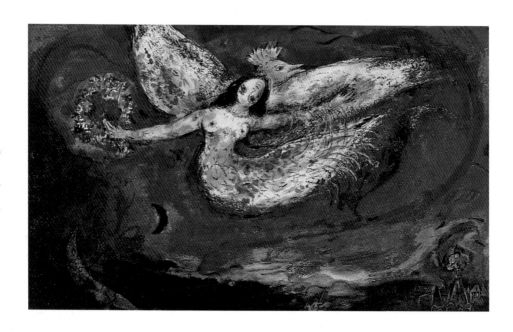

188
The Enchanted Forest,
set design
for Act I of
The Firebird,
1945.
Gouache
on paper;
38 × 63 cm,
15 × 24¾ in.
Private
collection

189
Chagall paint-
ing the set
for Act 1 of *The Firebird*, 1945

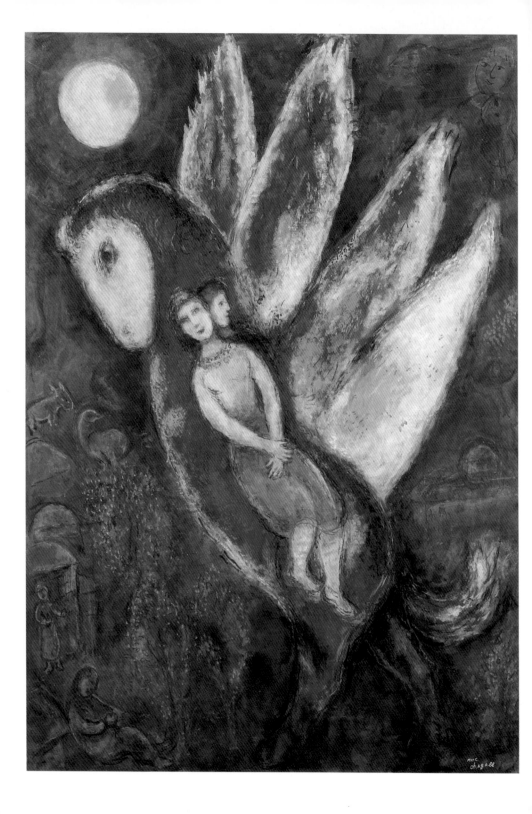

In the same year Chagall began work on his illustrations to *The Arabian Nights* (190, 191), his first foray into colour lithography, commissioned from him by the *émigré* publisher Kurt Wolff, a close friend of Claire Goll. Again, Virginia provides a rare and invaluable insight into his working methods: 'I read him the stories again and again. The sketches were spread all over the floor to dry. He was remarkably unconcerned by the puddles, blots and smudges that occurred and plodded away with concentrated determination.' The result was a series of richly coloured, sensuous and exotic images that on one level, like the gouaches for *The Firebird*, pay homage to his new lover.

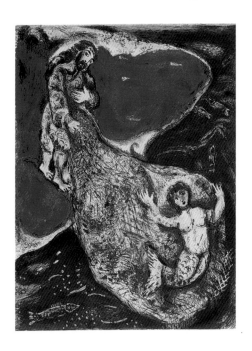

190
Julnar the Sea-Born and her son King Badr Basim of Persia, illustration for *The Arabian Nights*, 1948. Lithograph; 37 × 28 cm, 14 ⁵⁄₈ × 11 in

191
Abdullah the Fisherman and Abdullah the Merman, illustration for *The Arabian Nights*, 1948. Lithograph; 37 × 28 cm, 14 ⁵⁄₈ × 11 in

In April 1946 Chagall was given a major retrospective exhibition at the Museum of Modern Art in New York, which was also shown at the Art Institute of Chicago. Eighteen months later he was the first artist to be honoured with an exhibition (a reduced version of the one seen in the United States) at the newly reopened Musée National d'Art Moderne in Paris. These marked the beginning of a flood of prestigious and high-profile exhibitions all over the world, and the establishing of a truly international reputation for the artist. Chagall's daughter Ida had already returned to France, and was working hard on her father's behalf;

not surprisingly, she now urged him to follow her, so as to benefit from all the publicity being generated by the exhibition in Paris.

Chagall complied in May 1946 by paying his first visit to France since the war. As Virginia was to recall: 'he had chosen May purposely so as to be absent at the time of David's birth. Birth always had frightening associations for him and he was better out of the way.' As with the birth of Ida so many years earlier, the over-sensitive male artist clearly felt unable to cope. In one of his letters home, Marc wrote revealingly: 'France has changed a lot. I don't recognize it. America is more dynamic, but also more primitive. France is a picture already painted, America has still to be painted. But when I work in America it's like shouting in a forest, there's no echo.' 'In art', he went on, 'the same names are on everyone's tongue, Picasso and Matisse, Matisse and Picasso. Sometimes Rouault and Léger and Braque. I avoid Montparnasse.'

In spite of the fact that, by his own account, Chagall spent most of this visit lunching, dining and seeing 'endless people', he still found time to embark on a series of painted sketches, which in 1953 would evolve into the so-called 'Paris Series', comprising images such as *The Madonna of Notre Dame*, *The Banks of the Seine*, *Quai de Bercy*. On one level these are clearly a celebration of his postwar rediscovery of the city of Paris (not untinged with melancholy due to its association with Bella). Other images, such as *Red Roofs* (172), also contain references to Vitebsk. On another level, as evidenced by the predominance in the series of the mother and child motif, many of these paintings comprise a homage to Virginia and their new-born son. In *The Pont Neuf*, for example, a mother lies in the foreground holding her baby, while on either side of her hover Marc with his palette and Bella in her wedding gown.

In October 1947 he travelled to Paris again, for the opening of his exhibition at the Musée National d'Art Moderne. Chagall was both flattered, it seems, and dismayed. 'A retrospective exhibition', he stated with typically self-deprecating humour, 'gives me the painful feeling that people consider my work is finished. I want to cry out like a man condemned to death: "Let me live a little longer, I shall do better." I feel I have hardly begun, like a pianist who hasn't yet settled down comfortably on his stool.'

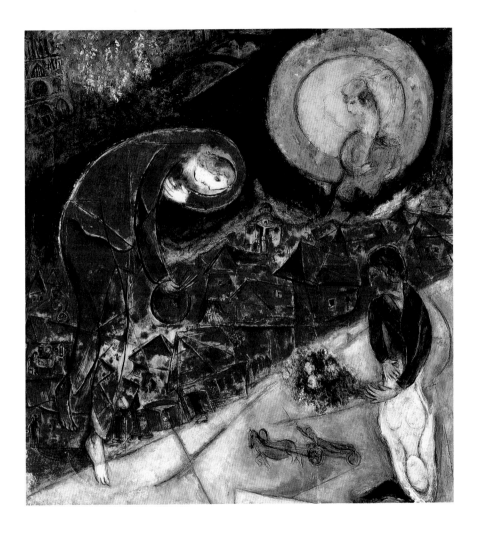

192
Red Roofs,
1953.
Oil on paper,
mounted on
canvas;
230 × 213 cm,
90¹₂ × 83⁷₈ in.
Musée National
d'Art Moderne,
Centre Georges
Pompidou, Paris

With certain misgivings, therefore, Chagall finally returned to France in August 1948. Not only did he, quite rightly, sense that he would never again enjoy the privacy, tranquillity and relative freedom of his life with Virginia at High Falls; but France's capitulation to the Nazis during the war had engendered in him a distinct bitterness towards that country. In the event, however, the lure of fame and fortune proved too strong, and he settled with Virginia in Orgeval, Seine-et-Oise, outside Paris. 'Yet', Virginia tells us, 'he nourished a hope of keeping his hide-out. We locked up the house, leaving large quantities of our belongings. But we never saw High Falls again. After a couple of years the house began to rot and our belongings with it and Ida had to go back and put the finis on this chapter.'

Although Marc and Virginia lived in Orgeval for nearly a year, their lives there – as both of them had anticipated – were interrupted by numerous trips necessitated by Chagall's new postwar status and the growing number of retrospective exhibitions accorded to him. In 1948 alone there were major exhibitions at the Tate Gallery in London and at the Stedelijk Museum in Amsterdam. Since, moreover, Orgeval was only about 30 km (20 miles) west of Paris, their home was constantly being invaded by a stream of distinguished visitors: writers such as their old associates Jean Paulhan and Pierre Reverdy; the dealer–publishers Louis Carré, Christian Zervos, Aimé Maeght and Tériade; and curator–critics such as Jean Lassaigne, Raymond Cogniat and Jean Cassou (all of whom would in due course write monographs on the artist). Amid all this hubbub Chagall still found time to rework old canvases and to paint several new works, among them *The Green Cock*, which features the eleventh-century church spire of the village of Orgeval.

193
Blue Landscape,
1949.
Gouache on
paper;
77×56cm,
30¼×22 in.
Heydt
Museum,
Wuppertal

Perhaps most influential in the short-term of all these visitors was the art critic turned publisher Tériade, described by Virginia as 'brilliantly intellectual, highly cultivated, sensual, refined, secret, and in spite of his Buddha-like aspect perhaps capable of volcanic rage which his gentle-manly education kept under control.' Tériade, whom Chagall had first met in 1940, had purchased all the printed plates belonging to Vollard's estate, including, of course, those by Chagall, and was in the process of making sure they at long last saw the light of day. Thus, the etchings for *Dead Souls* (see 129, 130) were published by Tériade in 1948. This was undoubtedly a major reason for Chagall being awarded the prestigious International Prize for Engraving at that year's Venice Biennale, since until then his reputation as a graphic artist had rested almost exclusively on the earlier *Mein Leben* prints. Marc and Virginia's trip to Italy, during the course of which they visited Padua and Florence as well as Venice, was a great success; Virginia recalls that Marc was 'deeply moved' by the frescos by Giotto in the Arena Chapel in Padua and 'bowled over' by the

'savage strength' of Tintoretto (1518–94), whose 'flying figures were very near to his own visions'. Next, Tériade set about printing Chagall's first coloured lithographs, the illustrations to *The Arabian Nights* (see 190, 191), on which Chagall had worked in High Falls. In 1950, Chagall was to produce ten wash drawings to illustrate Boccaccio's *Decameron* (1353), which were published in *Verve*; edited by Tériade, this was one of the liveliest and most important artistic and literary journals of its day.

It was Tériade who now urged Chagall to leave Orgeval and settle in St Jean-Cap-Ferrat on the French Riviera, where he himself resided for half the year. The contrast between the grey north of the country, still scarred by the war, and the warm, luxuriant south intoxicated Chagall, and inspired him to produce a series of joyously bold gouaches and paintings, among them *Blue Landscape* (193) and *The Fishes at St Jean*, in which the taller, russet-haired figure is undoubtedly Virginia. Chagall's abiding ambition to work on a larger scale found some minor satisfaction when two British women knocked on their door one day, introduced themselves as founders of a small experimental theatre in London called the Watergate, and expressed their fervent wish that Chagall paint murals to adorn the auditorium. Although they had no funds whatsoever at their disposal, Chagall eventually agreed to 'lend' them two paintings that he made expressly for that purpose. When Virginia took these two canvases, *The Blue Circus* (194) and *The Dance* with her to England to present to the theatre, a British customs official ordered her to unroll them for inspection: 'You call these art?', he said.

In 1950 they moved to Vence, and installed themselves in a house called Les Collines, owned by Claude Bourdet, and before that by his mother, the poetess Catherine Pozzi, whose lover, the poet Paul Valéry, had often visited her there. Valéry's watercolours still adorned the walls, but they were soon removed, since Chagall disliked being surrounded by other artists' work. Indeed, unlike many practitioners, he and other artists never exchanged works; the only examples of other artists' creativity that he owned seem to have been a small sculpture of a washerwoman by Auguste Rodin (1840–1917), another small statue by Henri Laurens (1885–1954) and a small still life by Georges Braque. An Alexander Calder mobile was a gift from the artist, only grudgingly accepted.

194
The Blue Circus,
1950.
Oil on canvas;
35 × 27 cm,
13 3/4 × 10 5/8 in.
Tate Gallery,
London

Although Virginia did a substantial amount of work of a secretarial nature for Chagall, business matters continued to be dealt with by Ida, whose own artistic ambitions were completely subordinated to the furtherance of her father's career. Now separated from Michael Gorday, she married again in 1952. Her new husband was the Swiss art historian and curator Franz Meyer, later director of the Basle Kunsthalle and author in the early 1960s of a massive scholarly tome on Chagall, which for many years served as a definitive reference work on the artist. In the early 1950s, however, a new figure appeared on the scene, who would gradually oust Ida from this position of power: this was Aimé Maeght, whose gallery on the rue de Téhéran in Paris had soon established itself as the most important commercial gallery in postwar Paris. Maeght's chief rival was Carré; but since Pierre Matisse, Chagall's New York dealer, disliked Carré, the artist, to please him, agreed to sign a contract with Maeght.

Among the friends who visited Marc and Virginia at Les Collines were the poets Paul Éluard, Pierre Reverdy and Jacques Prévert. Although Virginia recalls that they also received visits from Masson, Joan Miró (1893–1983) and Braque, virtually the only close painter friend Chagall had at this time was André Lhôte, a minor talent as a painter but an important teacher, and hence, presumably, less of a threat than Masson, Miró or Braque. The South of France had long been a favourite haunt of artists. Indeed, by the postwar period, many of the giants of twentieth-

195
Picasso and Chagall working in the Madoura ceramics studio, Vallauris, in the early 1950s

century art had forsaken Paris and settled there. Henri Matisse, now in his eighties, lived in Cimiez, a suburb of Nice; although bedridden he continued to be immensely productive, presiding imperiously over the making of his joyous *papier collés* (coloured paper cut-outs). With this great artist Chagall had a relatively unproblematic relationship: there was mutual respect, a certain amount of jealousy on Chagall's part (he apparently found it irksome that Les Collines happened to be located in the avenue Matisse), no overt hostility or animosity, but equally no real warmth.

Chagall's relationship with Pablo Picasso, now resident in Vallauris, not far from Vence, was another matter altogether. As a young man in Paris before World War I, he had urged Apollinaire to introduce him to Picasso, but the poet had apparently refused to do so, replying, only half in jest: 'Picasso? Do you want to commit suicide? All his friends end up like that.' In the event, he was not to meet the great Spaniard until the 1920s and the relationship between the two men was always an uneasy one. For Chagall, Picasso was a frequent and passionate topic of conversation; his jealousy of the Spaniard was so well known that his friends teased him about it relentlessly. So conscious was Chagall of Picasso's larger-than-life status that he had written to the latter from America, informing him that he would soon be returning to Europe, and looked forward to meeting him. It seems that he also enclosed a photograph of David, which Picasso, touched, proceeded to pin up in his bedroom. Ida apparently paved the way for this visit by entertaining Picasso at a magnificent meal prepared by her in his honour, and several months later, Chagall duly arrived in the South of France. When, however, this change of residence prompted the latter to try his hand at ceramics, Picasso grew distinctly wary – all the more so, when Chagall, after working with several other kilns – at Vence, Antibes and Golfe Juan – had the effrontery to start frequenting the same studio as Picasso, the Madoura workshop in Vallauris (195). In fairness to Picasso, it was he who had almost singlehandedly breathed new life into the ceramic industry in Vallauris, which had languished since World War I. Picasso's revenge involved playing a wicked joke on Chagall by completing with a flourish 'à la Chagall' a pot that the real Chagall, still a relative novice in the medium, had left incomplete.

Inevitably, the two massive egos clashed, sometimes with amusing results. In her book *Life with Picasso*, Françoise Gilot, his mistress at that time, recalls a disastrous lunch hosted by Tériade in about 1951:

Surrounded by skinny women, he [Picasso] was in a bad mood, and he decided to put it to good use. He started in on Chagall, very sarcastically. 'My dear friend,' he said, 'I can't understand why, as a loyal, even devoted, Russian, you never set foot in your own country any more. You go every-where else. Even to America. But now that you're back again and since you've come this far, why not go a little further, and see what your own country is like after all these years?' … He [Chagall] gave Pablo a broad smile and said, 'My dear Pablo, after you. But you must go first. According to all I hear, you are greatly beloved in Russia [Picasso had joined the Communist Party in 1944], but not your painting. But once you get there and try it awhile, perhaps I could follow along again after. I don't know; we'll see how you make out.'

Then suddenly Picasso got nasty and said, 'With you I suppose it's a ques-tion of business. There's no money to be made there.' That finished the friendship, right there. The smiles stayed wide and bright but the innuen-does got clearer and clearer and by the time we left, there were two corpses under the table. From that day on Pablo and Chagall never set eyes on each other again.

When I saw Chagall quite recently, he was still smarting over that luncheon. 'A bloody affair', he called it.

'But in spite of his personal differences with Chagall,' Françoise Gilot also reveals,

Pablo continued to have a great deal of respect for him as a painter. Once when we were discussing Chagall, Pablo said, 'When Matisse dies, Chagall will be the only painter left who understands what colour really is. I'm not crazy about those cocks and asses and flying violinists and all the folklore, but his canvases are really painted, not just thrown together. Some of the last things he's done in Vence convince me that there's never been anybody since Renoir who has the feeling for light that Chagall has.

On another occasion, Picasso is said to have exclaimed: 'He must have

an angel in his head …'. 'Long after that,' Gilot continues, 'Chagall gave me his opinion of Pablo. "What a genius, that Picasso," he said. "It's a pity he doesn't paint."'

Chagall's foray into the field of ceramics was soon followed by a wish to experiment with the medium of sculpture (196), 'inspired', Virginia recalled, 'by an Italian marble-cutter's workshop opposite the entrance to Les Collines where he passed every day on his morning walks'. Although his work in both these media bears the unmistakable stamp of his artistic personality, his sensibility is, it could be argued, better suited to two dimensions than to three. In the ceramics, freely handled motifs, primarily of lovers or biblical figures, often borrowed directly from his paintings or prints, are superimposed on the clay without much

196
Moses.
Rogne stone;
53 × 22 cm,
20⅞ × 8⅞ in.
Musée National
Message
Biblique Marc
Chagall, Nice

adjustment to the very different nature of the medium (197). His first
ceramics (198) were based on the gouache illustrations to the *Fables* of
La Fontaine he had produced in the 1920s (see 131). Although the result
is frequently charming, only rarely are the decorative elements and the
form of the piece completely integrated. This, presumably, is why he
tended to favour the flat or almost flat plate format, which could be
treated more or less in the same way as a canvas or lithographic stone.
Exceptions to this are the more sculptural forms of certain pots (199),
endowed with a punning wit and vigour distinctly reminiscent of some
of Picasso's ceramics. In the medium of sculpture, too, the motifs –
again lovers and biblical figures predominate – tend to be carved close
to the surface of the stone, rather than being conceived of in the round
from the outset. Notable exceptions to this include the more fully three-
dimensional bronzes produced in 1959.

197
*The Lovers'
Offering (The
Dream of the
Couple)*,
1954.
Ceramic vase;
43 × 17 cm,
17 × 6¾ in.
Private
collection

198
*The Amorous
Lion*,
1950.
Ceramic dish;
22·5 × 19·5 cm,
8⅞ × 7¾ in.
Private
collection

199
*Woman with
Trough*.
Earthenware;
44 × 22 cm,
17⅜ × 8⅞ in.
Private
collection

In the summer of 1951, the Chagall family spent time at the quiet seaside village of Le Dramont, near St Raphaël in the South of France, where for the first and last time Virginia posed for the artist in the nude. In the event, the resulting gouache, *Nude at Le Dramont*, was finished in 1955, after Virginia had left him. The latter also writes of two other 'rather tragic pictures', *The Blue Boat* and *Sun at Le Dramont*, over which 'the shadow of things to come was already hovering'. Virginia and Chagall were indeed leading increasingly separate lives. As she herself put it:

From now on Marc's life was more and more a public one. I had to try and play the part Bella would have played had she been there. I had to try and be worthy of her succession … Needless to say I felt hopelessly unworthy but I thought I might try and be myself instead. I didn't quite know what I was but I knew what I wasn't.

Meanwhile, a visit to Israel, also in 1951, temporarily succeeded in papering over the cracks in the couple's relationship. (This visit was to be followed by several others, in 1957, 1962 and 1969.) This was an emotive trip for Chagall, and a difficult one for Virginia. Everywhere they went, Chagall – the most famous of all Jewish artists – was fêted in public as a national hero. In private, however, many Israelis in the newly founded state, intent on turning their back on the world of the Diaspora, looked askance at the artist's seeming obsession with the world of the *shtetl* – and wondered, too, why Chagall, for all his lip-service to the new state, still chose to make his home in France. As in 1931, Chagall must have felt

most at home with the Yiddishists, those who sought, against the mainstream of the population, to preserve a dying culture and its language. On this visit, he was to forge a lasting and important friendship with the poet Abraham Sutzkever, whom he had first met in Vilna in 1935. While his poetry in certain respects echoes the crazily metamorphic world of Chagall's paintings, Sutzkever, who had emigrated to Israel in 1947, also acted as editor of the Yiddish-language literary and artistic journal *Di Goldene Keyt* (The Golden Chain), which he had founded in Tel Aviv in 1949 and was still editing in the 1980s.

Over the years, many of Chagall's own poems and letters were published in this journal. Chagall's command of Yiddish by this point in his life was far from perfect; and at first, it seems, he urged his friend to correct his language as he saw fit. Ultimately, however, Sutzkever persuaded Chagall that the texts should be printed as written, the better to preserve their original flavour. The private letters Chagall wrote over the years to friends such as Sutzkever reveal an even more intimate, less self-conscious side of his personality than do the poems – although one cannot help wondering to what extent he was aware of the likelihood of their eventual publication. Like many of the poems, these letters are noteworthy for the unashamedly emotional loyalty they demonstrate to Israel and the Jewish people – in marked contrast to the emphasis on universal values to be found in Chagall's more public statements. The two positions are not, of course, mutually exclusive: what is striking is the way Chagall, consciously or unconsciously, adapted to the expectations of his audience.

In the autumn of 1951, Virginia at last got a divorce from John McNeil. Neither she nor Marc, however, were in any hurry to formalize their relationship. And indeed, by 1952, Virginia had had enough. The warmth and spontaneity that had characterized their relationship in the early days had all but vanished; instead, as she herself put it, she felt,

trapped in a part I couldn't play … I knew that Marc was headed for greater fame and greater riches. The Great Machine that he had helped to set in motion was carrying him along with it inexorably. Already his own freedom was threatened but he didn't seem aware of the fact.

All this aside, the fact that Virginia was not Jewish (for all that she was an avowed philo-Semite) and came from an entirely different cultural background, undoubtedly played a significant part in the weakening of the bonds between them. In any event, she had been attracted for some time by a Belgian photographer called Charles Leirens, and in due course became his lover. Leirens was about the same age as Chagall, but far less successful and much more vulnerable – Virginia clearly needed to be needed. 'My departure was not violent,' she later wrote, 'it was the logical conclusion to an unhappy situation.'

Both Chagall and his pride were seriously damaged. His whole life had been marked by dependence on women: first his mother and his six sisters; then, for the better part of three decades, his beloved Bella, and after her death – more improbably – Virginia. That the latter should have left him for a mere photographer rankled badly. Although they saw little of each other, Chagall's relationship with David and even with Jean (Virginia had taken both children with her when she left) continued to be relatively close, until his son reached adolescence, when contact between them virtually ceased. Virginia herself was to see Chagall again only once. To this day, David remains peripheral to the Chagall family and its commitment to the artist's memory.

Ida, whose relationship with Virginia (never completely unstrained) had in any case been deteriorating, at once came to the rescue, and very soon provided her father with a new and more suitable companion. This was Valentina Brodsky, better known as Vava (200). She too was of

200
Vava and Marc
Chagall, 1962

Russian–Jewish stock, although her family, before being ruined by the
Revolution, were far richer and grander than Chagall's: as the latter
liked to point out, 'When my father was hauling herrings, the Brodskys
of Kiev were buying Tintorettos!' On the other hand her knowledge of,
and interest in, Jewish culture was, compared with Chagall, minimal. At
the time of her summons by Ida to act as Marc's housekeeper, she was
forty years old (that is, twenty-five years younger than the artist) and the
owner of a millinery business in London. According to an uncorroborat-
ed story, she agreed to leave England only on condition that Chagall
marry her. Whatever the true course of events, Chagall did marry her
almost immediately, on 12 July 1952. Some accounts claim the couple
divorced six years later, to remarry for a second time shortly after, the
official reason given being that, 'both of them suffered from having
been originally wed in circumstances displeasing to one of them'. In the
end, they were to remain husband and wife until Marc's death in 1985.
Although she never fulfilled all the multiple roles that Bella had per-
formed in Chagall's life, Vava clearly played an important part in her
husband's later years. The artist's son David once commented that
'Marc and Vava get on well because they both have wit and joust with
each other.' Vava herself died in 1995, maintaining to the end a tight
control over all matters pertaining to her famous husband's private and
professional life.

201
Illustration for
*Daphnis and
Chloë*.
Lithograph;
41·9 × 64·1 cm,
16$^1$$_2$ × 25$^1$$_4$ in

The newlyweds travelled to Greece for their honeymoon, Chagall's first
visit to that country, to be followed in 1954 by a second one. Although
Chagall produced a number of sketches directly inspired by the land-
scapes and monuments of that country, the main artistic outcome of
these visits was the series of coloured lithographs on the theme of
Daphnis and Chloë (201), commissioned by Tériade in 1952 and pub-
lished in 1961. In 1958 the Paris Opéra would commission him to pro-
duce the sets and costumes for Ravel's ballet of the same name. *Daphnis
and Chloë*, attributed to the third-century AD Greek writer Longus, is a
pastoral romance, the story of the love of a goatherd and a shepherdess.
Chagall seems to have succumbed to the seductiveness both of the story
and of Greece itself, producing pleasing images of a gentle rural idyll –
with associations more often biblical than classical, however, and replete
with an increasingly familiar repertoire of semi-fantastical motifs.

Chagall's working routines, both in Vence (and later, in nearby St Paul-de-Vence, where they moved in 1966) and Paris (where they owned an apartment on the exclusive Île St Louis), were hereafter to be punctuated by long trips abroad, not only to supervise the installation of major international commissions and to be present at the openings of important one-man exhibitions, but also to give lectures and receive honorary degrees from several academic institutions. The Great Machine, it seems, was indeed carrying all before it.

Meanwhile, between 1953 and 1956, Chagall was working on his 'Paris Series'. Essentially, these richly coloured, joyous and affirmative works are a celebration of a new-found stability and contentment, in which – temporarily at least – Paris ousts Vitebsk as the centre of his consciousness. (Vence, although his main home from 1950 onwards, would never acquire such rich symbolic resonance in his work.) Some of them were based on sketches started in the late 1940s, on his first return visits to Paris after the war. Although completed after Virginia's departure, they still retain references to his erstwhile companion and their baby. A mother and child also feature in the highly atmospheric *Bridges over the*

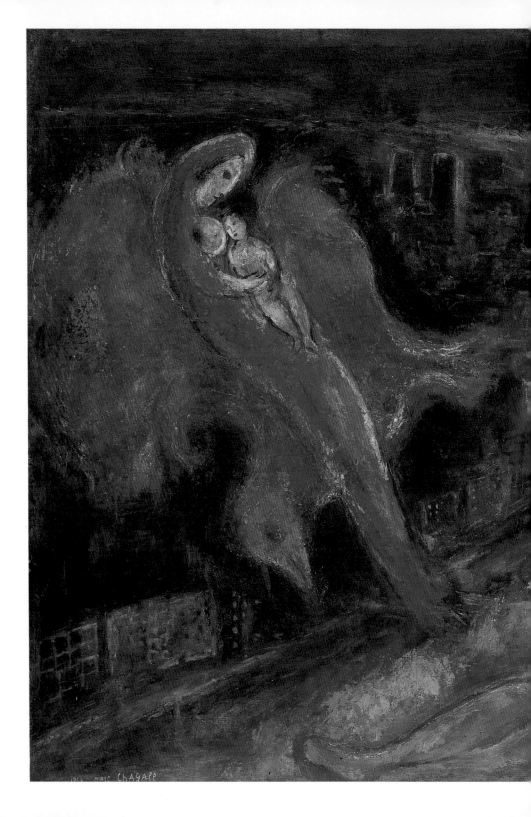

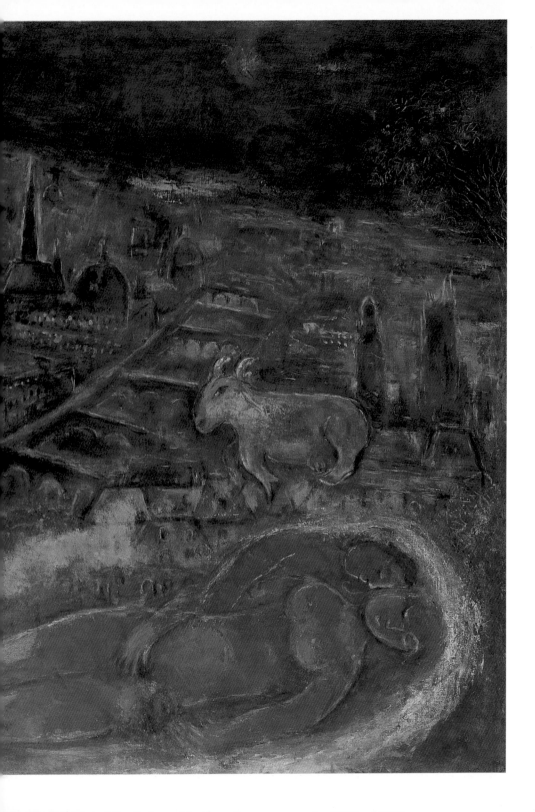

Seine of 1954 (202), whose panoramic depiction of Paris recalls Robert Delaunay's monumental canvas of 1912 entitled *The Three Graces*, as well, perhaps, as *Homage to Paris* of 1930 by Mané-Katz, an artist Chagall loved to hate. Others, such as *Le Champ de Mars* of 1954–5 (203), are more obviously a homage to Vava and their new life together, although a ghostly Bella and buildings reminiscent of Vitebsk still haunt the lower part of the composition. Yet, tempting as it is to make a direct link between the images of women and lovers in Chagall's work and his own domestic circumstances, to do so is to limit the possible meanings of such images. Although autobiographical elements are undeniably present in the work, they are rarely literal or straightforward.

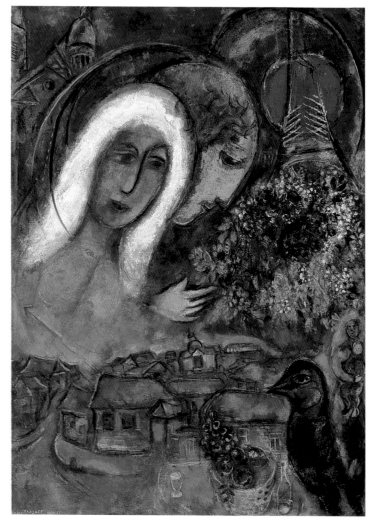

202 **Previous page**
Bridges over the Seine,
1954.
Oil on canvas;
111·5 × 163·5 cm,
43⅞ × 64⅜ in.
Kunsthalle,
Hamburg

203 **Right**
Le Champ de Mars,
1954–5.
Oil on canvas;
149·5 × 105 cm,
58⅞ × 41⅜ in.
Museum
Folkwang,
Essen

Chagall's interest in producing a series of monumental oil paintings on biblical themes had first been fired in the early 1950s by the availability of a disused Christian chapel in Vence – the very town in which Matisse had just created his stylistically radical but still unequivocally Catholic Chapelle du Rosaire (204). However, he had had misgivings about the location from the outset; and when practical problems made the project unviable, it was soon abandoned. For all Chagall's lifelong reluctance to be labelled a Jewish artist and his insistence on the universality of his art, the idea of producing artworks that would be seen – and hence, inevitably, interpreted – in an explicitly Christian context, filled him with a profound unease.

Indeed, when in 1950 he was asked by the enlightened Dominican priest Father Pierre Couturier to create an artwork for the church of Notre Dame de Toute Grâce at Assy in the Haute-Savoie – already adorned with works by the Jewish Lipchitz and the Communist Léger, among other eminent contemporary artists – he conveyed his disquiet to many of his Jewish friends, consulted the Chief Rabbi of France and even wrote to Chaim Weizmann, president of Israel, asking for advice. His letter to Weizmann also contained a barely disguised – but disregarded – plea for commissions to decorate Jewish buildings. In the event, he listened to his own heart, as Weizmann had urged him to do, and in 1957 did indeed produce a ceramic mural and a stained-glass window for the baptistery of the church at Assy (205).

205
*Moses Leading
the Jews across
the Red Sea*,
1957.
Wall ceramic;
306 × 230 cm,
120¹⁄₂ × 90¹⁄₂ in.
Church of
Notre Dame de
Toute Grâce,
Assy

Yet Chagall still felt compelled to inscribe the tile mural depicting *Moses Leading the Jews across the Red Sea* with the words 'In the name of the freedom of all religions'. Lipchitz, interestingly, had felt similarly moved to inscribe the bronze sculpture he had contributed to the church as follows: 'Jacques Lipchitz, a Jew loyal to the faith of his ancestors, made this Virgin for the good understanding of mankind upon the earth so long as the Spirit reigns.' Lofty statements such as these may have salved these Jewish artists' consciences, but they did nothing to prevent Catholics interpreting the work according to their own convictions. The catalogue of the artworks at Assy describes the ceramic mural thus: 'Chagall who, despite the fact that he is a Jew, possesses a keen liturgical sense, has not failed to depict in a corner of the work, the scene from Calvary, baptism in the blood of the Lord, of which the passage of the Red Sea is a prefiguration.' As mentioned earlier, other writers, including Jacques and Raissa Maritain, tried hard to represent Chagall as a Christian in spite of himself, and it remains true that aspects of Christianity held a lifelong fascination for him – not an uncommon phenomenon, however, among secularized Jews operating within a gentile culture. Yet even the Maritains, for all their ardent proselytizing of others, knew better than to try to convert Chagall to Catholicism.

Although from 1960 onwards Chagall would produce numerous stained-glass windows for Christian churches, his misgivings persisted, albeit in private. A Yiddish journalist once commented astutely, if bitterly, that 'cathedrals are for eternity, synagogues are for burning' – one persuasive reason why Chagall the artist (rather than Chagall the Jew) chose again and again to put these misgivings to one side, and to work for the Church. The age-old orthodox Jewish suspicion of the figurative graven image meant that the synagogue, which might well have provided a more natural home for Chagall's religious impulses, generally failed to avail itself of his talents – an irony which, given Chagall's status as the greatest living Jewish painter, did not go unnoticed. The one notable but problematic exception to this is the Hadassah Medical Centre in Jerusalem.

Chagall's first direct experience of the stained-glass medium had occurred in 1952, when he visited Chartres Cathedral and made detailed studies of its magnificent Gothic windows; the conspicuous delight in intense, luminous colour characteristic of many of his paintings of the early 1950s is due in no small measure to this encounter. His own handling of the medium from the late 1950s onwards was blithely unorthodox, heedless but by no means disrespectful of tradition. As usual, the artist's own pronouncements, however vivid, offer no practical information whatsoever:

Stained glass looks quite simple: the material is light itself. For a cathedral or a synagogue, the phenomenon is the same: something mystical that passes through the window. And yet I was very afraid, as afraid as when keeping a first tryst. Theory, technique – what's that? But the material, light – there's creation!

It was following a third visit to Israel in 1957 that Chagall embarked on the twelve stained-glass windows for the synagogue of the Hadassah Medical Centre. Extant preparatory studies reveal his working methods at this juncture. The first stage was to produce small sketches in pen and pencil; these were followed by somewhat larger ink and wash drawings; and these, by two sets of designs in gouache and collage, the first one-twentieth, the second and final set one-tenth of the windows' actual size. Since Jewish orthodoxy forbade the rendering of the human figure

in a synagogue, Chagall used the animal symbolism that was already so integral a part of his vocabulary to allude in a vigorous and poetic way to the Twelve Tribes of Israel (206). Four colours – blue, red, green and yellow – dominate; colouristically, each window is a dramatic variation on a single theme. When presented with the architect's plans, Chagall was apparently so dismayed at the mediocrity of the building being specially constructed to accommodate his windows that he insisted on making certain changes to the blueprint himself. When the stained-glass windows were finally placed *in situ* in 1962, he expressed himself satisfied with the setting that had been provided for them. The fact that he kept any remaining reservations he may have had to himself suggests that affection and loyalty both to Israel and to the Jewish religion for once took priority over more egotistical concerns, although the possibility of future commissions may also have encouraged him to be tactful.

206
Dan,
1961.
Stained-glass
window;
3·5 × 2·4 m, 11 ft
6 in × 7 ft 10 in.
Hadassah
Medical Centre
Synagogue,
Jerusalem

Ironically, by this point he had already had one of his stained-glass windows installed in the magnificent Gothic structure of Metz Cathedral in France – a far cry indeed from the nondescript architecture of the Hadassah Medical Centre Synagogue, the only building ever constructed expressly for his windows. The Metz commission marked the beginning of an extremely fruitful collaboration between Chagall, now in his early seventies, and glassmakers Charles and Brigitte Marq of the Jacques Simon Atelier in Reims. In the 1960s he created not only the windows for the Hadassah synagogue; but also further windows for Metz Cathedral (207); a window for the United Nations building in New York (208), where, even in a secular context, Chagall's vision of 'the ideal of peace and brotherhood' demanded the inclusion of a Christ figure; for the church of Pocantico in Tarrytown, on the Hudson River just north of New York; and in England for All Saints Church, Tudeley in Kent. This extraordinary activity continued into the 1970s (Chagall was now well into his eighties), with his windows in the choir of the Fraumünster in Zurich; in the apse of Reims Cathedral, burial place of France's kings; in Chichester Cathedral, England; and the church of St Etienne in Mayenne. In 1976 he also designed a mosaic for the chapel of Ste Roseline les Arcs near Draguignan in the South of France. The third series of windows for St Etienne was inaugurated as late as 1981.

207 Overleaf
Stained-glass
window,
transept,
Metz Cathedral,
1968

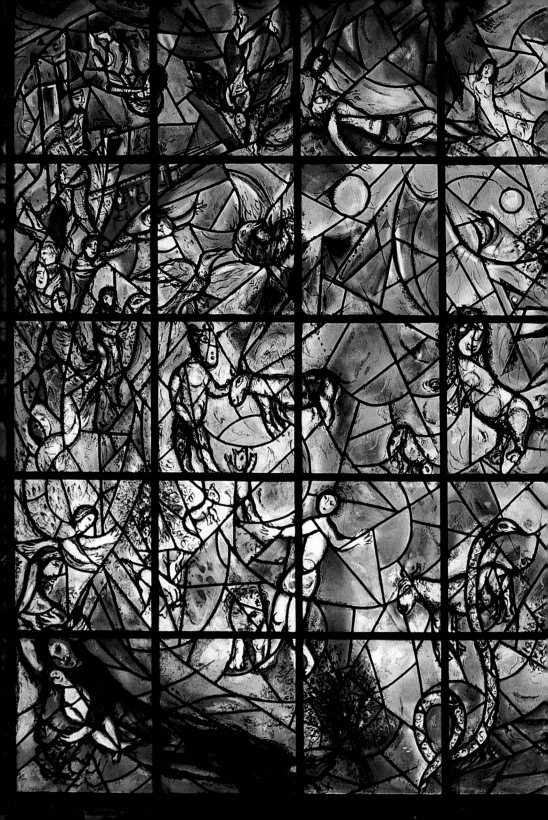

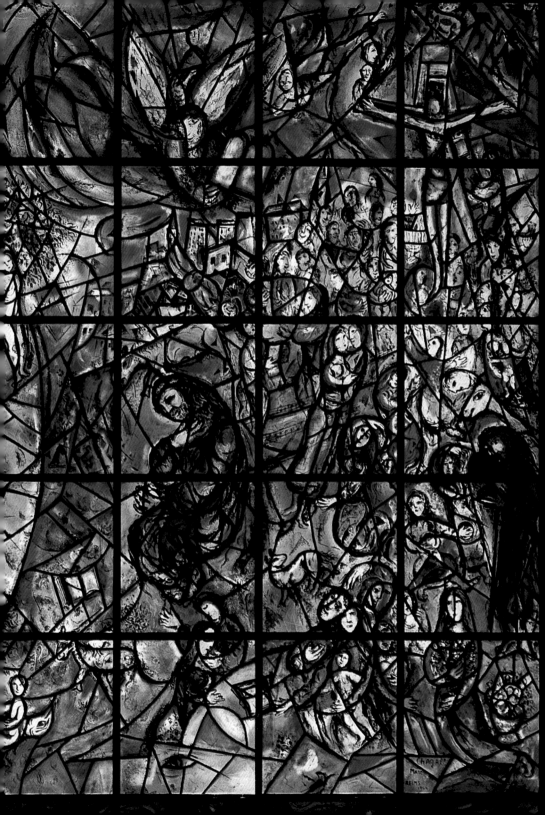

Fortunately, film of the artist at work, combined with written descriptions by the craftspeople who worked with him (many of them, however, coloured by Chagall's reluctance to dwell on purely technical matters) enable us to reconstruct something of his working methods. Small-scale preparatory sketches would ultimately metamorphose into life-size working drawings, which acted as blueprints for both artist and craftsperson. The latter would then take over, coating the glass with thin films of the required colours, which could subsequently be treated with acid to achieve subtle variations in intensity. Once the panes of glass were mounted, Chagall could reassert himself, treating the surface almost as a painting by using whatever means were at his disposal (brush, rag,

scraper) to build up his repertoire of forms in varying intensities of black. Because the coloured glass could, if required, be etched away to create areas of white, it was unnecessary to use lead to mark the boundaries of each colour change. Thus, while still structurally essential, lead was used, not to enclose and define form, as in most stained-glass windows past (209) and present, but in lines that sweep independently and rhythmically across each composition.

In spite of all his public achievements, the discomfiture that Chagall felt as a Jewish artist working for the Christian Church persisted. It is no accident, then, that Chagall should in the end have chosen to display his

magnificent – and uncommissioned – cycle of biblical canvases in a religiously non-specific setting, namely the National Museum of the Biblical Message in Nice, opened to the public in 1971 with the intention of providing a spiritual haven for all, irrespective of creed. The building and garden were designed by the architect André Hermant and financed by the French state; the writer André Malraux, minister of cultural affairs since 1959 and one of Chagall's staunchest allies, lent the project his influential support. The museum's contents – like the mural at Assy and the window in Reims Cathedral – were the personal donation of the artist. The following public statement – naïve perhaps, but undoubtedly well intentioned – makes Chagall's utopian ideas clear:

Ever since my earliest youth, I have been fascinated by the Bible. I have always believed, as I still believe, that it is the greatest source of poetry of all time. Ever since then, I have sought its reflection in Life and Art. The Bible is like an echo of nature, and this is the secret I have endeavoured to transmit. During the course of my life and to the best of my ability … I have created these pictures in unison with this youthful dream. I want to leave them in this house, so that people may find here a certain peace, a certain spirituality, a religious atmosphere, a feeling for life. I believe these pictures do not merely represent the dream of a single individual, but that of all mankind … Perhaps young and less young people will come to this House seeking for an ideal of love and brotherhood such as my colour and line have dreamed of … And all, whatever their religion may be, will be able to come here and talk of this dream, far from all unkindness and provocation … In Art, as in life, everything is possible, so long as it is based on love.

Although an awareness of the Bible underpins a great number of Chagall's early compositions, the first time that the artist worked on biblical themes in a concerted fashion was in the 1930s, when Vollard commissioned him to illustrate the Old Testament with a series of gouaches, later to be translated to even greater effect into the medium of etching (see 150, 153–155). Vollard's death and the outbreak of war had brought the project to a temporary halt, and it was only in the early 1950s that Chagall resumed work on it, finally completing the last four images in the series in 1956, the year in which it was published by Tériade. In 1958 these etchings were reissued in a slightly modified form, heightened

with watercolour, with a resultant loss of intensity. In the late 1950s, commissioned by Tériade, Chagall embarked on another series of biblical illustrations, in the form this time of coloured lithographs. Far more colourful and fluently linear than the gouaches and etchings, these possess a decorative, occasionally facile, quality far removed from the solemnity and subtlety of the earlier works. It cannot be accidental that Chagall in the postwar period generally chose to abandon the demanding medium of etching in favour of lithography, which lends itself more easily to a straightforward transposition of freely drawn motifs.

Both sets of Old Testament illustrations can be viewed at the National Museum of the Biblical Message, together with a number of carved sculptures, a mosaic depicting the prophet *Elijah* (210), a tapestry with non-specific pastoral allusions and three richly luminous, predominantly blue stained-glass windows on the theme of *The Creation of the World* specially designed for the auditorium (in which even the harpsichord is decorated by Chagall with references to the story of Rachel and Leah). These works, all produced after World War II, are evidence both of Chagall's ever-increasing preoccupation with the Bible in later life, and of his impressive technical versatility and willingness to experiment with new media. In addition, space is frequently given over to temporary exhibitions of work by other artists, often from other cultures, a policy which conforms to Chagall's ideal of universal love and a non-sectarian spirituality. Recitals of music and poetry, and the contents of the library, all further reinforce the museum's fundamental purpose. In its utopian thrust, the museum differs dramatically from other, more conventional ones dedicated to the *oeuvre* of a single artist – for example, Matisse and Léger – to be found in the South of France, and indeed, anywhere else in the world. And yet the visitor is never allowed to forget that this is after all Chagall's National Museum of the Biblical Message. As so often in the artist's career, humility and arrogance were clearly close companions here.

Chagall worked on his Biblical Message cycle of oil paintings for over ten years, between 1955 and 1966. Most of the paintings in the series are based, at least in part, on earlier gouaches and etchings of the same subjects. In keeping with the monumental and public nature of the series,

210
Elijah,
1970.
Mosaic;
c.7·1×5·7 m,
23×19 ft.
Musée National
Message
Biblique Marc
Chagall, Nice

however, and as a result too of Chagall's greater maturity and the impact of World War II, the canvases are considerably more ambitious, complex and allusive than any previous handling of the Old Testament in Chagall's *oeuvre*. Conversely, the biblical images of the 1930s have a focused intensity and a deeply impressive austerity that is for the most part absent in his later works.

Illustrative of certain key moments in the Old Testament Books of Genesis and Exodus which highlight and reinforce the uniquely intimate relationship between God and his Chosen People (the series opens with *The Creation of Man*, and concludes with *Moses Receiving the Tablets of the Law*; 211, 212), these paintings rely mainly on a repertoire of highly personal images evolved many years earlier. Only rarely are there overt allusions to Old Master renderings of biblical themes. The canvases fall into several natural and interrelated groupings, according to subject matter or dominant colour scheme or both. Over two hundred sketches

211
The Creation of Man,
1956–8.
Oil on canvas;
300 × 200 cm,
118$^1_8$ × 78$^3_4$ in.
Musée National
Message
Biblique Marc
Chagall, Nice

212
Moses Receiving the Tablets of the Law,
1956–8.
Oil on canvas;
236 × 234 cm,
92$^7_8$ × 92$^1_8$ in.
Musée National
Message
Biblique Marc
Chagall, Nice

and preliminary studies for the paintings, also among the museum's holdings, provide an important insight into the artist's working methods. Fluent yet exploratory, executed in a wide variety of media (pencil, pastel, ink, gouache and oil), these are restless variations on a theme which both confirm the essentially intuitive workings of Chagall's hand and eye, and reveal the relentless internal logic by which the final composition was achieved.

In addition, five somewhat smaller paintings (213) inspired by the Song of Songs form a self-contained unit. Like their literary source, these are

primarily a hymn to love, both celestial and terrestrial. On one level, they constitute a lyrical homage to the women in Chagall's life – above all perhaps, Bella, but Virginia and Vava as well (the series is officially dedicated to the latter) – and to the places important in his life, notably Vitebsk and Vence, which was more suited to the pastoral nature of the Song of Solomon than metropolitan Paris, and was in any case by the later 1950s beginning to displace Paris in Chagall's artistic world view. United by their extraordinary pinkish-red colour harmonies, these images are both deeply sensual and curiously chaste. On another level, the series makes reference both to the Bible and to the vanished world of eastern European Jewry – a reminder, once again, of the intimate link

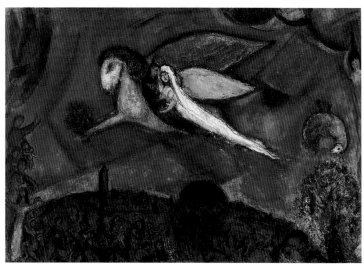

213
The Song of Songs IV, 1958.
Oil on canvas; 145 × 211 cm, 57$^1$8 × 83$^1$8 in.
Musée National Message Biblique Marc Chagall, Nice

214
Ceiling of the Paris Opéra, 1964

between past and present in the Jewish psyche, and of the Bible's continuing relevance to the people of the Book.

From the 1960s onwards, Chagall received numerous commissions to produce monumental works for secular buildings all over the world in a wide range of different media. In 1960 he painted *La Commedia dell'Arte* for the foyer of the theatre in Frankfurt, one of the rare – and uneasy – occasions he produced work for a building in Germany. In 1964 his painted ceiling at the Paris Opéra (214) was unveiled. It was André Malraux who gave Chagall this important and controversial commission, which placed him right at the heart of French cultural life and which he

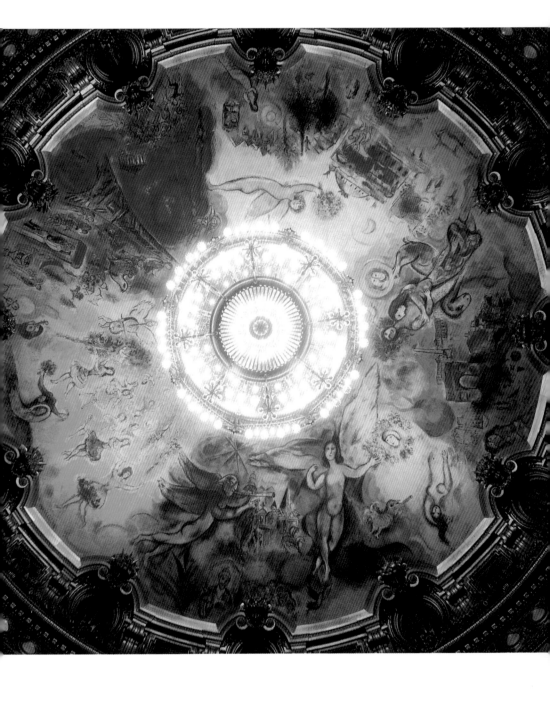

donated to the French nation. Sections of the Opéra ceiling are devoted to scenes alluding to famous ballets and operas by composers such as Ravel, Berlioz and Tchaikovsky. Less obviously relevant to the ceiling's context is the inclusion of a typically Chagallian Jewish wedding scene. So full of *élan* was the finished product that many of those who had initially expressed misgivings about letting a 'foreign' artist such as Chagall loose in a bastion of French culture declared themselves won over. The exuberance of Chagall's imagery does indeed accord surprisingly well with the neo-Baroque extravagance of the mid-nineteenth-century opera house, designed by Jean-Louis-Charles Garnier and one of the most celebrated public monuments of Second Empire France. In its defiance of gravity, Chagall's design is brilliantly suited to its position in the building. This was, however, the only ceiling commission that Chagall ever received.

In 1965–6 Chagall produced the sets and costumes for the New York Metropolitan Opera's production of Mozart's *The Magic Flute* (215), and murals for auditoria in Tokyo and Tel Aviv. A year later, the monumental canvases on a musical theme he created for the new Metropolitan Opera House at the Lincoln Center in New York were unveiled to the public. He began work on the tapestries on the theme of *The Entry into Jerusalem*, *The Exodus* and *Isaiah's Prophecy* (216), woven at the Gobelins factory in Paris, and a number of mosaics, all of which he was to donate in 1969 to the Israeli Knesset (parliament building) in Jerusalem. In 1968 he created a mosaic for Nice University; in 1972 a mosaic on the theme of the *Four Seasons* for the First National Bank of Chicago; and in 1977 stained-glass windows for the Art Institute of Chicago. At the time of his death in 1985, he was working, assisted by weaver Yvette Cauquil-Prince, with whom he collaborated on over thirty different projects, on a tapestry inspired by a verse from the Book of Job dealing with the virtue of hope. It was to be hung in the lobby of the Rehabilitation Institute of Chicago. Chagall's energy – and ambition – seemed to know no bounds.

Some critics, perhaps justifiably, regarded all this activity with a certain scepticism. Robert Hughes, for example, wrote scathingly of how Chagall's 'quasi-religious imagery, modular and diffuse at the same time, would serve (with adjustments: drop the flying cow, put in a

215
Performance of
The Magic Flute,
1967, showing
Chagall's set
design.
Metropolitan
Opera, Lincoln
Center, New
York

216
*Isaiah's
Prophecy*,
1964–7.
Tapestry;
4·7 × 5·3 m,
15 ft 7 in × 17 ft
6 in.
Knesset,
Jerusalem

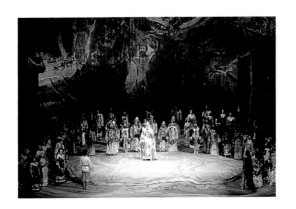

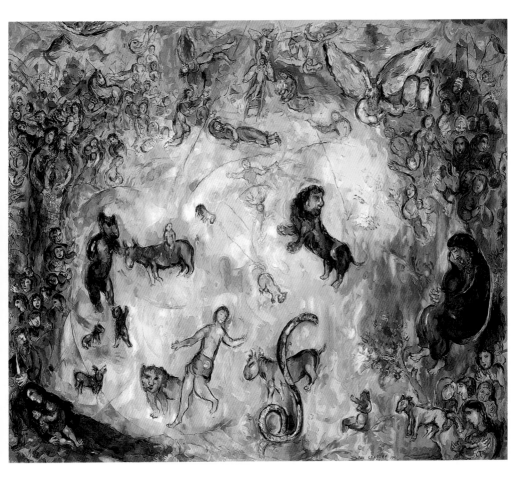

menorah) to commemorate nearly anything, from the Holocaust to the self-celebration of a bank'. His work in mosaic and tapestry, in contrast to his early empathy with the etching and, later, the stained-glass medium (but in keeping with his postwar work in lithography, ceramics and sculpture), shows little real understanding of, or interest in, exploiting the intrinsic properties of each medium. On the whole, the artist seemed content merely to transpose, with due humility, it is true, and the help of expert craftspeople (who tend, all the same, to receive less credit for their work than they deserve), images derived principally from his paintings. His compositions for these public commissions do indeed tend to be both 'modular and diffuse', reliant on an over-predictable repertoire of motifs and too often lacking a real cohesiveness, but redeemed by his mastery of large-scale colour and lyric rhythm.

Not that Chagall stopped producing smaller-scale work as well. Many of his paintings of the later 1950s and 1960s – most of them, admittedly, considerably larger than the majority of his early canvases – are joyous and richly coloured celebrations of the pleasures of life and love, not

217
Life,
1964.
Oil on canvas;
296 × 406 cm,
116 1/2 × 160 in.
Fondation
Marguerite et
Aimé Maeght,
St Paul-de-
Vence

218
War,
1964–6.
Oil on canvas;
163 × 231 cm,
64 1/4 × 90 7/8 in.
Kunsthaus,
Zurich

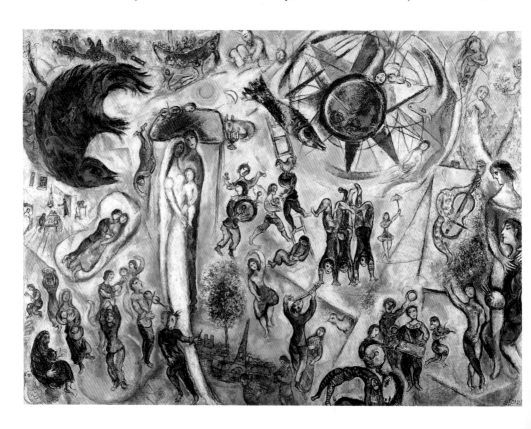

untinged, however, with a sense of the darker side of existence (217).
This sense of tragedy finds full and explicit expression in powerful works
such as *Exodus, War* (218), *The Prophet Jeremiah* (219) and *In Front of
the Picture* (220), which do much to counter the widespread view of
Chagall, especially in later years, as facile purveyor of nostalgia-ridden
images of sweetness and light.

As we have seen, the circus appeared as a sustained motif in Chagall's
art in the 1920s, with his *Cirque Vollard* lithographs and the related
paintings of acrobats. While it underlay much of his subsequent work,
it reappeared as a primary motif only in 1956, after Chagall had been
invited to attend the shooting of a film set in the same Cirque d'Hiver
in Paris that he had frequented thirty or so years earlier. The circus
would feature prominently in his work thereafter. In 1967 Tériade pub-
lished an energetic and vibrant series of twenty-three colour and fifteen
black-and-white lithographs by Chagall simply entitled *Cirque*. A canvas
of 1968, *The Big Circus* (221), is one of the largest, and probably the most
impressive, of all the artist's treatments of the subject. The cosmic and

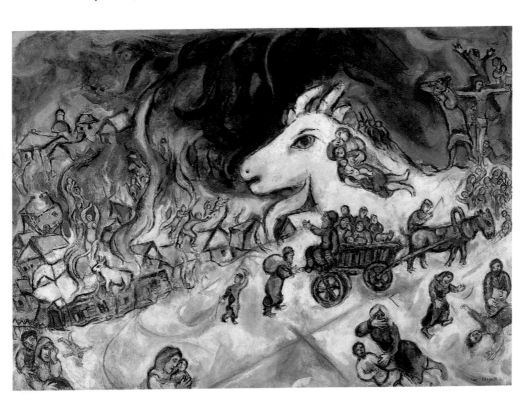

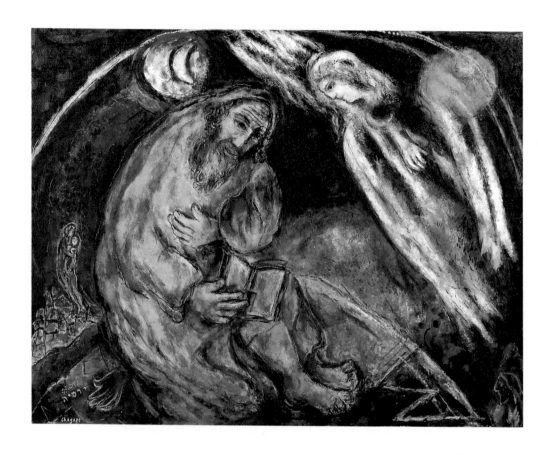

219
*The Prophet
Jeremiah*,
1968.
Oil on canvas;
114 × 146 cm,
44⅞ × 57½ in.
Musée National
d'Art Moderne,
Centre Georges
Pompidou, Paris

220
*In Front of the
Picture*,
1968–71.
Oil on canvas;
116 × 89 cm,
45¾ × 35 in.
Fondation
Marguerite et
Aimé Maeght, St
Paul-de-Vence

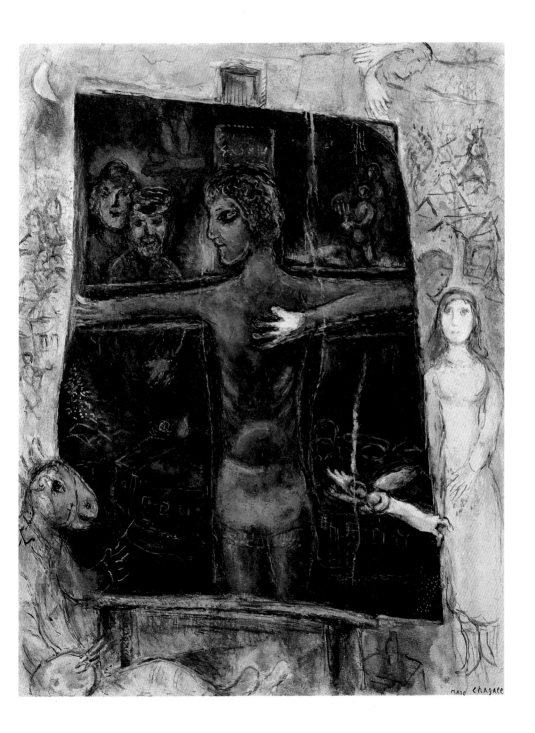

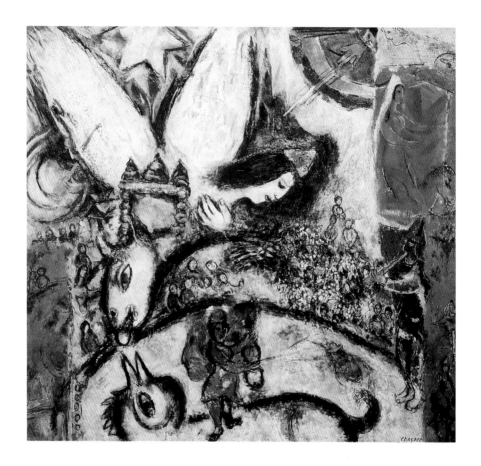

221
The Big Circus,
1968.
Oil on canvas;
170 × 160 cm,
67 × 63 in.
Private
collection

222
**Georges
Rouault**,
*The Injured
Clown I*,
1932.
Oil on canvas;
200 × 120 cm,
78¾ × 47¼ in.
Musée National
d'Art Moderne,
Centre Georges
Pompidou, Paris

philosophical implications of his previous renderings of the circus are here made more explicit. Aside from the stark black-and-white contrasts, the dominant colours are green and blue, the one suggestive of terrestrial, the other of celestial existence. The blocks of colour, apparently unrelated to the definition of form and almost certainly influenced by Chagall's preparatory procedures for stained-glass designs, act as revelatory curtains. The religious significance of the subject is confirmed by the motif in the top right-hand corner: the hand in a segment of a sphere and the rays of light, all emblematic of the divine presence. This device is found both in Byzantine and in Jewish art, where God never features in person, and was one that Chagall had already used in his Biblical Message cycle (see 211, 212). The dabs of colour, moreover, are distinctly suggestive of a painter's palette. Interpretations of individual details will vary, but the overall message is clear: if the world is a circus, then the artist hovering at the extreme top right, palette in hand, is God's clown, his servant but also partaker of his divinity – a concept which, however personally rendered, dates back to the Renaissance.

Chagall himself wrote of the affinity he felt existed between the world of the Bible and that of the circus:

I have always considered the clowns, acrobats, and actors as beings tragically human who, for me, would resemble characters from certain religious paintings. And even today, when I paint a Crucifixion or another religious picture, I experience again almost the same sensations that I felt while painting circus people.

Again, he is hardly the first artist to explore these affinities. Georges Rouault (222) is another notable twentieth-century example, although his tragic, essentially Catholic vision is unrelieved by the life-affirming wit and fantasy so characteristic of Chagall's world view.

Chagall's paintings of the 1970s and early 1980s, such as *Rest* (223), *Fiancée with Bouquet* and *Peasants by the Well*, do perhaps too often lapse into a pastel-hued, soft-edged and nostalgia-tinged sentimentality. A comparison between *The Big Circus* (221) of 1968 and *The Large Grey Circus* (224) of 1975 or *The Grand Parade* of 1979–80 confirms this tendency in his later work. Occasionally, however, one finds a painting that

possesses something of the strength, if not the originality, of the best of his earlier work: *The Walk* of 1973, for example, is a witty and vigorous invention; while *The Myth of Orpheus* (225) of 1977 is striking for the intensity of its colours and its incorporation into a figurative composition of boldly abstracted forms. As the subject matter of this and certain other late works such as *Don Quixote* and *The Fall of Icarus* (226)

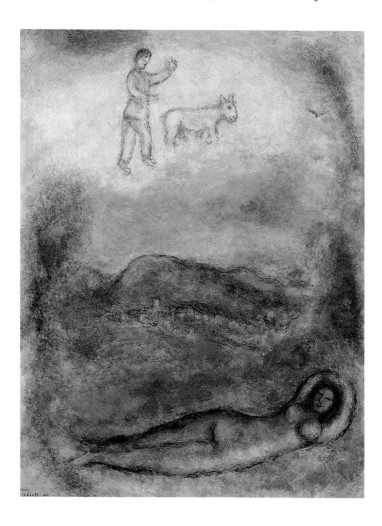

223
Rest,
1975.
Oil on canvas;
119 × 92 cm,
47 × 36¼ in.
Private
collection

224
The Large Grey Circus,
1975.
Oil on canvas;
140 × 120 cm,
55¹⁄₈ × 47¹⁄₄ in.
Private
collection

suggests, Chagall's horizons remained wide enough to embrace the world of classical myth and Western literature. There is little doubt, however, that the focus of his artistic universe continued to be Vitebsk. That Icarus falls from the sky not towards a classical landscape but a Jewish *shtetl* is proof enough.

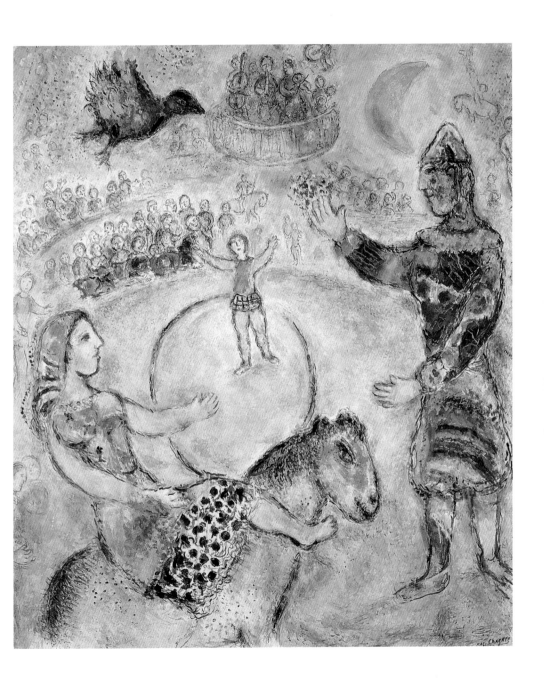

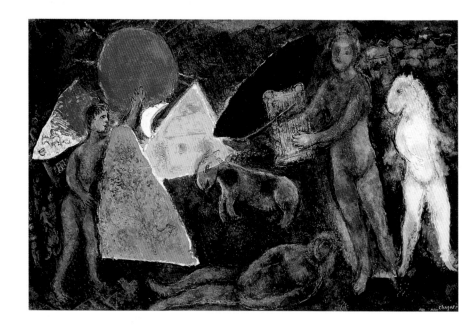

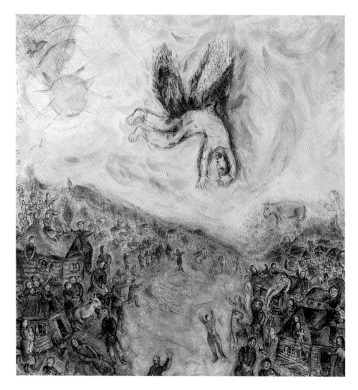

225
The Myth of Orpheus,
1977.
Oil on canvas;
97 × 146 cm,
38¼ × 57½ in.
Private
collection

226
The Fall of Icarus,
1975.
Oil on canvas;
213 × 198 cm,
83⅞ × 78 in.
Musée National
d'Art Moderne,
Centre Georges
Pompidou,
Paris

Throughout the 1960s, Chagall's numerous public commissions had left him less time than previously to devote to the field of book illustration. He did, however, manage to produce a rather formulaic and facile series of twenty-four lithographs entitled *The Story of the Exodus* (many of them reworkings of the 1930s Bible illustrations), which was published by Léon Amiel in Paris in 1966; and to illustrate a number of contemporary texts, mostly by poet friends such as Paul Éluard. As he grew older and more frail, Chagall's work in the graphic medium began gradually to take precedence over his work in other media. In 1972–5 he produced illustrations for *The Odyssey*, and in 1975 for *The Tempest*; while the Old Testament, as evidenced by his *Psalms of David* series of 1979, continued to preoccupy him. In 1975–6 he produced twenty-four colour etchings with aquatint to accompany Louis Aragon's *Celui qui dit les choses sans rien dire*; in 1977, fifteen etchings for André Malraux's *Et sur la terre*. In 1981 *Songes* ('Dreams'), a series of nineteen colour etchings, whose imagery self-consciously refers back to his pre-World War II *oeuvre*, and to his pre-1914 output in particular, was published in Geneva by Gerald Cramer, who in the artist's last years became the foremost publisher of his graphic work. The last series of prints to appear, in May 1984, was *Six Gravures sur linoleum*, poignantly hesitant linocut images of lovers and the artist at work.

Much of Chagall's prodigious – one might even say profligate – graphic output in the last three decades or so of his life displays a certain superficiality masked by technical bravura, and an over-reliance on stylistic and iconographic formulae. His lithographic output alone exceeds one thousand images. His assistant here was Charles Sorlier of the Atelier Mourlot in Paris, whom he authorized to create 'interpretations' of some of his paintings in print form. As the commercial demand for Chagall's graphic work increased, unscrupulous dealers, it seems, began to market these engravings by Sorlier as original works by the master – with results detrimental to the artist's reputation and integrity. Since it is through his prints even more than his paintings that Chagall has become almost a household name, the later graphic work is largely to blame for the critical disrepute into which the artist has fallen in certain quarters.

In June 1973 Chagall paid a visit to the Soviet Union, the first since his departure in 1922 and probably the most important and emotional of all the many journeys he made in the postwar period. 'The title of "Russian painter" means more to me than any international fame,' he had written in 1934, 'in my paintings there is not one centimetre that is free from nostalgia for my native land.' Even in 1973, however, Russia was not yet ready to accord him the hero's welcome he so longed for. The Tretyakov Gallery in Moscow mustered enough energy to mount a modest exhibition of his graphic work and brought his Yiddish Theatre murals out of storage so that the artist could, however belatedly, append his signature to them in a semi-official ceremony. Naïvely, Chagall seems to have been content, even flattered by this attention, and seemingly impervious to the attacks on him in the Yiddish and Hebrew press for visiting the Soviet Union at the height of that country's anti-Semitic and anti-Zionist campaigns.

On Chagall's ninetieth birthday in July 1977, Pope Paul VI sent the artist a congratulatory message, special celebrations were held all over France, and the media were flooded with interviews with the artist and those who knew him. Earlier that year, President Giscard d'Estaing had awarded him the Grand Cross of the Legion of Honour, the highest French decoration to which anyone but a head of state could aspire (227). Picasso

227
Chagall receiving the Legion of Honour from President Giscard d'Estaing, 1977

had died in 1973, Braque in 1963, Matisse as early as 1954; Chagall was now the last surviving representative of the heroic days of the avant-garde. No matter that the numerous 'isms' of postwar culture had passed him by; as the grand old man of twentieth-century art, he had become an almost emblematic figure.

Marc Chagall collapsed and died at his St Paul-de-Vence home on 28 March 1985, at the age of ninety-seven. A friend of the artist described how he 'died naturally as a man worn out. He certainly had been tired for some months, but he was not suffering from any illness … He had stopped painting several months ago, but he continued to work on drawings and also watercolours' (228). Following his widow's instructions, he was buried, not in the Jewish cemetery in Nice, as one might have expected, but in the Catholic cemetery in St Paul-de-Vence. According to Virginia Haggard McNeil

the ceremony was simple and moving. Jack Lang, France's minister of culture, made a short speech. Marc had expressed a wish for the simplest form of burial, without religious rites [the ultimate proof, surely, of the profoundly ambivalent nature of his religious and cultural identity], but as the coffin was lowered into the ground, an unknown young man stepped forward and pronounced the kaddish, the Jewish prayer for the dead.

In 1987, the one hundredth anniversary of Chagall's birth, the Pushkin Museum in Moscow played host to the first full-scale exhibition of the artist's work ever to be seen in the Soviet Union. The opening was a festive occasion, presided over by the poet Andrei Voznesensky, long a champion of Chagall's work, and with the artist's widow Valentina in attendance. One Moscow newspaper loftily praised Chagall for his depiction of 'the deliverance of the human spirit from the bondage of a stagnant, narrow-minded world'. Voznesensky himself spoke of the exhibition as 'a victory for *glasnost* and artistic democracy. For too many years, Chagall was ignored or disdained because he emigrated, because he was a modernist and, for some people, because he was a Jew.' Before this long-overdue 'rehabilitation' of Chagall, *The Great Soviet Encyclopaedia*, now at last discredited, had given him just two paragraphs, describing him as a 'French painter and graphic artist', who studied art in St Petersburg.

Not everyone welcomed the event, however, as hostile speeches and articles by Communist Party Members in Chagall's native Belorussia and the Vitebsk authorities' categorical refusal to honour him in any way made clear. Miraculously, the house in which the artist was born survived Vitebsk's destruction during World War II. In 1987 it was lived in by an elderly Jewish couple: 'Zyama is a retired house painter,' Voznesensky revealed, 'and he knows from his father that in this house lived a crazy artist with hair like a demon.' One criticism among many levelled at the artist was the way his 1937 painting *Revolution* (see 157) 'compares October 1917 to a clown act in the circus'. The exhibition was a great popular success, however, with seventy-five or so works out of a total of 250 lent by the Chagall family and the remainder drawn from collections, both public and private, in the Soviet Union.

Vitebsk was soon to change its mind about its most famous native son. In 1991 a modest museum with a grand title, the Chagall Art Centre, was established on one floor of a disused red-brick building; while in 1992 a statue of the artist, accompanied by his palette and an airborne Bella, was erected to his memory in Pokrovskaya Street. A plaque has for some time been affixed to the façade of the house where he spent his childhood, and for the last few years, a 'Chagall weekend' has been celebrated every July with concerts, lectures and other special events. In 1997 his parental home – restored and furnished with replicas of the objects featured in his early paintings – was opened to the public as a museum with due ceremony, and a fair share of political dissent.

A conspicuous lacuna in the 1987 Moscow exhibition was the magnificent work Chagall executed for the Yiddish Theatre in 1920. In the early 1990s the situation was remedied when, for the first time since 1973, these monumental mural paintings were taken out of storage and extensively restored. They have since been exhibited around the world to considerable acclaim, alongside a wealth of hitherto unknown or unfamiliar early works from Russian collections. If Western viewers were beginning to tire of images weakened by over-exposure, with the advent of *glasnost*, the prodigious energy and originality of Chagall's early *oeuvre* looks set to continue to astonish and impress. Conversely, politics permitting, art lovers in the former Soviet Union should now have ample

228
Towards the Other Light, Chagall's last work produced the day before his death. 1985. Colour lithograph; 63 × 47·5 cm, 24¾ × 18¾ in

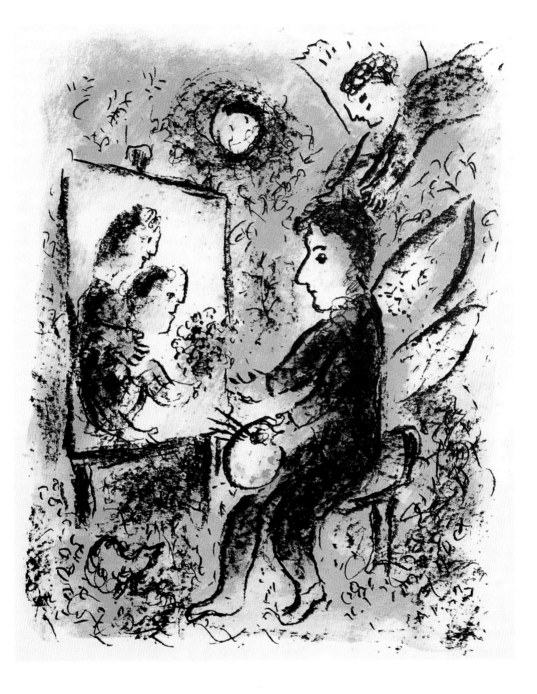

opportunity to get to know the work of one of their most important artists in all its rich variety.

Marc Chagall's status as part of the canon of modern masters has rarely been challenged. In the art world, however, it has long been fashionable to focus on his first Parisian period (1910–14) as the most original and fruitful of his entire career, and to regard his later work (and the work he produced after 1945 in particular) with a certain tolerant condescension. Exposure to the magnificent work he produced during the period of the Russian Revolution may yet persuade some of these cognoscenti to change their minds. Lay viewers, on the other hand, have often favoured the later work as being less complex and more readily accessible than the work of his early Parisian years.

Certainly, any career that spans so many decades is likely to lead to a certain amount of repetition and a reliance (over-reliance, perhaps) on well-tried formulae; and Chagall is hardly unique in not being as innovative in his later years as in his youth. His initial exposure to the Parisian avant-garde released in him a creativity of unparalleled intensity and originality. However, to suggest that he was later a facile, perhaps opportunist, purveyor of nostalgic, even sentimental, images of a long-lost world is misleading. Even those who, like the French president Georges Pompidou, praised him as 'le peintre de la joie de vivre, du bonheur et du rêve heureux' ('the painter of the joys of life, of wellbeing and of happy dreams'), wilfully ignore the range and complexity of his *oeuvre*. As this book may go some way to prove, Chagall was a complicated and many-faceted individual, who was more than able throughout his long career to produce images of considerable strength, in which an acknowledgement of the powers of darkness coexists with a moving faith in the powers of love, art and the creative imagination.

Glossary

Abstract Expressionism Term used to describe the large-scale, compositionally non-hierarchical, abstract paintings, produced by members of the so-called New York School in the decade 1945–55, which were largely responsible for New York displacing Paris as the centre of the art world after World War II. There were two main types: uninhibited, gestural 'action painting', represented by such artists as Jackson Pollock (1912–56) and Franz Kline (1910–62), and the more contemplative 'colour-field painting', represented by, among others, Mark Rothko (1903–70), Barnett Newman (1905–70) and Adolph Gottlieb (1903–74).

Automatism The suppression of conscious control over the creative process, in order to give free rein to unconscious imagery and associations. The means used to achieve this included the taking of hallucinogenic substances and the employment of techniques based on chance, such as ink blotting or frottage (rubbing). 'Psychic automatism' was one of the central principles of **Surrealism**, which the Abstract Expressionists adapted to their own more pragmatic ends as 'plastic automatism'.

Constructivism Russian art movement, sometimes also referred to as Productivism, founded c.1913 by Vladimir Tatlin (1885–1953) and which was at its height between 1917 and the early 1920s. It espoused geometric abstract principles derived largely from **Suprematism**. After the Russian Revolution the movement's followers held a utopian belief in the possibility of creating a new society by applying geometric design principles to all the arts that affected everyday life: architecture, furniture, poster design, etc. Its main practitioners included **El Lissitzky**, Aleksandr Rodchenko (1891–1956), Lyubov Popova (1889–1924) and Aleksandra Exter (1882–1949).

Cubism Probably the most radical and influential of all twentieth-century art movements. Pioneered by **Pablo Picasso** and Georges Braque (1882–1963), it explored the paradoxes involved in transposing a three-dimensional scene onto a two-dimensional surface, questioning the logic of a single, fixed viewpoint in favour of multiple perspectives and the fragmentation of form. Analytical Cubism (c.1907–12), muted in colour, broke up recognizable objects into volumetric planes; Synthetic Cubism (c.1912–14), generally more colourful, built up recognizable images from abstract parts, combining paint and collage techniques. By 1910 a Cubist 'school' had emerged, comprising such figures as **Robert Delaunay**, Henri Le Fauconnier (1881–1946), Jean Metzinger (1883–1956), Fernand Léger (1881–1955) and André Lhôte (1885–1962).

Drypoint A method of engraving, often employed in conjunction with etching, in which the design is drawn on a metal plate with a 'pencil' made of hard steel. The burr, or shaving of metal created by applying the pencil, is retained, so that when ink is applied to the plate, it adheres both to the incised areas and the burr, endowing the printed line with an extra richness and subtlety.

Etching A method of engraving in which a copper or zinc plate is given a resinous coating or ground impervious to acid. Lines are drawn on this ground with a needle, or burin, to expose the metal beneath. The plate is then put in an acid bath, where the acid eats away the exposed parts. Variations in the intensity of line can be obtained by removing the plate from the bath, stopping out with resin those lines which are sufficiently bitten by the acid, and then returning the plate to the bath.

Expressionism The term usually refers to two main groups of artists working in Germany before World War I: Die Brücke (The Bridge) in Dresden and Berlin between 1905 and 1913 and Der Blaue Reiter (The Blue Rider) in Munich between 1911 and 1914. It is sometimes used, however, to refer to all artists intent on expressing strong emotions (often of a troubled, even anguished nature) and/or a deeper sense of reality, by means of distortion or exaggeration of form and colour. Its main practitioners included Ludwig Kirchner, Erich Heckel (1883–1970), Franz Marc (1880–1916) and Wassily Kandinsky (1866–1944). Chagall is often, if inaccurately, identified with this artistic tendency.

Fauvism The first major avant-garde movement of the twentieth century. The Fauves were a group of artists, working in Paris between c.1905 and 1910, centred around **Henri Matisse** and including André Derain (1880–1954) and Maurice Vlaminck (1876–1958). Influenced primarily by Vincent van Gogh (1853–90) and Paul Gauguin (1848–1903), their paintings were characterized by strong, often anti-naturalistic colour and emphatic brushstrokes. When they exhibited together at the Salon d'Automne in 1905, they were dubbed 'fauves' (wild beasts) by a bewildered critic. Although stylistically radical, their subject matter tended to be relatively mundane; and their attitude to life, in contrast to the Expressionists, celebratory.

Futurism Aggressive Italian movement founded by the poet Filippo Tommaso Marinetti (1876–1944) in 1909, which included such visual artists as Giacomo Balla (1871–1958) and Umberto Boccioni (1882–1916). Celebrating the dynamism of the machine age and city life, many of their paintings were stylistically influenced by **Cubism**, but they put far greater emphasis than the Cubists on evoking a sense of movement. In a Russian context, the term Futurists is used to refer to those avant-garde artists who were active just before the 1917 Revolution.

Lithography A printing process that relies on the mutual antipathy of oil and water. The design is drawn in reverse in greasy chalk on a thick slab of stone (or zinc plate) which is then washed with water. When greasy printing ink is applied with a roller to the surface of the stone or plate, it adheres to the drawing, and is repelled by the water from the area untouched by chalk.

Mir Iskusstva (World of Art) Group of artists based in St Petersburg, largely from aristocratic backgrounds and supported by aristocratic patrons. Established in the 1890s, its members included **Sergei Diaghilev**, Alexandre Benois (1870–1960), **Léon Bakst**, Valentin Serov (1865–1911) and Mikhail Vrubel (1856–1910). It published a journal of the same name between 1898 and 1904 and organized exhibitions. The intention was to revive Russian art both by stimulating interest in indigenous folk traditions and by establishing contacts with the western avant-garde, initially the exponents of **Symbolism** and Art Nouveau, later the Neo-Impressionists and Paul Cézanne (1839–1906).

Orphism Term coined by **Guillaume Apollinaire** in 1912 primarily to describe work of **Robert Delaunay**, but also that of **Sonia Delaunay-Terk**, Francis Picabia (1879–1973), Marcel Duchamp (1887–1968), Fernand Léger and Frantisek Kupka (1871–1957). A colourful and poetic offshoot of **Cubism**, but also indebted to the Neo-Impressionism of Georges Seurat (1859–91), it was the first movement to concern itself explicitly with non-representational colour abstraction.

Socialist Realism The dominant art and literature of Stalinist Russia, declared official cultural policy in 1934. All other styles of creative expression were repressed. Indebted to the example of the **Wanderers**, it was purportedly realistic in its depiction of the development and triumph of Marxist Socialism and intended to be accessible to the masses. In reality, it was blatantly idealizing and propagandist in approach.

Suprematism A philosophy of abstract painting created by **Kasimir Malevich** in Moscow in 1915. He believed in a vocabulary of geometric abstract forms (the circle, triangle, rectangle, cross and, above all, the square) entirely independent of the visible world and expressive of 'pure artistic feeling'. The most extreme, and minimal, manifestation of these ideas came with his 1917–18 series, *White on White*, comprising white squares barely discernable against a white background. The Constructivists adapted Malevich's repertoire of forms to their own, more utilitarian ends.

Surrealism A literary and artistic movement launched in Paris in 1924 by André Breton (1896–1966). It intended to liberate both the viewer and the artist by exploring the world of the unconscious and subconscious mind by means of unorthodox techniques which exploited the random and accidental. Its members included the artists Max Ernst (1881–1976) and Salvador Dalí (1904–89), and the writers Paul Éluard (1895–1952) and Louis Aragon (1897–1982). Although Chagall's sometimes dream-like imagery, his fondness for incongruous juxtapositions and emphasis on the irrational and intuitive allied him with the Surrealists, he refused to join the movement, regarding it as too doctrinaire.

Symbolism A late nineteenth-century tendency in art and literature which, in reaction to Realism and Impressionism, sought to probe beneath the surface of things, emphasizing the world of the imagination, of ideas, dreams and emotions. Representative artists include Paul Gauguin, Gustave Moreau (1826–98), Odilon Redon (1840–1916) and Edvard Munch (1863–1944). In certain respects, Symbolism can be seen as a precursor of both **Expressionism** and **Surrealism**.

The Wanderers (Peredvizhniki) A group of populist Russian artists formed in the 1860s, headed by **Ilya Repin**, who took travelling exhibitions to the provinces in order to reach as wide an audience as possible. Anti-classical and realistic in style, their work focussed on portraiture, landscape and, above all, depictions of peasant life and customs, and scenes from Russian history. They were supported largely by industrialists and merchants. By the 1890s, with the widespread acceptance of their art, the radical social commitment of the group had faded.

Woodcut A method of relief printing in which lines are incised in a piece of soft wood. When the ink is applied, it adheres to the areas which are left in relief, producing bold, often somewhat crude results.

Brief Biographies

Nathan Altman (1889–1970) Jewish artist active in avant-garde circles in Revolutionary Russia. Born in the province of Podolia in the Ukraine, he studied art in Odessa. In 1911 he was living in Paris, where he first encountered Chagall. After his return to Russia in 1912, he gradually established a reputation as a painter, sculptor, book illustrator and stage designer, mostly on Jewish themes. In 1916 he became a founder-member of the Society for the Encouragement of Jewish Art. Immediately after the Revolution, he became active in the organization of artistic education and culture at state level in Petrograd. In 1918 he moved to Moscow, where he became increasingly active as a Constructivist stage designer, both for the Habima Theatre (*The Dybbuk*) and the State Yiddish Chamber Theatre (*Uriel Accosta*). He lived in Berlin in 1922–4, taking part, with Chagall, in *Die Erste russische Kunstaustellung* (First Russian Art Exhibition). While in Berlin he published *Jewish Graphics* (1923), which comprised his own copies, made in 1913, of tombstone and synagogue decorations in the province of Volhynia. After a further period in Paris 1928–35, he spent the rest of his life in Russia, illustrating books and designing for the theatre and cinema.

Mark (Mordechai) Antokolsky (1843–1902) Leading naturalistic sculptor of both Jewish and non-Jewish subjects, associated with the **Wanderers** group; the first Jew to make a mark in the Russian art world. He was born in Vilna (now Vilnius in Lithuania) into a poor orthodox Jewish family, and in the liberal atmosphere of the 1860s achieved the distinction of being the first, and at the time the only, Jewish student at the St Petersburg Academy of Arts. In the 1870s, however, anti-Semitic responses to his work made him decide to live mainly abroad. In the words of his disciple, the sculptor Ilya Ginsburg (1859–1939), his talent represented 'an exceptional phenomenon in the intellectual life of Jews; he was the first to eradicate the old superstition that Jews are incapable of creating sculpture. After him there followed a group of talented Jewish artists who began tackling sculpture and the other arts with the same success.'

Guillaume Apollinaire, born **Wilhelm Apollinaris de Kostrowitzky** (1880–1918) Influential poet and art critic; early admirer and promoter of Chagall's work. Said to be the illegitimate son of a Polish woman, he was educated in the South of France. He settled in Paris in 1899, and from 1903, after working in a bank, supported himself by his writing, soon becoming a leading figure in avant-garde literary and artistic circles, and an important spokesman for **Cubism**; it was he who coined the term **Orphism**. As a poet, he focussed on the affinities between apparently disparate objects, rejected punctuation and experimented with pictorial typography. His best-known works include *Alcools* (1913), *Calligrammes* (1918) and *Les Mamelles de Tirésias* (*The Breasts of Tiresias*, 1918), which he dubbed a 'surrealist drama', the first known use of the term.

Boris Aronson (1898–1980) Russian–Jewish graphic artist and stage designer. Born in Kiev into a family of rabbis, he graduated from the Kiev Art Institute in 1916. He continued his studies at the Theatre School there, and joined Aleksandra Exter's studio. Between c.1918 and 1920 he was active in nationalist Jewish art circles, and was closely associated with the Kiev Kulturlige. In 1919 he was co-author, with **Issachar Ryback**, of an influential essay published in the Yiddish journal, *Oyfgang*, entitled 'Paths of Jewish Painting'. In 1922 he left Russia for Belin, where, like Chagall, he studied under **Hermann Struck** and in 1924 published two books, *Marc Chagall* and *Contemporary Jewish Graphics*. In the same year, he emigrated, via Paris, to America, settling in New York and working thereafter primarily as a designer for the theatre.

Léon Bakst, born **Lev Rosenberg** (1866–1924) Russian–Jewish painter and stage designer; taught Chagall at Zvantseva School of Art, St Petersburg, from 1908 to 1909. Born in Grodno, western Lithuania, into a relatively assimilated Jewish family, he trained at the St Petersburg Academy of Arts, and lived in Paris between 1893 and 1900, after which he settled in St Petersburg. Here he soon became an active member of the **Mir Iskusstva** group and a close associate of **Sergei Diaghilev**, establishing a reputation for himself as an illustrator, society portraitist, stage designer and teacher. In 1909 he moved to Paris, where his sensual orientalist designs played a major role in the success of Diaghilev's Ballets Russes.

Paul Cassirer (1871–1926) German–Jewish art dealer and publisher, whose Berlin gallery was an important centre for German avant-garde art prior to World War I. He was the first to exhibit the work of Édouard Manet (1832–83), Claude Monet (1840–1926), Van Gogh and Cézanne in Germany, and he championed the work of German Impressionists such as Lovis Corinth (1858–1925) and Max Liebermann (1847–1935). The Paul Cassirer Publishing House was founded in 1909; in 1910 he established the Pan Presse and launched the bi-monthly journal *Pan*. In the same period he founded the Gesellschaft Pan to present unknown or banned dramatic works to a small group of theatregoers. In 1922 Cassirer commissioned Chagall to illustrate his autobiography *My Life* with etchings, and was thus instrumental in turning his attention to printmaking.

Blaise Cendrars, pseudonym of **Frédéric Sauser** (1887–1961) Eccentric novelist and poet; a close friend of Chagall in Paris between 1910 and 1914. Described as 'one of the greatest liars of all time', he claimed to have been born in Paris, Egypt and Italy, but in fact was born in Switzerland to a

Swiss father and a Scottish mother. An inveterate traveller, he tried his hand as a businessman, student and horticulturalist before beginning to write seriously in c.1908. Consciously anti-literary in his approach, his poetry is impressionistic, apparently formless and full of incongruous juxtapositions. His subjects embrace the world of travel and high adventure, evoked with almost cinematic vividness. His writings include *19 Poèmes élastiques* (1913–14), *Panama* (1918), *Du Monde entier* (1919), *L'Or (Sutter's Gold*, 1925), *Les Confessions de Dan Yack* (1929), *Rhum* (1930).

Robert Delaunay (1885–1941) French artist; with his wife, **Sonia Delaunay-Terk**, one of Chagall's few close painter friends. Born in Paris, he first trained as a commercial decorative artist. From 1906, an interest in Neo-Impressionism and scientific colour theory led him to investigate the interaction of areas of contrasting colours, and in particular the effects of light on colour and the relationship between colour and movement. In 1911 he began to exhibit with the German Expressionist Blaue Reiter (Blue Rider) group, and to exert an influence on some of its members, notably Paul Klee (1879–1940), August Macke (1887–1914) and Franz Marc. In 1911 and 1912 he exhibited with members of the Cubist movement at the Salon des Indépendants, emerging as the pivotal figure in **Orphism.** Throughout his career, an interest in figuration (above all, the Parisian cityscape) alternated with the pursuit of pure abstraction.

Sonia Delaunay-Terk (1885–1979) French artist and designer of Russian–Jewish origin. Born in the Ukraine, she grew up in St Petersburg and studied drawing in Germany before settling in Paris in 1905. She married **Robert Delaunay** in 1910. Co-founder with him of **Orphism** she worked not only as a painter but also as a textile designer and book illustrator, notably *La Prose du Transsibérien et de la petite Jehanne de France* (1913) by **Blaise Cendrars.**

Sergei Diaghilev (1872–1929) Russian impresario. Born at Perm, near Novgorod, he moved to St Petersburg in 1890, where studied law at St Petersburg University, and music with Rimsky-Korsakov. Through his cousin he became involved with the **Mir Iskusstva** group and in the years 1898–1904 edited their journal, *Mir Iskusstva*. In the late 1890s he turned to collecting pictures and organizing exhibitions. His presentations of Russian music in Paris in the first decade of the century culminated in the first performance there of the Ballets Russes in 1909. His productions, which toured Europe and the USA, employed many outstanding figures, both of modern Russian art, such as **Léon Bakst** and **Natalia Goncharova**, and of western European art, including **Pablo Picasso** and Georges Braque, as stage and costume designers.

Mstislav Dobuzhinsky (1875–1957) Russian painter, graphic artist and stage designer; Chagall's teacher at Zvantseva School of Art in St Petersburg. In 1885–7 he attended the School of the Society for the Encouragement of Art in St Petersburg, but then trained as a lawyer. He studied art in Munich in 1899, returning to Russia in 1901. In 1902 he joined the **Mir Iskusstva** group and soon abandoned historical landscapes in favour of often surreal urban and suburban images, some with

political implications. From 1907 he was active as a teacher, book illustrator and designer for the stage, working for the experimental director Nikolai Evreinov and for the Moscow Arts Theatre. In 1919, at Chagall's invitation, he joined the staff of the Vitebsk Public Art School. In 1924 he left Russia to live in Lithuania and later moved to western Europe and the USA.

Natalia Goncharova (1881–1962) Born into an eminent artistic family in the province of Tula, south of Moscow, she initially studied science at Moscow University, before becoming interested in sculpture in 1898. She began to exhibit in 1900 and travelled extensively in Europe, turning to painting in 1904. Forming a close and long-standing relationship, both personal and professional, with **Mikhail Larionov**, she shared his (and **Kasimir Malevich**'s) enthusiasm both for the European avant-garde and for Russian folk art; Russian icons were another important source of inspiration. In c.1912, possibly influenced by Chagall, she produced a number of primitivistic images of Jewish family groups. Settling in Paris in 1915 with Larionov, she too worked thereafter primarily for the theatre.

Mikhail Larionov (1881–1964) Russian painter. Born at Tiraspol near Odessa, he trained at the Moscow Institute of Painting, Sculpture and Architecture, where his fellow students included **Natalia Goncharova**. His earliest work can be seen as a form of Russian Post-Impressionism; between c.1908 and 1913, however, he cultivated an emphatic primitivism, based on his admiration for Russian folk art, and was active in organizing a number of avant-garde exhibitions in Moscow (*Donkey's Tail*, 1912, *Target*, 1913) to which Chagall was invited to contribute. By 1912, he was experimenting with a variant of Italian **Futurism** which he dubbed Rayonism. He settled in Paris in 1915, virtually abandoning easel painting in favour of creating stage sets and costume designs, notably for **Sergei Diaghilev**'s Ballets Russes.

El (Eliezer) Lissitzky (1890–1941) Russian–Jewish painter and graphic artist. Born in the province of Smolensk, he grew up in Vitebsk and as a teenager his interest in art was encouraged by **Yehuda Pen**. In 1909 he moved to Darmstadt, Germany, to study architecture, before returning to Russia in 1914. His interest in Jewish folk art was confirmed in 1916 by his exploration, with **Issachar Ryback**, of the wooden synagogues along the River Dnepr. Between c.1917 and 1923, he was active as an illustrator of Yiddish children's books and other texts. In 1919 Chagall invited him to teach architecture and graphics at the Vitebsk Public Art School, where he seems to have switched his allegiances, both personal and artistic, from Chagall to **Kasimir Malevich**. Between 1922 and 1925 he travelled in western Europe, but returned to the USSR thereafter, devoting himself primarily to typography and industrial design.

Aimé Maeght (1906–1981) French dealer and publisher; represented Chagall from the early 1950s. In his twenties he worked as a lithographer and poster designer. In 1928 he married Marguerite Devaye (1905–77); in 1937 they opened the Galerie Arte in Cannes. In 1945, with the encouragement of Pierre Bonnard (1867–1947), **Henri Matisse** and other artists and writers they had met in the South of France, they moved to

Paris, where they opened the Galerie Maeght at 13 rue de Téhéran. Refusing to confine themselves to any one artistic trend, they also became increasingly active as publishers, notably of *Derrière le Miroir*, a magazine which doubled as a catalogue of exhibitions held at the gallery, and of three periodicals: *L'Ephémère*, a quarterly literary journal, published in the late 1960s; *L'Art Vivant*, a monthly covering early 1970s contemporary arts; and *Argile*, a late 1970s poetry magazine.

In the early 1960s the Maeghts' created a cultural centre in St Paul-de-Vence near Nice, known as the Fondation Maeght, which played host to a number of important Chagall exhibitions.

Kasimir Malevich (1878–1935) Russian painter and theorist, founder of **Suprematism**; Chagall's rival at the Vitebsk Public Art School. Born and trained near Kiev, he settled in Moscow in 1905. His painting style thereafter reflects the influence of a succession of European movements, from Impressionism and Post-Impressionism, through a primitivist celebration of peasant life – due largely to his association with **Mikhael Larionov** and **Natalia Goncharova** – to **Cubism** and **Futurism**. By 1915 he had produced his first purely abstract geometric compositions, which he labelled Suprematist. In late 1919 he joined the staff of the Vitebsk Public Art School, from which Chagall was to be ousted by Malevich's followers. In the late 1920s, out of favour with the Soviet authorities, but with an international reputation as a pioneering abstract artist, he returned to figurative painting.

Henri Matisse (1869–1954) French painter, sculptor and graphic artist. Born at Le Cateau-Cambrésis, near Cambrai in northern France, he moved to Paris in 1887 to train as a lawyer. In 1890, however, he abandoned law to study art, first under the academic painter Adolphe Bouguereau (1825–1905) at the Académie Julian and then under the symbolist painter Gustave Moreau (1826–98) at the École des Beaux Arts. His earliest work shows the influence of Jean-Baptiste-Siméon Chardin (1699–1779), Jean-Baptiste-Camille Corot (1796–1875), and the Impressionists. By 1905, under the influence of the Post-Impressionists, he had evolved a distinctive style of his own, characterized by bold colours and rhythmic composition, and had become the uncontested leader of the Fauve group. By 1914 his reputation as a major figure in the avant-garde art world was assured. From the 1920s he divided his time between Paris and Nice, and in 1943 settled in Vence, near Nice, where he worked on the Chapelle du Rosaire between 1948 and 1951. From 1949 until his death he lived in Nice.

Pierre Matisse (1900–89) Art dealer; second son of **Henri Matisse**. He initially worked in a Paris gallery, but settled in New York in the mid-1920s, opening the Pierre Matisse Gallery at 41 East 57th Street in 1932. One of the most important early supporters of **Surrealism** in America, for many years he handled the work of Joan Miró (1893–1983), Balthus (b.1908), Alexander Calder (1898–1976), Alberto Giacometti (1901–66), Yves Tanguy (1900–55), and Wilfredo Lam (1902–82), among others. He acted as Chagall's main New York dealer from 1941 until 1982.

Yehuda Pen (1854–1937) Russian–Jewish painter of portraits, Jewish genre scenes and landscape,

inspired by the ideas of the **Wanderers** and of Jewish national revival. He studied at the Imperial Academy of Arts, St Petersburg, between 1880 and 1886, where he encountered the ideas of **Vladimir Stasov**. Between 1891 and 1896, he worked as an artist on the estate of Baron Korg near Kreisburg, where **Ilya Repin** was a neighbour and associate. In 1897 he founded a School of Drawing and Painting in Vitebsk, the first predominantly Jewish art school in the Russian Empire, where his students included Chagall and Solomon Yudovin (1892–1954). At Chagall's invitation, he taught at the Vitebsk Public Art School between 1919 and 1923. Weathering all ideological storms, he continued working in Vitebsk until his murder, in mysterious circumstances, in 1937. During the Nazi invasion of Belorussia, his works were evacuated to the Ural Mountains for safekeeping. After the war, 300 of his paintings were returned to the Belorussian State Art Museum, Minsk, where they remained in storage until their rediscovery in the late 1980s.

Pablo Picasso (1881–1973) Spanish-born painter, sculptor and graphic artist; dominated the visual arts during the first half of the twentieth century. Born in Malaga, the son of a painter, he grew up in Corunna and Barcelona, showing a prodigious talent from an early age. He first visited Paris in 1900 and settled there in 1904. His early career can be roughly summarized as follows: Blue Period (1901–4); Rose Period (1904–6); 'Negro' Period (1907–9), during which he painted the seminal work of **Cubism**, *Les Demoiselles d'Avignon* (1907); Analytic (c.1907–12) and Synthetic (c.1912–14) Cubist periods. From c.1917 until the early 1920s his work veered between a more decorative form of Cubism and a classicizing tendency; in the later 1920s a more emotional, surrealist element entered his work, culminating in *Guernica* in 1937. Picasso spent World War II in Paris, but settled in the South of France in 1946, where for the first time he worked in the ceramic medium.

Ilya Repin (1844–1930) Leading painter of the populist **Wanderers** group. He grew up in the military settlement of Chuguyev in the Ukraine, whose inhabitants included Jewish cantonists (forced child converts to Christianity), and was thus familiar with traditional Jewish customs. His *Volga Boatmen*, exhibited in Vienna in 1873, made him internationally famous. As well as specializing in scenes from Russian life and history (his best-known paintings include *Ivan the Terrible with the Body of his Son* of 1885 and *Cossacks Defying the Sultan* of 1891), he was also a portraitist. He was an associate of **Yehuda Pen** in the 1890s and encouraged him to incorporate the ideas of **Vladimir Stasov** and **Mark Antokolsky** in his paintings. Although both the **Mir Iskusstva** group and the avant-garde of the early twentieth century rejected his brand of social realism, his work later became a model for Soviet **Socialist Realism**.

Issachar Ber Ryback (1897–1935) Russian–Jewish painter and graphic artist. Born into a Hasidic family in Elizavetgrad, he attended the Kiev Art Institute between 1911 and 1916, the year in which he and **El Lissitzky** explored the art and architecture of the wooden synagogues along the River Dnepr. His entire career was devoted to a portrayal of Jewish subjects, depicted in a style

indebted both to Western avant-garde movements and to ethnographical sources. Between c.1917 and 1919 he took an active part in the search for an authentic modern Jewish art, and was co-author, with **Boris Aronson** of an important essay, 'Paths of Jewish Painting'. In 1919 he moved to Moscow, and in 1921 to Berlin. Returning briefly to Russia in 1925, he settled for good in Paris in 1926.

Vladimir Stasov (1824–1906) Art and music critic; theoretician and leading spokesman for the **Wanderers**. Stasov was not Jewish, but his belief in the need for creative expression for all ethnic groups in Russia led him to encourage the young **Mark Antokolsky** and to take an active role in promoting an interest in indigenous Russian–Jewish art. He wrote *Russian Folk Ornament* (1860–72) and *Slavic and Oriental Ornament According to Manuscripts of the Fourth to the Nineteenth Centuries* (1886). In 1886 he collaborated with the Jewish scholar and philanthropist Baron David Ginsburg in an influential compilation of Hebrew manuscripts, which was published in French in 1905 as *L'Ornament hébreu*.

Hermann Struck (1876–1944) German–Jewish graphic artist and teacher; introduced Chagall to the etching medium. Born in Berlin into an orthodox family, he remained an orthodox Jew throughout his life and was also an ardent Zionist from an early age. He studied at the Berlin Academy. During World War I he served with the German army in Lithuania, and thus came into contact with eastern European Jews and their way of life, which inspired much of his subsequent work. As well as producing naturalistic scenes of Jewish life, landscapes and ex-libris images, he excelled as a portraitist (his sitters included Theodor Herzl, Henrik Ibsen, Friedrich Wilhelm Nietzsche, Sigmund Freud and Albert Einstein). In 1908 he published *Die Kunst des Radierens* ('The Art of Etching'), which was reprinted and revised many times. Struck emigrated to Palestine in 1923.

Abraham Sutzkever (b.1913) Yiddish poet. He was born in Belorussia and educated at the University of Vilna. His first lyric poems were published in 1933 and by 1937 he was widely recognized as an important new voice in Yiddish literature. A survivor of the Vilna Ghetto, he settled in Palestine in 1949 and became editor of the important Yiddish literary quarterly *Di Goldene Keyt* ('The Golden Chain'), to which Chagall (who had first met him in Vilna in 1935) was a regular contributor. His poems include *Sibir* (Siberia) of 1953, illustrated by Chagall.

Tériade, born **Efstratios Eleftheriades** (1897–1983) Greek-born writer, editor and publisher resident in France; after World War II, he commissioned and published much of Chagall's graphic work. He arrived in France in 1915, aged eighteen, and began to study law, but abandoned this in favour of the art world. He started his career as writer (with Maurice Raynal) of an art column for the famous Parisian newspaper *L'Intransigéant* (1928–35). He was co-founder (with Christian Zervos) of the journal *Cahiers d'Art*, and (with Albert Skira) of the Surrealist publication *Minotaure*; editor of *Verve*, an art review in French and English, from 1937 to 1960, and publisher in 1940s and 1950s of the *Grands Livres*, which combined visual art and poetry.

Max (Maxim) Vinaver (1862–1926) Jewish lawyer and politician; Chagall's first patron. Born and educated in Warsaw, he settled in St Petersburg, where he became a prominent civil lawyer. After the 1905 Revolution, he became a founder-member of the Constitutional Democratic Party, and in 1906 a member of the first Duma (parliament). During the civil war, he acted as foreign minister of the regional government set up by his party in the Crimea. Extremely active in the promotion of Russian–Jewish culture, he was a founder-member of the Jewish Historical and Ethnographical Society, a keen supporter of the Society for the Encouragement of Jewish Art and the editor of several influential newspapers and journals. In 1919 he emigrated to France, where he continued to be politically active in Russian circles. The fact that Chagall invited him to Ida's eighth birthday party in 1924 suggests that the two men maintained some contact with each other.

Ambroise Vollard (1867–1939) Pioneering Parisian dealer and publisher; commissioned a major series of book illustrations from Chagall in the 1920s and 1930s. Born on the island of La Réunion, he originally moved to France to study law. A shrewd judge of aesthetic innovation and in a position to take financial risks, he was the first dealer to buy the work of Paul Cézanne. Cézanne, **Henri Matisse** and **Pablo Picasso** all had their first one-man shows in his Paris gallery and he mixed socially with many of those at the cutting-edge of French artistic and literary life. His memoirs, *Recollections of a Picture Dealer*, were published in the 1930s.

Herwarth Walden, born **Georg Levin** (1879–1941) German–Jewish dealer and editor; gave Chagall his first one-man exhibition in 1914. Born in Berlin, he established himself as the leading promoter of German Expressionist art and literature and other avant-garde trends, founding *Der Sturm* magazine in 1910, and a gallery of the same name in 1913. His first wife was the poet Else Lasker-Schüler. In the late 1920s he responded to the rise of Fascism by joining the Communist Party, and in 1932 he emigrated to the Soviet Union. He disappeared in 1941, probably the victim of deportation to a Soviet labour camp.

The Life and Art of Marc Chagall

1887	Mark Chagall born in Vitebsk, 6 July
1906	Studies at Yehuda Pen's School of Drawing and Painting in Vitebsk, then moves to St Petersburg. Attends school of the Imperial Society for the Protection of Fine Art, directed by Nikolai Roerich
1908	Enters the Zvantseva School in St Petersburg
1910	Spring: Two paintings included in exhibition of pupils of Zvantseva School held at offices of journal *Apollon*. Late summer: Vinaver's financial support enables Chagall to go to Paris
1911–12	Lives in studio in Impasse du Maine in Montparnasse. Studies sporadically at Académie de la Grande Chaumière and Académie de la Palette
1912	Spring: moves to La Ruche. Exhibits at Salon des Indépendants [35], Salon d'Automne, Paris; *Donkey's Tail*, Moscow
1913	Exhibits at Salon des Indépendants; April. Work shown at Der Sturm with that of Alfred Kubin; Attends opening of first German Herbstsalon, Berlin [35, 54, 56]
1914	Exhibits at Paris Salon des Indépendants [34, 52, 57]. Goes to Berlin for opening of first one-man exhibition at Der Sturm. Travels on to Vitebsk
1915	March: work included in *The Year 1915* exhibition, Moscow. July: marries Bella Rosenfeld in Vitebsk. Goes to live in Petrograd; works in Office of War Economy; begins to write *My Life*
1916	May: Birth of daughter Ida. Work included in *Knave of Diamonds* exhibition, Moscow
1917	April: Work included in exhibition of *Paintings and Sculptures by Jewish Artists*, Moscow. Nominated

A Context of Events

1881–3	First wave of pogroms against Jews
1890s	Mir Iskusstva (World of Art) group forms in St Petersburg
1900	Paul Gauguin publishes his memoir *Noa-Noa*
1903–6	Second wave of pogroms against Jews
1904	Russo–Japanese War (to 1905)
1905	Revolution in Russia. Fauves' work exhibited at Paris Salon des Indépendants. Die Brücke Expressionist group formed in Dresden
1907	Picasso completes *Les Demoiselles d'Avignon* [24]. First exhibition of Cubist works in Paris
1909	Ballets Russes perform in Paris
1911	German Expressionist group, Der Blaue Reiter (The Blue Rider), forms in Munich
1911–13	Beilis Affair in Russia
1912	Guillaume Apollinaire coins the term Orphism to describe Robert Delaunay's work
1914	Outbreak of World War I. St Petersburg renamed Petrograd
1916	Society for the Encouragement of Jewish Art founded in Petrograd
1917	Russian Revolution. Leads to civil war in which the Red Army is ultimately victorious (1920).

The Life and Art of Marc Chagall	A Context of Events
for post of Director of Fine Art in the Petrograd Ministry of Culture; refuses, and in November returns with his family to Vitebsk	Wave of progroms begins (to 1921). Marcel Duchamp exhibits the first 'ready-made' in the form of a urinal in New York
1918 Appointed Commissar for Art for region of Vitebsk. Organizes street decorations for first anniversary of Bolshevik Revolution [87]. Two rooms devoted to his work in Winter Palace, Petrograd. Publication of *The Art of Marc Chagall* by Abram Efros and Yakov Tugendhold	**1918** March: Treaty of Brest-Litovsk ends Russian involvement in World War I. November: Armistice ends World War I. Kaiser William II abdicates in Germany leading to establishment of Weimar Republic
1919–20 Presides over Vitebsk art school while working for Theatre of Revolutionary Satire (Terevsat)	**1919** Communist revolt in Berlin. Murder of Karl Liebknecht and Rosa Luxemburg
1920 Moves to Moscow; works for State Yiddish Chamber Theatre [95–108]	**1920** Palestine becomes a British mandate following the Balfour Declaration of 1917
1921–2 Teaches at war orphans' colony, Malakhovka	
1922 Leaves Russia; travels to Berlin, via Kaunas, then in Lithuania. October: work included in *Die Erste russische Kunstaustellung*, Van Diemen Gallery, Berlin. Commissioned by Cassirer to illustrate *My Life*; learns woodcut, lithography and etching techniques [117, 118]	**1922** Union of Soviet Socialist Republics (USSR) established. Mussolini forms government in Rome
1923 *Mein Leben (My Life)* etchings published [121–124]. Returns to Paris. Commissioned by Ambroise Vollard to illustrate Gogol's *Dead Souls* [129, 130]	
1924 First one-man exhibition in Paris, at the Galerie Barbazanges-Hodebert. Holiday in Brittany (first of many French holidays in 1920s)	**1924** Petrograd renamed Leningrad after death of Lenin
1925 Commissioned by Ambroise Vollard to illustrate *Fables* of Jean de La Fontaine	**1925** Sergei Eisenstein's film *The Battlship Potemkin*, about the 1905 Revolution first shown. First Surrealist group exhibition in Paris
1926 First exhibition in New York, at Reinhart Galleries	**1926** John Logie Baird makes first television transmission in London
1926–27 Produces gouaches for *Fables* of La Fontaine [131], and for *Cirque Vollard* project	
1927 Presents ninety-six etchings for Nikolai Gogol's *Dead Souls* to Tretyakov Gallery, Moscow. Contract with Bernheim-Jeune (until 1929)	
1928 Works on etchings for *Fables* of La Fontaine [132]	
1930 Commissioned by Vollard to illustrate the Bible [153, 155]	**1929** Wall Street Crash leads to Depression
1931 First visit to Palestine [148, 149]	
1932 Visits Amsterdam	
1933 Restrospective exhibition at Kunsthalle, Basle. Work included in *Images of Cultural Bolshevism* exhibition, Mannheim, Germany	**1933** Adolf Hitler becomes Chancellor of Germany. In USA President Franklin Roosevelt takes office and initiates New Deal
1934 Visits Spain	**1934** Socialist Realism declared official cultural policy in USSR
1935 Travels to Vilna, Poland	**1935** Death of Kasimir Malevich
	1936 Outbreak of Civil War in Spain (to 1939)

The Life and Art of Marc Chagall	A Context of Events
1937 Granted French citizenship	1937 Nazi *Degenerate Art* exhibition opens in Munich
1939 Awarded American Carnegie Prize. Leaves Paris for Gordes in the South of France	1939 Outbreak of World War II. Death of Ambroise Vollard
1940 Exhibition at Galerie Mai, Paris. Invitation from Museum of Modern Art, New York, to come to USA	1940 France: Nazi occupation; puppet Vichy regime in southern France
1941 Travels via Lisbon to New York (arrives 23 June). November: exhibition at Pierre Matisse Gallery, New York	1941 June: German invasion of Russia. Nazis occupy Vitebsk; systematic liquidation of Vitebsk Jews. December: Japan attacks Pearl Harbor and USA enters the war
1942 Participates in *Artists in Exile*, Pierre Matisse Gallery [173], and *First Papers of Surrealism* exhibitions. Works on *Aleko* for American Ballet Theater [167, 176, 177] in Mexico August–September	
1943 Re-encounters actor Solomon Mikhoels and writer Itzik Feffer who are in New York on a USSR cultural mission	
1944 September: death of Bella	
1945 Begins relationship with Virginia Haggard McNeil. Designs sets and costumes for *The Firebird* for American Ballet Theater [188, 189]	1945 End of World War II. Nazi concentration camps liberated
1946 Birth of his son, David McNeil Retrospective exhibition at Museum of Modern Art, New York, and the Art Institute of Chicago. Produces first colour lithographs for *The Arabian Nights* [190, 191]. First postwar visit to Paris	1946 First meeting of the Gerneral Assembly of the United Nations
1947 Retrospective at Musée National d'Art Moderne, Paris	
1948 Permanent return to France; settles in Orgeval, near Paris. Tériade publishes *Dead Souls* etchings; awarded Engraving Prize at Venice Biennale, Italy. Exhibitions at Stedelijk Museum, Amsterdam, and Tate Gallery, London	1948 Creation of state of Israel. Mahatma Gandhi assassinated
1949 Moves to St Jean-Cap-Ferrat, French Riviera. Paints murals for Watergate Theatre, London [194]	1949 Chinese People's Republic proclaimed
1950 Moves to Vence. Produces wash drawings for Boccaccio's *The Decameron*	
1951 Visits Israel. Produces first sculptures	
1952 Tériade publishes etchings for the *Fables* of La Fontaine . End of relationship with Virginia Haggard McNeil; marries Valentina (Vava) Brodsky. Produces gouaches for *Daphnis and Chloë* [201]	1952 United Nations headquarters opens in New York
1953 Visits London	1953 Death of Joseph Stalin
	1954 Death of Henri Matisse
1955 Starts work on Biblical Message cycle of paintings [211–213]	
1956 Bible etchings published by Tériade	1956 Hungarian Uprising; Suez Canal crisis

The Life and Art of Marc Chagall	A Context of Events
1957 Third visit to Israel. Produces ceramic panel and stained glass for Nôtre Dame de Toute Grâce, in Assy, Haute-Savoie [205]	
1958 Commissioned by Paris Opéra to design sets and costumes for ballet *Daphnis and Chloë*. Begins stained-glass windows for Metz Cathedral	
1960 Paints *Commedia dell'Arte* for Frankfurt theatre	
1962 Completes first stained glass for Metz Cathedral. Travels to Israel for inauguration of Hadassah Medical Centre windows [206]	1961 Berlin Wall built
1964 Visits New York for inauguration of Peace window at United Nations [208]. Ceiling at the Paris Opéra unveiled [214]	1963 President John F Kennedy assassinated
1965 Begins sets and costumes for *The Magic Flute* and murals for Metropolitan Opera House, New York [215]	
1966 Moves to St Paul-de-Vence, France Eight windows installed in church at Pocantico Hills, Tarrytown, New York	
1967 Commission for stained glass at All Saints' Church, Tudeley, Kent, England	1967 Six Day War in the Middle East ends in Israeli occupation of Sinai and the Gaza Strip
1968 Completes stained glass for triforium in north transept, Metz Cathedral, Germany [207]	1968 Warsaw Pact countries invade Czechoslovakia
1969 Foundation stone laid for Museum of Biblical Message, Nice, France. Opening of Knesset (parliament) building, Jerusalem, with work by Chagall [216]	1969 Neil Armstrong is first man on the moon
1971 Mosaic for Museum of Biblical Message, Nice [210]	
1972 Designs stained-glass windows for Museum of Biblical Message	
1973 Returns to Russia for first time since 1922. Visits Moscow and Leningrad; exhibition of lithographs at Tretyakov Gallery, Moscow. Inauguration of Museum of Biblical Message, Nice	1973 Last US troops leave Vietnam Yom Kippur War between Israel and Egypt. Death of Pablo Picasso
1974 Unveiling of window for Reims Cathedral. Visits Chicago for unveiling of Four Seasons mosaic	
1975 Works on lithographs for Shakespeare's *The Tempest*. Publication of lithographs for Homer's *The Odyssey*	
1976 Designs mosaic for Ste Roseline les Arcs, near Draguignan, France	
1977 Awarded the Grand Cross of the Légion d'Honneur [227]. Visits Italy and Israel	
1978 Inauguration of windows at Church of St Etienne, Mayenne and window at Chichester Cathedral, Sussex, England	
1980 Exhibits *Psalms of David* at Museum of Biblical Message	
1985 Dies 28 March in St Paul-de-Vence, where he is buried	1985 Mikhail Gorbachov initiates *glasnost* and reforms that lead to the break-up of the USSR

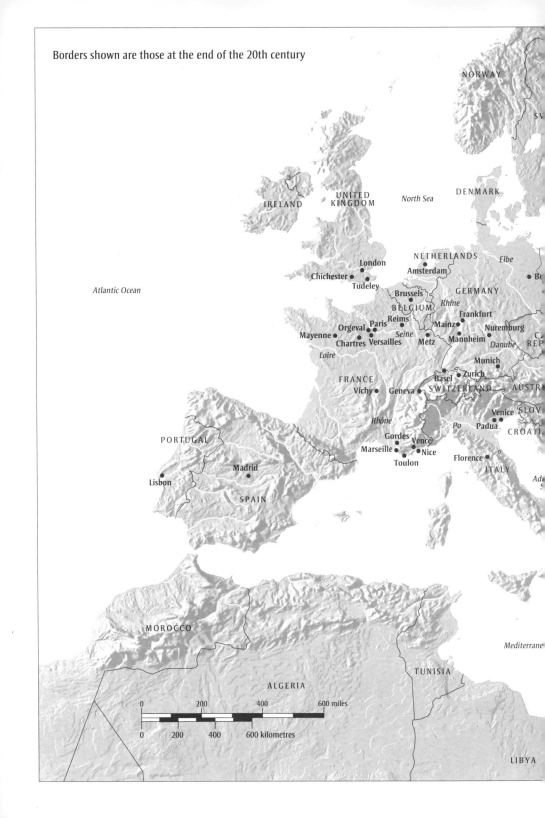

Borders shown are those at the end of the 20th century

Further Reading

Works on Chagall

Sidney Alexander, *Marc Chagall, A Biography* (London, 1978)

Ziva Amishai-Maisels, 'Chagall's Jewish In-Jokes', *Journal of Jewish Art*, 5 (1978), pp.76–93

Irina Antonova, Andrei Voznesensky and Marina Bessonova, *Chagall Discovered from Russian and Private Collections* (Moscow, 1989)

Umbro Apollonio, *Chagall* (Venice, 1949)

Ruth Apter-Gabriel (ed.), *Chagall: Dreams and Drama, Early Russian Works and Murals for the Jewish Theatre* (exh. cat., Israel Museum, Jerusalem, 1993)

Boris Aronson, *Marc Chagall* (Berlin, 1924)

Michael Ayrton, *Chagall* (London, 1948)

Jacob Baal-Teshuva (ed.), *Chagall, A Retrospective* (New York, 1995)

Jennifer Blessing, Susan Compton and Benjamin Harshav, *Marc Chagall and the Jewish Theatre* (exh. cat., Solomon R Guggenheim Museum, New York; The Art Institute of Chicago, 1993)

Marcel Brion, *Chagall* (London and New York, 1961)

Julien Cain, *The Lithographs of Chagall* (Monte Carlo and London, 1960)

Jean Cassou, *Marc Chagall* (London, 1965)

J Chatelain, *The Biblical Message of Marc Chagall* (New York, 1973)

Raymond Cogniat, *Chagall* (Zurich, 1964)

Susan Compton, *Chagall* (exh. cat., Royal Academy of Arts, London, 1985)

—, *Marc Chagall, My Life – My Dream, Berlin and Paris, 1922–1940* (Munich, 1990)

Patrick Cramer, *Marc Chagall, The Illustrated Books: Catalogue Raisonné* (Geneva, 1995)

— and Jean Leymarie, *Marc Chagall, Monotypes*, 2 vols (Geneva, 1976)

Jean-Paul Crespelle, *Chagall: L'amour, le rêve et la vie* (Paris, 1969)

Theodor Däubler, *Marc Chagall* (Rome, 1922)

Abram Efros and Yakov Tugendhold, *Die Kunst Marc Chagalls* (Potsdam, 1921)

Walter Erben, *Marc Chagall* (New York, 1957, revised edn, 1966)

Paul Fierens, *Marc Chagall* (Paris, 1929)

Sylvie Forestier and Meret Meyer, *Chagall Ceramik* (Munich, 1990)

Matthew Frost, 'Marc Chagall and the Jewish State Chamber Theatre', *Russian History*, 8: 1–2 (1981), pp.94–101

Waldemar George, *Marc Chagall* (Paris, 1928)

Werner Haftmann, *Marc Chagall: Gouaches, Drawings, Watercolours* (New York, 1975)

Virginia Haggard, *My Life with Chagall, Seven Years of Plenty* (London, 1987)

A M Hammacher, *Marc Chagall* (Antwerp, 1935)

Aleksandr Kamensky, *Chagall: The Russian Years 1907–1922* (London, 1989)

Isaak Kloomok, *Marc Chagall, His Life and Work* (New York, 1951)

Eberhard W Kornfeld, *Marc Chagall: Catalogue raisonné de l'oeuvre gravé, vol. 1: 1922–1966* (Bern, 1971)

Sandor Kuthy and Meret Meyer, *Marc Chagall 1907–1917* (exh. cat., Kunstmuseum, Berne, 1995–6; Jewish Museum, New York, 1996)

Jacques Lassaigne, *Marc Chagall* (Geneva, 1952)

—, *Marc Chagall, dessins et acquarelles pour le ballet* (Paris, 1969)

Jean Leymarie, *Marc Chagall, The Jerusalem Windows* (London, 1968)

Isaac Lichtenstein, *Marc Chagall* (Paris, 1927)

André Malraux and Charles Sorlier, *The Ceramics and Sculpture of Marc Chagall* (Monte Carlo, 1972)

Raïssa Maritain, *Chagall ou l'Orage enchanté* (Geneva and Paris, 1948)

C Marq and R Marteau, *Les Vitraux de Chagall 1957–1970* (Paris, 1972)

Roy McMullen, *The World of Marc Chagall* (New York, 1968)

Franz Meyer, *Marc Chagall, Life and Work* (London and New York, 1964)

—, *Marc Chagall: The Graphic Work* (London and Stuttgart, 1957)

Suzanne Page et al., *Marc Chagall, Les années russes, 1907–1922* (exh. cat., Musée d'Art Moderne de la Ville de Paris, 1995)

Gill Polonsky, *Chagall* (London, 1998)

Edouard Roditi, *Dialogues on Art* (London, 1960), pp.16–38

Jean Bloch Rosensaft, *Chagall and the Bible* (exh. cat., Jewish Museum, New York, 1987)

André Salmon, *Chagall* (Paris, 1928)

René Schwob, *Chagall et l'âme juive* (Paris, 1931)

Charles Sorlier, *Chagall, The Illustrated Books* (Paris, 1990)

James Johnson Sweeney, *Marc Chagall* (exh. cat., Museum of Modern Art, New York, 1946)

—, 'An Interview with Marc Chagall', 1944, repr. in part in Herschel B Chipp, *Theories of Modern Art* (Berkeley, 1968), pp.440–3

Lionello Venturi, *Marc Chagall* (Geneva, Paris and New York, 1956)

C Vitali, A Kamensky, A Shatskich *et al.*, *Marc Chagall, The Russian Years 1906–1922* (exh. cat., Schirn Kunsthalle, Frankfurt, 1991)

Alfred Werner, *Chagall Watercolours and Gouaches* (New York, 1970)

Works Illustrated or Written by Chagall

Bella Chagall, *Burning Lights* (New York, 1946)

—, *First Encounter* (New York, 1983)

Marc Chagall, *Arabian Nights, Four Tales from a Thousand and One Nights* (Munich, 1988)

—, *Daphnis and Chloë* by Longus (New York, 1977)

—, *Fables* by La Fontaine, 2 vols (Paris, 1952)

—, *My Life* (London, 1965, repr. 1985, New York, 1994))

—, *Poèmes* (Geneva, 1975)

Charles Sorlier (ed.), *Chagall by Chagall* (London, 1979)

Historical and Cultural Background

Ziva Amishai-Maisels, *Depiction and Interpretation: The Influence of the Holocaust on the Visual Arts* (Oxford, 1993)

—, 'Christological Symbolism of the Holocaust', *Holocaust and Genocide Studies*, 3:4 (1988), pp.457–81

Ruth Apter-Gabriel (ed.), *Tradition and Revolution, The Jewish Renaissance in Russian Avant-Garde Art 1912–1928* (exh. cat., Israel Museum, Jerusalem, 1987)

Stephanie Barron (ed.), *Degenerate Art: The Fate of the Avant-Garde in Nazi Germany* (exh. cat., Los Angeles County Museum of Art, 1991)

—, *Exiles and Emigrés: The Flight of European Artists from Hitler* (exh. cat., Los Angeles County Museum of Art, 1997)

Monica Bohm-Duchen (ed.), *After Auschwitz: Responses to the Holocaust in Contemporary Art* (London, 1995)

John E Bowlt, *Russian Stage Design* (exh. cat., Mississippi Museum of Art, 1982)

Michèle C Cone, *Artists under Vichy: A Case of Prejudice and Persecution* (Princeton, NJ, 1992)

Ken Frieden, *Classic Yiddish Fiction: Abramovitsh, Sholem Aleichem and Peretz* (New York, 1995)

Susan Goodman (ed.), *Russian-Jewish Artists in a Century of Change 1890–1980* (exh. cat., Jewish Museum, New York, 1995–6)

Nigel Gosling, *Paris 1900–1914, The Miraculous Years* (London, 1978)

Camilla Gray *et al.*, *Art in Revolution: Soviet Art and Design since 1917* (exh. cat., Hayward Gallery, London, 1971)

—, *The Russian Experiment in Art 1863–1922* (London, 1986)

Grace Cohen Grossman, *Jewish Art* (New York, 1995)

Irving Howe and Eliezer Greenberg, *A Treasury of Yiddish Stories* (London, 1990)

Rabbi Louis Jacobs, *The Jewish Religion: A Companion* (Oxford, 1995)

Avram Kampf, *Chagall to Kitaj: Jewish Experience in Twentieth Century Art* (exh. cat., Barbican Art Gallery, London, 1990)

G Kasovsky, *Artists from Vitebsk: Yehuda Pen and his Pupils* (Moscow, n.d.)

Joseph C Landis (trans.), *The Great Yiddish Plays* (New York, 1980)

Henning Rischbieter, *Art and the Stage in the Twentieth Century* (Greenwich, CT, 1970)

Nahma Sandrow, *Vagabond Stars: A World History of Yiddish Theater* (New York, Hagerstown, San Francisco and London, 1977)

Gabrielle Sed-Rajna, *Jewish Art* (New York, 1997)

Kenneth E Silver and Romy Golan, *The Circle of Montparnasse: Jewish Artists in Paris 1905–1945* (exh. cat., Jewish Museum, New York, 1985)

Ambroise Vollard, *Recollections of a Picture Dealer* (New York, 1978)

M Vorobiev [Marevna], *Life with the Painters of La Ruche* (London, 1972)

Jeanine Warnod, *La Ruche et Montparnasse* (Geneva and Paris, 1978)

Z Yargina, *Wooden Synagogues* (Moscow, n.d.)

Index

Numbers in **bold** refer to illustrations

Acknowledgements

A book such as this one inevitably owes much to
the scholarship of others. While the synthesis of
material is very much my own, and my approach,
I hope, distinctive, I am particularly indebted to the
researches of the following: Aleksandra Shatskikh,
Aleksandr Kamensky, Benjamin Harshav, Ziva
Amishai-Maisels, Avram Kampf and Susan
Compton. Details of these scholars' publications
can be found in the Further Reading section.

I should also like to thank the staff of the Tate
Gallery Library and Barry Davis for their help, and
Peter Owen Ltd, London, for permission to quote
passages from Chagall's *My Life*. I am grateful to
Marc Jordan for inviting me to write this book, and
to Pat Barylski, Michael Bird, Giulia Hetherington,
Sophie Hartley and, above all, Julia MacKenzie of
Phaidon Press for their meticulous comments and
practical assistance. They have been a pleasure to
work with.

Last but by no means least, my thanks go to the
long-suffering members of my family who, no less
than the author, are delighted that this volume has
finally become a reality.

M B-D

A Note on Spelling

Readers will be aware that spellings of foreign
names found in this book do not always correspond
to those found in other publications. Transliteration
from languages employing different alphabets is a
notoriously tricky business, and attempts at consis-
tency are often doomed to failure, since it seems
foolish to spell well-known names in unfamiliar –
even unrecognizable – ways for the sake of linguis-
tic accuracy. Nevertheless, I have tried as far as
possible to be consistent within the confines of the
book, and to adhere to spellings that, while not
seeming too alien to an English-speaking reader-
ship, give a clear sense of the authentic sound of
the names.

Photographic Credits

AKG London 116, 152, photo Erich Lessing 86, photo Walter Limot 31; Albright-Knox Art Gallery, Buffalo, New York: General Purchase Funds, 1946, 169, Room of Contemporary Art Fund, 1941, 125; Aquavella Galleries, Inc, New York: 223; Art Gallery of Ontario, Toronto: gift of Sam and Ayala Zacks (1970) 68, 77; The Art Institute of Chicago: gift of Mr and Mrs Maurice E Culberg (1952.3) 47, gift of the Print and Drawing Club (1952.138) 130, gift of Alfred S Alschuler (1946.925) 161; Jacob Baal-Teshuva Collection, New York: 190, 228; Baltimore Museum of Art: the Cone Collection, formed by Dr Claribel Cone and Miss Etta Cone of Baltimore, Maryland 175; Bibliothèque Inguimbertine, Carpentras 73; Photo Clive Boursnell 111, 112; Bridgeman Art Library, London: 18, 38, 39, 55, 72, 75, 141, 151, 165, 178, 193; British Museum, London: 115, 119; Christie's Images, London 201; Courtauld Institute of Art, Conway Library, London: 7; The Finnish National Gallery/Ateneum, Helsinki: photo the Central Art Archives 60; Fondation Maeght, Saint-Paul: 217, 220; Fondation E G Bührle Collection: 20; Fukuoka Art Museum, Japan: 183; Fundación Coleccion Thyssen-Bornemisza, Madrid: 137, 180; Galerie Daniel Malingue, Paris: 197; Galerie Kornfeld, Bern: 114, 134; Galerie Rosengart, Lucerne: 80; Giraudon, Paris: 27, 41, 69, 83, 85, 87, 94, 216; Solomon R Guggenheim Museum, New York: photo David Heald 42, 128; Photo Guillet-Lescuyer: 205; Sonia Halliday Photographs, Weston Turville: 209; Hamburger Kunsthalle: photo Elke Walford 202; Israel Museum, Jerusalem: 37, 76, 120, 142, photos David Harris 79, Robin Terry 171; The Jewish Museum, New York 121, 124; David King, London 92; Metropolitan Opera, New York: photo Winnie Klotz 215; Kunsthalle Bielefeld: 59; Kunsthaus Zurich: 21, 218; Kunstmuseum Bern: photo Peter Lauri 54; Kunstmuseum Düsseldorf im Ehrenhof: photo Studio K 191; Kunstsammlung Nordrhein-Westfalen, Düsseldorf: photo Walter Klein 19, 65; Mountain High Maps © 1995 Digital Wisdom Inc: p.342; Musée Nationale d'Art Moderne, Centre Georges Pompidou, Paris: 127, photos © Centre Georges Pompidou 61, 159, 186, 222, photo Jacques Faujour 14, 172, photo Philippe Migeat, 10, 13, 29, 35, 84, 93, 95, 96, 98, 104, 105, 106, 146, 157, 158, 160, 168, 170, 185, 192, 219, 225, 226, photo Bertrand Prevost 103; Museum Folkwang, Essen 203; Museum Ludwig, Cologne: photo Rheinisches Bildarchiv, Cologne 28; The Museum of Modern Art, New York: 166, acquired through the Lillie P Bliss Bequest 56, 70, 167, 176, 177, Mrs Simon Guggenheim Fund 51, gift of Mr and Mrs Allan D Emil 143, National State Art Museum of the Republic of Belarus, Minsk: 8; Öffentliche Kunstsammlung Basel, Kunstmuseum: photo Öffentliche Kunstsammlung Basel/Martin Bühler 48, 50, 187; Philadelphia Museum of Art: the Louise and Walter Arensberg Collection 40, given by Hessing J Rosenwald 117, the Louis E Stern Collection 63, 118, 179, gift of Mary Katharine Woodworth in Memory of Allegra Woodworth 64;

© Photothèque des Musées de la Ville de Paris: 44, 138; RMN, Paris: 210, photo Gérard Blot 150, 154, 196, 211, 212, 213, photo H del Olmo 204; Roger-Viollet, Paris: 23, 32, 33, 46, 82, 182, 189, 200, 227; by courtesy of Schirn Kunsthalle, Frankfurt: 97, 99, 100, 102, 107, 108; Francis Skaryna Belarusian Library, London: 3; Sotheby's Inc, New York: 136; RA/Gamma Liaison/Frank Spooner Pictures, London: 195; Sprengel Museum, Hanover: 89, 122, 123, 129, 132, 153, 155; Stedelijk Museum, Amsterdam: 131, 140, 144, 149, on loan from Netherlands Institute for Cultural Heritage 34, 53, 57; Stiftung Archiv der Akademie der Künst, Berlin: 163; Stiftung Sammlung Karl und Jürg im Obersteg, Geneva: photo Peter Lauri 66, 67; Tate Gallery, London: 71, 91, 126, 184, 194; Tel Aviv Museum of Art: 147, 156, gift of Mr Israel Pollack, Tel Aviv (1979) with assistance from the British Friends of the Art Museums of Israel, London 88, Collection of Habima Theatre, Tel Aviv, on loan to Tel Aviv Museum of Art 109, presented by the artist (1948) 148; Union Centrale des Arts Decoratifs, Paris: photo Laurent-Sully Jaulmes 15; Yad Vashem, Jerusalem: 164; United Nations, New York: 208; Van Abbemuseum, Eindhoven: 43; Visual Arts Library, London: 58, 135, 206, 207, 214; Whitney Museum of American Art, New York: gift of the Chase Manhattan Bank 174; Richard S Zeisler Collection, New York: 139

Phaidon Press Limited
Regent's Wharf
All Saints Street
London N1 9PA

First published 1998
© 1998 Phaidon Press Limited

ISBN 0 7148 3160 3

A CIP catalogue record for this book is available
from the British Library.

Typeset in Strayhorn

Printed in Italy

Cover illustration Detail from *The Green Violinist*,
1923–4 (see p.181)